W9-CUA-726

CASSATT

And Her Circle ❦ Selected Letters

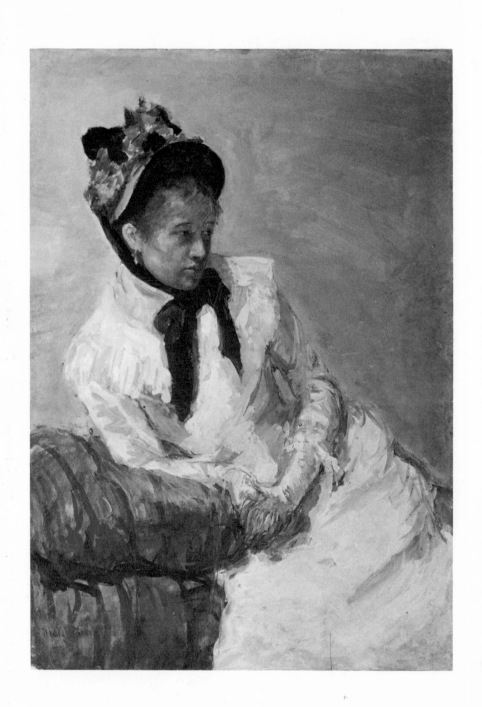

CASSATT
AND HER CIRCLE

Selected Letters

❧

EDITED BY

Nancy Mowll Mathews

Abbeville Press ❧ Publishers ❧ New York

Editor: Nancy Grubb
Designer: Howard Morris
Picture researcher: Amelia Jones
Production manager: Dana Cole

JACKET FRONT: *The Letter*, 1891. Color print with drypoint
and aquatint, 13⅝ x 8¹⁵⁄₁₆ in. National Gallery of Art,
Washington, D.C., Chester Dale Collection.

JACKET BACK: *Self-Portrait*, c. 1880. Watercolor on paper,
13 x 9⅝ in. National Portrait Gallery, Smithsonian
Institution, Washington, D.C.

FRONTISPIECE: *Self-Portrait*, c. 1878. Gouache on paper, 23½ x 17½ in.
The Metropolitan Museum of Art, New York.

Library of Congress Cataloging in Publication Data
Main entry under title:
Cassatt and her circle, selected letters.

Includes index.
 1. Cassatt, Mary, 1844-1926. 2. Artists—United
States—Biography. 3. Artists, Expatriate—France—
Biography. I. Cassatt, Mary, 1844-1926.
II. Mathews, Nancy Mowll.
N6537.C35A3 1984 759.13 [B] 83-21449
ISBN 0-89659-421-1

First edition

CONTENTS

Editorial Note

From the more than 1100 letters I was able to locate in European and American collections, I selected the following 208 to chronicle the life and times of Mary Cassatt. My goal was to discover, research, and present those that offered the greatest insight into Cassatt's character and circumstances as an artist. With this in mind, I concentrated on the periods of her life when she and her friends and family wrote extensively about her career—her student days, her early days as a professional, her Impressionist period, and the period of emerging international fame when she had her first individual exhibitions and painted the *Modern Woman* mural for the World's Columbian Exposition. The letters from the years after 1900, although rich in business and family matters, tended to be less revealing about Cassatt's art, and, as a consequence, I have represented that period more selectively.

All the letters written by Cassatt have been reproduced with the greatest possible faithfulness to the original form, syntax, spelling, and punctuation, with an occasional explanation inserted in brackets to clarify an obscure reference. The letters by her friends and family have been reproduced with equal fidelity, but irrelevant sections have been excised in order to focus on Cassatt. All deletions are indicated by the use of ellipsis points: three dots within a sentence indicate deletion of a phrase; four dots at the end of a sentence indicate deletion of one or more sentences, including full paragraphs.

Unless they are informatively idiosyncratic, the headings have been standardized: the first citation for a place is provided in full, with subsequent references given in shortened form. Dates and locales that are known but that do not appear in the original have been added in brackets.

In all cases the current location of the original letter has been provided in the list of sources, so that the interested reader can consult the unedited version. I have translated those letters written in French with the aid of my colleague, Dr. Elise Lequire of Randolph-Macon Woman's College (each of these letters is identified by the notation "original in French"). Once again, I would urge the interested reader to consult the original letters.

Brief italicized passages have been added between letters when necessary to fill in gaps in the chronology or to provide information essential to understanding the next letter. Footnotes have been used to identify as many of the persons mentioned in the letters as it was possible to identify; a few characters, unfortunately, have been lost in the mists of time.

Introduction

THE LETTERS OF MARY CASSATT, her family, and her friends offer a fresh opportunity to examine a well-known era in American and European culture and to become more intimately acquainted with the prominent artist whose life and career they chronicle. Because most were written by Americans living in Europe, the letters provide a wealth of descriptive detail meant to convey a thorough picture of the expatriate experience to friends and family back home. Today, as vividly as when they were first written, these narratives bring past scenes and events to life.

The power of these letters to carry the reader into the writers' bygone world does not result simply from the use of quaint phrases or reference to old-fashioned customs. Rather, the writers of these letters had expressive abilities that, while appearing informal and effortless, were truly masterful. Even seventeen-year-old Eliza Haldeman, best friend of the young Cassatt, communicates a spirited image of an art student's Philadelphia despite her youthful spelling and grammatical errors. In part this skill resulted from frequent exercise. All the correspondents acquired regular letter-writing habits at an early age; and since they belonged to a social class that encouraged travel and study far from home, they were forced to achieve a high level of competence through continuous practice.

Most of the letters were part of long-term exchanges that sustained relationships for years at a time. The importance of the letters

9

compelled the writers to search for new and better means of conveying information, thoughts, and feelings. Fortunately they had broad linguistic experience that came from their study and use of foreign languages (Mary Cassatt studied French, Italian, German, and Spanish), so they used phrases and expressions in the original languages as well as incorporating fresh structures and vocabulary into their English. The letter writers could also draw on their knowledge of poetry, drama, and fiction in several languages to add richness and subtlety to the communication; the Cassatts were extremely well read and often used quotations or literary references to help express moods or emotions.

Moreover, the appeal of the letters owes a great deal to the personalities of the writers themselves. An animated, intelligent person, Mary Cassatt surrounded herself with people of similar qualities, who saw more and did more than most of their contemporaries. Like Cassatt, they dared to break out of conventional roles, and consequently their letters are surprisingly free of clichés and posturing. Their perceptions were fresh, their evaluations of people and situations were incisive, and their flashes of irony were quick and unpredictable. The force of these strong personalities was tempered only slightly by their innate good manners.

An awareness of historical circumstances permeates these letters. The correspondents were affected by three major wars—the American Civil War, the Franco-Prussian War, and World War I—and, because of Alexander Cassatt's ascent up the corporate ladder to become president of the Pennsylvania Railroad, they also participated in the rapid development of American industry during that expansionist age. Along with political and economic changes came drastic changes in the world of art. From the earliest letters describing the state of art in Philadelphia in the 1860s, we follow the dramatic rise of American involvement in European art at the turn of the century as artists, dealers, and collectors on both sides of the Atlantic took advantage of the new international passion for art. In addition, the letters also trace the ongoing struggle between the old and the new, the gradual acceptance of Impressionism and the inevitable challenge of subsequent avant-garde styles seeking to replace it.

The strongest character here is the artist herself, Mary Cassatt. Tall, wiry, elegantly dressed, she occupied center stage in any

gathering of friends or family. She was skillful in social situations; wherever she went she made friends quickly, drawing people to her by her wit, her energy, and her entrancing conversations about art. Her lifelong friend, Louisine Havemeyer, described the effect Cassatt had on her when she spoke of a particular artist:

"... I owe it to Miss Cassatt that I was able to see the Courbets. She ... explained Courbet to me, spoke of the great painter in her flowing, generous way, called my attention to his marvelous execution, to his color, above all to his realism, to that poignant, palpitating medium of truth through which he sought expression. I listened to her with such attention as we stood before his pictures and I never forgot it.[1]

Cassatt's power was felt not only by Americans, but by people of various nationalities as she traveled abroad. Because she spoke French fluently and learned other languages quickly, she struck up acquaintances with the many artists she met in museums and art gatherings in France, Italy, Spain, Belgium, and elsewhere. In addition, she sought out European masters for advice on her work and won their lasting admiration. Her eagerness to be a part of an international circle of artists led her ultimately to become the only American member of the Impressionists.

And yet, in spite of her social skills, Cassatt was, at heart, a loner. Brought up in a close family, she learned to be independent of outsiders and to pursue her own interests with an unusual single-mindedness. She frequently traveled by herself, under difficult circumstances if necessary, to arrive at a desired artistic destination; for instance, she went to Seville in 1872 to paint for several months, knowing no one and with only a limited knowledge of Spanish. As she got older, she maintained retreats outside of Paris—one in Beaufresne, an hour's train ride away, and the other in Grasse, near Nice. As strong as her social relationships were, her intellectual independence and critical nature often caused conflicts to arise, and, at times, she preferred to keep her distance.

As was typical in the Victorian era, Cassatt's closest and most lasting friendships were with women. When she was an art student, she shared with her friends the excitement of exploring new paths; later, she was active in the circles of women artists in Paris. She gravi-

1. Louisine Havemeyer, *Sixteen to Sixty, Memoirs of a Collector* (New York: Privately printed, 1961), p. 190.

tated toward other gifted and achievement-oriented women such as art educator Emily Sartain, artist Berthe Morisot, collector and suffragist Louisine Havemeyer, and architect Theodate Pope Riddle; and in her letters, she openly expressed affection and respect for these friends. In addition, her relationship with her mother was especially close; they shared an interest in travel and cultural matters that made them frequent companions during Cassatt's first years in Europe, and later, when her parents made their home with her in Paris, the arrangement was a happy one for both mother and daughter.

But Cassatt had friendships with men that were only slightly less strong than those with women. As an artist, she had ample opportunity to associate with men on a professional basis and did not shy away from the relationships that resulted. She mixed easily with her peers and often formed close ties with older male artists and teachers; even before her well-known relationship with Degas, she had been close to her teachers Paul Soyer, Charles Bellay, and Carlo Raimondi. Later in life, her most important ties were with art dealers like Paul Durand-Ruel and his sons and collectors like Henry O. Havemeyer and James Stillman. Within the family circle, she and her brother Aleck had a special closeness that was based on shared personality traits and common interests.

Cassatt's relationship with her father, although warm, was more complex. His idiosyncracies clearly annoyed her, and, in later years, she expressed resentment over his earlier efforts to prevent her from becoming an artist. In 1912 she told her biographer, Achille Segard, that her father had been alarmed when she disclosed her intention of returning to Europe for a serious artistic career and that he had announced that he would rather see her dead. Yet however strongly Cassatt may have felt her father's disapproval, no evidence of it appears in his letters. Throughout the years they lived together in France he showed nothing but interest in her work and pride in her as an artist.

Romantic involvement in Cassatt's life remains an elusive subject. Certainly as a young woman she was part of a high-spirited circle that indulged in flirtations and mock engagements such as hers with Eliza Haldeman's brother Carsten. But among her friends there was a strong belief in a woman's steadfast pursuit of her career, and since many of her friends married late or not at all, her own

unmarried state would not have been remarkable. Furthermore, after her parents and sister came to live with her, she was even less inclined to marry and leave the comfortable home they established. As for her true feelings for the irascible Degas, she apparently took care that their correspondence be destroyed before their deaths, protecting their privacy and preventing us from drawing any definitive conclusions. It might be inferred, however, that their relationship was quite warm, even in many ways romantic—along the lines of her earlier relationships with older artists—but not romantic enough to tempt either of them to consummate it.

Cassatt's feelings toward children fell into a similar pattern of closeness and distance. She was fond of her nieces and nephews, enjoying their company and finding them interesting as artistic subjects. She showed great concern for their education, both by sending them books and by helping them to attend superior schools in Paris or the United States. And she was thrilled that her brother Gardner wanted his first daughter, Ellen Mary, to be her namesake. But beyond that, children in general did not occupy her thoughts. She sought them out as models, but seldom formed lasting relationships with them, nor did she express a desire to have any of her own.

What emerges from the letters is that Cassatt's passion was, above all, for art. Without being a recluse or detaching herself from normal human interests, she quite unaffectedly reserved her enthusiasm, pride, anger, speculation, and even financial drive for that one overriding topic, which preoccupied her for at least sixty-six years. Aside from her family and a few close friends, most of the people in her life were in some way contributors to her art: teachers, colleagues, collectors, dealers, or models. Cassatt's interest in them was warm as long as they shared her enthusiasm.

The Cassatt letters propel us through a time of historical and cultural upheaval, at the center of which stands the compelling figure of Mary Cassatt, whom we follow from age sixteen to eighty-two. This condensation of an era and of a life takes on an unexpected poignancy, as we pass quickly from decade to decade, youth to age. But in large part the poignancy is due not only to the awareness of the relentless passage of years, but even more to the power of the letters to bring to life a remarkable woman. We might say that the letters stand with Cassatt's art as significant and stimulating contributions to modern culture.

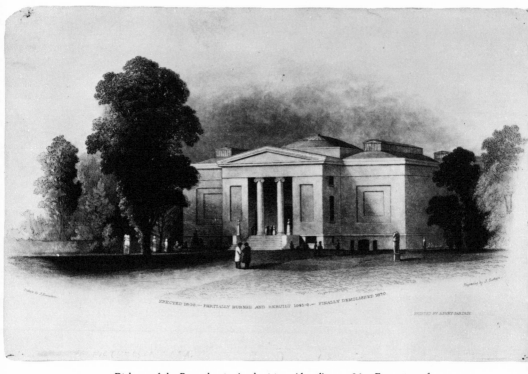

1. *Diploma of the Pennsylvania Academicians* (detail), c. 1860. Engraving after drawing by James Hamilton. The Pennsylvania Academy of the Fine Arts.

1

The Student Years

1860-1869

IN 1860, when Mary Cassatt and her friend Eliza Haldeman became art students at the Pennsylvania Academy of the Fine Arts, Philadelphia was a prosperous city. The railroad that carried the teen-age girls from their homes in the countryside was a major reason for the prosperity. The railroad stretched westward—now that the link to Pittsburgh was completed—bringing trade from Chicago and the other growing Midwestern cities. On the eve of the Civil War, Philadelphia, as the nearest northern city to the Mason-Dixon Line, would become the central depot for the movements of men and materials.

Philadelphia was the second largest city in the United States, the fourth largest in the world; it challenged New York in industrial growth in the middle decades of the century. Cultural life was also flourishing. The new Academy of Music opened triumphantly in 1857, and the Pennsylvania Academy of the Fine Arts (figure 1) welcomed an average of 13,000 visitors annually to its exhibitions of contemporary and Old Master art. It was an exciting place for two young women to seek their fortunes; and, thanks to the recently improved police department and the urban railcar system, it was also safe and convenient.

Like most of the art students at the Pennsylvania Academy, Mary and Eliza came from educated and financially secure families. Mary's was a distinguished old Pennsylvania family; her father, Robert S. Cassatt, had already taken them to live in Europe for four years.

Eliza Haldeman had a similar background: her family was Swiss in origin, but had settled in Pennsylvania before the Revolution. Her roots were in Lancaster County, where Mary's family had also resided. Eliza's father, Samuel Stehman Haldeman, was a prominent naturalist and philologist whose writings were widely published. Mary and Eliza's companions—Howard Roberts, Edward McIlhenny, and Thomas Eakins—also came from educated, comfortable families who supported their sons' pursuit of the fine arts. Brought together in the informal classes at the Pennsylvania Academy on Chestnut Street, these young people formed an eager, high-spirited group.

By 1860 classes had grown so large that the old building could barely accommodate them. The students, inspired by two writers on art—Rembrandt Peale, who preached the practicality of art, and John Ruskin, who celebrated artistic genius and new art styles—came to the Academy in increasing numbers during this period. Once enrolled, they were expected to spend up to two years learning to draw from life and from other works of art, before specializing in painting or sculpture. Apart from the lectures on anatomy at the Penn Medical University, classes generally were conducted without a teacher. On-the-spot corrections and advice would be given by the more advanced students or by the Academy curator, Robert Wylie. To supplement this, students went independently to an established artist like Christian Schussele, Joseph A. Bailly, or Peter Frederick Rothermel for lessons. The program of instruction at the Academy was determined by the Council of Academicians, which was headed by Schussele and John Sartain (a prominent Philadelphia engraver and publisher of *Sartain's Magazine*) and included the sculptor Bailly and Dr. Joseph Sommerville among its members. The president of the Academy was Caleb Cope, a powerful Philadelphia banker.

By the time Mary Cassatt and Eliza Haldeman arrived, the Academy offered women a program similar to the men's. At the core of Academy instruction was mastery of the human figure, which was accomplished through a three-pronged approach: first, drawing from the Antique, which meant copying the Academy's collection of plaster casts of famous ancient statues; second, learning anatomy from lectures and the dissection of human corpses; and third, drawing from live models, both clothed and nude. Each of these phases of art instruction had been closed to women in the early days of the

16

Academy, but they were opened one by one as the female students demonstrated that their seriousness took precedence over modesty. By 1860 women students received instruction in all but the nude model (which was added eight years later). Cassatt and Haldeman reflected the spirit of those days: above all, they wanted to be *professionals*—to master their craft, to exhibit, and ultimately, to sell.

For inspiration the students eagerly studied the masterpieces available to them in Philadelphia. They were taken to see the art amassed by wealthy collectors in the city such as Joseph Harrison and Henry C. Carey, and at the Academy they soon grew familiar with such works as Erastus Palmer's bust of *Spring* and J. B. Wittkamp's *Siege of Leyden* in the permanent collection. Special exhibitions at the Academy also helped to broaden the aspiring artists' horizons. A major annual exhibition combined Old Master art, the best contemporary work from Europe, entries from the elected members of the Academy, and selections from up-and-coming artists. In 1864 the annual was supplemented by another art exhibition in Philadelphia that was part of the Central Fair, a grand benefit exhibition held on behalf of the U.S. Sanitary Commission, which aided wounded Union soldiers. (A year before, the Civil War had become a grim reality to Philadelphians when a threatened invasion of the city was averted, and the Confederate march into Pennsylvania was stopped at Gettysburg.)

The European art shown in these exhibitions had a profound effect on the Academy students. In 1858 the landmark *American Exhibition of British Art* acquainted them with the art of the Pre-Raphaelites; but even more influential was the French art that was shown frequently in Philadelphia exhibitions during these years. The circle of Cassatt, Haldeman, Roberts, Eakins, and the rest came to know such works as Jean Léon Gérôme's *Egyptian Recruits Crossing the Desert*, shown in 1860, 1861, and 1862, and Rosa Bonheur's *Horse Fair*, shown in the 1864 Central Fair. The teachers Schussele and Bailly, who were themselves trained in France, taught them to admire the consummate craftsmanship of the French masters. The result of the French influence is plain to see: six months after the war was over Mary Cassatt was in Paris; by the end of May 1866, Howard Roberts, Earl Shinn, and Eliza Haldeman had arrived; in September, Thomas Eakins joined them. A new era was dawning: not only did the young art students crowd the classes

in Philadelphia, they began to make Paris their second home, flooding the museums and ateliers. This had its frivolous side, as voiced in Eliza Haldeman's lament in 1868: "There is a quantity of our old Artist acquaintances over here just now and I am afraid the Louvre will become a second Academy for talking and amusing ourselves."

The Philadelphians would find the spirit of Paris in the mid-1860s a familiar one. On the surface, at least, the city was prosperous and vital, a center of transportation and industry. Following Napoleon III's plan for greater international trade, Paris was redesigned to accommodate the business brought to the city by the growing rail system. Wide avenues and bridges began to replace the centuries-old maze that was Paris of the past. Napoleon III borrowed from London the idea of the large public park, and by reorganizing the Bois de Boulogne, he made riding (by carriage or horseback) and racing newly accessible to the city's inhabitants. These reforms, as well as a widespread Anglomania, made Paris a more comfortable place for Americans who were used to convenience, sport, and Anglo-American customs.

Furthermore, Paris in 1866 was in the midst of preparations for the Exposition Universelle, which would bring foreigners of all kinds to the city the next year. This lavish world's fair was intended to represent every human endeavor in every country of the world; and, for the satisfied throngs who descended on Paris, it was successful. The young Americans were impressed with the cosmopolitan aspirations of the Second Empire; a young artist from Boston, Elihu Vedder, wrote home to his father, "Paris is without doubt the most splendid City in the world."

Mary Cassatt and Eliza Haldeman arrived in Paris at separate times and it took them until October of 1866 to clear up a now-obscure misunderstanding and become friends again. Since women were not admitted to the official Ecole des Beaux-Arts, they made other arrangements to continue their studies. Cassatt chose one route: she took private lessons from one of the principal masters of the Ecole des Beaux-Arts, Jean Léon Gérôme. Haldeman, on the other hand, joined a class for women held by another prominent Parisian master, Charles Chaplin. Although they were denied the range of courses taught at the Ecole, they found that there was no dearth of instruction available to women. Above all, they discovered that they could work regularly from models and that they could copy

endlessly in the Louvre (they both obtained permits to copy in 1866).

In early 1867 Cassatt and Haldeman decided to explore another avenue of study that had attracted a number of Americans. They left Paris for the picturesque French countryside, where they would be able to hire local peasants to pose in regional costumes for genre paintings: scenes of everyday activities taking place in humble settings. At first, after the two young women settled in Courances, they continued to take their work back to Paris for Chaplin to critique. But soon they decided to move to Ecouen, a small town about ten miles north of Paris, to join an established art colony led by the two foremost genre painters of the day, Pierre Edouard Frère and Paul Soyer. The small-scale scenes of fresh-faced women and children engaged in humble activities that these two artists created won the hearts of American artists and collectors. Part of their appeal, which may account for Cassatt's particular interest, was the creamy texture of the paint surface, which brought alive the drab gray-brown palette used to evoke the peasant ambience. Soyer, who took on the two friends as pupils, advised them on their technique as they worked on sketches and paintings at home or in a picturesque corner of the hillside town. They enjoyed another benefit of working in an art colony: the relaxed social life that sprang up in this congenial group. They were friendly with artists of all nationalities, but were closest to the other Americans, such as Henry Bacon, a Massachusetts artist who had studied in Paris for two years, and his wife.

Cassatt and Haldeman briefly visited Barbizon to investigate the special approach to landscape painting that had become identified with that town on the edge of the Fontainebleau Forest. Barbizon, as well as Pont-Aven, two towns now famous as sites of radical artistic activity in the nineteenth century, were both popular with Americans, who were charmed by the artistic potential of the sites and eager to receive instruction from the French artists there.

Even though Cassatt and Haldeman no longer worked in Paris, they were still tied to it by the most important event in the artist's year: the Paris Salon. Originally established as an exhibition of the latest work by members of the Academy, since 1791 it had been open (by jury selection) to all artists. Every year, as the spring deadline for submissions approached, this year's entry occupied

everyone's thoughts. In 1867 the paintings that Cassatt and Haldeman sent to the Salon were refused. But in 1868 the jury was more lenient: not only did it accept works by the controversial artists Edouard Manet, Edgar Degas, Camille Pissarro, Claude Monet, Auguste Renoir, Alfred Sisley, Frédéric Bazille, and Berthe Morisot, but also Cassatt's *La Mandoline* (page 53), Haldeman's *Une Paysanne*, and a number of other American entries. The two friends left Ecouen to stay in Paris for the duration of the Salon. They reveled in their success, impressing friends and family with free tours of the exhibition during non-public hours—an exhibitor's privilege. At the same time, they were initiated into the social aspect of the Salon, observing the thousands of fashionably dressed Parisians and tourists who flocked to the galleries of the Palais de l'Industrie on the Champs-Elysées.

To the Americans, the most important art at the Salon was by the established French masters whose work they had learned to admire back home and who were now their teachers. Consequently, they would pass by the works of the less familiar artists like Manet, Monet, or Renoir in search of the latest offering by Gérôme, Alexandre Cabanel, or Gustave Doré. But the radical artists' challenge to the academic system in the 1860s had an effect on American opinion: one finds in the Cassatt and Haldeman letters of the late 1860s a more critical attitude toward the established masters and the Salon system in general.

Cassatt soon tired of the circuslike atmosphere of the Salon and she returned to the country, settling this time in the small town of Villiers-le-Bel, less than a mile from Ecouen. The attraction of Villiers-le-Bel was the notorious painter Thomas Couture who, after a wildly successful career as an official painter (following the triumphant Salon appearance of his most famous painting, *Romans of the Decadence*) and teacher (Manet studied with him for six years), renounced the Paris art world and took up residence in this small town. Although he led a secluded life behind the walls of his villa, he took on a number of pupils, principally Americans. Eliza Haldeman eventually joined Cassatt in Villiers-le-Bel and spent her last months in Europe as a Couture student.

Left on her own after Haldeman's return to Philadelphia, Cassatt continued to study in a variety of settings. She painted in Paris early in 1869 and later took a sketching trip to the Alps with her friend

Miss Gordon. This trip, which offered a new group of peasants—the Savoyards—and a new landscape to study, was refreshing to Cassatt after her disappointment at being rejected by the Salon that spring. It also produced a painting called *Contadina di Fabello; val Sesia (piémont)* (*Peasant Woman of Fabello, val Sesia, Piedmont*) which was accepted at the Salon of 1870.

Cassatt's travels eventually led to Rome and finally back to Philadelphia in the fall of 1870. She had accomplished a great deal in the first decade of her career: she had taken advantage of the best training offered in the United States; she had studied in Paris, Ecouen, Villiers-le-Bel, and Rome, in addition to traveling and working on her own; and she had twice been accepted at the Salon. We see in this youthful accomplishment—resulting from her eagerness to take advantage of new opportunities for advancement and her unshakable dedication to her art—the seeds of her mature success.

The story of Cassatt's student days in the United States and France unfolds in the correspondence of her friend Eliza Haldeman. Haldeman's letters to her family while the two young women were studying together at the Pennsylvania Academy and traveling together in France reveal the common experiences of the two aspiring artists; and the few letters from Cassatt to Haldeman fill in the picture when the two were apart. Since the correspondence commences when they were at the ages of sixteen and seventeen, it tells the story with a typical youthful neglect of spelling, punctuation, and literary style, but at the same time it evokes the exuberance of that age.

<div style="text-align: center">Philadelphia

January 26, 1860</div>

Dear Father,

I received your letter yesterday just in time to answer it this week, it is snowing very hard at present so that I cannot go out today though I have two engagements. . . .

Last week Mr. Cope took all the young ladies to see the collections of Mr. Cary and Mr. Harrison at the former's.[2] I saw the original of "Mercy's dream" by Huntingden and the companion to it "Christina and her Children," the first is one of the most beautiful pictures I have ever seen, you cannot form any idea of it from the engraveing.[3] I only wish you could have been with me for I still rely on your judgement. I saw some copies of Rembrant an original of Sir Thomas Lawrence several of Leslie's, includeing "Sancho and the Duchess" some very fine ones of Sully and one very beautiful, "The Poet's Dream" by Leutche.[4] I dont know if that is the way his name is spelt but I think it is the same one who sketched that little pencil likeness of Uncle Eddie's. Mr. Harrison has also one of his and he has Wittkamps "Lear" that caused such a sensation when it was on exhibition here, and also Rothemels which is very much like it only not near so good.[5] I heard say that Wittkamp was only 24 years old when he painted the "Siege of Leiden."[6] I saw some of the English painter Lucy's works, and one of Haydon who committed suicide, and he has a beautiful full size statue of "Eves repentance" by Bartholemew.[7] It is fixed on a pedestal and an oval of purple velvet set in the wall behind it, but I think you will be tired reading so much about pictures though that is almost the only thing I take any interest in. Dr. Sommerville thinks I am still improveing.[8] Today I asked Mr. Wylie to look at my drawing.[9] While he was correcting it Mr. Wharton[10] came up and said "I might as well try to cross Mount Blanc as to draw that head it was one of the hardest ones in the Academy." I had a mind to tell him that no less than three ladies had crossed it. . . .

Miss Cushman made a singular remark at the Academy.[11] You remember that bust Mr. Wylie was modeling in his room, he took her to see it when she was there, and she said she wondered such a homely person would have her face cut in marble. I wonder if she thinks she is handsome, for you know her bust is on exhibition at Earle's.

I believe I have told you all. I was glad for the corrections in your last letter and hope if it is not too much trouble you will do so in all of them, it will improve me more than any thing I know of. I am trying to be careful and think I will soon be able to write you a letter without any mistakes.[12] If you go [to Europe] next week where do you sail

from? and will you be here to bid me good bye?

Your affectionate Daughter

Eliza J. Haldeman

1. The earliest known letters from Eliza Haldeman Figyelmessy (1843-1910) to her family in Chickies, Pennsylvania, date from January 1860, when she went to Philadelphia to study at the Pennsylvania Academy of the Fine Arts. She stayed at Miss Howes's boarding house with a number of other young ladies, including, at times, Mary and Lydia Cassatt. Eliza wrote most frequently to her father, Samuel Stehman Haldeman (1812-1880), a distinguished scholar who was named professor of comparative philology at the University of Pennsylvania in 1868. She apparently did not continue her career as an artist after her return from Europe and none of her student works is known to exist today. It is impossible to pinpoint when Mary Cassatt joined her at the Academy, but by the fall of 1860 Mary's artistic ambitions were well known by the Cassatt family, indicating her exposure to artistic life, and when Haldeman first mentions her by name at the end of 1861 she speaks of her as a longtime colleague. Twenty-nine letters from Eliza Haldeman to members of her family are in the archives of the Pennsylvania Academy of the Fine Arts.

2. Caleb Cope (1797-1885) was a philanthropic Philadelphia financier who served as president of the Pennsylvania Academy from 1859 to 1872. Henry Charles Carey (1793-1879) and Joseph Harrison (1810-1874) were prominent collectors of American and European art. Carey, head of a leading publishing house, owned works by Huntington, Leutze, and Thomas Sully. Harrison owned, in addition to the works mentioned by Haldeman, Benjamin West's *William Penn's Treaty with the Indians* and John Vanderlyn's *Ariadne on Naxos*. Both collections were later given to the Pennsylvania Academy.

3. Daniel Huntington (1816-1906) was a prominent American painter who had studied in New York and Rome. He became president of the National Academy of Design in New York in 1862.

4. Emanuel Gottlieb Leutze (1816-1868), born in Germany, came to Philadelphia as a child. He studied there before returning to Düsseldorf, where he began his career and painted his most famous work, *Washington Crossing the Delaware*.

5. Johann Bernhard Wittkamp (1820-1885) and Peter Frederick Rothermel (1817-1895) were well known to the Academy students. Wittkamp, a Dutch artist, enjoyed great success in Europe and the United States and placed a number of his paintings in Philadelphia collections. Rothermel, a Pennsylvanian, studied in Europe and returned to Philadelphia, where he was a member of the Pennsylvania Academy and taught painting to the Academy students.

6. Wittkamps's *Deliverance of Leyden from the Siege by the Spaniards under Valdez in 1574*, measuring 14 by 23½ feet, had been a highlight of the Pennsylvania Academy collection since its purchase in 1851. In 1952 it was presented to the Netherlands and entered the collection of the Rijksuniversiteit in Leiden, Holland.

7. Charles Lucy (1814-1873), Benjamin Haydon (1786-1846), and Edward Bartholomew (1822-1858) were prominent British artists.

8. Joseph Sommerville was on the Committee of Instruction of the Academy.

9. Robert Wylie (1839-1877), born in England, studied at the Pennsylvania Academy and became its curator. He went to France in 1864 to study sculpture but switched to painting and settled in the artists' colony of Pont-Aven.

10. Philip F. Wharton (1841-1880) had studied at the Academy before finishing his artistic training in Dresden and Paris. He returned to Philadelphia, where he specialized in genre and literary themes.

11. Charlotte Cushman (1816-1876), one of America's greatest actresses, had retired to Rome in 1858. In 1860 she returned to the American stage for a brief comeback. She

frequented artistic circles and was a close friend of the American sculptors Harriet Hosmer (1830-1908) and Emma Stebbins (1815-1882). Stebbins's bust of Cushman was then on view at Earles, Philadelphia's leading art dealer and auction house.

12. Eliza Haldeman's mistakes in spelling and punctuation have been faithfully reproduced; in some cases essential punctuation has been added where the handwritten text indicates a clear pause or the end of a sentence.

ELIZA HALDEMAN TO SAMUEL HALDEMAN

Philadelphia
February 4, 1860

Dear Father,

I received your letter this morning and as I have a little time before tea will answer it. . . .

I have commenced taking drawing lessons from Mr. Schuchelle,[1] that is, one of the young ladies at the Academy and my self go to his Studio once a week, and have him criticise the drawings we made that week, almost all the Pupils at the Academy take lessons in this way. As for painting, I don't think I shall commence it at all this winter. They generally study from the Antique two winters before commencing, and one of the young gentlemen studied two and a half years here, and then went to Paris to finish, when he got there they put him to copying for a year before they allowed him to commence painting, so you see I have plenty of work before I can call my self an artist.

You remember Mr. Roberts Mrs Weir's brother who I told you was so indolent, he surprised us all very much last week by bringing down a bust of himself which he had modeled and which was an excellent likeness.[2] He did it with the aid of looking glasses, and must have spent a great deal of patient labour on it, he is now finishing an Ajax at the Academy, "Chinebonago."

Mignots landscape has been recently sold for 550 dollars, the original price being 1100.[3] I suppose the hard times makes the difference. If you go to Europe you ought to take the Lens of your Microscope with you and get another, you know last time you forgot it.

Carsten was to see me last week he spent Sunday in the city, he told me they had all gotten well at home and all the news.[4] My health is excellent. I am obliged to walk every day which I suppose accounts for it. I think the same practise would improve your health and by giving the body more strength would increase the action of the mind. Ain't I learning physiology? I just wish I could tell you all the hard latin words I know, the names of the foramins fosses fissures fibers and functions, but I will astonish you with these when I come home.[5] My letter was com-

menced according to date but since then I have had no time to finish it until now the 7th of the month. My time is so occupied that Friday evening when I have no lessons to study for Saturday is the only time I have to write so that when I do not get your letters before that I have to leave them until the next week to answer them, that is the reason I could not get a letter to you this week although I tried. I am so glad you think I am improving, your praises are all the reward I want for my labour and when I can please you I feel I have well employed my time. I am glad to know your book is finished and wish you would not work so hard and care more for your health. When I hear you are ill I only begin to think how impossible it would be to live without you.

<div style="text-align:right">

Yours affectionately
Eliza J. Haldeman

</div>

1. Christian Schussele (1824-1879), an Alsatian who studied art in Paris before arriving in Philadelphia in 1848, was active in shaping the instruction at the Pennsylvania Academy and taught drawing to Academy students.

2. Howard Roberts (1843-1900), a good friend of both Mary Cassatt and Thomas Eakins at the Academy and later in Paris, was beginning a career as a sculptor. After his studies at the Ecole des Beaux-Arts he returned to Philadelphia, where he was elected a member of the Academy and enjoyed great success.

3. Louis Remy Mignot (1831-1870), born in South Carolina, painted in New York and London.

4. Carsten was Haldeman's elder brother.

5. The study of anatomy was part of the Academy program. Lectures given at the Penn Medical University were open to women for the first time that year.

ELIZA HALDEMAN TO SAMUEL HALDEMAN

<div style="text-align:center">

Philadelphia
December 21, 1861

</div>

Dear Father,

I received your letter this morning and hasten to answer. The reason you do not get my letters until Teusday is that I write them in the evening Saturday and they can not be mailed till Monday morning so that of course they are late getting to you—however if Mother likes to get them better on Monday I could just as well write Friday eve and mail Sat. and then they would go in time. . . . I was to hear Forest as "Jack Cade" in the time of Henry Sixth, and liked it more than I can tell you.[1] I went with Miss Brodhead and her brother, who insisted that I should accompany them, it is wonderful considering the hard times what crowded houses he draws, there was not a space in the whole place that was not

filled. Jack Cade is considered one of his best pieces and was written especially for him. . . .

I see Mr. Cope every day, he frequently asks after you. Mr. Wylie makes himself generally disagreeable, hardly anyone at the A—— [Academy] likes him. I like him as well as ever, as I never was very intimate with him of course I could not fall out with him, but we dont see much of him. We have several new pupils both male and female but Miss Cassatt and I are still at the head* *(i.e. of the ladies). Most of the old gentlemen scholars have gone away and commenced to paint. Mr. McIlhenney is going to commence after Christmas, but he has been drawing 3 years. Miss C— [Cassatt] is doing the Atlas. We keep pretty nearly together. She generally getting the shading better and I the form, she the "ensemble" and I the "minutia" but I am trying hard to get ahead. I have not taken my Laocoon up yet so I dont know what Schuessele will think of it. The last one he said was better in some respects than hers and worse in others. So it left us equal. . . .

Dont you think slavery will be abolished before the war is ended? I would like to know your opinion on the subject, and dont you think it would be a good thing if it was? I think it could be done constitutionally, or rather that we need not be ruled by the constitution in regard to them. What do you think. I meet lots of abolitionists here many who said they were not so before the war, but now that there was a good opportunity to free the slaves it should be done. Do you think slavery right? if so Why? Tell Mother I will send the edging, and tell Vic I will send him something.[2] How I would like to see him. Love to all at home, and believe me Yours as ever

<div align="right">Eliza J. Haldeman</div>

1. Philadelphian Edwin Forrest (1806-1872), America's first great actor, was well known in Philadelphia, New York, and London for his histrionic style. Forrest awarded over $20,000 in prize money for new plays to showcase his talent, and Jack Cade was one of the nine plays written for him during the 1830s.
2. Vic was Haldeman's younger brother.

FROM MARY CASSATT AND ELIZA HALDEMAN,
TO THE COMMITTEE ON INSTRUCTION
OF THE PENNSYLVANIA ACADEMY OF THE FINE ARTS

<div align="center">Philadelphia
March 7, 1862</div>

Comm: on Instruction of the Penna: Academy of the Fine Arts

Gentlemen.

We wish to copy one of the Heads in the picture entitled "The Deliverance of Leyden" by Wittkamp. The size of our Canvass to be 20 x 25 inches.

<div align="center">
Mary S. Cassatt.

E. J. Haldeman
</div>

The Comee are unaware of any reason why the President should not issue the Permit applied for

Comee John Sartain

 Joseph Sommerville

Phila March 7th 62

Philadelphia
March 7, 1862

Dear Father,

I am afraid from my last letter you will think I have given up telling you the news, but as the time grows shorter I find I have so much to do that I have to be even more industrious than usual. In the evening I am tired and this is the first spare moment I have had in the morning for an age.

I made a slight mistake as to the monogram both as to the wood and also Mr. John Stevens, when the artists do not themselves draw all thier designs on wood, receives the credit of them. He (John) has had several in since then but I cannot discribe them. When I come I will show you. Mr Wylie also had one in that he drew on wood, very good. The artists are trying to get up a commic paper in this city, it is to be called "Rack." It is a secret yet, as they don't know whether it will suceed. I have seen some of the drawings, and they are real good.[1]

We had some fun about a week ago. Miss Welch, one of our amature students, that is to say she dont intend to become an artist, wanted to cast the hand of a friend of hers, a gentleman. So they came down one morning and commenced. As she did not know the first thing about casting you may know how she proceeded. Miss Cassatt and I went in to look at her and asked, Why dont you do this! how will that come out? You have too much undercasting here. So she finally found it would be well to have some assistance, introduced us to the gentleman, and asked us to help her which we did, making an excellent cast and flattering the specimen of Genus "Homo" exceedingly. His experience of Artist life was so pleasant that he beged if we were willing to send for a photographer and have the whole scene taken just as we were. We consented and the man came. It was in Mr. Wylies room and the first impression was too dark, so we got Mr Copes permission to go in the galleries and had it taken there with the Gates of Pisa or Paradise for the background and the little bust of Palmer's Spring[2] and another, on each side. Miss Welch had a hammer and chisel knocking off the plaster. Miss C— had the plaster dish and spoon which we had used in her hand. Inez Lewis was knocking also, I had a spoon helping Miss C— and Dr. Smith the owner of the hand in question was behind. It was an excellent picture and he is going to present us each with one when they are finished [see page 35].

I have been going pretty regularly to the Germania and find it of great profit. They have played several of my pieces.[3] Cousin Sarah and Hannah Ross are in the city I have not been to see them yet but am

going today. I saw them yesterday in a carriage. I do hate to waste the time, you have no idea how busy I am now. I had the blues the other night when I wrote but they are all gone now and I am as happy as a bird. We are having beautiful weather and I am so glad. I would like you to send me a little money this week if you can. I need some for art purposes. The last dollar went to Gottschalk's concert. I enjoyed it so much. He played the "Last Hope" and the "Banjo" so you can see I have some new ideas. You must excuse the writing as I am in a great hurry to go the Academy and the ink is bad. Dont forget the money. Give ever so much love to everybody. . . .

Good bye little Darling and write soon

Eliza

1. What Haldeman meant by "monograms" and what ultimately happened with the "Rack" are now unknown.

2. Erastus Dow Palmer (1817-1904), the largely self-taught American sculptor, was known for his portraits and allegorical subjects.

3. The Germania was an orchestra in Philadelphia. Haldeman studied piano and frequently attended musical events.

ELIZA HALDEMAN TO MRS. SAMUEL HALDEMAN

Philadelphia
March 17, 1862

Dear Mother,

I have just come in from spending an evening with Miss Chillas and as Miss Howes is not yet in I thought I would write a little to you. I have had such a pleasant evening and it is now 10 o'clock, early for the city but I was afraid the house would be shut up and I could not get in if I stayed longer. I went early and took tea after which several of her friends came in and I played for them to dance. . . . And now for a grand secret that you finally force me to tell you. Dont be frightened! it is only paint and painting. But to commence. I wanted to make you a surprise in the way of a painting before I come home, and have been hard at work for about two weeks. It is a head copied from the "Siege of Leyden" but as you have insisted on my taking lessons & as I have finally concluded it will be best to follow your advice, I thought I would tell you so that you could account for my being so busy and giving you so little news in my letters. Miss Cassatt is also copying from the same picture and a Mr. Wilson has kindly assisted us so that we are getting on nicely. We can have as many teachers there as we wish for all are anxious to have a "finger in the pie" but we only take his advice and some times he will sit

29

2. Women students at the Academy sewing the flag, 1862.

down for two or three hours and show us. In this way he almost finished a head for me so that I commenced another and I will have two from that source to bring to you. I am going to Rothemels the first of April as it will be best if I learn coloring to learn it right. I only did and am doing the other for an experiment and as a surprise for you and did not intend to do more than one head but since you wish me to take lessons I will go to him. He will teach me best and his lessons are $10 and $20. The last two days we all at the Academy have been working at a large flag. It was bought by subscription of the gentlemen and the ladies offered to make it. Of course I had to help. It is seven yds long so you know that we have been pretty industrious as it is nearly finished. Tomorrow we will put the last touches on it and I think in the afternoon I can paint a little. But I must stop as it is 11

oclock. . . . I will see about the pattern for Vic and also the little girl. Little short English jackets are worn for covering entirely this spring, coming a little below the waist. Garibaldies and Zouaves will be worn a great deal in summer. The former are a kind of shirt of the material of the dress, plain on the sholders and plaited in box plaits at the waist. Love to all! The edging was 4cts the old kind, and 6cts the new.

Send me two or three postage stamps the next time you write if convenient and tell Father I will write to him soon and am much obliged for the Art notices. . . .

Yours as ever

Devotedly,
Eliza

EDWARD A. SMITH TO THE MISSES WELSH, HALDEMAN, CASSATT, LEWIS

Philadelphia
Tuesday evening,
March 26, 1862

To the

Misses Welsh / Haldeman / Cassatt / Lewis

Among the charming morsels of reminiscence which Dr. Edward A. Smith will ever cherish is the delightful note this day received; and he begs to assure them, that however ethereal etc may be the photograph, the remembrance of the morning spent at the Academy will remain as new, as distinctly and sharply cut for his future as will for Art the choice emanations from their chisels and pencils. He would also add that he anticipates much from them; and, as those less gifted can sometimes lend a hand, they may feel a positive certainty that he will enter the lists in their favor against all comers.

Thus he thanks them.

Edward A. Smith

MARY CASSATT TO ELIZA HALDEMAN

[Cheyney, Pennsylvania] [1]
Friday, January 2, 1863

Dear Ite,

I have waited in vain for an answer to my letter, which I must acknowledge hardly deserved one, and as I have a commission for you to do if you will be so kind, I break through my invariable rule of not writing one letter until a former one is answered.

Lyd[2] & I propose if it is pleasant weather to make our appearance in

31

to Eliza Haldeman
Mary Cassatt

Friday Jan 2ⁿᵈ 1863.

Dear Miss

I have waited in vain for an answer to my letter, which I must acknowledge hardly deserved one, and as I have a commission for you to do if you will be so kind, I break through my invariable rule of not writing one letter until a former one is answered.

Lyd & I purpose if it is pleasant weather to make our appearance in the good city of P. some time next week always supposing Miss Howe's can accommodate us. And as Lyd could not—

the good city of P. some time next week always supposing Miss Howe's can accomodate us. And as Lyd could not or would not go until she finished braiding a dress to wear, she wrote a note to Mrs. Palmer corner of Samson & Fifteenth enclosing the money, to send her up a graduated S pattern for the body of her dress. In case you should not know what that is I will make one

[see sketch]

I hope you understand. Now said Mrs. Palmer not having as yet answered the note and Lyd being in a hurry we would be infinately obliged to

32

you if you would go there and get one & send it up in the next note you condescend to write to your ever loving friend.

M. S. Cassatt

P.S. Please also ask Mrs. Palmer if she received the note and if she has not we will pay for it when we go to town.

M.S.C.

1. Although the Cassatts had lived in Philadelphia since 1858 in a house at Olive and Fifteenth streets, they often stayed in the small town of West Chester, where they had close

family ties. In 1861 they built a country house in Cheyney, not far from West Chester, where they spent weekends and summers. In 1862 they moved out of Philadelphia to live year round in Cheyney. Cassatt's visits to Philadelphia were sporadic after this time, and although the letters indicate that she continued to paint, she was probably no longer following the Academy program.

2. Lydia Simpson Cassatt (1837-1882) was Mary's elder sister.

MARY CASSATT TO ELIZA HALDEMAN

> [Cheyney]
> Friday, March 18 [1864]

"Dearest Love do you remember" when we were reading "Timothy Titcombs Letters" that I pointed out to you one passage about husbands & wives when they were seperated for a short time burdening the post with tender epistles.[1] Very well I dont intend to do so but if perfectly convenient to you I will burden the Pennsylvania R.C. with myself & two canvasses (two in case I should spoil one of them) likewise a carpet bag on Wednesday next. You see I am coming earlier than I expected because I want if possible to have my picture dry enough to be varnished before I send it to the 'Cad.' Now please dont let your ambition sleep but finish your portrait of Alice so that I may bring it to town with me & have it framed with mine sent to the Exhibition with mine hung side by side with mine be praised, criticised with mine & finally that some enthusiastic admirer of art and beauty may offer us a thousand dollars a piece for them.[2] "Picture it—think of it!"

Remember all this is only on condition that is perfectly convenient. If you can write so that I may get the letter before Wednesday I shall be much obliged if not I will wait until Thursday. I have been painting all day at your portrait & must finish it—so adieu & believe me your affec. friend

> M. S. Cassatt

P.S. Mother thinks that it is likely your mother dont take as much interest in our pictures as we do and wishes you would come here instead of my going to you but we have no one here to compare to Alice & some one else.[3] Much love to your mother and Fanny Ly.

> Yours truly
> M. S. Cassatt

1. *Titcomb's Letters to Young People, Single and Married* by Timothy Titcomb, Esquire (pseudonym of Josiah Gilbert Holland), was a lighthearted book of advice on morals and manners first published in 1858. Cassatt refers to a passage on the beneficial separation of husbands and wives: "The first week will pass off very pleasantly; the second will find them

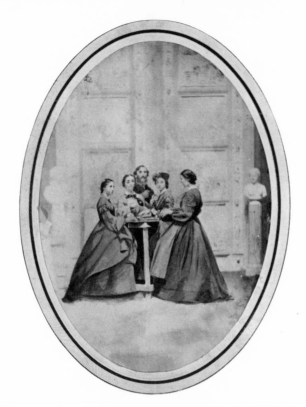

3. Mary Cassatt, Inez Lewis, Miss Welch, Eliza Haldeman, and Dr. Smith, 1862.
See letters on pages 22 and 31.

rather longing for one another's society again; the third will burden the mails with tender epistles in which the romance and ardor of courtship will be revived. . . ." (New York: Charles Scribner's Sons, 1910, p. 184.)

2. There is no record of a painting by either Cassatt or Haldeman in the Academy's exhibition of 1864.

3. This probably refers to Haldeman's brother Carsten, with whom Cassatt formed a mock engagement when they were in France in 1868.

ELIZA HALDEMAN TO SAMUEL HALDEMAN

> Direct Care of Robert Cassatt
> Street-Road P.O.
> Media R.R.
> Chester Co. Pa
> Sunday afternoon [Spring 1864]

Dear Father,

I am here at the Cassatts having ended my visit in the city where I

had a very pleasant time. Was invited to a party the evening I went down by one of Nannies friends but was too tired to accept. But the next evening we went to the concert of Perellis pupils with Mrs. Waterman. Her daughter sang in the chorus. It was all very fine and some of the girls had voices worthy of the stage. One a Miss Hewitt is to be an opera singer and trills more wonderfully than any one I ever heard. A little girl Theresa Carenno ten years old played on the piano beautifully, music the most difficult both in expression and execution. It completely disgusted me as to my ability and created the greatest astonishment among the musicians even.

Of course I was at the academy. The exhibition disappointed me as I had seen most of the best pictures before. The artists are saving up for the exhibition for the benefit of the Sanitary that will they say be very fine.[1] Rosa Bonheurs horse fair is to be there and a great many great pictures. One of Ary Sheffers is at the Academy but I cannot say I like it much, also a great and very large picture of the revolution in France of /48.[2] Some fine drawing in it but it is not my style i.e. the style I admire. Another by a French *lady* that has some fine painting in it, color especially. An excellent bust by Powers that has been presented to the academy and Baillys life sized statues of Adam and Eve, and Eve and her children were the best statuary.[3] Miss Stoddard and Miss Pollock have each a bust in and also Mr. Roberts, they are all very good.

I went to see Mr. Rothermel and he was very polite and kind but I could see him but a little while, time was so short. . . . Mary came to town to see me and bring me home with her. We called together on Mr. & Mrs. Cope.[4] I think they were glad to see us and I told him you sent your congratulations and he was very much pleased. She is more beautiful than ever, dressed magnificently and creates quite a sensation. Every one in this city is talking about it they call him an "old fool" and some of his friends wont speak to him and I heard there was to be a piece about it in the Sunday Mercury but I can write no more as we are going out riding. I bought Mother her vail and gloves two pairs and shoes and a vail for myself and would like you to send me five more dollars. Tell Mother to buy everything she wants as everything is going up. With much love to all

<div style="text-align:center">

I remain

E. J. Haldeman

</div>

1. The exhibition for the benefit of the U.S. Sanitary Commission was part of the Central Fair held in Philadelphia in June 1864. The Fair was the latest fundraising idea of the Commission, which was a private organization providing supplies to Union troops during the Civil War. The fairs held in Philadelphia and New York each raised one million dollars. However, only in Philadelphia was an art gallery a main attraction.

2. Many of the works shown in Philadelphia were by well-known French artists such as Rosa Bonheur (1822-1899) and Ary Scheffer (1795-1858).

3. Hiram Powers (1805-1873) was America's best-known sculptor; his famous *Captive Slave* had been exhibited in Philadelphia in 1848. Joseph A. Bailly (1825-1883), born and trained in France, emigrated to the United States, where he was active in the administration of the Pennsylvania Academy and taught sculpture to Academy students.

4. Caleb Cope, president of the Academy, married Josephine Porter of Nashville in 1864.

Mary Cassatt departed for Paris in late 1865, planning to study art abroad for several years. Apparently a misunderstanding caused her to stop writing to her intended companion, Eliza Haldeman, so that when Haldeman arrived the following June the two were no longer on speaking terms. They were finally reunited in October 1866 through the efforts of one of their American friends.

ELIZA HALDEMAN TO MRS. SAMUEL HALDEMAN

Paris
October 28, 1866

My darling Mother,

I have an idea the last letter I wrote home was rather a gloomy affair. I suppose I was *blue* for tonight I am much better contented even with my drawing than before. We have a wonderful old man for model who has posed for Horace Vernet, David, and all the modern french artists. He tells us anecdotes and better than that my study of him is better than any I have done yet. I have also finished the portrait of Mrs. Corbet's daughter and they are all highly delighted with it.[1] But what delights me most of all is that we begin Monday week to have the model everyday so that I can study in earnest and maybe get on faster. Then Mrs. C— [Corbet] has a good cook and I think her dinners have done some thing to enliven me in fact everything is going on nicely and I would stay on here if it were not for my french. It seems a pity after staying in france not to know the language when I return. In the spring it is likely I will go into the country someplace near Paris to study painting for I hear you can get excellent modles and that the scenery of france is lovely. What will be your surprise when I tell you that Miss Cassatt and I are friends again. I think it is all through the kindness of Mr. Roberts for he was very anxious we should make up and told me it was as much my fault as hers & finally, how, I cant say made her come to see me. We met at the door of the Louvre one day. She came up and said she was just coming

37

to see me. We took a walk on neutral ground (the garden of the Tuileries) and had a talk. She said the last letter I wrote her was very cool and I have no doubt it was, not that I intended it to be so. Though we did not talk much about the coolness, but about art matters, and today she came to see me and staid two hours at least and brought me some Litells and Blackwood magasins[2] to read and on the Tous Saint I mean All Saints day which is a great feast here, we are going out to Père la Chaise to see the poeple who go to put wreaths and pray for thier dead friends and after I come home I shall write you a long account of it for I know you are very much interested in it.[3] Mary is also coming to our studio to study as we have modles all the days.[4] I am getting to write french quite well, dont make half as many mistakes as I used to and think in two months more would be able to do quite creditably but my teacher is going to leave me. She has had an offer as governess in a grand Spanish family who have a hotel on the Boulevard Malsherbes and I think she will take it. I am sorry to lose her for I like her so much but think it will be best for her for going out in all weathers in a place like Paris in winter when it always rains is not very pleasant or healthy. . . . I hope you keep very well dear Mother and are not to be lonely. I dream of you all constantly and of our little boy. I have not had a letter from you this week but suppose I shall get one tomorrow. Love to all

<div style="text-align:center">

Yours very affec.

Elisa

</div>

1. Like all the young Americans in Paris, Haldeman stayed with a family (in this case, the Corbets) that rented out rooms. Board was usually included as well as practice in speaking French.

2. *Littell's Living Age* (Boston) and *Blackwood's [Edinburgh] Magazine* (Edinburgh and New York).

3. The Père Lachaise Cemetery was a great tourist attraction in Paris. Founded in 1804, it contained the graves of many French literary and artistic figures such as Molière, Jean de La Fontaine, Honoré de Balzac, Jacques Louis David, and Eugène Delacroix.

4. Haldeman had begun studying in the atelier of Charles Chaplin (1825-1891), who was at the height of his success in the mid-1860s. He was known for his decorative schemes for interiors and for his paintings of young women.

ELIZA HALDEMAN TO SAMUEL HALDEMAN

<div style="text-align:center">

Paris

December 4, 1866

</div>

Dear Father,

I was strongly reminded of you, of home, and of pleasant May weather, today when in passing a florists window I saw three beautiful Cyprideum

in bloom. They were evidently from some warm climat and fine specimens as the slipper was very perfect, one of green and a brilliant orange red and another olive green with marks. The petal hanging over the first had a white velvet spot on it and they all had a great many leaves instead of two though they were the same shape as ours. I stood looking at them a long while and did not find them a bit more beautiful than ours the first time *we* found one. But I was so delighted when I recognized an old friend, and have been thinking of them ever since. On Sunday evening I was invited out to my first dinner party in France as it may interest Mother I will tell you what we had. First soup, cant say what kind as french soups are always a mysterious compound. Then what they call boeuf braisé or stewed with beans and radishes. Next, goose done with olives, next a hare and peas. We had a cream cake for desert, fruit and raisins and after that cheese and wine, after all café noire. We then adjourned to the parlor, had music and I sang an english song as the company insisted on my doing so. About nine o'clock were invited into the dining room again and had tea and cake, some using brandy as a flavor in the tea and some milk. I had a very pleasant evening and talked bad french to my hearts content. One old gentleman was from Alsace and talked a little german and I quite won his heart by understanding it. I forgot to say it was with Melle. Meculsky that I dined.

As for art. I made quite a step in my last head a young girl with black hair. Mr. Chaplin said it was good, the first praise he has given me, except his usual "pas mal." Of course it is nothing wonderful, but I am very glad I have done as well. He said I had improved a great deal since I came to him and asked me if I did not feel it myself, to which I answered yes! in fact now, Miss Cassatt and myself are about as "forte" as any there taken all in all, and we have really more prospect of improving rapidly than they have, as it is all ground we have once been over and though in the years that have passed I did not study much still it has made it all familiar to me and though I have the blues often yet it will please you to hear that I am really making progress. Our evening school goes on finely three evenings every week. It is in the quartier Latin and I feel quite like a student when I go there. If I can only study well till spring I know I can do a great deal. The days are never long enough for me and I only know the week has passed by Sunday coming and not painting. My health still keeps very good and if I feel badly I will slacken work so tell the Mother not to be anxious. . . . I am so happy that Mary and I are friends, she is the only bit of home I have here and she never would have stopped writing if there had not been a misunderstanding, she is as kind as she can be. Love to all and a kiss to dear Mother.

Yours as ever

E. J. Haldeman

ELIZA HALDEMAN TO ALICE [?] HALDEMAN

Courances
February [1867]

My dear Sister,

I suppose Mother has told you that I have left Paris for a little while
and am staying with Mary Cassatt for a companion in this little out
of the way French village.[1] It is the first time I have been in the country
since I left home and you can easily imagine I enjoy it extreamly. The
country is very flat and the few hills that one sees are very far off, but the
fields are green and the old trees covered with ivy and mistletoe so that
you scarcely miss the foilage. Everything is in the most primitive style.
The bedroom we have is floored with red tiles, we have a fire place
and a wood fire with the accompaniment of tongs shovel and bellows.
We have also a bed warmer with a long handle which I need not tell you
I make use of every evening much to Marys amusement. I believe she
has written a description of my performance in that line to all her friends,
and intends painting a picture of the same at some future date. Another
amusement is to make candy in the evenings and after several failures
we have finally succeeded in becoming quite expert, though Mary says I
have no genius for that art. The Chateau and Park which is near are
very beautiful.[2] I suppose I appreciate them more as they are the first I
have ever seen. We have permission to enter the Park whenever we like
and last Sunday I spent two hours walking about in it though without
seeing half as it is so large. It is beautifully laid out—avenues of elms
covered with ivy, lakes and streams, temples with marble ornaments,
statues all broaken and lying about, beautiful stone bridges and lawns of
short grass, in one place, wild clymatis had covered the trees that
looked at a little distance like spider webs, waterfall surrounded with
great ferns and tall reeds, and one place about a mile from the house a
raised semicircle of stone, the steps covered with green moss, and the
seats all broaken. You have a magnificent view of the country round the
Park and the Chateau. The latter is of stone covered with white plaster
excepting the facing of grey stone round doors and windows. It has a
dark peaked roof and at one end a wing in which was a ball room theatre
&c. when the family lived there. This has not been for forty years as
the Marquis left for germany when Napoleon was made Emperor, in the
first revolution his father and brother were beheaded so of course France
has no pleasant recolections for him. I have not told you of the moat
of fresh water which encircles the house, nor of the stream falling from a
great dolphins head in stone, which feeds it and it would be impossible
to discribe the color of the old mossy stones, the odd shaped doorways
and windows and the old chaple, frescoed, that lets in day light through

the roof. The cottages of the peasants are also very romantic, we were painting in one today. It is several hundred years old, the rafters are all bare black and wormeaten. The old chimney was beautiful and we were entertained with the music of a spinning wheel and the ticking of a clock, the latter exposing its weights and pendulum some two yds from its unblushing face and weaving like an old woman whenever it struck. The folks were very kind and brought out some pancakes to regale us on. They were laid across the tongs to warm and then the old woman (75 years old) handed them to us in her hands. I eat one mouthful for decencys sake and then put the rest in my pocket when they were not looking and said it was good! The mail is passing so you will excuse my hurry. Love to all, hope you are enjoying yourselves.

<div align="right">EJH</div>

1. The small town of Courances is about thirty miles south of Paris on the edge of the Fontainebleau Forest. It is only about five miles from Barbizon, the site of a large and influential art colony that attracted many Americans in the 1860s.

2. The château of Courances (meaning "running water") was built in its present magnificent form in the early seventeenth century. The lavish interiors date from the eighteenth century.

ELIZA HALDEMAN TO MRS. SAMUEL HALDEMAN

<div align="center">Courances
February 19-20, 1867</div>

My darling Mother,

I received a letter from you and Father this morning and also the two papers sent last week. The post man walks round to all the ajacent towns every morning and on Teusday we always go to meet him to get our home letters, and scold him soundly when he has none for us, which poor man is not his fault. He generally holds them up for us to see as soon as he appears in sight and this morning said "une seulment pour Mell. Elisa." . . . You speak of my not staying in Paris this Summer. I have no intention of doing so as I think I can learn more in some country place. Mary C— is anxious to go to the Pyrenees and it is said to be fine in every respect for our purposes. Miss Gorden has promised to go with us, so we will be quite safe and independent. She, Miss G— is going to England in March but will be back in time to start the middle of June if we go, and afterwards will go with me to Rome or whereever I want to travel. Miss C— thinks she will spend another winter in Paris as she is not returning for three years more. I would like you to tell me in your next when you expect me home so I can make my arrangements definitely. I hardly know enough of art yet to grow well at home, but it is six

<div align="center">41</div>

month yet till fall and I may know more then. If you want me, that is, think I ought to come. There is so much here to learn and knowledge is so pleasant that I am tempted to stay, but it takes a great deal of money and Vic is just commencing and all that. So I will depend on you dear Mother to tell me what you think my *duty* if you say next fall, I will be ready. I have learned a good deal already but it is long work. We have but two weeks to finish our pictures to get into the exposition that is even to *try* and I have not mine drawn on the canvas yet, it has taken so long to make the composition and colored sketch.[1] I am very sorry but it is likely it would have been refused any way so I must be satisfied especially as it has taught me more than the same amount of study in a studio in Paris would have done. Mr. Chaplin liked one of the figures very much and the *bold* way in which it was painted. His wife came in while we were there, and talked very pleasantly to us. He told us we should try for the exposition, that if we should be refused it did not matter and though that seems poor consolation to one not knowing art language, it is a great deal to be told to try at all. My health that you talk about is not in the least danger. I have never been so well nor able to work so hard and actually weigh 130 pds. more than I have ever weighed before. The old folks we are with were formerly pastry cooks in Paris and consequently know how to make good things, which we always do justice of. We also take long walks every day, and do not work too hard. Our little models tease us nearly to death, sing dance and cut up all sorts of capers. One little girl hearing us sing "Evangeline" caught the air and some of the words and surprised us the other day by singing it. As we applauded her performance she has been deafening us with it ever since. It is surprising to see how polite the children are if we pass a group of boys playing, when we are walking, they all get up and take off thier hats and say good morning though they are only pesants, and some but five years old. The men and women are the same and invite us into thier houses with as much grace as if they were ladys. I wish you would tell Fanny[2] when she comes home to copy and send me the words of "Rock me to sleep Mother," Mary and I sing it every night thinking of you, but we only know a few of the words and would like the rest. Walking out this evening I passed some Juniper trees, of which there are quantities, and eat some berries in memory of home. Every thing here is quite advanced in vegation and the grapes have sprouts an inch long. Send the enclosed letter to Miss Willcox 1439 Chestnut St. read it if you like. With much love to all, I remain your affec.

EJH

1. Haldeman and Cassatt were working on entries for the Salon of 1867.
2. Fanny was Haldeman's younger sister.

ELIZA HALDEMAN TO MRS. SAMUEL HALDEMAN

Courances
March 8, 1867

My darling Mother,

I have just received two letters from you by mail. . . . I was very sorry
you had been worried about me as I have written every week regularally
until last week when I had not time I was painting so busily. I hope
by this time you have received my letters from Courances. I have finished
my picture for the Exposition (not the great one [Exposition Universelle]
but the one in the Palais d'industrie [Salon]). I am very much disgusted
with it, but intend to show it to Mr. Chaplin tomorrow and if he likes
it will send it. Of course it will be refused but I shall not care if Chaplin
likes it. He praised the study for it quite a good deal said it was *bold*
which is quite a compliment for me as I did not have that quality when I
left home. I must add that it is only in painting I have acquired it.
He not only spoke well of my study to me but also in the studio so he must
think it, but the picture is not so good. However, I have learned a
great deal from it, and Miss Cassatt and I have concluded to go to Ecouen,
another little french village which I wrote you a discription of in one
of my letters. Frère and Soyer live there, the most celebrated Genre
painters in France and we think we will learn to make pictures there under
such good instruction.[1] We intend having Soyer for a master if he will
have us. Several americans live there and I think it will be very pleasant,
if I learn I shall stay there a long time. You ask me about money matters
in your last. I am happy to say I have just finished my *first* bill of credit
and have the last eight hundred Father sent me still untouched. I find it
not so very expensive to live here and now that I am out of Paris it
will be still less so. I count my 8 hundred will last for a year so I suppose
this time 1868, you will see me home I hope a good painter. You must
not think of sending me more money till I tell you for it is not worth
while to have it laying here in the bank. You must not think because I stay
so long away that I am forgetting home. I do not think it exageration
to say I dream of you every night. Last night I was with you gathering
flowers in the yard. I am fortunate enough never to be there in winter. It
has been quite cold here lately and we have been shivering to keep
ourselves warm though the old lady is continually scolding us for burning
so much wood. She has been telling all the neighbors of our 'extrava-
gence' as a proof of our wealth. They are such good old folks that I hate
to leave them, having told them the other day that we must go into
Paris for money, an hour after the old man came to us, after as I suppose
talked the matter over with his wife, and told us if we had no money
we should stay on with them. We would all live together and we should

not trouble our heads about the matter. We assured them we were obliged to go to Ecouen and thanked them for the offer. But as artists are always considered very poor over here I am sure they think we have nothing to live on. The carnaval has just passed and lent has commenced.[2] I was quite amused at the masks that were passing during the day under our window. Unfortunately the gayest day was ash Wednesday and it seemed an odd beginning for lent to see all the young men of the village dressed in fantastic clothes, dancing to the music of a drum and fife and generally very merry with wine. I was at the window all day for as soon as one party passed another arrived and as it was new to me, I wanted to see all that I could. On Teusday every body high and low, bake a kind of doughnut, only it is not sweet and invite the neighbours in to partake. We had quantities sent us from the different families of the village and were also invited to one of the houses but after my pancake experience I do not intend to be caught again. We have an invatation to return and stay here during the fête of Courances. They always have a celebration for two or three days on the Saints day who is the patron of the village and who the village church is named after. We have several invatations to waltze and Mde Lantren says we are not to pay any board. Dont you think we must be favorites? You must excuse my badly written letter. I have been painting all day and have just finished packing and am very tired. I will write and tell you what C. [Chaplin] says about the picture and discribe it to you if it gets in, other wise it is not worthwhile. You must not be anxious about my health. I am very fat weigh 130 pds and Mary says no one could accuse her of having the least idea of consumption, she is also getting fat, though we are both afraid that will spoil our artistic appearance. She is much obliged to you for your anxiety. Do not trouble about me disappearing in Paris, I know it thoroughly and I think likely the lady you read of *ran* off with some good looking frenchman. As I am to be an old maid there is no danger for me in that quarter. Love to all not excepting Cousin Josie. Tell Father my next letter will be to him. Did Carsten get my letter. I sent Vic a London News last week, did he receive it. Your affec.

EJH

1. Pierre Edouard Frère (1819-1886)—genre painter, engraver, and lithographer—lived in Ecouen for the last forty years of his life. His anecdotal paintings, especially of children, were admired by Ruskin and were widely exhibited in France, England, and America.

Paul Constant Soyer (1823-1903), after a promising early career as an official painter, moved to Ecouen, where he began to specialize in genre subjects. He became highly successful in this style in the 1860s; in 1865 his Salon entry, *Dentellières à Asnières-sur-Oise*, was acquired by the French government for the Musée du Luxembourg.

2. Carnival was the high point of the year for a small French town. Marking the end of winter, this ancient celebration consisted of feasting, dancing, and parades in outlandish masks and costumes.

ELIZA HALDEMAN TO MRS. SAMUEL HALDEMAN

Ecouen
May 15, 1867

My darling Mother,

Your letter telling of the arrival of the kid gloves received safely and also the one of the week before that father had forgotten to mark Poste restante, in fact it is useless now to continue that, as we are so well known now and the town is so small that there is no danger of my letters being lost. Miss Gordon writes she will be here next week to stay till Autumn. She is crossing the channel today and says she has enjoyed her visit in England very much. When she arrives, there will be eleven Americans in the town, two young gentlemen. We were to see the Bride last night and were amused at the housekeeping. You know they are both Artists and seem to think it unprofessional to be clean. They do not have carpets there and the floor was all spotted with black. She told me it would wash off but *she* would not do it and the only servant she could get did not know how to get it clean. Her husband said "What does it matter. Let it alone Fanny." They say it is a marriage conducted on French principles, viz a money match. He was so poor that he was obliged to cook his own meals not always being fortunate enough to have anything to cook, and to sleep on straw before he was married, though a little time ago he commenced looking up in the world and paints quite well now so as she is tolerably well off I hope she may have enough to support them till he is able to keep the wolf from the door. Just now they seem to be very happy, have beautiful furniture on thier dirty floor and call each other Darling. We are invited up to meet one of the wonderful young gentlemen of the town and have a game of cards. I pity her for she has only known her husband a year and was married at the American legation with a french lady and a german gentleman for witness. Of course they talk and gossip a great deal about it and say as soon as the money is all [gone] there will not be much love left. I tell this tattle to give you an idea of what artists do. I think I forgot to tell you we were invited to dinner at Mr. Bacons Sunday before last and went with them in the evening to see the ball the Peasants had at the fête.[1] They are another poor set of artists though now Mr. B. is out of the mire, gets good prices for his pictures and has a pretty house and garden to keep his wife in. He is very communicative and tells funny stories of when he lived in Paris on nothing. One time they did not have a cent in the house and had nothing to eat and finally after a great deal of thought the wife produced some coins she had put away for curiosities and they were able to buy bread. In return for thier hospitality we gave them a Picnic last Sunday. Oysters Champaigne and ham sandwitches, our

45

first entertainment since we are proprietors. We went on donkeys to a Chateau some six miles distant and were caught in a rain. The Chateau proved to be a relation to those that are said to be built in the air for we found nothing but a miserable inn and that was so full of poeple who had come from Paris to spend the day that we were obliged to eat in the stable with our donkeys by our side. We felt ourselves fortunate to get even that shelter and eat our refreshments with gusto much to the envy of the world in general who had not provided themselves with any thing in that line and could not be attended to by the waiters. Most of them were shop girls in thier Sunday best, thier poor white dresses drenched with rain and ribbons faded and limp. All the animation in thier bodies seemed to have been concentrated in thier tongues though that might have been caused by the wine that is always plentiful on such occasions, even our party were slightly merry. You asked me if Mary C. was accepted at the exposition, I thought I had told you we had both been refused though we have strong hopes for next year. I dont want to go to Rome till I have painted something for it as I can leave it with a friend here to be sent. Mary wishes to be remembered to you, she laughed when I told her your message and said she wanted to paint *better* than the old masters. Her Mother wants her to become a portrait painter as she has a talent for likenesses and thinks she is very ambitious to want to paint pictures. Her family are now living at Renovo on the railroad with her Brother Aleck C. but I believe they are going to move to Irvington very soon as he is going on another Rail R.[2] Mrs. Cassatt writes that she is tired moving, that being the twentieth time during her life. Mary expects to stay two years more abroad, she is getting on very well and studies hard. I think she has a great deal of talent and industry. One requires the latter living in France, the poeple study so hard and the results are wonderful. Though there is a great deal of talent in the Exposition, nothing equals the French painters. You would not wonder I am what you call ambitious if you could see what I see. The difference between Americans and French is that the former work for money and the latter for fame and then the public appreciate things so much here. You are not allowed to paint badly. But I must stop, excuse my badly written letter but I wrote so closely in order to enclose another to Father. Love to all. Tell our boy I am glad he is improving, that I will be glad to talk French to him when I return. Love to all.

<div align="center">EJH</div>

1. Henry Bacon (1839-1912), from Haverhill, Massachusetts, was one of the more active Americans working in and around Paris. He studied with Gérôme and Cabanel, as well as with Frère, and later became known as a specialist in Egyptian subjects.

2. Alexander ("Aleck") Johnston Cassatt (1839-1906) earned a degree from Rensselaer

Polytechnic Institute, then worked his way up from rodman in 1860 to superintendent of the Warren & Franklin line of the Pennsylvania Railroad in 1866. His parents and sister Lydia lived with him in Renovo and Irvineton, two of his headquarters, in 1866-67. When he was promoted and transferred to Altoona in November 1867, they returned to Philadelphia.

ELIZA HALDEMAN TO MRS. SAMUEL HALDEMAN

Ecouen (Seine & Oise)
September 5, 1867

My darling Mother,

I wish you could see us in our new appartement or I should call it Pavillion. For they have given it that name to excite our artistic imaginations and indeed I expect something wonderful to happen [to] us here after the Arabian Nights. Our little place is very clean and neat, and we have a beautiful view from the windows. Our Proprietor has been doing the gallant by offering parsely and carots for our soup. I have been in this evening to pay the rent. 50 frs for three month and he asked me to write the recipt and he would sign it. I believe he is a retired Butcher and though very wealthy, and living quite in style he is not strong in penmenship. As my adaucity never permits me to hesitate now in writing French, I did what he desired though I am sure I made mistakes. He complimented my French and said I looked eighteen, at which I told him he was mistaken in both cases.

I have just finished our moving this evening after having worked pretty hard all day. I use the egotistical prononic because poor Mary has been very ill for the last week.[1] The Dr has been to see her twice a day most of the time. She is almost well now but is very weak and we had to send for a Donkey and our friends Mr. & Mrs. Bacon to see her safely here, where I had prepared a bed for her reception as soon as she arrived.

You would have laughed if you could have seen me at the head of the procession of furniture showing the way to our new residence. Had it not been for my inevitable pink gingham you would have taken me for the chief morner at a funeral. I was obliged to walk very slow as the horse was blind and the load heavy, and ran the gauntlet under the fire of the eyes of the inhabitants who came to the window in crowds. Finally everything is arranged and I can go to work peaceably tomorrow. I forgot to say that Marys transit was made in a pelting rain but fortunately it ceased soon after.

Your letter in answer to my question just came two days ago and I am glad that you[r] and Fathers decision was so well in accord with mine altho I did not wait for it to make up my mind. I am thinking of nothing but of getting a picture in the exposition next Spring and am working hard for that purpose[.] If I am so fortunate I am afraid I shall have to stay

47

a month or two longer than Mary, otherwise I would have to leave it here. Miss Gordon has arrived safely in England and she writes she is enjoying herself very much. She sent us a letter on which was a view of Torquay and her Aunts house which faces the sea and must be in a very beautiful Situation.

I hope my letter will please you as it is entirely about myself. I make some little progress in Art but am never satisfied. I am very well and enjoy painting more than ever. Am getting old and experienced but am not beyond being cheated occasionally. I wont travel in any other country before coming home but may go to Brittany in the Spring and take Steamer from Breast [Brest]. With much love to all and a thousand kisses

> I am as ever
> Affec. Your Daughter
> Eliza

1. Mary Cassatt occasionally suffered severe stomach and intestinal problems. She had another attack in Parma in 1872.

ELIZA HALDEMAN TO SAMUEL HALDEMAN

> Saint-Valéry sur Somme[1]
> October 1, 1867

My dear Father,

You see by the heading of my letter that I have at last left Ecouen. Miss Cassatts health appeared so obstinatly bad that I finally had to comply with her desire for change of air. We are settled for perhaps two weeks at the "Bains de Mer" but your letters will go as usual to Ecouen and be forwarded here. You will think me quite au fait with traveling when I tell you I made all the arrangements for coming. Found when the trains started and the connections for we changed cars three times. Packed the trunks and gave orders to our Servant and put our house in order—And finally entertained Mary on the road by reading about the places we passed by from my Guide Book. But though Chateaux, Roman Remains &c were mentioned frequently in the book we saw few out of it and Mary amused herself at my expense saying the book was a humbug, though I only blamed the R.R. Company for not laying the track through a prettier part of the country. The Route is the same as the one we took together when we came to Paris from Boulogne but we left the main line at Nogelle and crossed the Somme here. The tide was up and we had our first breath of sea air a strong stiff breeze that almost took off our Bonnets and made me feel half sea sick in remember-

ance of our voyage sur mer. The only new feature I saw passing through
Picardy was the substitution of women with blue aprons and black sailors
hats, for the usual signal men who are stationed along the way whenever
there is a road crossing the track or a sideling. At Boves we also saw
miles of linen streached out for bleaching making quite a snowy looking
landscape. Our guide-book is at least correct about St. Valéry[.] Yesterday
(I am writing the 2. Oct.) I took a long walk through the village found
Harold's tower and dug a little shell from the plaster as a memento.
There are four towers still standing though none are perfect and about a
quarter a mile of a high stone wall which surrounded in times past the
Chateau and the remains of the moat is still visible. The sea formerly
dashed about the foot of the wall but now a breakwater prevents it enter-
ing. The church is near, also built on the cliff and washed by the sea
at least a hundred feet below. There is a small chaple dedicated to St.
Valéry who was I believe a patron of Mariners, and there is a little model
ship suspended before the altar and the nitch of the Saint is decorated
with sea shells and coral. In the graveyard near I found the little graves
of the poor ornamented in the same way. A plain wooden cross at the
head with "à mon fils agé deux ans" in white letters, a bead ornement
hung on one side with a figure and a willow tree mourning over a tomb
very like the one we have at home only smaller and some plaster statuettes
one a boy reading another a little angle [angel] in the act of flying away
struck my attention. Large flat sea shells surrounded the grave. In fact
every thing recalls that we are in a fishing village especially our breakfast
of red crabs (like those on the floor by Murillo's begger boy[2]) and the
soles for breakfast. We had our first sea bath yesterday. Warm, as the
season is to advanced for the open sea. And I never had a sensation more
delicious. The water is so strong that we could hardly keep in the bottom
of the bath tub, and were continually being renversé head down and
feet en l'air.

You should see the fisherman quarter of the town. Low white houses
so little and so covered with the straw thatch that a good sized cow
could easily finish one for a single dinner, indeed all the cottages look as
if sitting on their "hunkers" to avoid the sea winds.

Harolds tower dates from the 10 century and is built of a black round
stone that looks where broaken like agate or varigated marble, most
of the old walls and garden walls are made with the same stone and the
sea beach is covered with them. I was wishing you here to tell me what it
was, as I find my curiosity on the increase about everything. We have
been today—evening of the 2nd—, to an old Chapel of St. Valéry built
on the cliffs some distance from the church. It is a votive chapel and
filled with glass cases containing offerings of different kinds. The best
was a large picture of a shipwreck with a discription under it of how the

doner had been saved when all had perished at such and such lat. off
the island of I forget what. It was very old and not at all picturesque
but very curious to see. There is also an old Abby here but the ruins have
been taken posession of by some rich Burgoise and made a part of
his grounds. So as the owners were not at home now, we were not
permitted to enter.

Tomorrow we expect to go on Donkeys to Cayoux on the coast some
miles distant where we are told the scenery is very pretty. We intend
returning through Normandy. Stoping at Eu and Tréport, Dieppe and
Rouen. I have done nothing yet in the way of pictures since I have been
here and I hope to soon commence for I have never seen a place more
rich in genre pictures i.e. if they were painted. As you received the *Même
bon*[?] of Mr Soyer so well I will tell you the last dictum. "Du reste je
trouve que vous êtres *très colorist extrémément colorist.*"[3] Isn't that a
feather in my cap. I have saved it for you intact not even translating
it for fear of loosing some of its flavor and I hope before I write you another
letter to have something even more pleasant than that to tell you. You
see the "little pictures" are not so bad. I wonder if you ever read
Blackwood since I am away if so, How do you like The Oclophobists
Easter trip.[4] I think it by the Piccidilly man and very good, especially
the geology. I am able to sympathize with him in regard to his ettemologi-
cal [entomological] findings and think I could write quite a scientific
treatise on thier manners and customs. There is another family of the
same genus I think that Mary and I have been closely rather to closely
observing but we think for the honor of our friends we will keep our
recherches in that quarter to ourselves though we flatter ourselves no one
has ever given the subject such patient investigation. And du reste we
find the study severe on fine combs.[5]

I send a little book of fairy tales to Vic as he knows them already
they may be easier for him to read and little by little he will learn if he
only sticks at it. I will soon send another by Eckart Chartrieu a very
celebrated writer here, and you must read the Bear fight and say if you do
not think it good. I must say now good night and love to all

<div align="right">Affec Your Daughter
E. J. Haldeman</div>

1. Saint-Valéry-sur-Somme is a modest sea resort on the coast of Picardy, between Dieppe
and Boulogne.
2. The works of Bartolomé Esteban Murillo (1618-1682) were immensely popular in the
nineteenth century.
3. "Moreover, you have a fine sense of color, extremely fine."
4. "The Easter Trip of the Two Oclophobists [crowd-haters]," *Blackwood's Magazine*, July
1867.
5. They seem to have lice.

Courances
April 24, 1868

My dear Father,

I received your short letter two weeks ago and wrote last week to Vic
& brother [Carsten], if it would not be repetition I would say that the
mail is about to go and I have no time to write a long letter but by this
time without doubt you know that in France the mail *always* starts
immediately after I have finished my letters. . . .

Cousin S. [Sarah] wants me to go with her to Brussels, Antwerp and
through Holland. I think if it will be but an eight day trip that I will
go with her though I hate to waste time. I have concluded to go to
Paris for a month or two, the 15th May, enter an Atelier and draw at the
same time make sketches at the Louvre and Luxemburg[1] as I wont be
able to see good pictures at home it will be well for me to see as much as
possible of them here. I am painting two pictures here and when they
are finished I shall leave. Miss Cassatt has not yet decided when she will
go. We were at Barbizon last week but she was not pleased with the
Master she intended taking. You can imagine the horror we were seized
with on hearing he painted without models, a sort of french
Rothermel. Of course he dont draw well and though a very celebrated
painter would not be good as a master on that account. He is one of the
Best of the school of Barbizon and was engaged painting a fat pig
being led to slaughter. The school there is composed entirely
of landscape painters contrary to that of Ecouen who are all figure and
interior painters. Though at the former they also paint figures and
animals out of doors. Mary is very anxious to learn the style and it is very
fine. Troyon was at the head of it when he was living,[2] and it is the
most original manner of painting in regard to subject now in existance,
for none of the old masters ever did any thing like it. It is entirely French
though the Germans are trying it a little but do not suceed so well.
There have been a great many of them well known Breton,
Millais Troyen Jaque are the principal.[3] At the inn at Barbizon the
landlady has taken a novel way of having her debts paid, viz making the
Artists paint her pictures when they owe her. She has her rooms
arranged with panels everywhere and on each has been painted a picture
some of them very good, in one room all the furniture is painted over
the doors of the high clothes presses and sideboards sides of tables
& *everything*. There has been a great deal of ingenuity shown in the
frames of the pictures, the long narrow places above the doors and
sometimes in a corner by a window the narrow upright places. Those
latter usually filled by a mountain excursion, the former a horserace. I

have not had news of my picture yet nor will not till I go to Paris, it was a girl pealing potatoes, romantic was'nt it?[4] The background was a bufet full of dishes it is an Ecouen subject, but when I can paint I shall do something better. Much love to all and please make Vic write to me. I hope Carsten is getting on well. Cousin Sarah asked about him and also told me to thank you for your letter to her and wished the favor to be repeated, I think she had better tell you so herself. Love to all Affec your Daughter Eliza

1. The Palais du Luxembourg, built by Marie de Médicis in 1615 and enlarged in the nineteenth century, housed the French government's collection of works by living artists and served as a museum of modern art.

2. Constant Troyon (1813-1865) was a well-known landscape and animal painter. He was given a large retrospective exhibition in Paris in 1866.

3. Jules Adolphe Breton (1827-1906), who had been trained at the Ecole des Beaux-Arts, painted landscape and genre subjects. He achieved great success in the 1860s; in 1867 he was made an officer of the Légion d'Honneur and was awarded a first-class medal at the Exposition Universelle.

Jean François Millet (1814-1875) (Haldeman has confused him with the English painter John Everett Millais) had a difficult beginning until he settled in Barbizon in 1849 to paint monumental peasant scenes. Henceforth his fame grew, particularly in the United States; in 1867 he was well represented at the Exposition Universelle, where he was awarded a first-class medal.

Charles Emile Jacque (1813-1894) was a landscape and animal painter in the Barbizon School. In 1867 he was decorated by the Légion d'Honneur.

4. She is referring to the picture she sent to the Salon of 1868.

ELIZA HALDEMAN TO MR. AND MRS. SAMUEL HALDEMAN

Paris
May 8, 1868

My dear Father & Mother,

I am now in Paris stoping at the Prince Albert Hotel which is opposite the Prince Regent where Father & I staid when we first came to Europe. Miss Cassatt is with me as she has not yet decided where she will go for the summer. & we intend to draw from the pictures in the Louvre and from life until Carsten arrives. Cousin Sarah is at the Grand Hotel and we were there spending the evening with her yesterday[.] She is looking very well and her health is excellent. She still wants me to go with her to Belgium but I told her I would not be able to do so this spring. I suppose you received the Catalogue of the Exposition and saw my name.[1] I did not know until the day of the opening that my picture had been sent and when I heard it was in I took a good crying spell which lasted three hours. I had so hoped my first picture would have given me pleasure and I found that I was

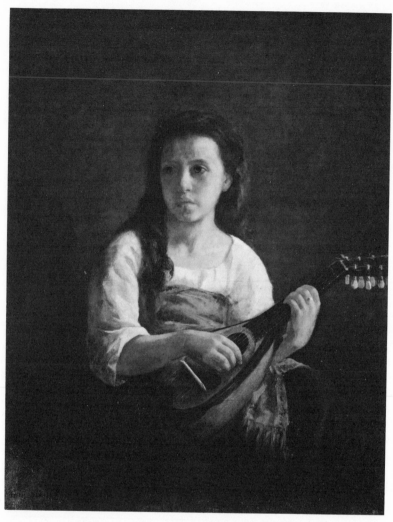

4. *La Mandoline*, 1868. Oil on canvas, 36¼ x 29 in. Private collection.

disappointed. But since I have come in and have seen it I feel better. In fact it looks very well and I find I have made a great deal of improvement since last year. I feel sure I should have been accepted even if Soyer had not touched it and I think it likely I would have been better hung had it not been painted on for this year the Jury are very particular about things being painted on and have rewarded the honest ones with the best places. The picture I have just finished at Courances is even better in

some things than the one in the Exposition and I think I have reason to be thankful if not satisfied and I only hope it has given you some pleasure by my success. Mary has also been successful even more so than I as her picture is well hung and was not painted on [figure 4]. Still I think we are pretty equal considering she has been here six months longer than I. Her name in the Catalogue is Stevenson as she dont exhibit under her own name.[2] It is much pleasanter when one is a girl as it avoides publicity. I think it likely I should have taken another also had I sent my picture myself.

The Exposition is very poor this year as there has been 1200 more pictures accepted than usual in fact almost anything would have passed. There is to be forty medals given though I cannot imagine who there is to deserve them all. Jerome has two very fine pictures. Dorée one large one, a new man Lefebre is the sensation of the year.[3] There has been especial favor shown this time to new beginners, and the old Exampts are all up at the ceiling.[4] In fact the pictures of the latter are so bad that I really would not care to be Exampt. Cabanel who used to be so fine who made things equal to Correggio has two horrible portraits.[5] I suppose they are making place for us. In fact the French school is going through a phase. They are leaving the Academy style and each one seaking a new way consequently just now everything is Chaos. But I suppose in the end they will be better for the change. I think by thirty I can get a medal.

Quite a number of Americans exhibit this year and show a great deal of talent. And the number of women artists is legion. Henrietta Brown has an atrocious picture and in fact the waste of good colors frames and canvas this year is astonishing. I have fare hopes now of becoming as good as any of them. I am expecting every day to see Carsten and count on showing him Paris. I have not received a letter from you this week hope nothing has happened. Dont you think my Exposition has cost you a great deal. I suppose at least two thousand dollars? I wish I could thank you as I would like to for your indulgence and generosity to me. If making me happy can recompense you I assure you that in making me an Artist you have done so, and I only wish you could just give me one kiss and say you think I have done well. Some day you will think it is first-rate. Would you like me to send my picture to you as soon as it is out of the Palace, which will be in six weeks, or wait till someone is going home? Excuse the pen it is a hotel furniture. Much love to all & Believe me very affectionately dear Father & Mother

Your Daughter

Excuse my letter but I have been the last two days at the Exposition and my head is in a whirl. . . .

1. She is listed in the Salon catalog in the following manner:
Haldeman (Mlle E-J.) née aux Etats-Unis, élève de M. Soyer.
A Écouen (Seine-et-Oise)
1198—Une paysanne
2. Cassatt is listed in the Salon catalog:
Stevenson (Mary) née en Pensylvanie (Etats-Unis),
élève de MM Chaplin et Soyer.
Rue de Bréda, 30
2335—La mandoline
3. Jean Léon Gérôme (1824-1904) studied with Paul Delaroche at the Ecole des Beaux-Arts. His first Salon entry, *The Cock Fight* of 1847, brought him immediate success; in 1863 he became a professor at the Ecole des Beaux-Arts, and in 1867 he was made an officer of the Légion d'Honneur.

Gustave Doré (1832-1883) was well known as a painter and an illustrator. In 1868 he opened the Doré Gallery in London to exhibit his drawings of the darker side of life in that city. He illustrated editions of Hugo, Milton, and Tennyson in 1867-68, as well as exhibiting his paintings in the Salon.

4. Artists who had won the Prix de Rome, a Salon medal, or who had been selected to the Institut or the Légion d'Honneur were "exempt" from submitting future works to the jury. But even these artists were subject to hanging decisions, which resulted in some works being hung at eye level ("on the line"), while the rest were crowded into higher and higher rows up to the ceiling.

5. Alexandre Cabanel (1823-1889) began teaching at the Ecole des Beaux-Arts in 1863, the same year he exhibited his most famous work, *The Birth of Venus*. He was awarded medals of honor in 1865 and 1867.

ELIZA HALDEMAN TO ALICE [?] HALDEMAN

Paris
May 13, 1868

My dear Sister,

I suppose nothing from Paris will give you more pleasure than an account of the spring fashions. I have an excellent chance of seeing them since I have been in town as I am continually at the Exposition and all the fashionable people of the city go there to see and be seen. I have bought myself a new bonnet grey blond with a crimson rose at the side and wear my black silk with a belt and bow behind with long ends. Yesterday Mary & I went with Cousin Sarah to do the honors to our pictures, a Mrs. Simmons was with us. She is a friend of Cousins and was a Harrisburg girl about thirty years ago. Mother may know her she ran off to be married and as Cousin S— says, is a connection of the Fosters. This latter lady has been very kind to us and promised to introduce us to Mr. Ryan the correspondent of the New York Times and Herald. Her daughter[1] is on the stage and on that account she takes an interest in young poeple who are making a reputation. Cousin Sarah was very much

pleased with our pictures and intends to write home all about them. Mrs. Simmons says mine is a "perfect little gem only it is to high up to see." It was a compliment. We were able to take them in on our artistic tickets by a private entrance which of course had an excellent effect especially as it saved them each a franc. The place is crowded with visitors and on last Sunday, which is a free day, there were 30,000 poeple in the Palace and some six thousand turned away from the doors, the Rooms being too full to admit them.

Today 14th, Mrs. Simmons brought Mr. Ryan to the Louvre to introduce him to us and we went with them to the Exposition to show him our pictures. He is a tolerable critic and knows more than most of the tribe on the subject on which he writes, and he has promised to notice us in the Times or Herald. I think it will be in the former.[2] I want you to look out for it when it comes and send me several copies of it if you can get them, as I would like to give one to Helmick as he has been so kind to me.[3] We pointed out all the American artists who had exhibited. I suppose they will get a little notice—

I find it awfully tiresome seeing all those people and talking & walking so much in Paris after my quiet life in the country. Mary calls it moral depravement, for really talking ones self into the opinion of the Publick is not the most genteel of occupations. Mrs. Simmons daughter married an italien opera Singer in New York, and she is now singing in Brussels. I write all this gossip as I suppose mother knows the family. There is a quantity of our old Artist acquaintances over here just now and I am afraid the Louvre will become a second Academy for talking and amusing ourselves. I have only been drawing there one day as I have had so much to do since I arrived. But as gentlemen cannot come to see us at the Hotel we are obliged to receive them at the Louvre. We have been frequently round to the Grand Hotel to see Cousin Sarah. Mrs Ware is very gracious and was going to make an engagement for us to meet Mr. Roberts at the Exposition, at least I think she was, but I had another engagement and could not go. Cousin Sarah amuses herself saying that Roberts is what she calls smitten with both of us, if she had said neither, she would have been nearer the mark. . . .

And now for the fashions. The dresses are short looped up over skirts of the same, the upper one with three narrow ruffles pinked at the edge and put on with a cord. Capes of the same crossed over the bosom with long ends behind trimmed with the same finishes the costume, Fringe is also very fashionable for trimming. Lagries are not worn the Fichue Marie Antionette or cape taking its place. I saw a dress of light silk looped up with bows of ribbon of the same color very pretty and a bonnet to match. They are more particular than ever to have the whole costume of the same material with bonnet the same color, and black silk dresses are taken up over a black

silk petticoat, with a box plaiture quilling three inches wide at the bottom.

I saw the Empress ride by yesterday on the Champs Elysée looking very lovely in a purple dress and white bonnet, four horses in the carriage a postillion and the Emperor sitting at her side.[4] They have about a dozen outriders and another carriage following with some of the ladies of the Court. The gentleman who was with me a [?] painter from Pittsburg is quite in love with the Empress and amused me by telling me the different Toilettes she was accustomed to appear in. . . .

Yesterday we were also to hear the music in the Tuilleries gardens I though of Father as we had been there together almost this time two years ago, I wish you could be here to enjoy this pleasant weather with me. We are so comfortable and independent & I have gotten so used to my own society that I find that of other people to be a bore. I have been twice to the Theatre just imagine hearing the finest actors in the world for a franc.

Fryday evening

I intended filling my sheet but have just time to say goodbye. Received Fathers letter last week and will answer it soon Tell Victor I am expecting a letter from him Write soon and believe me

<div align="right">Very Affec Your Sister
E. J. Haldeman</div>

Write and thank Mrs Cassatt when you receive the shawl. . . .
Irvington Waren Co. is the address of Mrs. Cassatt. Love to all.

<div align="center">E.J.H.</div>

1. Lucy Simmons: see Emily Sartain to John Sartain, December 15, 1871, footnote 5.

2. The following mention was made of Cassatt (Mary Stevenson) and Haldeman in Ryan's article in the New York Times, June 7, 1868:

"A portrait of an Italian girl, by MARY STEVENSON, of Pennsylvania, has obtained a place on the line, and well deserves it, for its vigor of treatment and fine qualities of color. Miss STEVENSON has been a pupil of GEROME, and proposes shortly to visit Italy to improve herself. She is only twenty years of age. [She was actually twenty-four.] Another Pennsylvanian girl, Miss HALDEMAN, has a small interior which displays unmistakeable talent. Miss HALDEMAN belongs to the Ecouen school, and was a pupil of SOYER."

3. Howard Helmick (1845-1907), born in Ohio, studied at the Pennsylvania Academy with Rothermel and then went to Paris, where he studied with Cabanel. He settled in London in 1872, became a well-known illustrator in England, and later continued this career in the United States.

4. The beautiful and ambitious Spanish countess, Eugénie de Montijo, became empress when she married Napoleon III in 1853.

ELIZA HALDEMAN TO MRS. SAMUEL HALDEMAN

<div align="center">
Paris

May 28, 1868
</div>

My darling Mother,

I have just finished writing a note to Miss Cassatt who is comfortably settled at Villiers le Bel about half a mile from Ecouen. I went out with her to see about the place as she did not feel like going to Ecouen all alone and her friend Miss Gore who she was expecting to go with her did not come from Germany. She is staying in the Boarding School where Miss Gordon staid for six weeks last autumn before going to Rome and she says she finds it very agreeable except that she is homesick so that I have to write to her often to keep her in spirits. For myself I think it better for the moment to stay here and study from life and the Louvre. You remember I thought of coming to Paris for that purpose last autumn and now that I am on the spot I do not care to loose the opportunity. I hope after a little study of this kind I will be able to paint a picture much better than heretofore and then when Carsten comes I will be ready to do the honors of the place and cure him in a short time. I expect you will think Mary & I are very hardhearted when I tell you that we both rejoiced to hear that the Viennese Dr. was dead Mary because she dont want me to leave France and I because it is in the South of Germany & requires 36 hours in the cars to go there. And you can have no idea of the heat here.

I have been making inquiries about the Drs here and the Sister St. Paul has promised to give me a list of the most celebrated. I hope Carsten will be able to find some one here who can cure him and then travel afterwards as he will enjoy himself so much more when well. The good Sister was delighted to hear I had a picture in the Exposition and wanted to take me to the Mother Superior to tell her about it. I asked the sister to go with me to the Exposition as we have been given a card that admits ourselves and a friend & the Artists can go from eight o'clock till ten before the crowd is admitted— I think she will go but she could not see the brother that evening to ask his permission— She asked after you & Father and said she thought you must want me home. I wish you could know her she has been such a kind friend to me. . . .

My days are divided between the Life Class in the morning which commences at eight o'clock and the Louvre in the afternoon and I find I am making some improvement. I hear sometimes funny remarks about myself in english that are not intended for my ears when working at the latter place. An old gentleman said to his wife a few days ago Thats a right pretty girl. I was glad to have unbiased testimony on the subject for I was afraid my hard work had taken away all the little pretentions

<div align="center">
58
</div>

I ever had that way and that you would find me old and ugly. I take my lunch which consists of bread and fruit to the Tuillerie gardens and eat it there. The part in front of the Palace which is about a dozen times the size of our yard is one great bouquet of flowers roses trimmed to little trees and geraniums.[1] The fontain plays in the centar and at each grass plot there is a marble statue. The part where I sit is in trees horsechestnut and in the warmest days it is delightfully cool there as the avenue extends uninteruptibly from the Tuilleries to the Bois de Boulougne a distance of three or four miles. The old women come here and bring their sewing and I often make acquaintances and am asked to take friendly pinches of snuff which I dare not refuse but am puzzeled sometimes how to let it fall without attracting thier attention and afterwards go through a pantomime of blowing my nose and sneezing[?] it amazeingly. . . .

I shall be glad to hear home news love to all I am constantly dreaming that I am at home and have no presants to give anyone I have been trying on a few things lately & I suppose that accounts for it.

<div style="text-align:right">Affec as ever your Daughter
Eliza</div>

1. The Tuileries gardens and palace were designed for Catherine de Médici in 1563 near the original palace of the Louvre. In Napoleon III's time, additional wings of the Louvre were built joining the Tuileries palace to the rest of the complex. In 1871, during the riots of the Paris Commune, it was burned and the central portion torn down.

ELIZA HALDEMAN TO MRS. SAMUEL HALDEMAN

<div style="text-align:center">Villiers-le-Bel
October 15, 1868</div>

My Darling Mother,

I just received a letter from you today, it was handed me with my breakfast (in bed) and I read it while drinking my coffee. Carsten was out to see me on Sunday and took breakfast with Mary & I at her Studio. He was impolite enough to say that he did not like the cheese nor the wine, nor the eggs—all the while eating very hardily. He says Mary & he are engaged, I believe it happened in this way. We saw one day at Granvariacks[?] a wedding veil which was to lovely to discribe and cost $1000, Mary said she would marry Carsten if he gave her the veil for a present which he said he would do, so the thing was arranged.
I need not say the veil is *not yet* bought. I suppose they will wait till the day is fixed for the marriage.

Carsten started for Italy this week, I believe it was yesterday. He was

looking well and in excellent spirits. He told me to write you about him and that he would let me hear from him frequently and I could forward his news to you when I write my weekly letter. It appears he dont want to keep up a double correspondence. When he was in Germany he had all his letters sent from Monroes to me and when he returned Mary & I pretended we had read some of them so he will not allow them to be sent here this time. He sails from Marseilles to Genoa Chivtia Vecchia and Naples. The Boat stopping at each city during the day to load freight and running the night. He has not decided where he will go after Naples but I shall hear from him there. I commissioned him to buy Annie Buckers set of coral at Naples as it is cheaper there than any other place. As soon as he returns we will set out for home. . . .

Mary and I had a half holiday in the woods this week and picked chestnuts. Mary laughs at my eagerness at this occupation. I tell her, it reminds me of home and when I was *young*—it is a regular treat to hunt them here though I learned afterwards that it was forbidden. We went to the park of a Chateau about a mile & a half from here where I had never been before and along the nicely kept roads w[h]ere there were rustic benches and beautiful views. The chestnuts were so thickly scattered that one could pick [them] up with both hands and in half an hour we had four or five quarts. We gave most of them to Mrs. Helmick to pay for our dinner as Mary said for we dine so frequently there and she is very fond of chestnuts. Fortunately for us we escaped with our booty for if we had been seen we would have had to pay a fine. I imagine the guard will think the squirrils have been unusually active. I noticed one thing that under the best trees the leaves had been carefully swept to one side, but I thought at the time they had only been taken out of the walks. You may imagine how convenient it was for our poaching proclivities.

Dinner is ready and I am at the end of my paper. I believe I told you Miss Gordon spent a day with us with a young gentleman from New York. We went to all the studios with them. . . .

<div style="text-align:right">

Yours as ever Very Affec.

Eliza

</div>

Eliza Haldeman returned to Philadelphia with her brother Carsten late in 1868. Mary Cassatt seems to have stayed in the Ecouen/Villiers-le-Bel area until the spring of 1869. She then spent April through June in Paris, before departing on a sketching trip in the French Alps with Miss Gordon.

Beaufort sur Doron, Savoie
August 1, 1869

My dear Lois,

I have had such a variety of mishaps lately & have changed places so often that most of my correspondents have had a respite, but I begin to think that it is quite time I was hearing from you again. I wrote to Aleck before I left Paris & the day we started I sent him the Consuls certificate;[2] I had been driving about for an hour hunting up our Consul who had moved since I last applied to him & only got the certificate in time to send it from the station just before the cars started. I am here with my friend Miss Gordon from Philadlphia, & we are roughing it most artistically. We made quite a trip before getting here. The first place we stopped at was Maçon where we were perfectly disgusted & from there we went to Aix les bains a very fashionable watering place entirely too gay for two poor painters, at least for one, for although my friend calls herself a painter she is only an amateur and you must know we professionals despise amateurs. So as Aix was too gay we went on into the mountains of Bauges to a place called Les Chesseures [?] our original destination. Unfortunately our hosts had but two beds & as we occupied them both they were obliged to sleep in the barn so we took pity on them & left & after further journeyings we came here. The place is all that we could desire as regards scenery but could be vastly improved as regards accomodations, however as the costumes & surroundings are good for painters we have concluded to put up with all discomforts for a time. These Savoyards are a most civil people & talk a sort of mixture of French & Italien very hard to understand.[3] We are just on the borders of Italy, we took a mountain excursion the other day & waded up to our ankles in snow, but were rewarded by a magnificent view of Mont Blanc & the St. Bernard, however we think we will rest satisfied with that & not try it again as we had to walk some twelve hours. Now my dear Lois I expect to have a long letter from you soon, indeed I dont know whether it is indiscrete but I expect a *very very* interesting piece of news from Altoona before long, it will give me sincere pleasure to hear that it is all satisfactorily over & I may venture to congratulate you beforehand, for my part I want a nephew.[4] Give my love to Aleck & believe me,

very affectionately your sister
Mary S. Cassatt

1. Maria Lois Buchanan (1847-1920), was the daughter of a Pennsylvania clergyman and niece of President James Buchanan. She was married to Mary's brother, Alexander, on November 25, 1868.

2. A consul's certificate was required to ship paintings out of the country. Every year, Cassatt shipped her finished paintings home.

3. The Savoyards had recently voted to be a part of France rather than the Italian region of Piedmont. In 1860 Napoleon III had rallied the enthusiasm of the people during a triumphant tour from Chambéry to Chamonix.

4. Edward Buchanan Cassatt was born on August 23, 1869.

MARY CASSATT TO ELIZA HALDEMAN

Beaufort sur Doron
August 17 [1869]

My dear Friend,

I thought when I last wrote to you that by this time both Miss Gordon & I wd be on our way home, instead of that we have been settled here for several weeks, & home seems as far off as it did this time last year. I was afraid you had not received my answer to your letter, but Mother tells me that you did. I cannot therefore imagine why you have not written, & am afraid I said something to offend you, if so I did not mean it & hope this will meet with a response. Did mother tell you of my misfortune last spring? I did not get in the Salon! My picture Mr. Frère said was infinitely better than last years, but it was large & not sufficiently finished. I was very much pressed for time & therefore was not very much surprised at my fate, although of course I felt dreadfully about it. Melle. Bourge was also refused on both of hers, both infinitely better than last years, but Mr. Frère got one in for her.[1] So you see they are not so very just after all; Mr. Gerome was very kind to me for when I heard that I was refused I went to him but alas! it was too late, he told me if I had come twenty four hours sooner he would have got my picture through! Miss Beller's Lilacs did not get in, I believe she is still in Spain, also your friend at Miss Beasleys was refused, I forget her name, but the one that painted the "Reponse du Levey." After I had heard my fate I went into Paris & staid there three months, but did but little work in fact none at all. I was not very well & of course very much discouraged, so I have only really been at work since I have been here, & even now I am taking it rather easy. Miss G. & I left Paris on the 10th of July & went to Aix les bains, from there to Les Chesseures in the Bauges mountains where we could find no accomodations, so came by way of Annecy & Albertville here. Annecy is a lovely old place, we might have lodged in the very house where St. François de Sales was born but did not think it looked inviting. Although the dirt & fleas exceed anything we have ever experienced before we are rather pleased here, the scenery is delightfull & we are within a days walk from Italy, five hours would take us

to the foot of the little St. Bernard. Models are not particularly plenty, but neither are they very dear. Mr. & Mrs. Helmick are staying at St. Gervais. Mrs. H. is taking baths there, I believe she is getting better, did you hear that they had lost their little boy? He died this Spring in Paris. Mr. H. has been making excursions over here & been staying in a town called Arèches further up the mountain with Mr. Meyer, he intends bringing over Mrs. Helmick as soon as she is through with the course at St. Gervais. I have been looking for a studio in Paris, but my plans are rather unsettled & I dont know what I shall do next winter, I think it probable however that I shall return to Ecouen at least for a month this fall. Miss G. & I are on the eve of leaving here to go—we don't know where yet. I am waiting to hear from home before deciding. So I wish if you answer this you would direct to Drexel Harjes & Co. 3 rue Scribe[2] & put Miss Gordons name on the letter, or send it to mother, but the other plan would be best. Have you seen Howard Roberts since he has been home, he had a very nice little bust in the Exposition. Have you been exhibiting & above all things selling? Miss Gordon sends her love, & I mine to your mother & sister, my compliments to the rest of the family, I hope your brother is better than when you wrote. With kind regards to him.

<div align="center">
Your friend

M. S. Cassatt
</div>

1. Pauline Elise Léonide Bourges (1838-1910) was a still-life and genre painter who studied with Frère at Ecouen.

2. Joseph Drexel, youngest brother of the Drexel banking family of Philadelphia, established the allied firm of Drexel, Harjes & Co. in Paris in 1867. Philadelphians abroad banked and received their mail there.

Cassatt's movements after her sketching trip with Miss Gordon are not well documented. Her mother joined her in Paris before Christmas 1869, after Cassatt had presumably spent the fall in Ecouen. She may have gone to Rome early in 1870 since she lists Charles Bellay (1826-1900), a French artist working in Rome, as her teacher in the 1870 Salon catalog. She was certainly in Rome during the summer of 1870; by the fall she was back in Philadelphia.

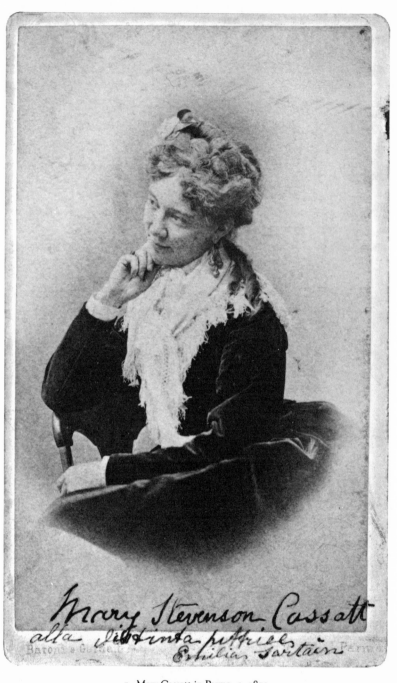

5. Mary Cassatt in Parma, c. 1872.

2

Travels and Early Career

1871-1875

WHEN SHE RETURNED FROM EUROPE in 1870, the twenty-six-year-old Mary Cassatt may have intended to settle down and practice art in Philadelphia, as Thomas Eakins and some of her other artist friends were doing. She rented a studio, located sources of models and art supplies, and became reacquainted with fellow artists like the Sartains—John and his children, Samuel, William, and Emily. But before long, Cassatt began to chafe at the limits imposed on artists in the United States and started plotting her return to Europe.

Even Philadelphia, which boasted a cosmopolitan community of artists and patrons, lacked the ingredients Cassatt considered necessary to serious art making: great collections of Old Masters, exciting modern art, and picturesque models. She became even more frustrated when she moved with her family to the small town of Hollidaysburg, near Altoona, and was forced to close her Philadelphia studio. As she struggled with the problems of obtaining materials and models in Hollidaysburg, her longing for Europe increased. Her letters to Emily Sartain, who had talked of going to Europe with her, show her growing obsession with Spain, a country she had never seen but that seemed to her an artist's paradise.

The obstacle standing between her and Spain at this time was money. Her parents were happy to support her, but felt that she should support her art: she was to pay for her studio, models, supplies, and other expenses, including travel. Cassatt, who had always

been eager to exhibit and sell, set out to raise the money. Capitalizing on her success at the Salons of 1868 and 1870, she was able to place some paintings with the dealer Goupil in New York. When these did not sell, in spite of the flattering attention they received, she took them to Chicago, where they were placed in the window of a fine jewelry store. By a stroke of bad luck, they were destroyed in the worst fire in Chicago's history, the Great Chicago Fire of October 8, 1871. Her hopes of selling now literally up in smoke, she turned to the young artist's last resort: copying. Fortunately, through relatives, she made the acquaintance of the bishop of Pittsburgh, who commissioned her to paint copies of two famous religious paintings in Europe for the cathedral. On the strength of this commission, she was at last able to end what she had come to consider her American exile and return to Europe.

The continent that Mary Cassatt and Emily Sartain were so happy to reach in December 1871 was just recovering from the Franco-Prussian War. When they passed through Paris, they found the wreckage and the reduced services—the aftermath of the siege of Paris and the violence of the Commune—a depressing contrast to the prosperity they had encountered in the 1860s. But elsewhere in Europe, they found that their lives were little affected by the war or other local squabbles; they traveled with ease through France, Italy, and Spain, especially now that unification and modernization had linked all the principal cities.

Temporarily postponing the trip to Spain, the two went directly to Parma, Italy, so that Cassatt could execute one of the copies commissioned by the bishop. Since Parma was ranked a secondary site among the great Italian attractions, Cassatt found herself outside the established circuit of American artists abroad. Without the usual hordes of American artists, amateurs, and tourists, Cassatt and Sartain had the opportunity to mix in Italian artistic and social circles. For Cassatt, this direct link to European culture proved to be an invaluable experience. She quickly made friends with the staff of the Accademia, including the professor of engraving, Carlo Raimondi, and his son Edouardo, also an artist. Her new friends were eager to help, putting themselves and the facilities of the academy at her disposal. When she produced some of her own work, including her entry for the Paris Salon of 1872, she became an overnight celebrity. The story of her success spread to Paris, where it was reported in an American newspaper:

Miss Mary Stevenson Cassatt has just finished an original painting which all Parma is flocking to see at her studio at the Accademia of that city. Prof. Raimondi and other Italian painters of reputation are quite enthusiastic in regard to our fair young countrywoman's talent which they pronounce to be nearly akin to genius and they offer her every inducement to make Parma her home and to date her works from that city.[1]

Emily Sartain, who was just beginning to master the art of painting after several years as an engraver, benefited from living and working with Cassatt in Parma, but felt that she needed more structured training and more exposure to modern art than was available there. Finally, in April 1872, she joined her family in Paris. With another American friend, she entered the atelier of Evariste Luminais, a painter of historical subjects who was having great success at the Salon that year. Cassatt, meanwhile, stayed on in Parma through the summer.

The copy finished and sent home, Cassatt was free to pursue her original destination—Spain—but was reluctant to travel there alone. When Sartain wrote her from Paris that two American acquaintances were about to make a Spanish tour, she set off immediately to join them in Madrid. There she encountered paintings of the Spanish school for the first time and was wildly enthusiastic. The superb collection of painting in the Prado, including works by Raphael, Titian, Correggio, and Rubens, in addition to Velázquez and Murillo, occupied her for some weeks.

But Madrid was just a stop on her way to Seville, where she stayed until April 1873. Unlike much of Spain, Seville was a clean, sunny city that offered artists a fine collection of Old Masters to study and many picturesque scenes to paint. It had become popular with artists in the 1850s and 1860s, in large part through the efforts of the prolific Scottish painter John Phillip, whose paintings and illustrations acquainted a large audience with Sevillian subjects. When Cassatt arrived, she joined the ranks of international artists taking advantage of the exotic models and settings and produced a series of paintings such as *Torero and Young Girl* (page 69) intended for major exhibitions in Europe and the United States. Once again, as in Parma, she received attention and assistance from local artists

1. Quoted in a letter from William Sartain to John Sartain, March 25, 1872, in the collection of the Historical Society of Pennsylvania, Philadelphia.

and Sevillian society. She was given a studio in the Casa de Pilatos, the palace of the dukes of the Medinaceli—a luxurious setting with its colorful tiled staircase and lovely garden. With such a studio, plentiful models, and few other amusements to distract her, she spent a productive six months.

Cassatt left Seville to see the Salon in Paris (where her *Torero and Young Girl* was on view), and then, instead of returning to Parma as she had intended, she continued northward. Meeting her mother in Paris, she traveled with her to Holland and Belgium, settling in Antwerp for the summer. That fall, after her mother returned to Philadelphia, Cassatt went south to Rome (after a stopover in Parma), where she spent the spring of 1874 consulting with her old teacher, Charles Bellay. Finally, late that spring, she made the decision to end her wandering and settle down in Paris, where she felt she could best develop her career. But after a brief stay in the city, Cassatt retreated to the countryside, spending the summer at her old haunt, Villiers-le-Bel. When she returned to Paris, she took up residence at 19, rue de Laval, her address for the next two years. One last trip to Philadelphia in the summer of 1875 ended her wanderings for good: she was in Paris to stay.

Throughout the Cassatt and Sartain letters, we catch tantalizing glimpses of Cassatt's theories of modern art in the early 1870s. In contrast to the more conservative Sartain, whose opinions were shaped by her father and her teacher, Luminais, Cassatt vehemently opposed the style that dominated the Salon and hence restricted the development of modern art in Paris. She was sharply critical of the "washy, unfleshlike, and grey" paintings of Cabanel and Léon Bonnat, and had no respect for favorites like Luminais. The artists she admired—Correggio, Velázquez, Murillo, Rubens, and the modern artists Raimundo de Madrazo, Mariano Fortuny, and Thomas Couture—had the qualities of realism, solidity, and emotional intensity that she wanted in her own work. Her opposition to the French school kept her away from Paris for several years, restlessly searching for alternatives in the work of the Old Masters and of modern artists practicing elsewhere.

By 1875 the opinions of Cassatt and Sartain had polarized, representing in microcosm the conflict in the larger art world between the established Salon artists and the "independents," some of whom came to be called "Impressionists" after their exhibition in

6. *Torero and Young Girl*, 1873. Oil on canvas, 39¾ x 33½ in. Sterling and
Francine Clark Institute, Williamstown, Massachusetts.

the spring of 1874. The misunderstandings that arose from the
clash of Sartain's conservatism and Cassatt's independence led to
the dissolution of their friendship. Sartain returned to Philadelphia
to assume a prominent position in the art establishment there;
Cassatt took up residence in Paris, determined to fight for her own
interests in an art center she despised, but that she recognized as
the most powerful in the world.

23 South 16th Street

Thursday morning [Spring 1871]

My dear Miss Sartain,[1]

Our model came for inspection this morning, he is'nt very handsome, but I have no doubt that he will look better in his costume. He is to be here at nine tomorrow morning, so if you find it convenient to meet me here we will all go to the studio together.

Please let me know if you can come. I am in hopes that I may be able to find some woman model through this man.

very truly yours

Mary S. Cassatt

1. Emily Sartain (1841-1927) was an active member of Philadelphia art circles all her life. A close friend of Thomas Eakins, she had been trained as an engraver and studied drawing at the Pennsylvania Academy by 1871. Before her trip with Mary Cassatt, she had traveled to Europe in 1862-63 and again in 1868. After the four years of European study that are chronicled in her correspondence with Cassatt, she returned to Philadelphia. There she was a portraitist, engraver, and art editor of *Our Continent* and *New England Bygones*. In 1886 she became principal of the Philadelphia School of Design for Women, a post she held for thirty-three years.

MARY CASSATT TO EMILY SARTAIN

do you believe in four leaved clovers?[1]

Hollidaysburgh[2]

Monday, May 22 [1871]

"Dear my Friend & Fellow Student" as Mrs. Browning says, "I would lean my spirit o'er you"[3] &&. In other words I was very glad to receive your letter this morning. I really thought you had completely forgotten me & were preparing to start for Spain with somebody else. Alas! we don't seem any nearer than we were some months ago, at least I don't, I have been abandoning myself to despair & homesickness, for I really feel as if it was intended I should be a Spaniard & quite a mistake that I was born in America, as the German poet says "Spanien ist mein heimats land."[4] Mother wrote to a friend in New York about my pictures & she went to see them & she praised them & pretended to be very much pleased & wound up by wishing me more *substantial admirers* which I heartily wish I had, it appears a number of people have seen them amongst the rest several millionaires but with no result.[5] "Patience" is my motto.

7. The Sartain family (left to right): John, Samuel, William, and Emily, c. 1871.
Library of Congress, Washington, D.C.

As to the matter of models I have not looked for them yet, but I have
found a studio & shall move in tomorrow. The room is a large one high
ceiling & a studio window built for a portrait painter rent $4 (four
dollars) a month! We have only just got settled & are very well pleased
with the town which is very pretty all the houses surrounded by gardens.
The mountains are too tame for my taste I should prefer the Sierra
Nevada. We have no horse or carriage yet. Gard sold his just after we
reached here & has not yet got another & the vegatables are not ripe
yet, which are considerable drawbacks, for the country without fruit or
vegatables suggests starvation. When these objections are removed I
want you to come up & pay us a visit, Father thinks that you ought to
come up when "Jorge" our Spanish friend comes & perhaps you could
arrange to go back to Spain together, but I won't consent to anybody's
going without me, besides I am afraid he is degenerated into a "Yankee"
& means to spend his life in Boston.

I am much obliged for the magazine, reading matter is very welcome

here. I enclose a Plea for the Commune[6] which I wish you would read,
I think it does them more justice than most of the newspaper corre-
spondents. Write to me soon again & let me know if you have any more
orders. I am sorry I did not have the pleasure of meeting Mrs. Este I hope
I shall be more fortunate another time; that is before we leave?! All
desire to be remembered to you & hope to see you this summer. Give
my kind regards to your father & mother & believe me

<div align="center">

very truly your friend

M. S. Cassatt
</div>

I found in unpacking our books a Spanish grammar & dictionary but
things are too uncertain for me to have the courage to attack them yet.

1. There is a four-leaf clover attached to the upper left corner.
2. By the end of 1869 Alexander Cassatt had been named general superintendent of
the Pennsylvania Railroad, a position that kept him in Altoona for another two years.
The Cassatt family—including Mary, Lydia, and their younger brother, J. Gardner Cassatt
(1849-1911)—moved to nearby Hollidaysburg in May 1871, probably to be with Aleck
and Lois for the birth of their second child, Katharine Kelso Cassatt, on July 30, 1871.
Both families moved back to Philadelphia when Aleck was promoted to general manager
in the fall of that year.
3. This is the first line of Elizabeth Barrett Browning's "Lady Geraldine's Courtship:
A Romance of the Age," published in 1844.
4. "Spain is my homeland."
5. Cassatt had placed two paintings with the art dealer Goupil in New York.
6. The Commune was a short-lived governing structure formed by the city of Paris
in the spring of 1871. After the failure of Napoleon III's imperial government and several
succeeding national governing bodies during the Franco-Prussian War (1870-71), Paris
withdrew to form its own "city-state" based on more democratic principles.

MARY CASSATT TO EMILY SARTAIN

<div align="right">

Hollidaysburg

June 7 [1871]
</div>

My dear Friend,

I was very glad to hear of your brothers return as I know it must be
delightful to be able to talk over your plans with some one who can
sympathize with you.[1] Father maintains that one always has more pleasure
in anticipation than reality. I am afraid that my pleasure will have to be
confined to the first as I have heard several times from New York but
nothing in any degree favorable to the sale of my pictures & I am begin-
ning to search for a field of operations for next winter nearer home.
However as you may be more fortunate than I am, I must tell you what I

8. *Portrait of Mrs. Currey; Sketch of Mr. Cassatt*, 1871. Oil on canvas, 32 x 27 in. Private collection.

have forgotten hitherto, that I had an acquaintance a lady artist [Fräulein Beller?] who spent a year or at least a winter near Madrid two years ago, she is a german & her means are very limited so I know the expenses were not great. She lived within a short distance of the city & was able to go in when she pleased, her account of everything was enthusiastic. The climate I have always heard was severe, but I doubt if there is a climate in the world so trying as this of America especially Philadelphia, I fancy you would find anything preferable to that. In Rome the hotels & restaurants are dear & yet one can live cheaply. I am in such low spirits over my prospects that although I would prefer Spain I should

jump at anything in preference to America, & would look upon any of the places you mention as paradise. I wonder at your being prejudiced against Munich the Gallery is fine & some good artists live there & it is cheap. I suppose though things will be changed since this affair in France. Poor Paris![2] I am anxious to hear from there but there is no one writing at present. I think you need have no fear as to climate—one can always make oneself comfortable & indeed if one can't one forgets the need of comfort when working hard. Capri is better than Naples & there is quite a colony of artists & it is extremely cheap. Enfin! all this is I am afraid not for me, but in the midst of my misfortunes I can heartily congratulate you on your two new orders & hope you will find some one else, if I am not able who will be able to accompany you. Father is in town today to see about some sort of a vehicle to carry us about the neighbour-hood, it has been so oppressively warm that we have not had the energy to settle anything as yet. I suppose I am getting acclimated but I find the process anything but palatable & wish myself in a more congenial climate, Rome last summer even with the fleas was as nothing compared to this place. I am very much obliged for your fathers kind offer about my pictures but for the present I will let them remain where they are. I am working by fits & starts at fathers portrait but it advances slowly he drops asleep while sitting. I commenced a study of our mulatto servant girl [figure 8] but just as I had the mask painted in she gave warning.[3] My luck in this country! I was amused at her finding that I had not made her look like a white person. I have run out of colors & have sent to town for more but they have not arrived yet. Do you know where I could get some good rough canvass? I don't think Janetsky has any. I wonder if Kurz has, if you pass his shop would you kindly ask & let me know. When I have struck a vein of models I will let you know & you must come up. I long to see you & have a talk about art. I cannot tell you what I suffer for the want of seeing a good picture, no amount of bodily suffering occassioned by the want of comforts would seem to be too great a price for the pleasure of living in a country where one could have some art ad-vantages. With kind regards to all

> I remain yours in the Heart
> M. S. Cassatt

1. Emily's younger brother, William Sartain (1843-1924), had also studied at the Penn-sylvania Academy and at the Ecole des Beaux-Arts in Paris in the 1860s. He had visited Spain before his return to Philadelphia in 1871.

2. The situation in France had steadily worsened since the Franco-Prussian War had begun in the summer of 1870. Paris was under siege by German troops until it capitulated on January 28, 1871. That spring, Paris withdrew from the new conservative national government to form the Commune. The suppression of the Commune by the right-wing government (headquartered at Versailles) during the week of May 21-28, 1871, was one of

the bloodiest battles in Paris's history. The aftermath that summer was even more horrifying, as the Versailles government arrested and killed almost fifty thousand people associated with the Commune. Order was finally restored, and on August 31, 1871, Adolphe Thiers was named president of the Third Republic.

3. A sketch for the portrait of her father is underneath the unfinished portrait of the Cassatt's servant, who later became Mrs. Currey.

MARY CASSATT TO EMILY SARTAIN

Hollidaysburg
July 10 [1871]

My Dear Friend,

I received the magazine & your portrait was pronounced excellent by all the family.[1] I have no doubt it will bring you in many orders. I never thought about the canvass since I wrote so you need not have distressed yourself. I am glad you have got the other portrait & hope it will pay you well. I too am ravenous for money & am determined to try & make some, not by painting though. I have fully made up my mind that it [is] impossible for me unless I choose to set to work & manufacture pictures by the aid of photographs. I have given up my studio & torn up my father's portrait, & have not touched a brush for six weeks nor ever will again until I see some prospect of getting back to Europe. I am very anxious to go out west next fall & get some employment, but I have not yet decided where. I have already spent on my art since I have been home enough of money to carry me to Rome, with no result.

This is excruciating weather is'nt it—too hot for the last two days to stir from the house, although we generally have cool nights here.

Have you heard anything of Mrs. Helmick?[2] I wrote to her after we came up here but never received any answer. Has your brother any intention of remaining in this country? I don't know if I could have resisted Mr. Howell's invitation if I had been you although I suppose you would have no chance for work, which is the main thing.[3]

I hope next month when you are at liberty I shall see you here although I cannot offer you any inducements as to models or work but it will be a change from town. Write to me soon & believe me

very truly
your friend
M. S. Cassatt

1. Emily Sartain learned the technique of mezzotint engraving from her father and became successful at engraved portraits for books and magazines.

2. Mr. and Mrs. Howard Helmick were friends of Cassatt's from her first trip to Europe. They lived in Paris throughout the Franco-Prussian War and the subsequent upheavals.

3. William Dean Howells (1837-1920) and his wife were friends of the Sartains. Howells's early Italian writings were based on his years as American consul in Venice (1861-65); from 1866 to 1881 he was editor of *Atlantic Monthly*. They may have invited Emily to accompany them to Europe as a companion and governess to their children.

MARY CASSATT TO EMILY SARTAIN

Hollidaysburg
Saturday, October 21 [1871]

My Dear Miss Sartain,

I received your letter this morning. & reply at once with many excuses for not having written before. The fact is I did not wish to write until I had someting definite to propose, nothing is settled yet but still I begin to see daylight. What do you say? are you still in the same mind, would you be willing to go abroad this fall, or not? If I go, I go to Spain probably to Seville, & with the letters that I have (one to the Arch-bishop) I think we could make sure of being settled to great advantage.

And now I must tell you all my adventures. I went to Pittsburg with my mother & went to call on the Catholic Bishop¹ who is a Spaniard, & he has given me two orders for copies for the church. In Pittsburg I joined two of my cousins & went with them to Chicago & took with me, my two pictures, (the ones that were at Goupils). In Chicago I met with more encouragement than anywhere else since I have been home, I had every hope, both for orders & selling my pictures, when the fire broke out, & the pictures (which were in the largest jewelry store in the city, were burned!² I was at the Sherman house & was fortunate enough to escape with my baggage. I think of making some further efforts to obtain more orders & if successful will start as soon as possible. You must have made a lot of money by this time & I hope you are still in the same mind about going abroad. I met an American who has lived a long time in Spain & she gives a very encouraging account of the people & their cleanliness & cooking. I specially wish to see something of Spanish society & with letters I suppose that will be easy; when I said I was to have a letter to the archbishop, I believe I was mistaken, I should have said a letter to *all the* bishops, stamped with the episcopal seal & enjoining them *all* to give me aid & comfort in every possible way. I think it may prove very useful. I wonder if I could get any orders for churches in New York? The Madonna's of Murillio are great favorites with Catholics. Write to me soon & tell me what you think, I am wild to be off, I have lost too much time already.

Can you fancy yourself revelling in pictures & models "ad libertum"

this winter instead of a meagre "three days in the week. But I will say no more perhaps I won't get off after all.

<div align="right">

affectionately yours,

M. S. Cassatt

</div>

1. Bishop Michael Domenec, second bishop of Pittsburgh, was from a wealthy and prominent Spanish family. He came to the United States in 1839 and held the position of bishop from 1860 to 1876. One of his accomplishments during this period was to complete work on the city's cathedral. Today, the diocese has no records dating from this period, nor can it document the fate of any of the original furnishings after the building was razed in 1903 to make way for the new cathedral—leaving us unable to trace Cassatt's work for the bishop.

2. The Great Chicago Fire began Sunday evening, October 8, 1871. In twenty-four hours it spread over five square miles, destroying over 17,500 buildings, including the central business district. Property loss totaled over $200 million. Alexander Cassatt wrote to his wife: "Mother it appears did not go to Chicago, but staid at the Meadows with Mrs. Johnston —Mary went in with Minnie & Aleck Johnston—they are now back at Pittsburgh—saved their baggage, but Mary's pictures were lost. I am glad they got off so easily." (October 12, 1871)

MARY CASSATT TO EMILY SARTAIN

<div align="right">

Hollidaysburg

Saturday, October 27 [1871]

</div>

My Dear Miss Sartain,

I am afraid that you are offended, or have changed your mind about Europe. I should be very glad if you would let me know what your idea's are. The Bishop of Pittsburg sent his promised letter this morning, it is everything that could be desired. We move to town next week our address will be 1416 South Penn Square. I heard last night from Chicago, it seems my pictures were removed, with other goods to the lake shore, & *burned there*! Pleasant to know that they might have been saved. If you make up your mind to go to Europe take my advice & try & get orders for copies, of heads or small pictures, believe me it will pay & be most excellent practice for you. I hear that Healy asked ($6000) dollars for a *copy of Van Dyke*!! & it was bought in Chicago.[1] Of course that is absurd but still if one only gets one hundred dollars for a small copy it pays better than twice the sum for an original because you have no rent no models & no fire to pay while at work, & a *little copying* is good for one; not too much however. Oh how wild I am to get to work my fingers farely itch & my eyes water to see a fine picture again.

<div align="right">

truly yours

M. S. Cassatt

</div>

I am going to Washington before I will be in Philadelphia.

1. George Peter Alexander Healy (1813-1894), a painter from Boston, spent most of his career in Europe. In the 1860s and '70s he was considered one of the finest American painters working in Paris.

With their financial problems finally solved, Mary Cassatt and Emily Sartain departed for Europe early in December 1871.

EMILY SARTAIN TO JOHN SARTAIN [1]

> Hotel Prince Albert—rue St. Hyacinthe St. Honoré [Paris]
> December 15, 1871
> Mailed from Parma, December 23

Dear Father,

Miss Cassatt has gone to call upon some friends, and so I have time in this busy Paris to write up, from the time my letter mailed at Queenstown has informed you of. We reached Liverpool Friday morning and were taken ashore by a tender about ten o'clock. After a bare formality of opening our trunks at the Custom House, we drove up to the splendid new hotel opposite St. George's Hall, and right at the station. It is a very large handsome house, beautifully decorated, with not only a fine coffee room, but an elegantly furnished drawing room, an unusual feature in English hotels. We were well served at a comfortable breakfast, for we were both almost famished, had a good bath, and a rest in bed after it,—and considerably refreshed, started for London in the 4. P.M. train. When I talked with Dr. Forman and Mr. Hartshorne about their plans, there was no uniformity with ours,—they were going to the Adelphi, would stay over night in Liverpool, would travel first class etc., but having called on us at the North Western, they expressed themselves already disgusted with Liverpool,—and having found themselves mistaken on the first point I suppose, they yielded on all,—and when we went down to the train, they had bought their tickets second class, had tipped the guard to reserve us the best carriage, and were waiting to attend to our luggage and tickets—So we had their company all the way up to London, and besides two exceedingly entertaining English gentlemen were with us in the compartment, who kept us laughing and jolly all the way. As we had the protection of our friends, we felt free to unbend and enjoy ourselves. One of the Englishmen bought a box of delicious chocolate bonbons to get into direct conversation with the ladies. When Miss C. got faint from fatigue and weakness, the other Inglese opened one of the several bottles fitting in his handsome travelling bag, and

insisted on her taking some sherry, and after the gentlemen had crowded on one side that she might lie down with her head in my lap, he took his heavy shawl from his own knees and covered her with it, in spite of remonstrances,—sharing the lap-cover of his next door neighbor. If you had seen how carefully both of them had bundled themselves up to start with,—exchanging hats for fur caps, wrapping themselves carefully in heavy shawls so as not to leave a chink for the cold draught to reach their precious bodies, you would have been as much amused as we were. There is one advantage in the 2nd class carriages on that line, over any we have been in in France,—they have those things full of hot water for the feet. We arrived at London a little after nine,—our cavaliers looked after our luggage [for] us and cabbed us to Charing Cross Hotel,—giving up the Langham to follow us there. We were so tired that we rose the next morning at such a late hour as would have made you despair if you had been along. I went first to Soho Bazar to see Catharine Hiscox, who is fatter than ever. . . .

From there I went to Miss Toby's and Mr. Stewart's as I have written to Maria, and then to Mr. Fahey's.[2] Mrs. Fahey and Eliza welcomed me most smilingly. Mr. Fahey was at a private view of his Institute of Water Colors, and had left ticket in case Miss C. and I should like to come,—having received your letter in the morning mailed by me the night before. Mrs. Fahey invited us both to dinner next day (Sunday)— I then went back to the Hotel for Miss Cassatt who was superintending the mending of my trunk-lock, and afterwards went to the National Gallery— We went to the rooms of the Institute and found there a good collection of Water Colors and also Teddy and Mr. Fahey,—who were very polite to us,—though Teddy had a "tiresome" cold that made him feel somewhat stupid. Mr. Fahey was exceedingly kind. Failing in finding Gen. Schenck's address for us, he drove with us to some place in the Strand, and then giving our coachman the address, paid the fare right-through— "His Excellency" was not home but from his daughter we first heard of the burning of Warwick Castle. Of course, the Prince of Wales' illness was the all absorbing topic everywhere. From Schenck's we went to Miss Starr's, and made the engagement to spend the next evening (Sunday) with her— But when the next day came, Miss Cassatt was so worried and anxious about the crossing the Channel awaiting for her the next day that she declared herself too ill to keep either engagement, so I went alone. . . .[3]

At Starrs' I was quite frightened by being asked if I had my passport visée for France. We were going at half past seven the next morning and it was then nine in the evening. On asking at the hotel I was told it was absolutely necessary to have the visa. Miss Cassatt and I almost determined we must postpone for a day,—but summoning Dr. Forman to

the conclave,—he said he was willing to try it without,—so we went the next morning, four strong,—no visas and only three passports— And goosey-ganders we would have been to have waited, for the officer who was standing at the end of the plank as we walked off the boat at Calais, never noticed the omission. The examination was the merest formality. We suffered dreadfully from the cold going up to Paris— The ground was covered with snow, and the air filled with a thick fog, —the same as we had had in England. We had a funny scene at the station at Paris. Miss Cassat returned the many courtesies of our fellow travellers by securing a cab for them, as well as ourselves and packing them off first; whereupon one coachman protested loudly that the other had to carry only two *small* boxes while he had two *large* ones. Five commissionaires exerted themselves violently in our behalf to make him understand that we were two parties going to two hotels. It ended in our trunks being landed again in the street and a new carriage found. The streets were so deep in snow that all horses went at a funereal pace, the city was not so well lighted as it used to be, and the place altogether seemed sad. And by daylight it seemed no better, for then thick fog clouded everything— The ruins appeared more desolate yet, from the caps of snow the piles of stones wore.⁴ The Hotel de Ville seems like a Roman ruin,—the standing arches look very fine— Only the public buildings attract attention as ruins on the north side of the Seine,—but on going up the rue du Bac on the other side,—we saw stretching on each hand a street in ruins. We expected to see the destroyed quarter near the Bastille in driving to the station to leave,—but the fog was so thick everything was lost at fifty feet off. I could scarcely see the pictures in the Louvre it was so dark. It thawed most slushily our last two days in Paris,—but men were busy opening the gutters and carrying away the snow, so we were not quite drowned— I am finishing this you see at Parma— We were so much occupied at Paris, and so tired always that I could not finish it. I forgot to tell you, the channel was perfectly smooth when we crossed—like a lake— Miss C. was not sick,—not having the slightest excuse.

We left Paris Saturday afternoon at 3 o'clock and reached Turin the next night at 9,—*twenty-eight* hours. We started second class, but the cold was so intense that next morning at Amberieu we changed into first class, to have the hot water bottles to our feet. It was dark when we entered the tunnel,—and anyway we could have seen nothing, for when we attempted to open the window the smoke poured in— It took 30 minutes. When we left France we were forced to abandon the chaste precincts of "Dames-seules,"—for in Italy there is no such compartment,—and from Modane [?] we had the company of two Germans, a Prussian and Austrian—the former of whom talked English the latter

Italian. The Prussian was a musician and was very funny,—had served in the war against France. He told us of the Beethoven festival in most extraordinary English— He said the war made much distress in Germany —that in the conscription "nice young men like me were drawn, who were a loss to the nation— Now, the soldiers' trade was to die—they did not matter" etc. We had so little time in Turin the next morning we thought it best not to deliver M. Cloos' letter of introduction. The address we found was at Mr. Sella's place of business, and before he could have got home and brought his wife to see us, we would have been gone— Besides, Mr. Cloos had said nothing in his letter about their giving us letters to Parma, and they might not have thought of it. Mr. Muzio the impressario, now director of the Italian opera at Paris, and his wife are intimate friends of Miss Cassatt's,[5] and very warmhearted pleasant people (the wife is American),—and they gave us a letter of introduction to Signor Rossi the director of the opera here— He has been exceedingly kind. We left the letter of introduction at the theatre on the way to the Academy, and he called in the evening to say that he had at once consulted his mother about finding a suitable lodging, and that she thought Signora Toschi, widow of the celebrated engraver had a room we might have[6]— The next evening (yesterday) he came to say Signora Toschi had no room, but would look out [for] a place for us and he would come today to inform us— Yesterday at the Academy the custode brought to us an artist who is copying the Madonna of the Scodella who talks English perfectly—is the son of English parents though a native of Italy— He went with us to find canvas etc., and today called to offer his services to find us rooms, studio etc—so we went room hunting with him— He took us to a friend of his wife,—and it turned out to be the same people the Signora Toschi had been to to inquire about for us— We shall probably move there tomorrow— The name of the family is Bricoli—a lawyer and his wife— We are to pay 3 fcs. a day apiece. I have found a studio at 10 fcs. a month, —not a regular studio, there is none, but a room with a good light. Models are half a franc an hour— I will not close my letter till we have moved and got settled,—then the bill here being paid, and future expenses calculable, I can tell you how soon it will be important for me to receive money— Gold here is 6.75 per ct. above par— I was glad my bill was on London for Miss C's bill on Drexel Harjes & Co. was paid in notes, and she had to pay 13 fcs. to have five hundred fcs. changed into gold.

The St. Jerome[7] here is superb— Each time we see it, it seems more glowing and finer— Miss C. is delighted to copy it— The room it is in is warmed for copyists— There was talk of giving me a room at the Academy for a studio, but none suitable was found— The Madonna of the Scodella is not done justice to in the copy our Academy has,—but

I like it less than the St. Jerome— I will tell you more about the pictures and the city when I get more settled and less tired— . . .

<div align="center">Parma Dec. 23rd—</div>

Could not move into our lodgings yesterday as Italians are prejudiced against beginning anything on Friday— We are now settled, but cannot commence painting till Tuesday, Sunday and Christmas intervening.

I have enough money for about six weeks— It will do to send me a bill for £20, *Do not cramp yourself* to send me more than that, I calculate £10 a month covers every thing here— If you are flush even, it is not worth while to send more than £40 or £50—Send the second of the bill a week after mailing the *first*, in case of loss— Address care

<div align="center">Signora Bricoli

Borgo Riolo, No. 21

primo piano

Parma</div>

Love and Merry Christmas to all— Will write to Helen soon Yours affectionately

<div align="center">Emily</div>

1. There are fifty-nine letters from Emily Sartain (written to her father, John Sartain, while she was in Europe from 1871 to 1875) in the archives of the Moore College of Art (previously the Philadelphia School of Design for Women). Since Emily Sartain and Mary Cassatt traveled and worked together for the first four months, and kept in contact after that, these letters are an excellent source of information about a hitherto little-known period of Cassatt's life.

John Sartain (1808-1897), born in London, was trained as an engraver before he emigrated to America in 1830. He settled in Philadelphia, where he became a prominent engraver of fine art reproductions and worked for several magazines. In 1849 he started his own publication, *Sartain's Union Magazine of Literature and Art*, which, although short lived, brought him national recognition. He was active in the administration of the Pennsylvania Academy of the Fine Arts and in a number of other cultural organizations in Philadelphia.

2. Maria was Emily's sister. James Fahey (1804-1885) was an English engraver and water-colorist who studied with his uncle, Emily Sartain's grandfather, John Swaine. He was a founder of the New Water-Colour Society in London. His son, Edward Henry Fahey (b. 1844), was also a painter.

3. Mary Cassatt was a notoriously bad sea-traveler; she claimed that it was her seasickness that prevented her from returning to the United States for over twenty years, once she had settled in Paris.

4. During the week of the suppression of the Commune in May 1871, the Hotel de Ville was burned; the powder magazine of the Luxembourg, on the left bank, exploded, causing widespread destruction; and fighting broke out in all quarters. The Communards made their last stand in the Père Lachaise Cemetery, not far from the Bastille, on May 28, 1871.

5. Cassatt had been introduced to Mr. and Mrs. Emanuele Muzio, and their friend Mr. Ryan in 1868 by Eliza Haldeman (see Eliza Haldeman to Alice Haldeman, May 13, 1868). Emanuele Muzio (1821-1890) was born in Parma. His career as a conductor and composer led him to the United States (1863-68), where he married Lucy Simmons from Harrisburg,

Pennsylvania. He became conductor and advisor of the Théâtre Italien in Paris in 1870.

6. Paolo Toschi (1788-1854), a famous Italian engraver, was named director of the Accademia of Parma and professor of engraving in 1837. He was best known for his engravings of Correggio's frescoes in the Parma Cathedral and Parmigianino's fresco in San Giovanni.

7. Correggio's *Madonna and Child with Saint Jerome* (1523) was considered in the nineteenth century to be one of the greatest paintings of all times. Marie Louise, Napoleon's wife, had caused this painting and Correggio's other masterpiece, the *Madonna della Scodèlla*, to be hung in the Galleria of Parma, each in its own silk-hung room. Although Cassatt had come to Parma expressly to copy the *Saint Jerome*, she apparently changed her mind, and instead she executed and sent to Pittsburgh a copy of the *Coronation of the Virgin* in the Accademia.

EMILY SARTAIN TO JOHN SARTAIN

Casa della Signora Bricoli
Borgo Riolo No. 21, Primo Piano
Parma
January 1, 1872

Dear Father,

I eat so much dinner every evening now that I have to remain torpid and drowsy for an hour or two afterwards and by the time I feel equal to any exertion it is our hour for bed. And so as my days are now fully occupied at the studio, my letters get postponed from one day to another— I wrote to Mr. Schussele last week, and week before that mailed a long one for you enclosing one for Hattie and Maria. I hope they arrived safely. It scarcely seems possible that this is only the beginning of the New Year. It appears to me so long since I left home that I fancy it must be about April or May though the cold and the chapped hands and frosted feet are enough to contradict that supposition— It is the custom here on the last of the year to give serenades especially to the army officers, and last night we had a magnificent one right in front of our house, as well as two others by different bands later in the night in the neighborhood— There have been grand discussions all day whom our serenade could be for. Miss Cassatt and I thought we might as well take the compliment to ourselves, since it was right under our window and no one else claimed it— To be sure, we did not know anyone who would be likely to send the municipal band of 25 or 30 performers to play delightful choir music and waltzes to us, while we were sweetly posing but we might as well appropriate the pleasure of imagining it so. At the dinner table, the last decision was that the prefect had sent it to the Countess di San Vitale who lives opposite, the grand-daughter of Maria Louisa.[1] The whole family is out of town now however.

Yesterday being a festa the Academy closed early and we went out to promenade on our favorite walk along the ramparts and then through the

83

Gran Corso,—avenue of trees, like the boulevards at Brussels— The paths for equestrians looked quite lively with officers exercising their horses— There was even a lady riding, the first we have seen. But I commenced about our walk, to tell you what a peculiar effect the land-scape had. There had been a heavy dew the night before, which had frozen,—and everything, every twig of the trees, every blade of grass was incrusted with a thick coating of white crystallized like frozen breath on a windowpane— There was a thick fog—but not like ours or the English,—it was white, and overhead you could see faintly the blue of the sky,—and it seemed dry too. Looking from the top of the walls over the landscape there was a most wonderful effect,—the trees relieved white against blue mist. In the Avenues, it seemed like fairy land,— very theatrical, like a stage scene. The sun looked perfectly white and rayless, like a moon, and yet here and there on the trees there was a suspicion of yellow sunshine, while the rest was gray and white, and below shadow with bright colored figures moving. Then besides there was the contrast between evergreens and bare-branched trees. But I think now it was foolish to have attempted to tell you about it,—it is so impossible to describe it.

We are very comfortably settled and our padrona shows herself anxious to oblige us. We have a very large room in an old palazzo with an angel frescoed in the centre panel of our very high ceiling. You may judge it is a large room by the amount of furniture, two beds, two washstands, a bureau wardrobe hatrack, writing desk, dressing table, centre table, two other tables, a big easy chair sofa, two arm chairs, five ordinary chairs, and our two trunks,—and yet room enough to move around. Our floor is of that cement that looks like stone, like the Pitti palace floors,— with a large pattern in the centre. Rugs of course at the bedsides and in front of dressing table and sofa— At quarter past seven the girl comes in and lights our fire, by half past we are up, and are ready for our breakfast by eight,—caffe latte and bread and butter, brought to our room and eaten comfortably by our fire. Then off to our work, to return at half past twelve to our colazione, beefsteak or mutton chop, bread and butter, wine and apples or grapes— We dine about five,—first a soup generally of some of the innumerable varieties of maccaroni,—then two courses (one almost always turkey or chicken) then cheese and apples or figs,— and on festas a kind of honey-cake afterwards and a kind of nuguat candy, —and today in addition we had panna montala, or as they call it here latte spumante— It recalled Florentine days. When we have extras, we generally also finish up with a bottle of Vino d'Asti, a nice sparkling wine like champagne. We did not like the wine the others drank, so we have a special bottle of vino rosso provided for us, and we always empty it— Our colazione is served in the sala, which *professes* to be warm, as our fire

84

of course out by that time; and for dinner we ascend to our padrona's dining room, a little room opening out of the kitchen up stairs, and from which it receives its only heat. The party at dinner consists of the Signor avvocato, Bricoli, and his wife,—two boys of about eighteen or nineteen, natives of San Remo and another town near Genoa, boarding in Parma now to attend the school of Pharmacy here— They have vacation now on account of the Christmas festas, a whole month, they commence school again next week and in fifteen days have another month's vacation for Carnival. They also have July, August, Sep., Oct. and I think, November. That is hard study, isn't it?

I told you how much we are paying here, three francs a day each, and you can judge we fare very well. I thought at first it was very cheap, but our landlady is so very anxious to please and the advocate notices so particularly when we do not eat freely of particular dishes and remembers to speak of it the next time the same dish is served, in reproof that it should be on the table when we do not eat it,—that I fancy now that they feel they have taken us in.

Sunday afternoon the Inspector of the Academy, Signor Barbieri, took us all over the school— There are a great many rooms, well lighted,— two or three for the different classes from the Antique,—two or three landscape rooms, a very large room for the Life Class and several very large rooms for the students in sculpture,— There are two professors for landscape painting as well as those for the other branches. The life class does not commence till May, and Sig. Barbiere talks some of letting Miss Cassatt have it for a studio in February, while she is painting her picture for the Salon— Miss C. is now at work on a very large canvas, copying the "Virgin Crowned," a copy by Annibale Carracci from Correggio— The original fresco was in the half dome off the chancel of San Giovanni. They determined to enlarge the chancel so Carracci was commissioned to make this copy in oil and his pupils repeated it in fresco on the new semi dome— The figures of the original fresco were put up in the Library— The room in which it is, is not warmed, so of course at this season of the year it is impossible to copy it. Miss Cassatt thinks the Virgin's figure alone will do for an Assumption. It is large and simple in its manner of painting, and after dashing it through rapidly she will get on with so much more ease at her St. Jerome— She employed Mr. Cornish [2] (whose studio I have), to draw it for her by squares—as she dislikes the mechanical labor so much and could work with so much more profit on other things. It is only of value to her as far as placing the objects is concerned for it is drawn in such a round manner that every line will have to be changed.

I made a new arrangement with my model today. She was always so tired and sleepy in the afternoon that she was very little good,—so today

I fixed it that she was to come from 8½ till 12½ for a franc a day— She is very well satisfied with the change— She had frosted feet and preferred to wait at the studio for me while I went to colazione,—which was very tiresome. Her finger is getting well fortunately— I find painting lifesize very troublesome,—after being used so long to working so small— I shall now have more time for the Academy and the churches— By the way next Sunday, Sig. Barbieri is going to take us through the Engraving school which was closed when we went through the rest of the Academy.

I told in Mr. Schussele's letter that we went to the opera last Sunday week— Sig. Rossi presented us with a box— There is a very fine orchestra, nearly sixty performers— We think of going again Saturday night to hear Trovatore— I am glad to hear that during Lent we will have a "commedia" here. We can be cheap in the reserved seats and practice Italian— After Lent there will be a very fine opera troup—

As I am writing, you are about getting through dinner— I am wondering how many you had to eat Christmas turkey with you,—and to wish you a happy New Year— Cousins are still with you I hope, and quite reassured about the [smallpox] epidemic I hope— I am anxious to know whether I may look for Ma's sailing for Europe in about six weeks—and by what time Willie is coming—I hear of the news only though Sig. Bricoli— There are no newspapers about the house,—he goes to the caffe every evening to read them— . . .

Love to all— Write soon— Hope the Academy is coming on all right[3]—

Yours
Emily

1. Marie Louise (1791-1847), archduchess of Austria, empress of France, and duchess of Parma, had an important influence on Parma in the first half of the nineteenth century.
2. Giacomo Cornish (1837-1910) was a painter and drawing master in Parma.
3. John Sartain was active in the campaign to build a new Pennsylvania Academy building, and discussion of the project runs throughout the Cassatt and Sartain letters during these years. The new Academy, designed by Frank Furness, was finally opened in 1876.

EMILY SARTAIN TO JOHN SARTAIN

Borgo Riolo No. 21
January 12, 1872
Mailed January 13

Dear Father,

Raimondi is a jewel![1] One of the custodians told him today that Miss Cassatt was anxious to have a studio,—and he at once hunted her up

86

in the gallery, and offered for her use one in the Academy free of charge—
It is a very large room with a fine large window,—formerly occupied
by a Countess something or other, who gave up the keys two or three days
ago— He turned to me and said "also for you,—there's room for you
to work here too"— I shall wait and see whether Miss C- really wants me
to come, before giving up my own room,—there might be difficulty
in posing two models in it, in good light. Last Sunday by invitation, we
went in to see Raimondi in his own studio. Besides a good many of
his own and Toschi's works, he showed us a number of splendid photo-
graphs after Meissonier.[2] I admired very much an engraving he had made
from a miniature of Franklin, and today when we were in his room
again, I spoke again in praise of it, whereupon he told me he would give
me one before I left. He engraves on an *almost perpendicular* table, a
double table,—on the upper one an arrangement to fasten the plate,
—then underneath an affair that will hold the upper plank in any position
whatever— I should think it would be worth your while to try it on
your next large plate. It was a small one he was doing,—a portrait. When
we went down into the gallery on Sunday from his studio, we found
Sig. Barbieri the inspector, waiting to take us through the school of en-
graving which I had expressed a desire to see. It was a large room, with
walls covered with fine engravings by the best masters,—on one side
a row of windows, with engraving tables at each—but all like Raimondi's,
and turned sideways to the window to get good light on the steep
slope— They were all working on copper,—mostly copying faithfully
fine engravings— Raimondi's plate was copper too. I asked Barbieri if
they were to be covered with steel afterwards and he said no— I think
very much less of Toschi's work, since I have seen the originals, he
has left all the squareness out. His copy of the *Virgin Crowned Queen of
Heaven* that Miss C. is doing, is absolutely miserable—it gives you no
idea of the picture— Correggio had a model for it, who had very short
legs (a peculiarity of Parmesan women),—and I don't know whether
it is his fault or Carracci's in copying him, there is great doubt as to the
position— There is a high light in the mantle covering the lap, that
to me is unquestionably the knee of her left leg bent,—the right leg
hanging nearly straight and the knee obscured by the drapery. That makes
a graceful and consistent attitude, the legs facing towards the right,
her body turned a little more towards the left, and her head bent quite
over her left shoulder. But you ought to hear the discussions that go on
daily and hourly about where her knees are. There are six custodes,
who continually renew the question, and all the professors the director,
secretary etc. as they pass through put in a word— Raimondi says what
I call her left knee is her right and that her left is a way off to her left
over the head of a cherub that supports the drapery— Toschi engraved

it so, or rather had it in his mind though he doesn't express it,—and altered the foot entirely to make it suit. A doctor who was present at one of these talks, expressed the same opinion I hold, whereupon they all called him a fool— Nevertheless I am sure he and I are right— It would be impossible to get into the other pose,—and how awkward it would be! I forget whether I told you the picture was taken down and carried into the room where the custodes sit, where there is a fire— It is not everywhere that Miss C. would find people so anxious to make things convenient. It is an enormous canvas. The original fresco is preserved only to the knees—

Signor Barbieri, the inspector, received a commission from Rome to make copies of the cherubs of the hall of Diana[3]— And imagine how he is doing it! He works in his room from *photographs*! Toschi's watercolors from the frescoes,—preparatory for his engravings, are hanging in the Academy, and are very soft washy things.

This week we have had perfectly lovely days, the sky deep deep blue, the air full of sunshine, and the evening tints those beautiful rosy and violet hues we admired so often at Florence— We have taken long walks about sunset. We feel now we really are in Italy— Parma grows upon us more and more,—its picturesqueness is developed wonderfully by the bright sun— The "torrent Parma" as the river is called, is bordered on each side by houses and walls like the old part on the Arno, opposite Mr. Vanderwoort's house. Crossing the bridge this afternoon to the Public Garden the view down the river was beautiful,—the Appenines closing the vista— Until this week we have scarcely known how close the mountains were to us,—the air has been so misty— Today we saw them three fourths of the way around the horizon—

I find I cannot understand the Parmesan dialect scarcely at all— I had heard there was great diversity in the different cities,—but was surprised when one of the custodes told me he could not understand Neapolitan or Genoese at all,—they are like different languages— Speaking of it afterwards at table, Sig. Bricoli said that in the courts of law when there was a Neapolitan witness, they always called an interpreter. . . .

From Miss Cassatt's letter from her mother, I learned that my letter mailed at Queenstown had arrived safely— I was very glad to hear you had been up to see them,—much obliged— In my next letter I hope to hear what line of steamers Willie has decided on—I feel prejudiced in favor of the "White Star." If Ma has room in her trunk I wish she would bring over Miss Cassatt's riding habit,—go up to her mother's and ask for the whole rig. She would have put it in my trunk if she had received the note I sent her my last evening home. Ma ought to bring a trunk a little too large for her own necessities, as she is sure to take home more than she brings— I want my opera glass too. My idea at present about

88

seeing Ma is,—that if she will be in Paris in May, that would be the best time for me to go,—for then the Salon will be open— The color-man in Paris (Edouard) told us it was expected there would be an unusually fine exhibition,—so many artists had been working hard in England and Germany during the war,—without exhibiting,—and now their pictures would come out fresh. But if I make up my mind to return with her, then I will wait until just before sailing. I find it very hard to get "en train" in painting, but I think I am recovering the practice lost this summer—these bright days I have the model again in the afternoon— Several have told me, 2 francs a day is entirely too much,—1 f.20 is plenty— A hard working man cannot earn 2 f. a day— I hope to have a new model next week,— Raimondi and Signora Bricoli are both looking for me— This girl's face is too delicately modeled,—it is too difficult. I don't know whether I told you we brought paints and small canvases from Paris,—they are infinitely superior to what we used at home.

I think I told you of Mr. Cornish, whose studio I have— He copies at the Academy during the winter so as not to have the expense of fire in his room,—that's the reason he let me rent it from him. We heard more particulars about him— His father is an Englishman, and was coachman to the Grand-duke— One day he upset him, so the duke concluded he was growing too old to drive him, and retired him on a pension— The Italian government continues still all the pensions granted under the governments it superceded,—so Cornish senior gets a pension of 6 f. a day as ci-devant coachman,—Cornish junior, one of 600 f. a year for having done fine writing for the duke (he is professor of penmanship in the public school), and his sister I don't know how much for having been waiting maid to one of the grand-duke's daughters. Cornish has a copy on hand now of the Madonna of the Scodella, but I have not observed any progress in it since my first day here— He paints in an entirely different key from the original,—grey and white depending on glazes,—whereas Correggio, it looks to me, painted solid in the lights.

We dine in our own room now, comfortably before the fire. A third young man, student of the law returned from a visit home the other day,—and talked in such a way, trusting to our not understanding his rapid dialect, that the next day we asked the Signora to serve our dinner down stairs in future. The other students were nice boys,—notwith-standing their peculiar little habit of picking their teeth at the table with their dinner knives—

We have been very fortunate in the weather so far. Last winter they had 26 snow storms,—whereas we have had only one slight fall— The temperature now is exactly right.

I forgot to tell Willie I met a Mrs. Cram at Mrs. Muzio's who who spoke of him (in Paris)— Mrs. Muzio sent us an "American Register" the other day with a mention of Miss C. and me and what we were doing.[4] Miss C. sent it home to her mother and asked her to send it afterwards to you. A Mr. Ryan is the editor, and Mrs. Muzio, who is a charming little woman, insisted we should attend an evening reception at his house, to insure our being "noticed." A more inane stupid evening party I never assisted at. We had something to drink,—of which I afterwards inquired the name, and was told it was punch—

Here is something for Maria— Mr. Macauley escorted a young English lady home from a soirée at the Marquise de Boissy's (formerly Countess Guiccioli), and on the way she astonished him by saying "that was *filthy* cake the Marquise gave us"— That is the latest London slang—

You remember Thier's house was destroyed by the Commune.[5] I was surprised to hear how it was done. There was no mob or crowd. Workmen were sent, who first removed the pictures furniture and other valuables to the Louvre for safe keeping, and then coolly tore the building down stone by stone. Mrs. Edouard went round to see it while in progress— Helmick gave terrible accounts of the revolting cruelties of the Versailles troops on entering Paris (they were shooting women and children in crowds right by his house),—and Czapek, a Swiss watchmaker on the Castiglione said the same thing of what he saw in front of his house— He says they dragged women with their heads in the dirt, their legs over their shoulder,—and killed innocent people without any provocation. Neither of them saw anything of petrolium.

We went to the opera night before last,—heard Trovatore very indifferently sung. Last night the people hissed it. Miss Cassatt was very anxious to show Sig. Rossi that our only reason for going before was not because he sent us the box— It is very singular, he hasn't been to see us for two weeks,—after calling every day for a week.— He may be overwhelmed with annoyances about the fiasco of the opera,—or we may have unconsciously offended him— It seems very queer— . . .

<div align="center">[incomplete]</div>

1. Carlo Raimondi (1809-1883) was a student of Toschi and specialist in engraving on copper. He collaborated with Toschi on engravings of the frescoes by Correggio and Parmigianino and was Toschi's successor as professor and director of the School of Engraving at the Parma Accademia. His son, Edouardo, was a genre and landscape painter.

2. Jean Louis Ernest Meissonier (1815-1891) was a French portrait, history, and genre painter. His imitations of Dutch genre painting brought him success at the Salon and the patronage of Napoleon III.

3. Correggio's frescoes in the Hall of Diana at the San Paolo monastery were an important monument in Parma.

4. Begun in 1868, *The American Register* was an American newspaper published in Paris.

5. Adolphe Thiers (1797-1877) was a journalist and historian who became active in

French politics in the 1830s. After the 1871 siege of Paris, he was elected chief of the executive power by the Assembly. He remained in this position during the Commune and its suppression, becoming the first president of the Third Republic.

EMILY SARTAIN TO JOHN SARTAIN

Borgo Riolo No. 21
January 22, 1872

Dear Father,

I write again so soon, not because I have any special news to tell you, but that Ma may receive still another letter before sailing. . . .

We took a drive out to the Certosa this afternoon beyond the walls. It was a lovely day, but the mountains were not visible. Miss C. has not been well the last few days—a slight attack of inflammation of stomach and bowels which she had very seriously at Ecouen,[1]—brought on by constantly wet feet during these last drizzly days,—and also, perhaps, the brick floor of her studio— The second day, Raimondi had provided her with a thick board to put under her feet, as well as screens for the fire, some drapery for the model etc— He comes in every day to criticise her work,—and has commenced a sketch of Miss Cassatt—which he is going to finish in watercolors while she is at work from her model— These last two days that she has not been at the Academy, he has called each day to ask if her absence was caused by illness— Today our padrona informed him she was going to take a hot bath,—whereupon he expressed great concern and hoped she would consult a doctor first. You do here as you do in Paris, send to a bath house to order one— A man brings a big bath tub, with a sort of stove attached at the side. He fills the tub with water and a fire is lighted in the side arrangement. The next day he comes again to empty the water. They would not send the tub for less than five baths, and the cost of the whole was to be four francs. It may interest Maria to know that my first week's washing of 32 pieces cost less than 80 cents,—the things beautifully done up,—my nightgowns ironed in fine pleats down to the hem,—and collars and laces got up as they do them in Paris—

. . . Although my first study was a complete failure—I certainly learnt on it, for my second from another model is certainly the best head I have painted (which is saying very little of it), and I did it in five mornings, two and a half for the drawing and frotté (the under color in monotone), and the other half of the time for the painting— The girl was so restless and impatient, I rushed it in desperation to get rid of her— I did that frotté in burnt sienna and blue, instead of the asphaltum and light red I used with Mr. Schussele— It is very much the same

tone, and does not get slippery and lick up under the brush, as the other used to do— However I now am using French canvas which holds the color in its place— I also find it facilitates matters very much to make a complete drawing in that tint,—modelling the lights as well as the shadows— Painting with long pliant brushes, full of color, on top, I can work with comparative decision. I commenced from a new model Friday afternoon, to whom I paid f. 1.20 for the whole day— When I get through with her I shall have the one Miss C. now has for 2 f. a day,—a young woman with very fine bust and arms— The models who sit for the classes at the Academy get 1.50 f.—a sitting from 9 till 4,—a quarter of an hour rest every hour— That is for the head only I don't know how much for the nude—

The church of San Giovanni at the end of our street, where the Correggio "Regina Incoronata" was painted has on its Christmas dress yet of Crimson damask hangings around all the columns— It gives a very fine effect of color— We discovered some very fine frescoes of Parmagianino in two of the chapels,—in such a dark place it was impossible to see them except on very bright days.[2] We saw a wedding in the church the other morning, a wonderfully unceremonious affair though the bride was attired in full rig of white, flowers & veil etc. The sposo, an officer, was evidently afraid of spoiling his new pantaloons by kneeling, and stood up the whole time except when specially ordered by the priest to kneel—

The padrona has just come in to say her husband is waiting to take my letter to the post. I intended to write much more—. . . .

Did I tell you Miss C. always calls Raimondi "that angel"— By the way she is tonight pretty well again,—and tomorrow I have no doubt will go to work again in good spirits and health—

<div align="right">Yours
Emily——</div>

1. See Eliza Haldeman to Mrs. Samuel Haldeman, September 5, 1867, and Eliza Haldeman to Samuel Haldeman, October 1, 1867.

2. Parmigianino painted a series of saints, including the martyrdoms of saints Agatha, Lucy, Barbara, and George, in San Giovanni Evangelista.

EMILY SARTAIN TO JOHN SARTAIN

<div align="right">Borgo Riolo No. 21
February 18, 1872</div>

Dear Father,

. . . Miss C. has commenced a very nice picture for the Salon— She

has very little time left for it—her sickness put her back so much—
Prof. Raimondi had left the Academy when I went round there yester-
day—. . . . I wish you would tell me whether you are acquainted with him
by reputation— It seemed to me I knew his name very well,—and yet
I do not recognize any of his works I see here—except the Dome of
the Cathedral—the Corregio— They said he did a large proportion of
the work that has Toschi's name on it— They have no idea of what
mezzotint engraving is,—and I learned the other day that from Miss C's
description of it they had made up their mind I engraved in acquatint[1]—
I wish I had some of my things with me— He paid a visit to my studio
the other day— I think he judges from my want of facility in handling
color, that I know very little about Art— I notice that if Miss
Cassatt and I differ in our estimate of an artist, he adopts her opinion
immediately, without the least deference to mine—. . . .

I want to ask your candid opinion about my taking a trip to Rome in
the Spring. Miss Cassatt has all along talked confidently of going
down there for two or three weeks in April or May,—but now as the time
approaches she seems very doubtful about it— But even in case she
gives up the trip, don't you think I ought to go? It is possible I shall be
in Italy next Fall,—but there are always so many chances of disappoint-
ment I feel as though I ought to take the opportunity— Miss Cassatt's
idea was to take a studio down there for a month,—and that would
have been splendid— If I go alone, of course, it will be only to look at
the pictures— The R.R. fare is $10 each way— Do you think I
ought to go or not? I am going to Paris in May, on my way will stop at
Milan,—and perhaps go to Venice— What do you think? If Sophie[2]
joins me in Paris and is willing to stay there I think it would be
good to take a studio there for a while,—if not too expensive— I feel
a longing to be among modern pictures for a while,—and in Paris there
is the Louvre as well— I do not regret at all my stay here,—living and
models have been very cheap, I have improved by constantly looking
at the Correggio, and seeing Miss Cassatt work,—but I feel as though
now it would be best for me to be a while in Paris— What do you and
Mr. Schussele think? You can judge better than I can, for I change my
opinion according to whether I am in good spirits or bad— Miss C.
is very desirous I should make studies from the Correggio but I think I
had better stick to life,—especially where models cost so little— In
Paris they are a franc an hour,—here a franc a morning— All the artists
here have been constantly copying Correggio, and yet it has not done
them any good. They all paint miserably— If Sophie strongly objects to
stay very long in Paris, I propose going to Venice, where Miss Cassatt
talks of going when it gets too hot to stay here. By the way, can you send
me a draft for about £30. That I think will last me till I get to Paris,

even with all the proposed journeyings beforehand— I hope it will not inconvenience you—. . . .With living, studio, models, and all,—my expenses here are only at the rate of $500 a year. . . .

Miss C. has just come in for lunch, which warns me that my model will be here in about a half hour,—and I must finish up my letter to get ready for her— I would like you to send me the draft as early as suits your convenience— Please sit down with this letter before you and answer everything in it—. . . .

My model is waiting. Good bye— Write as soon as you can— My address is at the head of the letter— With love to all

> Yours
> Emily—

1. John Sartain specialized in mezzotint engraving, in which tonal areas are created by stippling the plate with a special tool called a "rocker." The more common technique was to create these areas with a series of parallel lines.

2. Mrs. Sophie Tolles was an old friend of Sartain's from New York.

EMILY SARTAIN TO JOHN SARTAIN

> Borgo Riolo No. 21
> March 7, 1872

Dear Father,

I finished my last letter to you by saying I had just received a message from Mr. Cornish that he needed his studio— I went round to see him the next day,—so tired and weak I could scarcely walk. I forgot to say that that same evening I wrote him a note, expressed very politely, but in the most frigid of tones, saying that I was surprised at the sudden summons to leave, while it was still too cold to do without a fire,—so that wherever I should move to, I would have to repeat the expense of putting up a stove, and only for two or three weeks— Early in the morning he came round and sent in word by the Signora that he was distressed by my letter,—that he had not meant that I was to go right off,—but had only casually mentioned that he would need his studio— In the afternoon when I went there he said the same thing,—but it was evident to me that he did wish I would give it up to him, and considered I had forgotten the agreement made before and was staying beyond my time—still he begged me to keep it— So I said I would begin next day and go on with something already started, and if I thought I could possibly finish in a week or two I would retain the studio a while longer— I was anxious to finish something before leaving Parma that I might send home by Ma— So I have been working for a week,— but badly—all the time with a feeling of being pressed for time—

Yesterday I got so discouraged that I scraped all the color off my canvas and went and gave up the key to Cornish. I made up my mind to go off to Milan for a few days— Madame Canziani (Louisa Starr's aunt) leaves Milan for London the 25th of March and it will be so much pleasanter and better to see the city when she is there to act as Cicerone, than to poke around all alone— Her son is a sculptor, and through him I can learn about studios, Art instruction, etc. in Milan— So tomorrow or Saturday I am going, and have written to her to that effect. In a week, Miss Cassatt will be finished with her studio at the Academy, and I can either take that, or accept Young Raimondi's offer of half of his— He has just taken a room that will come into his possession in a few days— He (as well as Cornish) is going to paint a picture for the Turin exhibition in April— He took a number of his sketches around to Miss Cassatt for her to select which he should finish—

All Parma is talking of Miss Cassatt and her picture, and everyone is anxious to know her— The compliments she receives are over-whelming— At Prof. Caggiati's reception men of talent and distinction to say nothing of titled people, are brought up to be presented, having requested the honor of an introduction— I shine a little, by her reflection— One of the custode yesterday, looking around carefully first to be sure he was not overheard, assured her she was much more "brava" than any of the professors— One of the professors has begged her to come to his studio and give him criticism and advice— This exceeding popularity has its counterbalance—we are not enough to our-selves for my taste. However I suppose it is my only opportunity to see genuine Italian society,—and when I reflect I have been here little more than two months I feel less discouraged.

Edouardo Raimondi took us to Madame Toschi's day before yesterday, at her request. She is an admirable talker, full of vivacity and interest, and can turn a compliment with the most perfect grace— She talks French with the same ease and fluency as Italian, so Miss Cassatt was at home with her— We then went down to the primo piano to call on the Countess Salimberti, who had sent word she would like us to come and see her pictures, her own productions— Notwithstanding she was made honorary member of the Milan Academy for her copy of San Gerolamo, her pictures are about as bad as her reputation, which is saying very little for them— We have had the luck of having a dead set made at us by the three most notorious women of the upper class of Parmagian society,—but fortunately Miss Cassatt tells everything to Prof. Raimondi, so we never have got intimate. There was one woman intro-duced to Miss Cassatt at Caggiati's, the wife of a colonel, who was so ugly she thought she must be perfectly proper, she was surely safe with her, and so talked with her a great deal— When she mentioned her

name to Edouardo R last evening he almost threw himself off his chair with astonishment— He said she was the worst of them all— As they are growing old they are now devout Catholics, and la Caggiati who is a bigotte, receives them and is attempting to rehabilitate them—. . . .

This morning Prof. Raimondi was going to take us out for a drive to Ponte di Tara, a splendid bridge about six miles off built by Maria Louisa, from which there is a splendid view. It was so foggy, it was not worth while to go, so the expedition is postponed till tomorrow— The family always have a horse in summer, and Edouardo is going to try one tomorrow to see if he will do, and he says if he takes him, we can go out driving whenever we want to— I must say they are wonderfully kind— The son seems exactly like an American, just as free and easy, and I am happy to say, without one bit of flirting or nonsense about him— In fact, I was surprised at Caggiati's to see how perfectly free and unconstrained the young girls and young men were with each other,—so entirely different from our preconceived notions of Italians— I might have thought myself with a party of Americans, except that the young girls were so exceedingly polite to each other and to me, whereas at home they generally save up their sweetness for the gentlemen—. . . .

. . . By the way, direct my next letter care of *Drexel, Harjes & co. 3 rue Scribe, Paris*— It seems to take so very long for an answer to come from America,—that I guess I shall be in Paris as soon as it will— And if you can spare it, I would like you to enclose another draft,—say for £30— I don't want to run short of money—

The doctor has ordered Miss Cassatt to ride on horseback,—and of course Prof. Raimondi immediately trots off to inquire about horses etc. He tells her she can go off for a ride of an hour or hour and a half, with a groom behind her (it would not do for her to ride alone here) the expense for it all, the two horses and the man included, would be four francs—eighty cents— Cheap enough, isn't it?—

I hope all at home are quite well— Give my love to all the family, to the Schusseles and to all my friends— Hope to hear from you soon—

With much love

<div align="center">Yours
Emily—</div>

Don't you think it would be a good idea for the Academy to order a copy of the San Gerolamo from Miss C—? She expects only $300 for it from the bishop,—and I think it would be nicer for the Academy to have it instead— It is very little money— This suggestion is private,— not pro-bono-pubblico— She knows nothing of it—

<div align="center">E—</div>

<div align="right">Borgo Riolo No. 21
April 1, 1872
Mailed April 2</div>

My dear Father,

 . . . I have made up my mind not to go to Rome this Spring— It wouldn't pay to go there for less than a month or so, and I haven't time enough for that now— I think I may go there for next winter— I am now at work upon a head at the Academy which Miss Cassatt insists that I must finish, and my judgment seconds what she says— It looks to me *very bad*, but she says it is much the best thing I have done—she reminds me that at home I had inferior members of my class to compare myself with and count my progress by—whereas here I see the masterpieces of Correggio so constantly that by contrast my own looks so badly to me— I derive sufficient consolation from what she says to take courage to continue— She comes in every day to criticise, and so does Prof. Raimondi,— the latter even twice a day generally— He is very kind and encouraging. . . .

I am expecting every day a letter from Willie to know how much longer Ma is going to stay in Paris— If he adheres to his original intention of going back to London early in May, I will leave Parma just as soon as this head is done, and after spending a few days in Florence, go to Paris— If Willie's movements give me time enough, I will also spend a few days in Venice— By leaving so soon I miss a number of delightful excursions that are proposed for our entertainment, and perhaps miss the dinner with Verdi to which we are invited[1]— Still I think the best thing I can do is to stay in Paris for a while— It will be a great deal more expensive than here but I fancy now that there will be compensation— You all at home are so good in urging me to stay and not think about the expense— I suppose it would be absurd to come back now with so little accomplished. All the money I have already spent would be wasted. At the same time, although the money is so freely offered, I feel badly about having to accept it, as I probably shall have to do in a few months,—especially as I feel so hopeless about ever succeeding in realizing much by Art— Still it would be cowardly to give up the fight so easily— In Paris I shall have fewer diversions and I think that will be better for me— Here it is impossible to withdraw myself as it would be forcing Miss Cassatt to abstain as well—. . . .

I am so glad to hear that Claghorn is president of the Academy[2]— You had forgotten to tell me before— How splendidly the Philadelphians are coming out for our Academy— Miss Cassatt says she will not consider it anything until they have established a fund to send students to Europe—. . . .

<div align="center">97</div>

I think I did not tell you about the last reception at the Caggiati's—
We had called in the morning, and learned the Marchesa was in bed
with a bad cold— We naturally concluded there would be no reception
in the evening, and instead of rigging ourselves out in all our finery,
prepared ourselves early for a long night's rest— When Miss C- had
already been asleep some time, a knock came at the door— I was just
ready for bed so could not open, but called through the door chi è?
Amici, was the answer— chi è said I again— We are gone to bed, I
cannot open the door— "The servant of Prof. Caggiati— Some ladies
are going to sing, and are unwilling to commence until you arrive"— I
was so surprised I couldn't think of anything else to say than "We are gone
to bed"—and we heard afterwards from different ones who had expected
to meet us there, that the fact was publicly announced— We had to
make our explanations afterwards— We dined with the Caggiati's
Sunday again & had a very pleasant evening—

Miss Cassatt is growing impatient for our regular evening consti-
tutional, so good night— It is getting late— Love to all and
everyone— Hope all are well

> With much love
> Yours
> Emily

1. Cassatt and Sartain were offered the opportunity to meet the great Italian composer
Giuseppe Verdi (1813-1901) through Cassatt's friend Emanuele Muzio, who had studied with
Verdi in Milan in the 1840s. At this time, Verdi had just completed Aïda (1870-71) and was
overseeing its Italian premier at La Scala in 1872.

2. James L. Claghorn, a wealthy Philadelphia businessman and art collector, became
president of the Pennsylvania Academy in 1872.

*In May 1871 Emily Sartain left Parma. After a brief stay in Milan,
she joined her mother and brother William in Paris, where she entered
the studio of the genre painter Evariste Luminais. Mary Cassatt
stayed in Parma to finish her copy and to paint on her own.*

MARY CASSATT TO EMILY SARTAIN

> Parma
> May 25 [1872]

My Dear Emily,
 What has become of you? All your friends here inquire in the most

affectionate manner after you, and I am unable to give them any news. I suppose you are immersed in the Luminais studio.[1] Are you pleased? Remember I have heard nothing from you since you have begun work. Did you get my two letters? Vieille wrote to me to send him the price of my picture, he says it is well hung, & "fait très bien,"[2] I have not unlimited confidence in his judgement however.

I wrote back, fixing the price at the lowest possible sum & asking him to send me canvas & brushes since then I have heard nothing from him.

This week my letters from home did not reach me until Friday, 21 days en route, I suppose they had been making the tour of Italy. Mother is not coming out this summer that is decided it seems & I will probably stay here until I can finish something for the Milan exhibition. Did I tell you in my last that Police brought Malderelli a Neopolitan Professor to see me & he was most kind in his offers of service?[3] By the way Police was hurt not because you did not bid him good bye but because you did not leave him your address. My copy is nearly done I have it in the frame & it looks "beastly"—I am more and more disgusted with it. The box to pack it in is ready & I forsee what a sum it is going to cost me, but fortunately I am in cash at the moment. Edouardo brought me a wood cut of Lumenais picture the other day "Invasion" it is called is it good? There is all sorts of a row with Caggiati at the university they want to oust him, his wife says he would be much richer if he resigned his post, but naturally his pride is roused & he won't do it & I am afraid they will turn him out. You see I give you all the Parma news. Don't you think you had better call & see Mrs Muzio 27 rue Tronchet? I know you don't like the Ryan set but still it is just as well to be in with the "*press*"? What do you think of the Greeley nomination. The Democrats all hoped the liberal republicans would nominate Charles Francis Adams.[4] Kind regards to your mother & brother. Hoping you are all well with love

<div style="text-align:center">

Your friend
Mary S Cassatt

</div>

1. Evariste Vital Luminais (1822-1896) was a specialist in hunting scenes, paintings of animals, and historical genre. He became known as "Le Gaulois" because of his many paintings of the Gauls and the early history of France. He won medals in the Salon throughout the 1850s, and was decorated by the Légion d'Honneur in 1869.

2. H. Vieille was apparently an art dealer and supplier of artists' materials. Cassatt had an agreement with him as early as 1868, as she listed his address in her Salon catalog entry: "rue de Bréda, 30." In 1870 she listed: "Chez M. Vieille, rue Bréda, 30"; in 1872, "Chez M. H. Vieille, rue de Laval, 35"; and in 1873, "Chez M. Vieille, rue de Laval, 35." Cassatt refers here to the picture she had in the Salon at that time.

3. Francesco Saverio Pollice (1840-1888) studied first in Naples under T. A. Juvara and then at the School of Engraving in Parma (1869-1873). He was a master draftsman and reproductive engraver. Federico Maldarelli (1826-1893) was a portraitist and history painter; he was director of the Accademia in Naples.

4. The Cassatt family shared an active interest in politics, making this sort of political news part of their correspondence. The convention of the Liberal Republicans, a splinter group of the Republican Party opposed to President Grant, began on May 1, 1872. Instead of nominating Charles Francis Adams (1807-1886), the former American ambassador to Great Britain, they decided on Horace Greeley (1811-1872), the politically active editor of the New York *Tribune*. The Democrats, who had formed a coalition with the Liberal Republicans, were then forced to accept Greeley as their candidate, in spite of a history of ill will toward him.

MARY CASSATT TO EMILY SARTAIN

Parma
Sunday, June 2 [1872]

My Dear Emily,

If the enclosed don't give you a half hours laugh, I shall think that you have lost all sense of humor. A package was brought in just now containing about twenty copies, and you are honored with the first. Two lines in the paper would have suited me better but I am menaced with a retranslation, & republishing in the *Gazetta di Parma*. Your nice long letter which reached me at last gave me much pleasure. The watch number [?] I had put on at once, and a half hour ago dropped my watch and smashed another number; such is life! My copy is packed and gone, but won't reach Genoa in time for the 5th when a vessel sails for New York so it won't leave for home before the 25th. I wish Mrs. Muzio would get Mr. Ryan to write a line or two for me in the *Register*. I find it has done me good and I am getting anxious to see myself in print; one gets used to anything in this world. Vieille sent me a roll of canvass and some brushes, out of two dozen of the latter I can use 6. Isn't he a sensible individual! He did not send me a bill but I am going to send you some money and write to him to call and you will pay him. I will send twenty five frcs, and I hope after you have paid yourself that there will be enough left to buy a French translation of Jane Eyre for which if you will be kind enough to send it I shall be very much obliged.

You don't tell me if you have the life model all day or if you have the nude or in fact any particulars of the Lumenais school, remember I am interested. I am much obliged for what you tell me about my picture I know that it is heavy, but how to get a thing solid & yet keep it easy. Voila! And then I know that the great fault of the modern school is flimsiness, enfin! I shall do better next time. Was'nt I right when I said that the tone of the Antonio Mor here was the tone most in vogue in the French school?[1] Along side of that even the Correggio would seem yellow.

I have been to here "Piggy" make a speech to the students at the

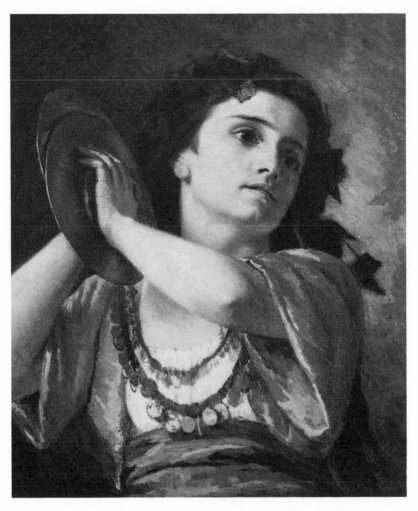

9. *Bacchante*, 1872. Oil on canvas, 24 x 20 in. The Pennsylvania Academy of the Fine Arts, Gift of John F. Lewis.

distribution of the prizes, and I was called upon by the Lyndie [?] and Prefect to give some of them, a high honor which I would as leave be spared. Your Edouardo is in Turin, he wrote to me this morning to tell me to go on & see the exhibition for it was excellent, I certainly shall do nothing of the kind, I am sick of Edouard. "Piggy" is a great deal nicer. On the whole I thought it better to send thirty frcs, if there is anything left over it can go toward buying the "Cahier Blue" of Gustave Droz.[2]

I have begun again on my cymbals [figure 9], changed the back-

ground &c it will do for a study and then I am going to have the
lame girl, she has a splendid head like a Roman. Everybody sends love
especially Angiolina, she is going off to visit her sister, and I don't
suppose I shall ever see her again, I like her much; she was delighted
with Alfred de Musset, by the way I recommended you particularly.
"On ne badine pas avec l'amour," and "Il faut qu'une porte soit ouverte
ou fermé."[3] You surely thought those exquisite. Write soon and tell me
something to keep me alive. I am tied down here until August and then
I hope I shall be able to leave and go either south to Naples or else
to Madrid. Kind regards to your Mother and brother, and my inquiring
friends and believe me affectionately yours

<div align="right">Mary S. Cassatt</div>

On the whole I think it best to send the printed matter in a seperate
envelope—

<div align="center">M.S.C.</div>

1. Antonio Moro (c. 1517/21-1576/77) was a Dutch portraitist who worked in Italy,
Spain, and England. His portrait of Alessandro Farnese hangs in the museum of the
Accademia in Parma.

2. *Le Cahier bleu de Mademoiselle Cibot* by Antoine Gustave Droz (1832-1895) was in its
thirty-first edition in 1879.

3. Cassatt refers to two plays by Alfred de Musset (1810-1857). "On ne badine pas avec
l'amour," a comedy in three acts, was published in 1834 and produced for the first time
in Paris in 1861. "Il faut qu'une porte soit ouverte ou fermée," a proverb in one act, was
published in 1845 and produced in 1848.

*On October 1, 1872, Mary Cassatt left Parma by train for Madrid.
Her intention was to travel in Spain with two young American
women, Mrs. Birney and her sister Miss Duell, who, she learned from
Emily Sartain, would be arriving there from Paris in early October.*

MARY CASSATT TO EMILY SARTAIN

<div align="right">[Madrid]
Saturday, October 5 [1872]</div>

My Dear Emily,

Where oh Where are Mrs. Bryen [Birney] and sister? I am at the Hotel
de Paris Madrid but have not yet heard anything of them, except on
Thursday evening at Pau, when I was told that they had left that
morning for Burgos. Emily Sartain if you and Mrs. Tolles don't wish to
feel everlasting and eternal remorse for opportunities wasted, put

yourselves into the train and come down, not to Madrid but to the "Academie Reale."

I got here this morning at 10 o'clock at 12 I had had a bath was dressed and on my way to the Academie Museo or whatever they call it.[1] Velasquez oh! my but you knew how to paint! Mr. Antonio Mor or Moro, whom you were introduced to at Parma has a word or two to say to you Emily. Titien also would like to introduce you to his daughter who is carrying the head of John the Baptist, holding it up on a platter with her beautiful bare arms. She says the one you saw in Dresden was a copy. Van Dyke's three children at Turin are beautiful, but he has a man in velvet and crimson satin that is a step beyond that in some respects. Oh dear to think that there is no one I can shriek to, beautiful! lovely, oh! painting what ar'nt you. I am getting wild I must eat some dinner if I can get any.

6 P.M. Just done dinner feel decidedly better, very tired though, & rather lonely. I dont see any women about, nothing but men.

Sunday 11 A.M. I have just seen Mrs. Burney and sister they arrived last night, they have just gone to breakfast afterwards we will go out. I suppose you will think I have written great stuff here, but I really never in my life experienced such delight in looking at pictures, no Titiens in Italy are finer, nor Rafaelles either, the Madonna of the fish is most beautiful. I am going to try and find a boarding house, and get settled and then I will write you the prices. I started off from Parma without getting my letters and with very little money, if I run out I will write to Drexel and borrow. Mother wrote to me that Father did not wish to send me a large bill but little and often,[2] as he was afraid, but when he hears that I came on without waiting for money I have no doubt he will be in an awful state of mind. My bill for the gloves weighs on my conscience but I am afraid just now to send any away, you see my journey lasted 4 days and two nights I spent on the cars.

If I can tell you of prices not too high do you think you and Mrs. Tolles can come down? I don't hesitate to tell you that although I think now that Correggio is perhaps the greatest painter that ever lived, these Spaniards make a much greater impression *at first*. The men and women have a reality about them which exceed anything I ever supposed possible, Velasquez Spinners, good heavens, why you can walk into the picture. Such freedom of touch, to be sure he left plenty of things unfinished, as for Murillo he is a baby alongside of him, still the Conception is lovely most lovely. But Antonio Mor! and then Rubens! I won't go on, oh Emily *do do* come you will never regret it. Rather come now and go back to Luminais after you have seen these, indeed it is not because I want you and Mrs. Tolles, it is for you both I wish it for your sakes. The Corregio here is beautiful but not nearly so fine as the St. Gerome.

Delicacy, expression of nobility and sublimity are not striking in this school but it is the extraordinary painting. So simple such breadth.

Monday. Haven't been able to find an apartement yet, and am beginning to feel alarmed about my finances especially as the letters from home have not arrived. Regards to Mrs. Tolles.

<div style="text-align: right">

affec. yours

Mary S. Cassatt

</div>

My copy reached home in a horrid state!

1. The picture gallery of the Prado, established in 1785 to house the Spanish royal collection, was called the "Real Museo." Here one found the Velázquez, Murillo, Titian, and van Dyck paintings mentioned by Cassatt. Madrid also had an Academia Reale, where one would find exhibitions of modern Spanish artists.

2. For a later version of this financial arrangement, see Mary Cassatt to Eugenie Heller, December 21 [1893].

EMILY SARTAIN TO JOHN SARTAIN

<div style="text-align: right">

Ecouen[1]

October 9, 1872

</div>

Dear Father,

Your nice long letter commenced the 5th Sep- and finished the 23rd, was sent to me by Willie today. I was very glad to have your opinion of Miss Cassatt's works & to have your expression of admiration of their fine qualities.[2] By the way, Miss C. had already written to me in high spirits that her mother had told her you said so many complimentary things of her Carnival picture that she was ashamed to repeat them to her. She was delighted to have your approval, for she valued it— About the drapery,—it was necessarily neglected because she had not time to finish it. At the time she ought to have begun the picture she was ill in bed,—and the two or three weeks thus lost counted heavily at the end, for there is a *last day* for receiving pictures at the Salon, terrible to artists in arrears. She spent so much time on the heads, unwilling to leave them before they were satisfactory, that within a very few days before it left Parma there was yet a hand and arm and all the drapery to do— She thought it would be discreditable to her to send it with the drapery so slighted,—but I persuaded her to let it go,— I knew it would be such a blight upon her not to be represented in the Salon after working so earnestly for it— And as you know, she was accepted.

I am very sorry to hear of the condition the copy arrived in— Raimondi is responsible for it more than she is— He even packed all of my studies for me. She wrote to me in dismay that "after all they at the last made the mistake of rolling it paint inwards." The cloud the

Virgin sits on is so uncloudlike, that I always supposed it was a rock until somebody spoke of it as a cloud. Mary intended to make it more fleecy, & I have no doubt has done so, but not sufficiently— All the lower part of the picture from near the waist down, had to be copied from Carracci's copy. The original no longer exists. You know the half dome of San Giovanni on which it was painted, was torn down to extend the chancel—the fresco was reproduced by a pupil of Correggio's on the new semi-dome. The centre portion of the original fresco, containing the upper part of the figures of Christ and the Virgin was removed to the library,—or, as it was then, the picture gallery of the Farnese palace. The Carracci copy in the Accademia which she must have used for finishing the figure and painting the cherubs below, was so different in tone, it must have been very difficult to harmonise the two— By the way, I forgot to say, *all* of Correggio's clouds are more rocks than vapor,—distressingly so in the Madonna della Scodella. One feels certain those lovely cherubs will be hurt,—their flesh is so fleshy and tender.

However,—the above apologies for what can be apologised for, to the contrary notwithstanding, I will not be a genius, if neglect of minor details is an essential component of said eccentric individual— Luminais is giving me too good a drilling on draperies, for me ever to leave them badly done for want of *trying*. Sophie says she never so proudly rejoiced in a sense of mediocrity as on hearing your letter.

. . . We go back to Paris on Saturday. I have not done near as much as I hoped. Constant cloudy skies and rain interfered with our outdoor sketches,—a kitten I wanted to put into my first indoor study was quite unrepresentable,—a little boy model we have had since, was just as frisky as the kitten,—and a woman whom I was very anxious to paint, had to bring her baby with her because she had no one to leave it with,—and her head turned so often to answer to its calls that she was as bad as the little boy and the kitten. She is the handsomest woman in Ecouen, and I was specially desirous to make a study of her head because she strongly resembled Mrs. Howells— However, notwithstanding our disappointments, I am very glad I came to Ecouen,—if it had only been to make Miss Bourges' acquaintance, it would have repaid. She is a dear friend of Miss Cassatt's,—a good artist and a delightful person. She gave us the great treat of a visit to Edouard Frères studio—as *invited guests*. His walls are covered with his own studies and sketches,—mementoes of every spot he has ever been in,—most interesting and beautiful— My estimate of his talent rose from what I saw there— I told Hattie in my last week's letter, that when we went sketching in the woods, with Mdlle Bourges, Frère was there too at work— At the studio, we saw his finished picture and his previous study of the same spot. It was very

interesting to see the differences he had made between the study of the *landscape*, and the landscape as a *background*, so that everything should be subordinate to the figures— Mdlle Bourges will be in Paris this winter at her other atelier there several days each week, and she promises to see a great deal of us—and also to take us to the ateliers of different artists whom she knows,—among them D'Aubigny who is a very good friend of hers[3]— She presented an American landscapist named Champney to D'Aubigny this summer, and secured him an invitation to go sketching with him,—thus earning his eternal gratitude[4]— Corot, she knows and says he is a delightful old gentleman.[5] He spent three days in Ecouen this summer, and won the hearts of all the peasants by his courteous manner to them. He would say, "Madame, will you have the complaisanse to direct me to such a place"— "Madame will you be so kind as to tell me so-and-so."— They never cease their praises of him. You know Couture lives within ten minutes walk of Ecouen, at Villiers le Bel. We walked down there this afternoon and walked around his big place,—it is too big to be called a garden—but *outside* not inside the high wall— Sophie wants me to go there with her to see him,—without any introduction but just to present ourselves— But I object— You have to be mistress of French to say very graceful things very prettily to excuse yourself under such circumstances,—and I don't feel I have sufficient "brass" for it and all the responsibility of the interview would be upon me.

I have had a deal of French correspondance lately,—not only with Mdlle Luminais, but also with a Mdme Thierry who has been anxious to have us as boarders. She has come down in her price to secure us,—saying that "she would infinitely regret if a mere question of money should deprive her of the pleasure of receiving us", so we are going there to try it for a month. It is so near Luminais we will be able to go home for lunch,—and everything is to be included in the price, even to washing and French lessons. My next letter will be written you from there. . . .

Thursday Morning

Reading over again this morning what I wrote last night I find it very stupid,—but if I were to commence over again it would probably be as bad— Ecouen is not the most exciting place in the world,—especially in rainy weather. This morning is bright and lovely. We are going out sketching a little in the courts etc—so as to be in the open air as much as possible before going back to hard work in town. . . . With love to all— Yours—

Emily—

1. Emily Sartain and her friend, Sophie Tolles, took a quick trip to Ecouen while waiting for Luminais to return to Paris and resume classes for ·the winter. Ecouen was

still the active artists' colony that Cassatt and Haldeman had known in the late 1860s.

2. Cassatt shipped her Salon painting, *Pendant le Carnaval* (*During Carnival*), and her copy of Correggio's *Coronation of the Virgin* to Philadelphia. The copy was then repacked and sent on to Pittsburgh.

3. Charles François Daubigny (1817-1878) was a renowned landscapist of the Barbizon School. He received official recognition in the form of the Légion d'Honneur and a commission to decorate the stairway of the salons of the Ministère d'Etat in the Louvre. He enjoyed painting in his boat studio, "Bottin," as he floated down the rivers of the countryside around Paris.

4. James Wells Champney (1843-1903) was a specialist in genre painting from Boston. He spent the 1860s and '70s painting in the artists' colonies around Paris and in Brittany.

5. Jean Baptiste Camille Corot (1796-1875) was a French artist well known and well loved by Americans. His career as a landscapist got off to a slow start, but by the 1850s he enjoyed both commercial and official success. He was a favorite with Americans because of the silvery, lyrical style of his later landscapes and because of his good nature and charity toward less fortunate fellow artists.

MARY CASSATT TO EMILY SARTAIN

> address Legation of the
> United States
> Madrid, Isabella Catolica No. 12
> Sunday, October 13 [1872]

My Dear Friends,

I am writing this in Mrs. Birney's room at the Hotel de Paris, I have moved, have found a much cheaper hotel, kept by an Italian, the address was given to me in Varallo. The people are very kind, I have a bed room and sitting room and plenty of good things to eat and *clean*, but the entrance is through a pastry cooks shop and the staircase is very dirty. I pay six (6) frcs a day, and I have no doubt I could manage to live for much less. My journey from Parma here everything included cost 200 frcs. I only travelled *1st* class in Spain and if I were you I think I would travel *third class in France* (*I did*) and *second* class in Spain. I am making a sketch from the Velasquez at the gallery, and I am quite if not more enthusiastic than before. I sincerely think it is the most wonderful painting that ever was seen, this of the Spanish school. Murillo has risen immensely in my opinion since I have seen his St. Elizabeth, it is a most tender beautiful thing, and I am told that his St. Anthony of Padua at Seville is even superior, Theophile Gautier says so.[1] I have been looking over the photographs of the Seville gallery and I think it must be very fine indeed. Now my dear friends both of you please do come, come and I will wait for you here and we will go to Seville together and I will return to Italy with you in March. Don't mind about clothes or anything, for the people here are little more than barbarians. I have found a

few French artists copying here, and all with one accord agree with me; I think that one learns *how to paint* here, Velasquez manner is so fine and so simple. I also greatly admire Boccanegra but have seen only photographs as his pictures are in Seville I believe, but perhaps I may be mistaken and he has pictures here which I have not seen, there are so many pictures. Oh! If I could only tell you instead of this miserable scratching. An artist who has lived years in Italy tells me that nothing is to compare to Andalusia, now if you could only come while we are all in Madrid still, for of course I intend to push further South, where I can paint in the open air. I feel like a miserable little "critter" before these pictures, and yet I feel as if I could paint in this style easier, you see the manner is so simple. Of course in high religious expression Velasquez fails and Murillo goes ahead of him. Oh St. Elizabeth I feel like worshipping her. Perhaps I have said too much but *no* I am sure you cannot feel anything but enraptured when you see these pictures. Must you stay in Paris? Do as you think best but dont for *one moment* compare the Italian galleries to this. How very kind your father is, I wish you would thank him for me. I would say more to you about coming here but I am afraid to influence you too much and that I might blame myself, I intended sending you a photograph of one of the finest pictures, but perhaps I had better not or you will go really crazy. Of course here there is nothing but *pictures* for nature and pictures and *climate*, Seville. Write to me soon at once if you can. I am naturally anxious to know if I am to wait or not. Fortuny is still at Granada, but he is coming here on a trip I believe this month.[2] Kind regards to you both and I will hope we shall meet before long.

<div align="center">
your friend

Mary S. Cassatt
</div>

I did not stop at Burgos. I am reserving myself for Toledo.

1. Théophile Gautier (1811-1872)—poet, novelist, and critic—first published his impressions of Spain, *Un Voyage en Espagne*, in book form in 1843. Americans set great store by this guide, particularly if read on the spot (see A. J. C. Hare, *Wanderings in Spain*, New York, 1873, p. x). The passage Cassatt refers to is as follows:
 Since I cannot speak of everything, I will confine myself to mentioning Murillo's *St. Anthony of Padua*, which adorns the chapel of the Baptistery. Never has the magic of painting been carried further. The saint is kneeling in ecstasy in the middle of his cell, all the poor details of which are rendered with that vigorous realism which characterizes the Spanish school. . . . I rank this divine picture higher than the *St. Elizabeth of Hungary* dressing a sufferer's scabs, which one sees in the Madrid Academy. . . .
 (Théophile Gautier, *A Romantic in Spain*, New York, 1926, p. 286.)
 2. Mariano José Maria Bernardo Fortuny y Marsal (1838-1874) began his career in Barcelona, traveled to Morocco, and then to Paris, where he began to attract international attention. Through his connections with Gérôme, Meissonier, the dealer Goupil, and the American collector William Hood Stewart, he became one of the most prominent artists in Europe in 1870. In 1872 he was working in Seville and Granada.

Seville
Wednesday, October 27 [1872]

My Dear Emily,

I am sure that you must consider me a faithful correspondent, a letter on Monday from Madrid and one of Wednesday from Seville. Much too much of a good thing you will say I am sure. Well, of course I thought I should find Mrs. Birney, but she left the evening I arrived, so I suppose I have seen the last of her. The American Consul tells me that she got here on Monday evening from Cordova that is from Toledo, did not stop at Cordova he says, but I think that seems impossible, she left a valuable diamond ring at Toledo and she left Tuesday evening for Cadiz from there to Gibraltar and Malaga and Granada Barcelona & Paris. It seems impossible that she could have come direct here and then only stayed a part of a day and it was raining all the time! However that is all I know about them.

Well I woke up this morning with the sun shining brightly on this brilliant clean town, a most delicious spring temperature, and if I had only had an artist friend for instance you and Mrs. Tolles and a free mind, financially speaking I think I would have been happy. Indeed Emily you *must* come. I see the immense capital that can be drawn from Spain, it has not been "exploited" yet as it might be, and it is suggestive of pictures on all sides. The American Consul and his wife are nice, and are going to try to help me find a place to stay but there ideas and mine will not tally I am afraid. Do you know, you and Mrs. Tolles ought to consider yourselves lucky, for I am here as a sort of pioneer to you two; by the time I have learned by bitter experience how to avoid being cheated, you two will be able to profit by it!

I suppose your brother Willie has told you all about the appearance of Spain. The landscape made me think of Miss Gore. She used to say she could paint landscape very well, she was sure, if there were no trees! Around Seville though there are enough trees, but miles and miles on the other side of Cordova without a tree, and no houses, here and there, a flock of sheep, a herd of cattle or swine, with the herdsman, wrapped in his cloak, immensely sad, vast, and dreary, but infinitely picturesque. Here it is very different, everything full of color, gay lively, the Cathedral magnificent, orange trees growing in the streets and squares, where the doors of the houses are open you see in the courtyard, orange trees, aloes, a fountain sparkling in the sunshine, & everything much cleaner than in Italy.[1] I would advise anyone to come here before going to Italy, for I think the first impression one receives is a shock, if you are used to Italy. There every few miles

a village or little town, plenty of people, bustle, &c, here on the contrary a desert and silence; the whole character much grander, but I should never care to live here. Whereas one can make ones home in Italy, however you know I am a fanatic about the latter country, perhaps I shall grow to be so here, about this scenery. The people are not to be compared to the Italians in my opinion, except for beauty. Write to me soon, and tell me if you have fully decided to come here this winter. In that case I should like to return and see Toledo and Cordova with you. A lady from Malaga who came down in the "Dames Seules" with me gave me the address of what she told me was a very nice place in Granada where one can board for 10 reales 2.50 frs. a day! We will see n'est-ce pas? Well, I believe I have nothing more to say for the present, later I will write what luck I have had, kind regards to you and Mrs. Tolles and believe me

<div align="right">truly your friend
Mary S. Cassatt</div>

I have just been looking out of the window. It is a nice place. If you leave Paris in January it will be like coming to Paradise. What a pity Mrs. Birney did not see it when the sun shines. I am sorry I missed her for I intended to have asked her to carry a sketch of the little prince Balthsar Charles (Velasquez) that I made in the gallery in Madrid.

5 o'clock. Adios! A delicious sunset, do you see the bright sky, the clean courts, the colored tiles &&? If you go to Drexels will you ask him to send my letters here?

1. Cassatt's description of Seville is remarkably similar to that in Hare's *Wanderings in Spain*, which was based on a trip the author took in the winter of 1871-72. The book may have just been published when Cassatt arrived in Spain.

EMILY SARTAIN TO JOHN SARTAIN

<div align="right">59, rue Pigalle, Paris
November 17, 1872</div>

Dear Father,

I was hoping to surprise you this week by the unexpected apparition of my last study. Miss Ladde (who called upon you in the Spring) was in Paris last week on her way home, and was willing to take it for me,—but when I commenced to take it off the strainer, I found the paint was too fresh. It would have been utterly ruined. I was very much disappointed,—and so was Mr. Luminais. He said he would like me to send my studies home constantly,—so that he might have no reproaches from "la-bas" about my progress,—and he feels this to be a great improvement upon what I have done before,—and what I am doing now

even greater. We had a very pleasant visit at his atelier this morning, by his invitation. He wanted me to see a head he had painted in a couple of hours. It was for a picture that he calls "A last insult" a Gaul holding up the head of an enemy, whom he has just decapitated,—and laughing in the corpse's face. He is very anxious we should acquire a rapid method of working after life. He says it is impossible to do any *important* work, if you proceed slowly. You lose the spirit, the life, the movement. Take out a figure over and over again until you get it to suit you,—but while you have the model before you, put down rapidly what you see. The boar picture I told you of, he has drawn upon the canvas. He has added a man on horseback and another dog to the composition, to make a larger mass. He says he is not sure he will be able to paint it now,—that he may not have the time to make anything for the Salon. He has an almost order for an immense decorative picture,—that will fill up all his time. He says he likes such work,—it gives him room enough, and then it has to be painted so broadly so simply. He showed us another sketch he had thought of painting for the Salon, to express the emotions of some Gauls at seeing a negress for the first time,—a scene in the sacking of Rome. It is a very beautiful effect of color. He showed us the card of an American who had been at his studio a few days before, who had amused him very much. Instead of looking at the pictures he only *measured* them with his umbrella— The one picture that was not ordered, exceeded the length of the whalebones, so he did not buy, but he hopes on his return from Italy to find one the right size. His name was A. B. Marks and he is of New York.[1] Do you know of him? Price was no object with him. . . .

Miss Cassatt writes in much better spirits— Her carnival picture is sold for $200,—and the Bishop likes her copy now that he sees it in the Cathedral. I forgot to say Mrs. Birney and Miss Duell enjoyed their trip in Spain very much. They have been back in Paris about a week,— and we had a very delightful dinner with them last Tuesday. . . . the Birneys were robbed twice in Spain,—once at Toledo of a valuable diamond ring,—her engagement ring,—and afterwards of an opal ring, some chains and other trinkets,—taken out of their trunk. Another time their diligence was stopped by Carlist troops and examined for dispatches,— nobody hurt. . . .

Thank Mrs. Schussele for the nice long letter I got from her last week. It was ever so nice to hear from her again. By the way she says that one of their class is coming to Paris in May. If she thinks of studying with Luminais, she must not count upon being received. Every day or two I hear of applications being refused. He will not take more than five. But in case there might happen to be a vacancy, she ought to bring some of her best studies with her to show what she can do. He was very glad to

hear you thought I had improved, and every now and then when he is pleased, he says "I am sure your father would find progress in that, etc." His having your engravings makes him value your opinion.

We heard the other day of Sully's death.[2]

I have learned from Sophie that Miss Cassatt *raved* to Mrs. Birney against Luminais, says that she never heard of him all the time she was at Ecouen,—that she asks about him of all the artists she meets and that no one knows of him,—that he is an obscure artist, and for him to demand such a price for teaching is preposterous—that he ought to do it for nothing,—for the love of Art,—that when Raimondi saw the woodcut of his picture (the one you have) he said "trash" and threw it aside,—that his finding worst the one of my two Parma studies that Raimondi and she found best, showed them the value of his opinion etc. The secret of this last (and perhaps all), is that she and Raimondi gave me advice upon the depreciated one (that horrid ugly blonde with the flowers in her hair.) She went on in that absurd style extensively,—but as they had heard her equally extravagant on other subjects with which they were better acquainted,—they felt inclined to doubt whether her judgment and Art knowledge was better than mine, but still told Sophie about it, as they feared that after all she might be throwing her money away. But Sophie admires him now as enthusiastically as I do and her faith was not shaken,—and she could tell them how she saw *everyone* recognize his name when mentioned,—even at Ecouen where Miss C. remained so long unconscious of his existence. Sophie was pretty much excited over Miss Cassatt saying that no woman artist ever sold her pictures except by favor in America,— that people bought them, not because they wanted them but only to patronize a woman. Perhaps now that her Carnival picture is sold, her opinion is modified,—although her pleasure in the sale is marred by Mrs. Courtney having received the same price for a crayon head she drew. By the way, you have never said anything about those engravings of Raimondi's I sent home,—nor about those photographs of the ruins I sent you.

I had better tell you now in case I should forget it at the important time,—what Luminais impressed upon me emphatically when I thought of sending home this last study, that you must never wash any of my *yellow* draperies until it has been varnished, for I use a great deal of indian-yellow, which from a most brilliant color turns into lead color on contact with water. He also said, "Beg your father, *from me*, not to show any of your studies till they have been varnished." I had intended to send home a bottle of varnish with my study. He says retouching varnish evaporates in about a couple of weeks and the picture is as it was before varnishing. I am afraid you are dead tired of hearing Luminais' name and of what I am doing,—but I think or hear of very little else,

and naturally I fill my letters with them. I'll try to reform, if you find it a bore.

We have two more boarders, Americans,—one of them Mrs. Dillon who went with our party to Versailles, and the other Mrs. Cormans of N. York,—both studying Art. It is singular that we are all six Unitarians, and Mrs. Birney & her sister are too. . . . hoping all are well—

<div align="center">

Yours

Emily.

</div>

I thought somebody might like this Spanish stamp.

1. A. B. Marks amassed a large collection of contemporary European art.

2. Thomas Sully (1783-1872) was born in England but came as a child to the United States. He settled in Philadelphia in 1808 and, with his Grand Manner portrait style, was the city's most famous artist in the first half of the nineteenth century.

MARY CASSATT TO EMILY SARTAIN

<div align="center">

Seville

New Year's Evening, 1873

</div>

My Dear Friend,

This is the first time I have written the above date. Here we are in 73. Happy New Year to you and Mrs. Tolles, and may you make as much improvement as you both desire. It is half past ten, but for some unaccountable reason, I do not feel in the least sleepy, so, I reply at once to your letter which the "Cartero" has just brought me. D'abord! About the tickets for the Theatre Français, it was Miss Biller or rather Fraülein Biller who told me about them; you know that there are always plenty of "sups" about a theater who are given "free tickets" well they are often glad to sell the same, and Miss B spoke to us of a very nice person that she knew who disposed of free entrances, and she gave me the reason that it was because we were art students. We accepted the same without question and frequently went in parties of 10 or 12 from the school in the rue d'Aguessian. The address is Mme. Fourchette no 9 quai Voltaire, as well as I can remember, the tickets cost one franc & entitles you to a seat in the third circle of boxes price 3 frcs, go early, and give 50 centimes to the old woman who takes the cloaks she will give you both good seats; keep your mouth covered, you know I always tell everything but you are wiser and it is no use to let every one know your affaires; however I never can remember that all persons don't take my views of things. Tell Madame Fourchette that I or Miss Biller sent you perhaps she remembers Miss B. best; what I recommend you to do is all right and proper and as I tell you was perfectly approved of at the school.

Everything here goes on as usual. I am all day at Pilats house,[1] and am known as the "Señora of the Casa Pilatos," Sundays and week days,

<div align="center">

113

</div>

Christmas and New Years day— I get up there sometimes at ten, or half past seldom as late as eleven, and work steadily to five. My present effort is on a canvass of thirty and is three figures life size half way to the knee [figure 10]— All the three heads are forshortened and difficult to pose, so much so that my model asked me if the people who pose for me live long. I have one man's figure the first time I have introduced a mans head into any of my pictures. I had hoped to send something if only a head to the Vienna Exhibition, but I have not the most remote idea of when the pictures must be sent.[2] You say that I have said nothing about the pictures here, but the fine ones are miserably lighted, and many of them inferior to their reputation, there is however a magnificent Zurbaran at the Museo. The great thing here is the odd types and peculiar rich dark coloring of the models, if it were not for that I should not stay, the artists here are perhaps more flattering than they were in Parma, but I think the Spaniards infinitely inferior in education and breeding to the Italians. There is I believe a fine collection of modern paintings owned by an amateur here. Fortuny's Madrazos &c, the gentleman called on me, but his gallery is undergoing repairs and I am not to see it yet.[3] Spanish artists see nothing out of their own school, in Madrid everything was inferior to Velasquez in their eyes. I don't know if it was the spirit of contradiction in me but towards the past I got disgusted and found that there were a few other masters who could paint *a little*. It "riled" me to be told as I was constantly that Giorgione and Titian &c was conventional. Now that I have begun to paint from life again, constantly the thought of Correggio's pictures returns to my mind and I am thankful for my six months study in Parma. In all of Velasquez pictures I can think of no beautiful hand, *no*! not *one*. Murillo's hands of the St Elizabeth are exquisite but even in that picture there is a boy scratching his head in the most grotesque manner; indeed throughout I think the Spanish school lack taste. Nowadays everything is fashion however, and at present it is grey color, here is Madrazo paints these gypsies with cheeks like some deep red peaches, and he paints them with Malachite green and white. His modelling and his manner as far as I have seen is fine. I confess that if I did not live to paint life would be dull here, dreadfully dull, nothing absolutely nothing going on, as for the comic opera, it is comic indeed, my only surprise is how people live through it and some of them go every night. I will perhaps add a few lines in the morning, but it is very late, so for the present, good night—

Thursday Evening. I am waiting to begin my first lesson in Spanish— my little man is rather late, I don't intend to take grammer &c I am too tired in the evening to study, but I want to read Lope de Vegas plays,[4] and my little teacher will serve as a walking dictionary, more convenient

10. *On the Balcony*, 1873. Oil on canvas, 39¾ x 32½ in. Philadelphia Museum of Art, The W. P. Wilstach Collection.

than looking up all the words I don't know. I confess the "Andalusian salt" doesn't seem to me so "salty," I don't see their great wit.

I have not told you about my second edition of Raimondi, but ah! with a difference. The "intendente" of the Duke of Medina Coeli is a Don Manuel Barrera, he paints very badly himself, but it is he who gave me my studio in the House of Pilate; for he lives there, strange to say although he paints so badly he knows all about art, and has seen so many good artists at work that he can give very good advice, so I profit by it. I suppose you know that the House of Pilate belongs to the Medina

Coeli. You were talking of the Exhibition of copies at the Palais d'Industrie, if the one by Reignault is the "lancers" that is the (surrendering of the keys) I have forgotten the name of the town by Velasquez, why Reignault only *commenced* the copy it was finished by some one else.[5] I should think that an Exhibition of copies would be a novelty, I should like to see it. One young Frenchman was copying in Madrid on order from the government, paid 6000 frcs! The copy was *awful*! I wrote to ask you about Harry Moore, for I heard about him here, one of the artists said that when he was here Eakens painted much better than he did.[6] Mother also writes from home that she saw two of his pictures at Haseltines[7] both extremely free in style looked as if they had been painted with a pallet knife, the draperies not well done she says, one was withdrawn, for the artist required $3000 for it! Did I write to you that I heard he did not get on well with his wife? I believe that I have scribbled enough by this time, but if you know anything and can find a minute to write I wish that you would tell me when the pictures must be in Vienna—not that I have much hope of finishing anything in time. Are you going to stay in Paris? Wasnt there some idea of you and Mrs Tolles going to Naples. I was to have gone back to Parma, but I believe I shall not be able to, for I *hope* that mother may be over; besides I think I ought to spend the spring in Madrid. I have little or no desire to go to Granada, the thought of the journey deters me. Father sent me a paper with the account of the laying of the cornerstone of the New Academy, if I were not sure you had seen it I would send it to you, Mr Cope made a brilliant speech! Good bye—my love to you both

<div align="center">very sincerely
Mary S. Cassatt</div>

1. Cassatt's studio was located in one of the attractions of Seville: the Casa de Pilatos, the palace of the dukes of Medinaceli. Built in 1520, it was intended to resemble the house of Pilate in Jerusalem, including the pillar of Christ's scourging, the basin in which Pilate washed his hands, the table on which the thirty pieces of silver were counted, and a stuffed cock representing the one that crowed the night Peter betrayed Christ.

2. The World's Fair of 1873 was held in Vienna. Like the Exposition Universelle of 1867, it featured the art of the participating countries. In order to enter, Cassatt would have had to send her paintings to a central agency set up to judge works by American artists in Europe, but there is no evidence that she did so.

3. Raimundo de Madrazo y Garreta (1841-1920), trained in Madrid and Paris, succeeded his brother-in-law, Fortuny, as the most famous Spanish painter of his day. He specialized in Spanish and gypsy genre scenes as well as portraits. In 1872 he painted in Seville with Fortuny.

4. Lope Félix de Vega Carpio (1562-1635) was a poet and playwright; the brilliant and witty dramatic effects in his plays had a great influence on the development of European theater.

5. The Museum of Copies at the Palais de l'Industrie opened in December 1872. On exhibit were copies of celebrated Old Master paintings commissioned by the French government from prominent artists such as Bonnat, Jean Jacques Henner, and Regnault.

Alexandre Georges Henri Regnault (1843-1871) was considered one of the most promising painters of his generation in Paris. He studied at the Ecole des Beaux-Arts, won the Prix de Rome in 1866, and painted in Spain in 1868. He was killed in the Franco-Prussian War in 1871.

6. Harry Humphrey Moore (1844-1926), born in New York, was a friend and traveling companion of Thomas Eakins in the late 1860s. They were in Seville in 1869-70.

Thomas Eakins (1844-1916) and Mary Cassatt crossed paths many times during their careers. They studied at the Pennsylvania Academy in the early 1860s, went to Europe in 1866, returned to Philadelphia in 1870. They were further linked by their mutual friendship with Emily Sartain. But their widely different interests, which led Eakins to stay in Philadelphia and Cassatt to settle in Paris, probably prevented them from becoming more than acquaintances.

7. Charles Field Haseltine (1840-1915) was a Philadelphia artist who became an important art dealer in that city.

Mary Cassatt continued to paint in Seville until April 1873, when she joined her mother in Paris.

EMILY SARTAIN TO JOHN SARTAIN

88, boulevard Courcelles, Paris
May 8, 1873

Dear Father,

I have been so very much occupied since the Howells have been here, that my letter has been pushed off till the very last minute, although I have lots of things I wanted to talk to you about. I went down there every afternoon, but although it was a great interruption to my work as far as time is concerned, I believe there was more than proportionate gain,—for the pleasure of seeing old friends, and being so much in the open air made my mornings work from the model jump along merrily. They left for Geneva yesterday. We were about talked out, so I could say good bye cheerfully— Mrs. Howells is wonderfully improved, and I consider that she is now in pretty good health if she would only believe so, and at the same time avoid over fatigue. It seems to me very doubtful whether she will remain here the summer,—I think she'll go home with her husband, though he counts on her staying for the summer on the lake of Geneva—

I think I wrote you of the arrival of Miss Cassatt and her mother. Oh how good it is to be with some one who talks understandingly and enthusiastically about Art. I find I soon get tired of even friends who are not interested cordially in painting— I by no means agree with all of Miss C's judgments,—she is entirely too slashing,—snubs all modern Art,—

disdains the salon pictures of Cabanel Bonnat and all the names we are used to revere,—but her intolerance comes from the earnestness with which she loves nature and her profession,—so I can sympathize with her— Her own style of painting and the Spanish school which she has been studying all winter is so realistic, so solid,—that the French school in comparison seems washy, unfleshlike and grey— Coming from Italy last winter, the salon made the same effect upon me. I agree with her in a measure in many of her criticisms, but am not so severe and sweeping in my deductions.

By the way, Luminais has seen her Salon picture and a couple of her sketches that I took him— He spoke of them as having a great deal of talent but mostly *talent of the brush*, as [he] called it— You must not repeat this to any one. He also thought it wanting in distinction,—in fact he called it *common*. He said too that he saw the influence of too many masters,—there was no personality in her painting,—he felt in her work, Goya, Couture, etc., etc., not Miss Cassatt— He thought she had wandered about too much,—she ought to settle down in one place, and work out her own style— Somebody else here had told her the same thing. I don't see how he could have derived this conclusion. Her work looks to me so original— But I believe he is right. I told her some of these things in a modified form. I don't think she thinks much of his pictures,—they are not in her school. She talks of leaving Paris next week—for Granada if it is possible to reach there by land,—she is afraid to tempt the Mediterranean.

I went to the Salon Monday afternoon. Although they refused 4000 pictures, there are so many left, that I brought away a very confused impression of them after my three hour examination of them— Bonnat has the same picture I saw at the "Cercle" exhibition, and which I described to you then. Cabanel's two portraits I had heard so lauded in advance, were utter disappointments to me. There is one arm though that is beautiful,—exquisitely modeled and for a wonder, fine in color. Vibert, Worms and some others have the same pictures as at the "Cercle,"—not by any means first rate representatives,[1]— There are as usual, a great many crudities in color, extravagant subjects, and nudities to attract the eye,—and perhaps in consequence, the landscapes seemed to me unusually fine,—they reposed the eye by their simplicity.

I went yesterday with Mary & Mrs. Cassatt, to see the pictures of a Mr. Stewart, a Philadelphian, who is reputed to have the best gallery in Paris.[2] Do you know of him? He has a superb house near the palace of Industry, facing the Seine. It was a great treat— He has four or five Fortuny's in oil, and as many water-colors— I had seen only one water color by him before,—never any oil pictures. I was delighted by their color, their force spirit and freedom— One negro or Moor's head, life

size, a present to Stewart from Fortuny,—was superb,—even Miss C. admired it unqualifiedly. One picture was an Arab dance, around the fire,—another a single figure standing in the open air,—most of the acquarelles were Alhambra or Moorish scenes— He has Zamacois[3] "The favorites of the King,"—a dwarf and a dog descending the stairs of the palace and the courtiers saluting them, that you know by photograph,— and also two dwarfs playing cards with a jester,—the dwarfs on the table— The first is the finest Zamacois I have ever seen— He has five or six heads by Madrazo, which I call absolutely miserable and commonplace, —though they sell at 10,000 francs apiece,—and one little genre picture by him of a Spanish girl in a yellow satin dress leaning back in a chair doing I don't know what, that is exquisite, delicious in color, a perfect gem— He has a number of water colors by a Spanish landscapist whose name I did not know before,—Rico,[4]—that were very fine—so calm and unaffected— He sells also at high prices— I cannot tell all the fine pictures he has, though they scarcely merit his assertion, that the best picture in this year's salon did not equal the worst he had— He only cares for the one school, and talks with ostentatious contempt of such idiots as Ingres, DelaCroix, Raphael, etc,—tells how he sat in front of the Transfiguration with Fortuny and Meissonier,—and after a long silence Fortuny jumped up with the exclamation "muy malo" *very bad*, which the others immediately seconded— How Gibson[5] and Claghorn would grit their teeth if they knew how he talked of them, which of course they must not—,—that Gibson knew no more of Art than a cow,—that Claghorne had filled up his gallery with the trash that he had cleared out of his own gallery,—mistakes he had made—old purchases that his present superior knowledge made insupportable to him,—that he had sent to Earle's without letting people know whom they belonged to, etc. and so forth. I forgot to say, his Bonnat he considers the best he has painted, which I think probable. It is Roman peasants or lazzeroni, lounging on the step in front of an old Roman palace,—you've seen a photograph of it,— one prominent feature is a man at full length right below the window— repeating the line of the projecting cornice—Stewart must be immensely rich to live in such style— He entertains his pet artists every Thursday. He invited us to come to see his pictures when we liked, and I hope to go again—Miss Cassatt had been there before—

. . . I am glad to hear you think so much of Mr. Luminais,—but it is rather too strong to place him above De la Croix— By the way, he gave me the other day for you, a photograph of one of his Salon pictures. It is very very black,—being taken in his atelier without enough light,—as he would not trust it to be taken to the photographers— A friend of mine going home next week, will take it to you, together with a few of my late studies. She probably will spend a day in Philadelphia on her way home

out West,—and in that case will come to see you,—otherwise will express them to you— If she calls upon you, make her very very welcome, for she has been exceedingly kind and pleasant to me— She is a widow lady, a Mrs. Tiers,—her husband was a Philadelphian— She boarded at Madame Thierry's with me, in the rue Pigalle, and I like her very much— She sails next week in the Abyssinia—

Do you remember meeting a Miss Gordon at the Cassatts'? Mrs. C. tells me she is gone insane,—believes she is the Queen of Heaven etc— Tell Mr. Eakins of it,—he knew her. See if he don't answer "She always was cracked."

I have already written to you about the tickets to Vienna in several letters— If you do not come over, I don't think I'll go— I hear so much of the crowds and expense and bad accommodation, that I care less and less for it. As for the pictures, one so soon learns every artist's capabilities here at Paris— If Cassatt's go to Granada,—and if they were to give the slightest hint of liking me to join them, I should feel strongly tempted to go down there for the three months Luminais will be away— It would be expensive, I suppose— It is a pity that both Miss C. and I both are so defective in drawing— Mr. L. says he is no longer anxious about my color, or luminousness, he is sure of that now,—but he commences to torment himself and me about my drawing, which certainly is outrageous—I have been so careless about everything but color, that I've gone from bad to worse. Next week I'm going to commence to draw every afternoon,—paint only in the mornings— It is growing dark and it hurts my eyes so much to write at night, that I must say good bye— I must not forget to say both the Howells and Cassatts say that I am looking very very well—I'm afraid I must groan in my letters home, most unwarrantably,—since you seem to have an idea I am overworking myself—I dined with the Cassatt's last night— Had a delicious dinner— One treat the Howells gave me, was an evening at the Theatre Français, to see *Marion De Lorme*,—superbly mounted.[7] Another evening we went to the Circus, which Ma remembers— We also went to the Panorama— Ma can tell you what a splendid thing that is— I never saw such a complete illusion, it is so admirably painted, —by Phillippoteaux.[8] Thank Mrs. Schussele for her letter received last week—will answer it soon— With much love to all

<div align="right">Yours affectionately
Emily—</div>

1. Jehan Georges Vibert (1840-1902) attended the Ecole des Beaux-Arts and won several medals at the Salon. His comic genre scenes of priests were very popular with Americans. Jules Worms (1832-1924), whose small, carefully finished genre paintings were similar to Vibert's, specialized in Spanish subjects.

2. William Hood Stewart, a collector from Philadelphia, was a major patron of Meissonier, as well as Fortuny, Madrazo, and other Spanish painters.

3. Eduardo Zamacois y Zabala (1843-1871) studied in Madrid and then in Paris with Meissonier. He was best known for his humorous genre scenes and collaborated with Vibert on at least one major painting.

4. Martin Rico y Ortega (1833-1908), a landscapist from Madrid, entered the circle of Fortuny and Stewart in Paris in 1866. He was widely known in the 1870s for his small, luminous views of France, Spain, and Italy.

5. Henry C. Gibson had an extensive collection of modern French painting in his Philadelphia home, including works by Courbet, Couture, Corot, Gérôme, and Cabanel. The collection went to the Pennsylvania Academy upon his death in 1891.

6. Miss Gordon had traveled with Cassatt in 1869. See Mary Cassatt to Lois Cassatt, August 1, 1869, and Mary Cassatt to Eliza Haldeman, August 17 [1869].

7. *Marion DeLorme* was written by Victor Hugo in 1829 and first produced in Paris in 1831.

8. Henri Félix Emmanuel Philippoteaux (1815-1884) was an illustrator and painter of battle scenes.

MARY CASSATT TO EMILY SARTAIN

37, place de Meir, Antwerp
June 25 [1873]

My Dear Friend,

Where are you? What are you doing? & What are you going to do in future? Write soon and tell me all about yourself. Mother and I have been "on our travels" since we left Paris. We went for a jaunt to Holland, and spent nearly a week at the Hague, which place we both fell in love with, and would have stayed there all summer if we could have found a studio; but that difficulty brought us back here, where I have a room with a north light, and have begun to paint.

I am enchanted with the Rubens' here, especially with the Adoration, but there is nothing else but the Rubens to admire, except one head of Rembrandt. Models are not pretty and difficult to find, so after all I might have chosen a better place. I met here a Mr. & Mrs. Tourny,[1] Mr. T. copies in water colours for Mr. Thiers, Madame T. paints also, & sells her pictures, the latter fact astonishes Mother immensely, she thinks they must be bought for lithographs for the top of pin boxes. However, she is a lively little woman, and has perfect confidence in her own abilities, which is just as well under the circumstances. We see a great deal of them too much in fact for they spend *every* evening here and prevent me from writing to anyone, dear Raimondi I am sure is offended with me. Please dont you be so but write soon and tell me what you are doing. I must not forget to make the "amende honorable" [apologize], the Bishop has paid me!!! Wrote me a very nice letter spoke of my demand as very moderate, but sent £ 10 more. That comes of following your advice. I

assure you I was glad to get the money for Mother absolutely refused to pay models this summer, considering them an unnecessary expense.

Please excuse this scrawl and believe me very sincerely your friend,

M. S. Cassatt

Mother sends kind regards.

I send a Spanish postage stamp, got a letter from Don Manuel, offers his studio for next winter, it is immense, two windows, so if you want to come, we can divide w/ curtains.

1. Léon Auguste Tourny, born in Paris in 1835, was connected with the tapestry manufactory at Gobelins. A friend of Degas, he was known as a portraitist and watercolor specialist.

KATHERINE CASSATT TO EMILY SARTAIN

Antwerp
Friday, July 4 [1873]

My dear Miss Sartain,

Your letter of the 2nd has just arrived & Mary having no time this morning I take the liberty of writing in her place to ask if you will do me the favor to take charge of a ring which I hope will be ready to forward to you in time to Paris— It is one of Mary's extravagances committed on the strength of that £50 of the Bishop's— If ready in time I shall forward it by Express to you and although I don't like to trouble you just on the eve of departure I must do so for the thing is rather expensive & it's loss would be regretted— Will you just drop *one* line to say if it reaches you safely?—

I pity you from my heart with all your commissions. I know from experience what a trouble they are—

I hope you will have a good passage[1] & that the heat (my bugbear) will have abated before you arrive in the land of the free— I have letters this morning saying it is fearful— Here we can't complain so far—

Mary & Mme Tourny are hard at work on the "ensemble," and have no time to bestow on poor me just now— In August we hope to take a trip either to the sea-shore or the mountains—at least that is my desire if art doesn't interfere—

I am going to send home a little sketch Mary has made—only a sketch but so pretty in color that I think it can't but please them at home— As the boxes have to be sent to the office on 3rd street because the house is shut up, Mary will let you know when it leaves & perhaps you will call & see it there—not being *"finished"* it cannot be put in Bailey's window— Her Balcony & girl with white veil are now there—and no

end of articles in the newpapers about them—some very funny you
will think if you see them— Unfortunately the weather being so hot the
right sort of people are out of town—so the chances for selling I am
afraid are small—

As I go home about the time you return I hope to be able to do for you
what I am asking you to do for me—take charge of anything you may
wish to send home to your friends—

Hoping to see you in October and with much love to yourself & kind
regards to your father & mother—

<div style="text-align:right">

I am very sincerely yours
K. K. Cassatt

</div>

1. After a year and a half in Europe, Emily Sartain returned home to Philadelphia to
visit her family. She left Paris around the first of August and returned at the end of No-
vember 1873.

MARY CASSATT TO EMILY SARTAIN

<div style="text-align:center">

[Rome]
November 26 [1873]

</div>

"Dear My Friend,"

I suppose by this time that you are back again, and once more at the
studio. Your letter from Phila. unfortunately reached me after I had left
Parma so I was not able to get you the photograph, but if I pass through
in the spring it will do, I suppose. My visit to Parma was a disappointment
in many respects, Raimondi behaved in the strangest way, but I cannot
write you about [it] I will keep it until we meet. The only satisfactory
thing in my visit was to see the improvement I had made, I only had
some few studies with me that I did in Belgium, but R. was enchanted;
Mr. Bellay here, also was pleased, he saw my Parma pictures but thinks I
have improved, he thought I was getting chicky[?] in Parma. I am glad
there are different opinions on the subject as I should not like to go back.
My great difficulty here is the models can't find a model, oh! how I
regret Spain! All the good models are taken for the winter and of course
would rather pose for men.

Write soon and tell me how you are getting on. My kind regards to
Mrs. Tolles.

I saw Mrs. Birney and Miss Duell before I left, if they are coming to
Rome and I can do anything for them before they come down I shall be
very happy. Please tell them that Miss Korn was obliged to give up her
extra room.

I have only made one visit since I have been here but that was sufficient to plunge me in the midst of all the backbiting and scandel; horrid as they are. But after all Rome is a beautiful place, stinks, is dirty, melancholy, but still fascinating. Dont forget to tell me what you are doing, and all about everything.

> Ever yours in haste
> Mary S. Cassatt

Mary Cassatt stayed in Rome from November 1873 until June 1874.

M^{LLE} MARY CASSATT.

32712
— *Ida.* — **Ces rousses ont un éclat'...**

11. *Caricature of "Ida" by Mary Cassatt, Le Salon de 1874 in Le Journal amusant,* June 27, 1874. The caption translates: "Those redheads—they're terrific!"

EMILY SARTAIN TO JOHN SARTAIN

> Paris
> June 17, 1874

My dear Father,

. . . I think I told you that Miss Cassatt is in Paris. She astonished me by telling me she is looking for an atelier here, for next winter. She has always detested Paris so much, that I could scarcely believe it possible

12. *A Musical Party*, 1874. Oil on canvas, 38 x 26 in. Musée du Petit Palais, Paris.

that she would consent to stay here,—but she says she sees it is necessary to be here, to look after her own interests. She thinks it is the fault of her picture dealer that her pictures do not sell. I told you what a washed-out affair she has in the Salon [figure 11],—but she has a picture now at her dealer's in the Boul. Haussmann, that is superb and delicate in color,—three figures singing [figure 12]. The light on the chest and face of the foreground figure, a blonde, is perfectly dazzling. It is as slovenly in manner and in drawing as her Spanish pochades, however. She says that her Salon head had a great deal of success among artists.[1] I asked Mr. Luminais to look at it, and give me his opinion, but he forgot it. I suppose you know as much as I do, about the probability of her coming home for the summer. It does not seem likely that her mother would have her make the two voyages in so short a time,—suffering as she does on the ocean. . . .

Trusting all are well,

Yours truly
Emily.

1. One of the artists who admired this painting was Edgar Degas. He was walking through the Salon with Léon Tourny, Cassatt's friend from Antwerp. When Tourny took him to Cassatt's painting and pointed it out, Degas said, "It's true. Here is someone who feels as I do." (Achille Segard, *Mary Cassatt, Un Peintre des enfants et des mères*, p. 35.)

In the year following Cassatt's decision to settle in Paris, she and Emily found themselves moving in the same social and artistic circles for the first time since Parma. Cassatt had spent the summer of 1874 in Villiers-le-Bel near Thomas Couture, then moved to Paris for the winter. She was joined by her sister, Lydia, sometime before January 1875. Sartain continued to work with Luminais, concentrating her efforts on two entries for the Salon.

EMILY SARTAIN TO MARY CASSATT[1]

[rough draft]
[Paris]
[c. May 25, 1875]

Miss Cameron called to see me the other day and was kind enough to tell me in what way I had unwittingly given you offense. Before writing to you to do myself the justice of letting you know precisely how your

name came to be mentioned in our atelier, I wanted to have the opportunity of asking Madame Durand what she had said to you that had given you such an erronious idea, I was sure she had said nothing with malice and that there had been misunderstanding on your part. She was astonished & indignant that you could have construed what she said into an evidence of bad faith on my part.

I had supposed you had not sent either of your pictures to the Salon, (as you had told me was your intention),—until a friend who had been at the Palace of Industry on business saw your portrait of your sister and recognized it as your work— A day or two afterwards when Mr. Luminais was speaking of different pictures that had been passed by the jury that day, I asked him if he had noticed a pink dress against a red background. He said yes,—that a gentleman had asked his interest in favor of it,—that he was sorry to say that its fate was doubtful, that it had been put aside for revisions. At the end of the examination (several days after) he told me that my pictures had passed safely through the second examination,[2]—"but I could not do anything for your friend" he said. "I did what I could for it, as you were interested in it, but the jury pronounced against it"[3]— Madame Durand came in towards the end of the conversation, and hearing your name, asked me point blank if you were accepted, and I of course had to answer that you were refused, at which she expressed great surprise and regret. There was no question of the other picture[4] which I still imagined had not been sent— So little was there "open announcement of your refusal" that Mrs. Gimble, a Philadelphian, who was working alongside of me, had not the slightest suspicion you had been refused— When ever she or any other American asked me if I knew whether you had sent I answered invariably that the last time I saw you, you had told me you would not have your pictures finished in time. Only ten days ago she informed me that you had had a picture refused—and I answered as if it were news to me—as I did to all who gave me the same piece of information.

I could not imagine what Mr. Luminais had ever said that could be interpreted as the result of prejudice against you instilled by me—for you have never been the subject of conversation with him in my presence, except as an artist, when naturally your works were discussed with the same impartiality as he would any of his confrères— On inquiring of Madame Durand about it, she told me that one day she had spoken of you (I was not there at the time) and had offered to take him to your studio to let him see your works— He answered thanking her, that he had already seen some of your works,—the two Spanish studies that you had lent me to show him and my comrades, and the Spanish Salon picture— And then he pronounced his opinion on them,—which as far as she could recollect was similar to what he has said to me on each of

the three times he has ever spoken of you,—the first time when I showed him those studies, the second time when the Spanish picture was in the Salon, the third time this Spring when your portrait was before the jury— He always accorded you a great deal of talent, that you were evidently highly organized as an artist, but that in your effort after frankness you fell into brutality, and that your pictures were not "distingué." Also, the same thing that you told me Vieille had told you—that you were too easily impressed by a master whom you admired, that your painting showed the influence of several different schools of art at the same time, and as a result was wanting in "orginality"—individuality— That is the resumé of all that I ever heard him say about you, I have kept back nothing—and if you heard of anything different, there is certainly some misunderstanding. If I had had any idea that you would have liked him to call upon you to give you a criticism as a confrère, I should have been happy to offer to ask him, and I do not doubt he would have gone with pleasure,—but as I had been told you had expressed yourself very contemptuously of his talent, I imagined his opinion would be of little value to you.

And now about my own grievances against you. You had persistantly refused to let me see your picture this winter notwithstanding that eight or ten people for whom you professed utter indifference had permission to see it— At last when I called by your invitation, and was again refused admittance I became very angry— But after a little reflection I resolved a charitable construction on it, thought perhaps you had a model and had not expected me so soon, etc.—and to show that my momentary vexation was over I called a day or two after under pretext of returning some books you had left me. You were unfortunately out, your sister received me coldly, but still I expected you would return my two calls that my two calls would be returned by you at least, not by your sister for she never returned any of my calls. Your sister never accorded me the honor of a visit but you I did expect, or at least a note to meet my advances. As for my offense in not inquiring often enough about your sisters grippe, I have equal right to be offended at your not inquiring about my brothers bronchitis when he was very ill at the same time. And I also think you might have acted in my favor, as I did towards you when people came to me brimful of disagreeable things you were supposed to have said to them about me. I refused to hear them, and said they had not understood you, that in the excitement of talking your tongue often ran

[incomplete]

1. This appears to be the rough draft for a letter Emily Sartain wrote to Mary Cassatt

when Cassatt was in Philadelphia visiting her family. Sartain enclosed the final version in a letter to her father of May 25, 1875, saying:

I enclose a letter for Miss Cassatt. Will you please put her father's address on it, and mail it— Glance through it before you seal it— I mean you, Father, individually— Miss C. is a tremendous talker and very touchy and selfish, so if you hear of her talking of me at home, as she has done lately in Paris, you will know the origin of it all. I shall never become intimate with her again, no matter how she receives my letter.

2. Sartain's two entries were a three-quarter-length *Portrait of Mlle. Del Sarte* and a small genre painting called *The Reproof*. Mlle. Del Sarte was the daughter of Sartain's landlady at 88, boulevard Courcelles. It was there that Sartain met Louisine Elder (later Havemeyer) and her sister in March 1874; she introduced Cassatt to the Elders in June 1874.

3. According to Cassatt's account to Segard in 1912, this was a portrait *en pied* ("full length"). She recalled that it was refused because the background was too light; after she repainted the background to darken it, she resubmitted it and saw it accepted in the Salon of 1876. (Segard, *Mary Cassatt, Un peintre des enfants et des mères*, p. 7.)

4. The only trace of this painting is the caricature by STOP which appeared in *Le Journal amusant*, no. 982, June 26, 1875, p. 3 (figure 13).

Mᴸᴸᴱ **MARY CASSATT.**

Ce qui me charme dans l'enfance, c'est la naïveté.

13. *Caricature of "Mlle. E.C." by Mary Cassatt, Le Salon de 1875*, in *Le Journal amusant*, June 26, 1875. The caption translates: "What I like about childhood is its naïveté."

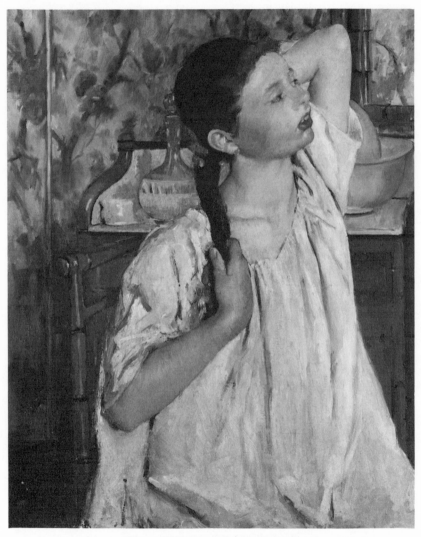

14. *Girl Arranging Her Hair*, 1886. Oil on canvas, 29½ x 24½ in. National Gallery
of Art, Washington, D.C., Chester Dale Collection, 1962.

3

The Impressionist

1878-1886

B Y 1878 the thirty-four-year-old Mary Cassatt had acquired what she had done without during her early years of study and travel: a home. She spent her first three years as a Paris resident creating surroundings of comfort and beauty in her studio at 19, rue de Laval. "Statues and articles of *vertu* filled the corners," wrote an artist friend after a visit to Miss Cassatt's, "the whole being lighted by a great antique hanging lamp. We sipped our *chocolat* from superior china, served on an India waiter upon an embroidered cloth. . . ."[1] Cassatt found that she enjoyed making her home into a work of art, giving pleasure to the senses; or, as she later expressed it, "making pictures with real things."[2]

Her second home in Paris was even more complete since it accommodated not just the young artist, but a close-knit Cassatt family unit. At the end of 1877 her parents, Robert and Katherine Cassatt, brought their elder daughter, Lydia, to join Mary in her life abroad. They found a comfortable apartment at 13, avenue Trudaine in the artists' district—not far from the place Pigalle and Montmartre. For the elder Cassatts, at the ages of seventy-one and sixty-one, the move was to provide the leisure and cultural life that they desired for their retirement. For Lydia, a home in Paris meant access to doctors, health care, and the European acceptance of her semi-

1. May Alcott Nieriker to Abigail May Alcott, [November 1876]. Quoted in Caroline Ticknor, *May Alcott* (Boston, 1928), p. 152.
2. See Mary Cassatt to Ada Pope, April 7 [1900].

invalidism. For Mary Cassatt, whose career as an Impressionist was just beginning, the new home meant that "the family" would have a sudden and profound effect on all aspects of her life and art.

Cassatt's intensified involvement with the family went beyond the day-to-day interaction with her parents and sister in their Paris home; it also encompassed the lives of the Philadelphia Cassatts— Mary's brothers, Alexander ("Aleck") and Gardner ("Gard"), their wives, and their children. During the first few years of this period, the focal points of these two units, Mary and Alexander, reached new heights in their careers, and the whole family prospered. For Mary, these were years of great artistic success and personal pleasure. On becoming an Impressionist, her career blossomed; as she later recalled, "I began to live. . . ." In the meantime, Aleck's career with the Pennsylvania Railroad had catapulted him to the lofty position of first vice-president. With the great wealth and power that accrued from this position, he contributed to the well-being of the entire family. He made an even greater contribution to the family with his four children—Eddie, Robbie, Katharine, and Elsie— who were a delight to their aunts and grandparents in Paris.

However, in 1882 the Cassatt family suffered multiple setbacks, both personal and professional. In that one year all were affected: Mary's career was halted by quarrels among the Impressionists and the financial crash in Paris, which forced the art market to plummet; Alexander, beset by growing dissatisfaction, resigned from the railroad; Gardner faced bankruptcy in his banking business; and, tragically, Lydia succumbed to the illness that had caused her increasing suffering. Lydia's death brought the family closer, thus involving them more deeply in each other's problems. These troubles took their toll on the household in Paris; by 1884 Mrs. Cassatt was fighting off a nearly fatal illness, Mary and her father were feuding, and finally Mary faced exhaustion. She clung to her work in the midst of this turmoil, but found her productivity seriously affected.

Not until 1886 did the family outlook begin to improve. That summer, Aleck's passion for horse-racing infected the family on both sides of the Atlantic as they watched the brilliant season of one of his champions. Gardner initiated a new brood of grandchildren with the birth of his first child. And Mary's career got back on track with the revival of the art market and the excitement of

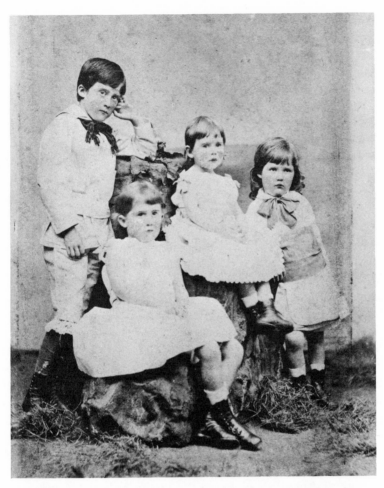

15. The children of Alexander J. Cassatt and Lois Buchanan Cassatt (left to right): Edward Buchanan Cassatt, Katharine Kelso Johnston Cassatt, Elizabeth Foster Cassatt, and Robert Kelso Cassatt.

another Impressionist exhibition—her first in five years.

Throughout these years of emotional highs and lows, Cassatt's letters have a tone of careful control. She transacts business, she cares for nieces and nephews, she nurses her parents and sister, and she discusses servants and *modistes* with authority. She is witty and communicative, but it is plain that her carefree youth is over. Similarly, these letters lack the fervent emotional responses to art that characterized the earlier correspondence. But they offer instead

something equally valuable: a well-rounded picture of Mary Cassatt as a professional artist. Documenting the pragmatic side of art, they bear witness to her dedication and constancy, showing her at work daily in her studio, usually with a model, even during periods of worry and grief.

A fundamental concern for Cassatt in these years was the buying and selling of art. In order to sell her own paintings, she had dealers and agents in the United States and in Paris. Her relationships with these people were always problematic, but always necessary. In addition, she was active as a buyer of art, for herself and for her family and friends. Like Berthe Morisot, Gustave Caillebotte, and other wealthier members of the Impressionist circle, Cassatt felt an obligation to support those who were struggling—Monet, Pissarro, and even Degas. She used her father's money to buy their paintings for her own household and persuaded Alexander to become a collector, playing on his horse-racing hobby to interest him in some of Degas's paintings of that subject. By keeping an eye on the art market, she was able to buy Impressionist paintings at attractive prices and had the satisfaction of seeing them rise in value within a few years.

Another aspect of Cassatt's life as a professional artist was her regular participation in exhibitions where she would unveil her latest work and receive important critical response. After ten years of exhibiting at the Salon, she was accustomed to the annual spring deadline for new work, and in the 1870s she had branched out to exhibitions in Philadelphia, Boston, and New York. As groups of younger artists broke away from the academic establishment, as the Society of American Artists did from the National Academy of Design in New York, she was invited to participate in their exhibitions. But increasingly Cassatt's efforts were channeled into her yearly output for the spring Impressionist exhibitions. The group had been formed in 1874 to give its members an opportunity to exhibit their works outside of the Salon. In 1877 one of the founding members, Edgar Degas, invited Mary Cassatt to join them, admiring her work and seeing that she too was frustrated with the Salon system. She worked hard to prepare for the 1878 Impressionist exhibition, but at the last minute the group decided not to try to compete with the opening of the Exposition Universelle in Paris that spring.

When her opportunity to exhibit with the Impressionists finally came in 1879, Cassatt was not disappointed. She received favorable notice in the reviews that appeared in French newspapers and journals, and won the respect of the French intellectual community. Her masterful interpretation of the Impressionist style—especially the effects of light and shade—impressed the artists and critics who had seen Impressionism develop over the past few years. The most important of these was Degas, who welcomed her both as a colleague and a friend. Cassatt and Degas were probably closest during that year after the 1879 Impressionist exhibition, when they worked together on etchings for a proposed print journal, which they called *Le Jour et la nuit* ("Day and Night") to suggest the experimental effects of light and dark to be found in the prints.

Cassatt's conversion to Impressionism was a natural outgrowth of opinions about art that she had held for a long time, but it is surprising that her parents were able to join her so enthusiastically in this new interest. Impressionism was by no means fully accepted in either French or American circles in Paris. The Cassatts could easily have been shocked at their daughter's choice of painting style and companions, as other Americans were when they visited the Impressionist exhibition at 28, avenue de l'Opera. One reviewer for an American newspaper in Paris had this reaction:

"We cannot in fact understand the purpose of the new school. It is founded neither on the laws of Nature nor the dictates of common sense. We can see in it only the uneasy striving after notoriety of a restless vanity, that prefers celebrity for ill doing rather than an unnoted persistence in the paths of true Art. . . . [The exhibition] was worth seeing for the same reason that one would go to see an exhibition of pictures painted by the lunatics of an insane asylum. . . .[3]"

The Cassatts distanced themselves from the American colony in this as in other aspects of their lives in Paris. They overlooked the bad reviews and dwelt with pride on the good ones; they echoed their daughter's satisfaction in seeing the growing acceptance of the movement and her own acceptance as an artist in the sophisticated Parisian avant-garde. In spite of his foibles, they welcomed Degas

3. *The American Register*, May 17, 1879, p. 4.

as a friend, finding horse-racing a common interest. The high social class of many members of the Impressionist group, such as Berthe Morisot, Gustave Caillebotte, and Ludovic Piette, probably went a long way toward reconciling the elder Cassatts to their daughter's colleagues, if only because they found a common ground in their broad intellectual interests.

For the next two years (1880 and 1881), Cassatt received increasingly positive responses to the work she showed with the Impressionists. The exhibition of 1881 was especially successful because she showed the paintings she had started in the open air the summer before. Her family had for the first time rented a country house at Marly-le-Roi outside of Paris, where they entertained Alexander's four children (whom Mary had not seen for several years). Combining the Impressionist interest in "plein-airism" and subjects from her own life, Cassatt produced a series of paintings so engaging that they were almost all sold from the exhibition. Not being a sentimentalist, she even sold a painting of her mother reading to the grandchildren (page 159), which she later had to retrieve from the buyer to give her brother.

The momentum of three successful annual exhibitions came to a halt, however, in the ill-fated year of 1882. The Impressionists held their usual exhibition, but internal disagreements kept Cassatt away. For the next few years, no more were held, leaving her suddenly without the reliable event that had given rhythm and purpose to each working year. Occasionally, the dealer Paul Durand-Ruel would enter her works in exhibitions in Paris or London, and they continued to sell; but she no longer had the challenge of offering up each year's efforts to public scrutiny or the reassuring framework of a group with shared artistic goals.

In 1886 Cassatt recaptured the sense of purpose that exhibitions had given her. That year the Impressionists held their eighth and last exhibition; and in addition to showing works, she had the satisfaction of being one of the major organizers and backers of the project. On the other side of the Atlantic, Durand-Ruel held his first exhibition of Impressionist art in New York, introducing the style to a wider American audience. This exhibition marked the beginning of the flood of Impressionist art to the United States, which meant gradual prosperity for artists and, for Cassatt, the satisfaction of seeing her chosen style accepted by her countrymen.

MARY CASSATT TO J. ALDEN WEIR [1]

13, avenue Trudaine
March 10, 1878

My dear Mr. Weir,

Your letter only reached me yesterday evening. Mr. Sargent forwarded it to me from Venice where it had followed him, that accounts for the delay. [2] I thank you very much for all the kind things you say about my work. I only wish I deserved them.

Your exhibition interests me very much. [3] I wish I could have sent something, I am afraid it is too late now. We expect to have our annual exhibition here, [4] and there are so few of us that we are each required to contribute all we have. You know how hard it is to inaugurate anything like independent action among French artists, and we are carrying on a despairing fight & need all our forces, as every year there are new deserters.

I always have a hope that at some future time I shall see New York the artists ground, I think you will create an American school.

You have been so kind to me that I feel thoroughly ashamed of myself for not having done something good enough to send you; next year I will do better; and I hope my artist friends here will send with me.

With many thanks

Very sincerely yours
Mary Cassatt

1. Julian Alden Weir (1852-1919) had studied with Gérôme and was very active in American art circles in Paris in the 1870s.

2. Cassatt became acquainted with John Singer Sargent (1856-1925) while he was a student of Carolus-Duran in Paris in the 1870s. An American who had been raised in Europe, Sargent practiced portraiture in Paris until 1884, when he moved to London. He painted a portrait of Alexander Cassatt after Cassatt became president of the Pennsylvania Railroad.

3. Weir was recruiting participants for the first exhibition of the Society of American Artists in New York. The Society was founded in 1877, incorporated in 1882, and finally reunited with the National Academy of Design in 1906. Cassatt, as promised, participated in the second exhibition of this group in 1879 and continued to send something every year until 1894. She was elected to membership in 1880 along with Whistler, Eakins, and Sargent.

4. Cassatt was still counting on an Impressionist exhibition that year.

ROBERT CASSATT TO ALEXANDER CASSATT [1]

13, avenue Trudaine
Friday, October 4, 1878

My dear Son,

It is a long while since I have either received a letter from you or

written you one— Our lasts I believe were about your mothers portrait [figure 16] and I wish to continue the subject in this— The portrait is now on the way to you, we sent it to the Red Star office on the 2ᴰ inst. [instant] and it is to leave Antwerp for Switzerland on the 15th— It goes in a frame—Mame [Mary] had a very fine one, bought a bargain in Rome, in which the picture was exhibited here & which suited it admirably. So she thought it a pitty to part them & moreover wished you to have the first view of the portrait in a frame as a picture always appears to greater advantage framed & & The freight & charges will of course cost something more but not so much more than if you had had a frame to buy at home— Mame thinks also that the picture will carry better this way than if rolled— I ordered the picture insured for 2500 fcs & the frame of 250 fcs. The frame is pretty of carved wood & would cost at home I suppose 100 to 120 $, but Mame paid only 200 fcs for it in Rome second hand there—& although she has had it *done up*, you may safely swear its value at 30$ if there is any question at the custom house about it— You should see that the box is opened with great care at the custom house & so that neither the frame or picture receives injury— I enclose the Consul certificate & later will send the bill of lading for the box— I hope you will be pleased with the portrait, in fact I do not allow myself to doubt that you will be, but hope all the same that you will speak "right out in meeting" if you are not— Here there is but one opinion as to its *excellence*— See that it is properly hung as to light distance etc. etc.—

Mame is again at work as earnestly as ever & is in very good spirits— She has recently sold one of her last pictures to a *french* amateur and collector and at the same time received an order from the same gentleman for another—a *pendant*—for the one purchased. Mrs. Mitchell took some of Mary's pictures home with her in June last & some two or three of them have been sent to the Boston Exhibition[2] & have received very flattering notices from the papers particularly the Transcript & Williams' the picture dealers have asked to have the agency for her pictures in Boston[3]— You will probably have seen some of the notices I speak of. This brings me to speak of Mrs. Mitchell—a great admirer of Mame's— She is the wife of that Mitchell formerly a well known merchant in Philadᵃ who was killed some months ago by the falling of a tree in Virginia— The family have been in reduced circumstances for several years & she has been struggling hard to make a living for herself & younger children—and among other means is trying to sell pictures. I believe she & Teubner[4] work in each others interest— Well Mrs. Mitchell has some connections in California & thinks she might be able to sell some pictures there if on the spot but unfortunately has not the money to pay passage etc— So she has written to Mame to ask her to

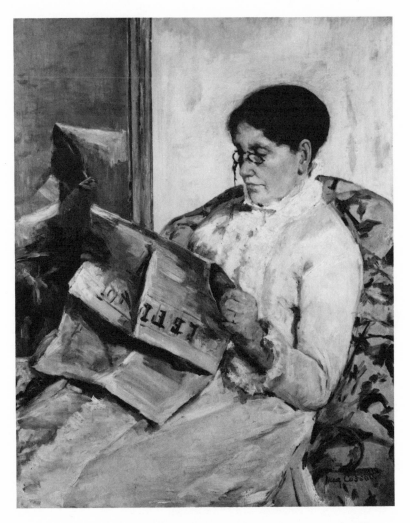

16. *Reading "Le Figaro,"* 1878. Oil on canvas, 39¾ x 32 in. Private collection.

use her influence with you to get her a pass— Mame has replied that
she did not think you could give a pass to San Francisco & that one over
your lines would not help her much—but in the end I believe telling
her she might call & see you about it— Now if you can *properly* do
anything in the way of a pass to help the poor woman, I wish you would.—
Your mother I belive at one time wrote you not to do anything
of the kind but then she was under a wrong impression——

Just now we are all very well— When I say we I must except Lydia, but
she too is well for her—and we hope again that the Doctors have been

mistaken in their opinions of her case last summer[5]— Certainly the
dangerous symptoms have disappeared in a great measure— She however
still looks thin & miserable but has a good share of strength & a very
fair appetite & also pretty good spirits— We are having delightful autumn
weather— Paris is a wonder to behold— Such universal movement
in every part of the city I am sure does not exist in any other city in the
world *not* excepting London. The Exhibition is a continued success
and its success has helped to establish the Republic[6]— The Monarchists
cannot conceal their spite at this— The fêtes preparing for the
closing hours are to eclipse all that has preceeded them & wind up in a
blaze of glory— In short the Republic is to show that there is no
need of a Monarchy to make Paris the gayest city in the world. However
the resident Parisians are praying for the *closing* & we heartily join
them— We are not altogether furnished yet & will not be I suppose
until the Exhibition closes—

We long to hear particularly of you all especially of the dear children,[7]
of their sayings & doings—by this time Elsie's prattle must be very
amusing & we would like to hear some of it as well as that of Rob—
The other two are past that— Gard writes very meagre letters & never
tells us anything of any of you except that you are well— We all join
in love to you all

<div align="center">

Yr aff father
RSC

</div>

1. Mary's father, Robert Simpson Cassatt (1806-1891), was born in Wheeling, West
Virginia, but raised in Pittsburgh. He became a prosperous banker and mayor of the subur-
ban Allegheny City in 1846. In 1849 he moved his growing family to Philadelphia and
then to Europe (1851-55), so that they might enjoy cultural and educational advantages.
The eighty-one letters written to his son Aleck and grandchildren while he lived in Paris
with Mary are in the Philadelphia Museum of Art; they provide one of the best records of
her life and career during this period (1878-91).

2. The thirteenth exhibition of the Massachusetts Charitable Mechanic Association,
Fine Art Department, in Boston. Cassatt showed *After the Bull-Fight*, *The Music Lesson*,
and *At the Français, a Sketch*.

3. Williams & Everett, 508 Washington Street, Boston, advertised "Fine Foreign and
American Paintings."

4. Little is known about Cassatt's art dealer in Philadelphia, H. Teubner. He lent several
of her paintings to exhibitions at the Pennsylvania Academy of the Fine Arts in 1878 and
sold at least one, *Young Lady Reading*, for $100.

5. Lydia Cassatt had Bright's Disease, a fatal disease of the kidneys.

6. The Exposition Universelle of 1878 could not rival the spectacle of 1867, but it
demonstrated the economic recovery of France after the fall of the Empire and the Franco-
Prussian War.

7. Aleck's four children were Edward Buchanan Cassatt (1869-1922), Katharine Kelso
Johnston Cassatt (1871-1905), Robert Kelso Cassatt (1873-1944), and Elizabeth (Elsie)
Foster Cassatt (1875-1949).

13, avenue Trudaine
Friday, November 22 [1878]

My dear Aleck,

Your father wrote to Gard on Monday a long letter about Teübner &
May's [Mary's] pictures which no doubt will bother him dreadfully &
bore him as well as he hates trouble—he was to show you the letter
& ask your advice as to how he should proceed— From Mrs. Mitchells
postal card it is plain that she thinks he is not honest although it is she
who recommended him—but she wrote the most mixed up letter I ever
read and she may be mistaken—There is one thing however which I don't
like—he never answers letters— May has written to him over & over
again & he has never troubled himself to reply but once & then it was
months after she had written— This is why I am obliged to trouble you
& Gard— I think that Teübner has an idea that it is of no consequence
to May whether she sells or not & so holds on for high prices in spite
of all she says to him— Mrs. Mitchell says he wants to keep the "Musical
Party" himself & pay for it out of commissions from the sale of the rest of
the pictures— Now I cant bear to trouble you but we want to be done
with this thing once for all— May wants all her smaller pictures sold at
auction either in New York or Phil[a] two or three at a time at every
important sale that may take place until they are all sold—the three or
four large ones—the "Musical Party" the "Torero & girl" the "Theater"
& the "Woman with the pink veil" she says are good enough to bring
higher prices & if Teübner cant or wont sell them—she will make arrange-
ments to send them to somebody else— After they are sold she will
never send anything except to New York where there is some chance and
where she is known & acknowledged to have some talent— In Phil[a]
it is the case of a "prophet is never without honor &c"— Now dear
Aleck since Teübner wont write we are obliged to trouble you & I am as
sorry as I can be to do it knowing that you are up to your eyes in
business, but this fuss over I hope it will be the last— May has written
to Teübner for an account of expenses for frames &c & he won't reply,
whilst Mrs. Mitchell writes that he charged *her* with the transportation
of Mrs. Ward's portrait from New York to Phil $10.00— What on
earth she had to do with it I cant imagine—

I had a telegram from Annie Scott[2] from Antwerp telling me they will
be in Paris to-night & will remain two days & asking me to call to see
her at the Hotel Liverpool & I am going tomorrow morning—

I hope you are all well & safely in town for the winter— Give lots of
love & kisses to the children for me— I hope your business will go

on prosperously in the absence of the head and that you may not have too much worry—

<div style="text-align:center">

Your affectionate
Mother—

</div>

1. Katherine Kelso Johnston Cassatt (1816-1895) came from a distinguished western Pennsylvania family. She was highly educated, especially in the French language, which she spoke fluently. She had often visited Mary in Europe during the period from 1866 to 1877. The Philadelphia Museum preserves forty-eight of her letters from 1878 to 1892, which, like her husband's, chronicle life with her daughter in those years.
2. Katherine Cassatt and Annie Riddle Scott were second cousins, both from Pittsburgh. Annie's husband, Colonel Thomas Alexander Scott, had been president of the Pennsylvania Railroad since 1874. In 1878 the Scotts came to Europe to nurse his failing health.

ROBERT CASSATT TO ALEXANDER CASSATT

13, avenue Trudaine
Friday, December 13, 1878

My dear Son,

On the 11th Dec. we sent off a box of Christmas presents. . . . It seems as if we were never to be able to get the poor *chillins* their Christmas things delivered on the magic day—and can only hope that when they do receive them they will find something to compensate them for the delay— Among the toys is a "baigneuse"—it is a mechanical doll dressed in bathing clothes—wind up with a key is then placed in a tub of water & swims about as natural as life & to the delight of all beholding young & old— It is the invention of a gentleman for the amusement of his own children, but on being exhibited created such a *furor* that a manufactory was immediately established & they have been selling hundreds of thousands of them—a shallow tub of 2 feet diameter will be about the thing to put it in & you may have it in your parlor if you please— I think the children will be sure to enjoy it— I shall be curious to know how the things get through the customs house and whether they do not make you pay more than they are worth. Also do not forget to let me know what you had to pay on the importation of your mother's portrait. I want all this information for future occasions— We have not had a letter from you for a *long time*.

I wrote you about Mames business with that fellow Teübner, whilst the Scotts were here, or immediately after they had left— Your mother has a letter from Annie dated 9th Dec at Nice— Scott was something

better, but I imagine from the tone of the letter nothing to brag of. & very impatient to be further South—the weather at Nice being rather cold. Both their children had been sick but were better, etc.

I do not know what the expectations are at home with regard to Scott's return but between ourselves I think you will hardly see him until the heats of next summer are well over—so make your calculations on that basis to be safe[1]— He was playing eucre when his wife was writing—

I did not like to trouble you about that Teübner business but did not know how *not* to do. So—I hope you found time to see & settle the fellow. He has not yet deigned to reply to Mame's letter. Mame, is working away as diligently as ever, but she has not sold anything lately & her studio expenses with models from *1* to *2* francs an hour! are heavy. Moreover I have said that the studio must at least support itself. This makes Mame, very uneasy, as she must either make sale of the pictures she has on hand or else take to painting *pot boilers* as the artists say—a thing that she never yet has done & cannot bear the idea of being obliged to do. Teübner has 15 of her pictures on hand unsold or had when last heard from— Now he is either scheming to tire her out & get the choice of them, himself, for nothing or else he is asking such high prices as drives purchasers away— Mame offered through Mrs. Mitchell to take 700$ clear for the lot, but Teübner made no reply— I do not think there is any doubt but that they would sell for that money at public sale— The scamp would not even risk the *framing* himself but managed to get you to pay for it— Gard however has orders to reimburse you for that— In short you see, we must get rid of Teübner I hope it is already done but in fear that it may not be repeat all this— I suppose you saw that the Boston people gave Mame a silver medal I believe she was the only woman among the silver medals— Her circle among artists & litterary people is constantly extending & she enjoys a reputation among them not only as an artist—but also for literary taste & knowledge & which moreover she deserves for she is uncommonly well read especially in french literature— . . .

I wish you could find time to write us more frequently & tell us not only about the children but also about yourself & how you get on in the Company— I saw that the city had put one of the *Standard* people in as a Director—& also that you had read the affidavit of Defense in the case against the RRd & Pape Lines etc— We rarely see any Americans, the Arnolds—Scotts—lately young Covoda— It is curious that even at the Exposition I did not encounter a single American acquaintance— You see we do not go to either of the chapels or in any way court the *Colony*—& from what we hear occasionally—have no doubt we escape a deal of very petty scandal—

Remember me to Lois & kiss all the children over & over again for me.

Your mother and sisters join in love to you all

Yr. affec. father
RSC

1. After a particularly bad year (1877), which included a violent strike and a showdown with John D. Rockefeller's Standard Oil Company, Alexander Cassatt began to have serious doubts about staying with the Pennsylvania Railroad under Colonel Scott. He began to talk of resigning in 1878, but Scott's illness made his plans uncertain.

ROBERT CASSATT TO ALEXANDER CASSATT

13, avenue Trudaine
Monday, May 21, 1879

My dear Son,

I have written you twice within the last six weeks, my last letter being on a very interesting subject to us all [Aleck's resignation?], an answer to which I am looking for with not a little anxiety!— We none of us have anything from you later than yours to your Mother 26th March— I expect certainly to have a letter from you by the mail which left New York 14th & which will probably be distributed here next Sunday— In addition to my letters I have also sent you a number of newspapers, art journals &c containing notices of Mame,—Her success has been more and more emphasized since I wrote and she even begins to tire of it— "The Artist" [L'Artiste] for May—edited by Arsène Houssaye—Alex Dumas etc. contains an extremely flattering notice of her[1]—and the Review des Deux Mondes has an article entitled "Les Expositions d'art" page 478 very hard on the Independant artists generally[2] —Makes an exception as to Mr Degas, & Mame, in terms that under the circumstances and the source must I think also be construed as very complimentary.[3] The Philada Library takes the Deux Mondes—& you can of course get it from them. We hear also, almost daily of notices in other French & English papers which have escaped our notice— In short everybody says now that in future it dont matter what the papers say about her— She is now known to the Art world as well as to the general public in such a way as not to be forgotten again so long as she continues to paint!! Every one of the leading daily French papers mentioned the Exposition & nearly all named Mame—most of them in terms of praise, only one of the American papers noticed it and *it* named her rather disparagingly!!! Your Mother had a letter from Scott dated friday last at Florence informing her of Mrs S's arrival home &

144

Toms improved health— He was to leave for Germany on Monday last—wrote in very good spirits about himself etc. There is a lady here now who travelled on the Nile with them who says he was very much recovered etc.—Carnegie [?], however who passed through Paris some days since, and who had seen Scott recently told Boris Holdman that he never would again be able to attend to business— How is all this going to affect you? Will you be able to carry out your plan of getting over here for six mo?— It will be a great disappointment to us all if you do not—

Gard writes in good spirits about his business, but does not tell us of anything else—except that you are in the country— We are *all* very well for the moment Your mother as well as ever she was— I hope you too are all well, we all join in love— Kiss the children for me tell Eddie I am expecting a letter from him soon

<div align="center">

Your aff Father
R.S.C.

</div>

1. F.-C. de Syène, "Salon de 1879," *L'Artiste*, May 1879, p. 292: "There isn't a painting, nor a pastel by Mlle. Mary Cassatt that is not an exquisite symphony of color. Mlle. Mary Cassatt is fond of pure colors and possesses the secret of blending them in a composition that is bold, mysterious, and fresh. The *Woman Reading*, seen in profile, is a miracle of simplicity and elegance. There is nothing more graciously honest and aristocratic than her portraits of young women, except perhaps her *Woman in a Loge*, with the mirror placed behind her reflecting her shoulders and auburn hair."

2. Although popularly known as the Impressionists, the artists themselves preferred the term "Independents," especially those artists closely associated with Degas. The wording of the catalog of the exhibition avoids both in its title: *Catalogue de la 4me Exposition de Peinture*.

3. George Lafenestre, "Les Expositions d'Art," *Revue des deux mondes*, May-June 1879, p. 481: "M. Degas and Mlle. Cassatt are perhaps the only artists who distinguish themselves in this group of 'dependent' Independents, and who give the only attractiveness and excuse to this pretentious display of rough sketches and childish daubs, in the middle of which one is almost surprised to come across their neglected works. Both have a lively sense of the fragmented lighting in Paris apartments; both find unique nuances of color to render the flesh tints of women fatigued by late nights and the rustling lightness of worldly fashions."

After the close of the Impressionist exhibition, Cassatt embarked on a summer of travel. She went first to England, and then with her father she retraced the sketching trip she had taken to the Piedmont region in 1869. She ended the summer at the resort city of Divonne-les-Bains on Lake Geneva.

13, avenue Trudaine
Monday, September 1, 1879

My dear Son,

Your letter of 18th enclosing that of Eddie to his grandmother arrived Saturday evening and was immediately dispatched to Divonne, where your mother & both your sisters still are— Last evening yours of 19th enclosing bill for 2000 fcs reached me and as it turns out just in time, for as I was returning from my walk just now I met Mr. Detaille coming out of the house[1]— He said he had been waiting an hour for me— declined to return, but is to call again tomorrow at 11 am. The ostensible object of his visit was to inquire whether or not you wished the picture framed— I could not recollect what you had said on that point & so he is to return & ascertain as I said tomorrow. On referring to your letter I see that you wish it to be framed— I think he said the picture was not quite finished—which I can readily understand, as artists always like to chose the frames for their pictures & finish them in the frame—

I was very glad to learn from your letter to your mother that you were all well & that the children are all so healthy— Also that you had had your holiday on board yacht & returned without accident. I returned from my tour friday evening last— Mame & I had a delightful trip— highly favored in weather. Went by way of Geneva—crossed Little St. Bernard in carriage being the first to cross from the French side this summer—then down the Val D'Osta [d'Aosta] to Ivrea—Novarato—to Mames paradise Varallo—and the Val Sesia. At Varallo we remained twelve days— Mame's friends there being among the principal people of the little city—capital of the canton or district— A lovely clean little town, surrounded on all sides by mountains & inhabited by a primitive people. A capital point to make excursions from— Then we returned by Lake Maggiori Milan & the Simplon to Lausanne—where your mother came to meet us—and carried Mame back with her to Devonne. At Lausanne being very much fatigued by the journey from Milan, and finding the place very agreeable & a capital & very reasonable hotel I remained a week & then home stopping over night at Dijon— The whole of this route is extremely interesting—"just lovely," as Mrs. Scott likes to say— There was but one thing to regret in it all—Mame's health did not improve— The fact is the journey to England & the subsequent one to Italy were mistakes— What she required was rest & quiet— She over worked herself last winter & the moment her Exhibition was over she ought to have gone quietly into the country somewhere near for a change of air & repose— When your mother saw how miserable she looked at Lausanne she at once decided to carry

146

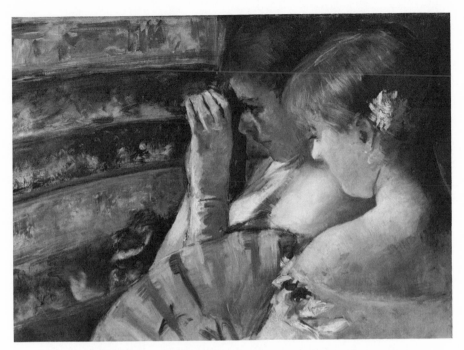

17. *In the Box*, 1879. Oil on canvas, 17 x 24 in. Mr. and Mrs. Edgar Scott.

her back with her to Devonne where she seems to be already improving—
She has been fretting over the fact that for three months she has not
been doing any *serious* work etc—and the next Annual Exposition
is already staring her in the face & it is more incumbant on her than
ever—after her last years success—to have something good to
present etc— Whilst I was at Lausanne, Lydia had one of her worst
attacks but at last accounts was as usual—

I expect your mother & Mame home by the 15 inst—Lydia will
probably remain until Oct 1st. I send you by this mail the number for
Aug 9th of the Vie Moderne containing a sketch of Mame's Lady in a
loge at the opera[2]— You will see that the front of the figure is in shadow
the light coming in from rear of box etc— The sketch does not do
justice to the picture which was original in conception & very
well executed—and was as well, the subject of a good deal of controversy
among the artists & undoubtedly made her very generally known to the
craft. The paper also contains a design by E. Detaille— If his brother
can draw horse flesh as well you will probably get the worth of your
money from him— I shall probably be able to write you on Monday

definitely about [the] picture— In the mean time I hope to receive your promised *full* one— With love to you all

<div align="center">

Yr affectionate
RSC—
</div>

Weather very clear & cool 54° at ½ hr 9 am 64° now

1. Jean Baptiste Charles Detaille was a pupil of his brother, the more famous Edouard Detaille (1848-1912); he exhibited at the Salon from 1876 to 1880. Alexander Cassatt had commissioned him to paint a portrait of his family on horseback.

2. See figure 17. A sketch of this painting accompanied an article by Armand Silvestre in *La Vie moderne*, May 1, 1879, p. 54.

EDGAR DEGAS TO COUNT LEPIC[1]

To M. Le Comte Lepic supplier of good dogs, at Berck

<div align="center">

[1879]
</div>

Dear Monsieur,

I have been twice too satisfied with your deliveries not to turn to you once again. Could you not either from your kennels and apartments, or from your friends and acquaintances, find me a small griffon, thorough-bred or not (dog or bitch), and send it to me to Paris if an opportunity arises or by carrier. As regards the price I shall not consider that further than you did. However if you should wish to draw on me for a sum exceeding 50 centimes, I should be grateful if you would warn me some months in advance as is always the custom in these parts.

Please accept, Monsieur le Comte, my sincere regards.

<div align="center">

E. DEGAS
</div>

I think it in good taste to warn you that the person who desires this dog is Mlle Cassatt, that she approached me, who am known for the quality of my dogs and for my affection for them as for my old friends etc. etc. I also think that it is useless to give you any information about the asker, whom you know for a good painter, at this moment engrossed in the study of the reflection and shadow of flesh or dresses, for which she has the greatest affection and understanding, not that she resigns herself to the use of only *green and red* for this effect which I consider the only salvation, etc. etc. etc.

This distinguished person whose friendship I honour, as you would in my place, asked me to recommend to you the youth of the subject. It is a young dog that she needs, so that he may love her.

By sending with the dog, if you do send the dog, you would give an

<div align="center">

148
</div>

appreciable pleasure to your requester, by sending with this dog some news of your health and of your noble pursuits.

Original in French.

1. This undated letter from Edgar Degas to the artist and dog breeder Ludovic-Napoléon Lepic was probably written in the fall of 1879, when Degas and Cassatt were working closely on *Le Jour et la nuit* and when Cassatt was experimenting with the effects of light and shadow in her painting. From Marcel Guerin, ed., *Degas Letters*, p. 144.

MARY CASSATT TO BERTHE MORISOT[1]

13, avenue Trudaine
Friday [Fall 1879]

Dear Madame,

Your letter found me at Divonne and I waited until my return here to respond. I think I can buy something of Monet's, I wanted to do so before I left. I say "I" but I mean my father. I gave Piette's pictures to Portier to sell[2] and my father told me that he would buy a Monet when the others were sold. I haven't been able to see Portier since my return and I am afraid that he hasn't done what he promised, I will do what I can but you know that it isn't easy to persuade the world.

I am so happy that you have done so much work, you will reclaim your place at the exposition with *éclat*,[3] I am very envious of your talent I assure you. This summer I didn't get anything done, we traveled for nearly four weeks, in Piedmont and then to Milan and returned through Switzerland by Lake Maggiore and the Simplon. I saw many things to admire, beautiful frescoes, really I don't see that the moderns have discovered anything about color. It seems to me that we haven't learned anything more about color or drawing.

I would have gone to see you before my departure but my father is never very decisive and I thought that we might return in eight hours.

Bring back many pretty things, and much health and courage, I am eager to see what you have done. The Swedish woman it seems is not happy, her Jule has disappeared, I will try to find another model.

Many kisses to Miss Julie and a thousand best wishes to her mother from their

Affectionate friend
Mary Cassatt

Original in French.

1. Berthe Morisot (1841-1895), daughter of a wealthy magistrate, had begun her career by

copying in the Louvre and studying with Corot in the 1860s. Her friends Fantin-Latour, Bracquemond, Pissarro, and Manet brought her into the avant-garde circles in Paris; and in 1874, when the first Impressionist exhibition was held, she was one of the participants. In 1878 she was considered one of the five leading members of the group by Théodore Duret in *Les Peintres impressionnistes*. Mary Cassatt bought one of her paintings that year, holding her in high regard as an artist. There are five letters from Cassatt to Morisot in the Collection Denis Rouart.

2. Ludovic Piette, a wealthy friend of Pissarro, was a painter and patron of the Impressionists. Little is known about Portier, an independent art shipper, dealer, and agent who occasionally worked closely with Durand-Ruel.

3. Morisot, awaiting the birth of her daughter, Julie, had not participated in the Impressionist exhibition of 1879.

MARY CASSATT TO BERTHE MORISOT

[13, avenue Trudaine]
[Spring 1880]

My dear Friend,

Unhappily we don't have our same place again, our landlord having changed his mind.[1] We are now looking for something else. I am very happy about your return, and I hope that everything will be arranged, because the exhibition promises to be good; with you returning; and among the new ones, Monsieur Raffaelli;[2] and several others whose names I don't recall right now. All the exhibitors from last year except M. Cals who I hear is very ill.[3]

My best to you.
Mary Cassatt

Original in French.

1. Instead of holding the exhibition at 28, avenue de l'Opera, which they had done in 1879, the group opened at 10, rue des Pyramides on April 1, 1880.

2. Jean François Raffaëlli (1850-1924) studied with Gérôme and debuted at the Salon in 1870. He was a genre painter who, under the influence of Degas, turned to scenes of Parisian life. Although he exhibited with the Impressionists in 1880 and 1881, his greatest success came at the Salon after 1884.

3. Adolphe Felix Cals (1810-1880) was known for his seascapes and views of peasant life in Honfleur. He exhibited with the Impressionists in 1874, 1876, 1877, and 1879; his illness prevented him from participating in 1880 and he died on October 3 of that year.

KATHERINE CASSATT TO ALEXANDER CASSATT

13, avenue Trudaine
April 9 [1880]

My dear Aleck,

I suppose of course your father has written to you since the receipt of

your last letter—since then we have several from the children which have all been answered. . . . They don't say anything more about coming over here and as Gard doesnt mention it either I am afraid you have abandoned the idea— I hope not, for I have been looking forward to the delight of seeing you all so long that it will be a severe disappointment if you don't come— . . .

I suppose your father has written or Gard has told you how ill Lydia has been—she doesn't often get alarmed about herself but this time she says she thought it was going to be the last—neuralgia to the stomach is far worse than to the head and lasts much longer—it is now a month since she was attacked, and although she is able to go out & is getting some appetite she still has some uneasiness which doesn't however amount to pain— She is now taking Spa water & if it agrees with her it is likely we will go there this summer—that is she & I will go for your father will not consent to go where there [are] many people—in fact will not tie himself to any one place and Mary must stay with him—

The exhibition of the "Independants" is now open [1]—it is not such a success financially as it was last year, but as the "Figaro" has opened on them this morning, it may do them good in that way[2]— Mary had the success last year, but this one she has very few pictures, and is in the background[3]— Degas who is the leader undertook to get up a journal of etchings and got them all to work for it so that Mary had no time for painting and as usual with Degas when the time arrived to appear, he wasn't ready—so that "Le jour et la nuit" (the name of the publication) which might have been a great success has not yet appeared[4]— Degas never is ready for anything— This time he has thrown away an excellent chance for all of them— As I said they have not had such a success financially but nearly all of the exhibitors have sold, which shows that the school is beginning to succeed even with the public—

I suppose you don't see much of Gard. . . . Write to us soon dear Aleck and tell us if we may hope to see you soon—

With best love to all I am your affectionate

Mother—

1. The catalog announced La 5ᵉ exposition de peinture par Mme. Bracquemond—M. Bracquemond—M. Caillebotte—Mlle Cassatt—M. Degas—MM Forain—Gauguin—Guillaumin—Lebourg—Levert—Mme Berthe Morisot—MM Pissarro—Raffaëlli—Rouart—Tillot—Eug. Vidal—Vignon—Zandomeneghi, to be held April 1-30, 1880.

2. Albert Wolff, "Beaux Arts," Le Figaro, April 9, 1880. The review praises Degas, Morisot, and Raffaëlli, although in general it is negative. It makes no mention of Cassatt.

3. Cassatt showed eight paintings and eight etchings.

4. Talk of publishing a journal of fine-art prints began among Degas, Bracquemond, and

Caillebotte as early as May 13, 1879, when the Impressionist exhibition was still open. In the fall of that year, after her trip to Switzerland, Cassatt joined the project. She was certainly familiar with print-making processes, especially engraving as it was practiced by Emily Sartain and Carlo Raimondi. But this may have been her first attempt to work in a graphic medium. For this project, Degas used Mary and Lydia Cassatt as models (see figure 18).

Aleck brought his family to Europe in the summer of 1880. While he and Lois visited Paris, London, southern France, and Switzerland, the four children stayed with their grandparents and two aunts at their summer house in Marly-le-Roi. The family returned to the United States in September, taking up residence in their new home, "Cheswold," in Haverford, Pennsylvania.

MARY CASSATT TO ALEXANDER CASSATT

<div align="right">

13, avenue Trudaine
November 18 [1880][1]

</div>

Dear Aleck,

Rob's letter to his Grandma gave us all a scare, but we have seen since that the fire only damaged you to the extent of a thousand dollars. I suppose it has put you to great inconvenience, as the papers said the kitchen was burnt. Little Rob used to pray every night at Marly that "the house mighn't burn down, or Robbers break in," it was well it didnt happen when you were away or Rob would lose all confidence in the "efficacy of prayer" as the religious people say.

Did you get the photographs I sent you? I only sent them to give you an idea of Degas style, I dont like to buy anything for you, without your having some idea of what it would be like. The pictures from which the photographs were taken have all been sold, & Degas has but one racing picture finished & that is the large one; I was just thinking of buying you a smaller picture of ladies and children on horseback when a dealer picked it up & I dont see anything else in horse subjects that I can get for you just at present. I feel it almost too much of a responsibility, am afraid you won't like my selection; & Mother does not give me much encouragement as "au fond" I think she believes picture buying to be great extravagence.

I sent home a Diaz to the Elders, for Mr. Havemeyer,[2] they are polite enough to say they were pleased, I hope they were; *do* call on them, I am sure you will like them.

I dont know if you have yet seen Mrs Mitchell, she wrote that she intended going to see you to ask you to give her youngest son a situation

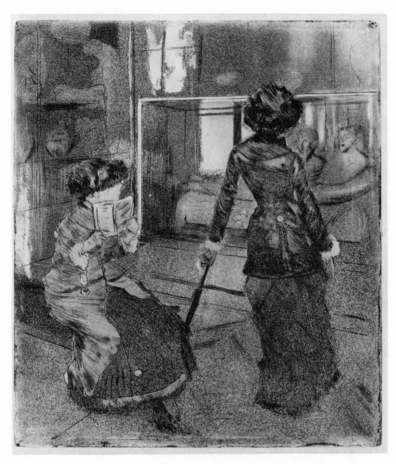

18. Edgar Degas. *Mary Cassatt in the Louvre: Museum of Antiquities*, 1879-80. Etching, aquatint, and electric crayon, third state, 10½ x 9⅛ in. The Metropolitan Museum of Art, Rogers Fund, 1919.

of some kind; I think it best to let you know that he is not much of a fellow, *very* idle & doless [?]. I feel sorry for the poor woman, but unless you can give him something to do wher he will have to *work hard* & where there would be *no* responsibility; dont do it.

We get meager letters from Gard, & I intend writing to ask him to write a letter more fully, as Mother would be so pleased if he would say a little more about himself. Mother is well as yet she talks of going south but I dont know if she will get off or not. The doctor dont wish her to go to Nice or anywhere on the seashore on account of her heart. You know she has heart disease & it is dangerous for her to catch cold.

Father talks of a trip to Rome, but as usual it will end in talk.

I intended writing to Eddie, this evening but I will have to put it off now until next week; I am afraid he will be disappointed that no picture has been bought yet, as he was very eager about it. When you write tell me what you thought of the photographs & if they gave you any idea of whether you would like the pictures or not.

I have a Swedish model, whose family are in America, & who is going over soon; when she goes I will give her your address, tell Lois I think she will find her an excellent sewing girl, she was at Worths for some time, & makes dresses very well, Lois might find her useful.

With much love from all to you all

> Your affectionate Sister
> Mary Cassatt

I have Robs drawings & his little picture hung up in the studio, dont tell him, but they are very much admired.

1. This letter was dated 1883 by Frederick Sweet in *Miss Mary Cassatt, Impressionist from Pennsylvania* because of the supposed reference to Mrs. Havemeyer (Louisine Elder married Henry O. Havemeyer on August 22, 1883). But the reference is actually to Mr. Havemeyer, who, before his marriage to Louisine Elder, had already started a collection of modern American and French paintings; he bought two paintings by Narcisse Virgile Diaz de La Peña (1807?-1876) from the New York dealer Knoedler in 1881. Mary Cassatt's mention of the fire at the Alexander Cassatt home dates the letter firmly in 1880.

2. Henry O. Havemeyer lived with his relatives, the Elders, in New York.

KATHERINE CASSATT TO ALEXANDER CASSATT

> [13, avenue Trudaine]
> Friday, December 10 [1880]

My dear Aleck,

Your father received your letter of the 19th, but I dare say has acknowledged it himself as he is constantly writing— I was glad to hear that you were all so well & so pleased with the country. . . .

I don't know whether Mary has written to you or not on the subject of pictures. I didn't encourage her much as to buying the large one being afraid that it would be too big for anything but a gallery or a room with a great many pictures in it—but as it is unfinished or rather as a part of it has been washed out & Degas imagines he cannot retouch it without painting the whole over again & he can't make up his mind to do that I doubt if he ever sells it—he says it is one of those works which are sold after a man's death & artists buy them not caring whether

they are finished or not—it is the same with a picture of danseuses which May would like to buy for you—he says he must repaint it all merely because a very small portion has been washed out— You know he is famous for his danseuses—he has painted them in any imaginable way— Mary is keeping a look out & whenever she sees anything of his or anyone else's which she thinks you would like at what she thinks reasonable prices she will buy them— She says she is afraid to order anything from Degas as he might make something so excentric you might not like it.

You don't say a word of the fire you had at your house—little Rob is the only one who has mentioned it— I suppose it was not very serious . . .

We are still thinking of going to Marly next summer— Gard agrees with you in thinking it unsafe to buy so that it is not likely we will do so—the trouble is we can not rent the place we want because it is furnished & the landlady is such a screw that I would be afraid to have anything to do with her furniture— Although not so large a place as the "Coeur Volant" which it joins it is more cheerful & much better furnished & she asks as much for it in *rent* as Rimmil does for his "Coeur Volant." Rimmil is an Englishman who has made a large fortune as a "parfumeur" in France and has lived so long here that he is almost a frenchman— I wouldn't mind at all renting his place although it is furnished as he is by no means a screw "tout parfumeur qu'il est" ["perfumer that he is"] as Degas says—the garden has all the appearance of being laid out by Le Nôtre & is just as it was in the time of Louis quatorze—that is the place we wanted last year—it would have been charming for the children—

I see you are going to have the famous "Sarah"[1]—as I suppose of course you will see her let me know what you think of her— I never saw her but once & didn't like her at all; but then it was one of Octave Feuillet's worst pieces "the Spring" & they said she didn't care how she played it as Croizette had the best rôle— I like to be amused & consequently don't like french tragedy so I never was tempted to go to see Sarah a second time—

We have abandoned the idea of moving for the present—we were tempted by the modern improvements in some new houses in the neighborhood of the Parc de Monceau[2] but the doctor & everyone we spoke to of our intention held up their hands in horror at the idea of our becoming "essuyeuses de plâtre" ["plaster-testers"] as they call the first lodgers in new houses— I thought it was only a french prejudice but the doctor explained that the plaster used here is not at all the same as ours & is so long in drying that people able to pay rent never go into new appartments—our rent here is very reasonable & as we want to spend six or seven months of the year in the country we have renewed

our lease for three years with the privilege of subletting if we please—

Your father complains of dyspepsia & Lydia is about as usual in the winter—that is we cannot count on her for more than a few days at a time— May & I are tolerably well but not much to boast of so you see we are not a robust family— We have been trying to persuade your father to go to Italy, but he is afraid to leave home when there is anything the matter with him— Lydia never having been to Italy would be the one to go with him but your father is afraid she might fall ill on his hands—he *talks* of going but will take it out in talk I think—it is a pity for change of air & diet would cure him I'm sure—

Give my love to Lois & the children. . . .

<div align="right">

Your affectionate
Mother

</div>

1. Sarah Bernhardt (1844-1923) began her career at age eighteen in 1862; by 1880 she was the most famous actress of her day, occasionally challenged by younger actresses like Sophie Croizette. On October 27, 1880, she arrived in New York for a tour of the United States that included 157 performances in 51 cities. She performed in Philadelphia early in 1881.

2. The elegant eighteenth-century Parc Monceau was gradually impinged upon by successive waves of residential construction. In 1880 new sections of townhouses were being built to the southwest of the park.

MARY CASSATT TO EDWARD CASSATT

<div align="right">

13, avenue Trudaine
January 1881

</div>

My Dear Eddie,

I have been intending to write to you for a long time, but I am afraid that a couple of quiet old Aunts & a grandmother & grandfather don't hear of much that would be likely to interest a little boy or even a big boy such as you are getting to be. While the Christmas box was being filled we were constantly talking about you all, & trying to think of what you would all like best; I suppose you will have recieved the box before you get this & know if we guessed right. We were all so much pleased with the apples & sweet potatoes, Your Aunt Liddy said she knew that *you* would keep your Papa in mind that we wanted some American apples.

I want you to tell Rob from me that when he gets his paint box he must promise to draw very carefully a portrait of one of you, beginning with the eyes (remember) & send it to Grandmother, that would please her more than any other Christmas present she could get.

Grandfather has been sending you some books, he hopes you will read them with care; when you write you can tell him if you have done so. I wish we were all looking forward to seeing you again next summer but I suppose that is not likely. Perhaps we shall have a visit from Uncle Gard, have you heard him talk about coming over?

Tell Katharine that her friend Bessie Eaton is back again at Nice they did not stay long at home, not long enough for Freddie to learn to talk English, I think Bessie will have to give up calling herself an American girl.

We all send lots of love and kisses to you all, & we want you to write sometimes, & not to forget your relations over here, for they think of you constantly.

<div align="center">
Your affectionate

Aunt Mary
</div>

"Batiste" [their horse] sends his loving respects he has broken both his balls[?]

MARY CASSATT TO CAMILLE PISSARRO[1]

<div align="center">
13, avenue Trudaine

Thursday [1881]
</div>

My Dear Mr. Pissarro,

We took the liberty of telegraphing to you today about that country house at Auvers, but as we had not your address we directed "Pontoise" I am afraid you did not receive it. We are in a peck of troubles, that dreadful woman at Marly has behaved so outrageously that we have to give up her house & now we are without anything. We wanted to know if the house at Auvers is still free and *if it is furnished.* I am so sorry to trouble you but I am at my wits end with my Mother not well & my sister incapable of helping anyone.

I went to Durand Ruel's for your address.[2]

Nothing new in the art world.

With many excuses & kind regards

<div align="center">
Mary Cassatt
</div>

1. Cassatt became friendly with Camille Pissarro (1830-1903) when they worked together on the proposed print journal *Le Jour et la nuit* in 1879. Since Pissarro was a native of the Danish island of Saint Thomas, Cassatt shared with him the status of expatriate in French artistic

<div align="center">
157
</div>

circles, and seems to have spoken and written to him in English. In 1891, when they found themselves excluded from exhibitions of the Société des Peintres-Graveurs Français because of their non-French citizenship, they banded together for an exhibition of their own. There are eight letters from Cassatt to Pissarro in the archives of the Galerie Schmit, Paris.

2. Paul Durand-Ruel (1831-1922), son of an art dealer in Paris, continued the family business and in the 1860s began to specialize in paintings of the Barbizon school. He made a special effort to cultivate American collectors in Paris by advertising in American newspapers and offering lectures on art. After he met Monet and Pissarro in London during the Franco-Prussian War (1870-71), he began to represent the artists of the new Impressionist style. He hosted the Impressionist exhibitions of 1875, 1876, and 1882 in his own gallery. He began handling Cassatt's work in 1881.

MARY CASSATT TO CAMILLE PISSARRO

[13, avenue Trudaine]
[1881]

My Dear Mr. Pissarro,

A thousand thanks for the trouble you have taken, we were so afraid of not finding anything that we finally made up our minds to take the house next to the "Coeur Volant" notwithstanding its many inconveniences. So unhappily we cannot be neighbours this summer.

I hope to see you in Paris before we leave, at any rate at Marly this summer. We all met at the ouverture of the "Peintres Européeains" [?] last night & Durand se promenait en rayonnant" ["strolled around beaming"] in the midst of those honors. Millais has one of aweful picture & two tolerable portraits.[1] Baudry is the best.[2]

With many thanks for your trouble & kind regards from all the family & compliments to Mme. Pissarro & the children.

Ever yours sincerely
Mary Cassatt

1. John Everett Millais (1829-1896) was a prominent English portraitist and painter of Romantic subjects, who had been a member of the Pre-Raphaelite Brotherhood from 1849 to 1853. He painted portraits of several Americans, including the daughter of the Cassatts' friend, Annie Scott.

2. Paul Jacques Aimé Baudry (1828-1886) was a prominent decorative painter and portraitist who based his style on masters of the High Renaissance and the Venetian school. Cassatt received a lasting impression of his decoration for the Grand Foyer of the Paris Opéra (1865-74) when it was exhibited at the Ecole des Beaux-Arts (before being installed in the Opéra) in 1874. She referred to it when she worked on her own decoration, Modern Woman, for the Chicago World's Columbian Exposition of 1893.

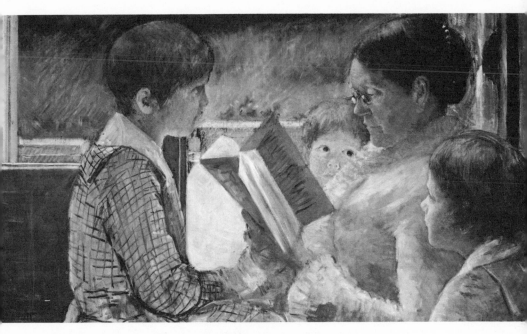

19. *Mrs. Cassatt Reading to Her Grandchildren*, 1880. Oil on canvas, 22 x 39½ in.
Private collection.

KATHERINE CASSATT TO KATHARINE CASSATT

13, avenue Trudaine
April 15 [1881]

My dear Katharine,

Your & Robbie's very nice letters which gave us all a great deal of
pleasure were received some time ago . . . I hope you are all quite well
& happy enjoying the mild spring weather which I hear you are having—
I dare say you are galloping on your ponies all over the country. . . .

We are going out to Marly again on the 1st of May to that pretty old
place that we missed getting last year—you would all have enjoyed
the garden so much—there are so many places to play hide & seek in
that we shall long to have you all with us & your Aunt Mary counts
on painting out of doors & wishes she had you all there to put in her
pictures— Do you remember the one she painted of you & Rob & Elsie
listening to me reading fairy tales [figure 19]? She finished it after you left
& it is now at the exhibition[1]— A gentleman wants to buy it but I don't
think your Aunt Mary will sell it—she could hardly sell her mother &
nieces & nephew I think[2]—

159

. . . When you write tell me how the music comes on. . . . Did Eddy get his postage stamps and were they of any value? . . .

All join in love to Mama & Papa & all the children— With best love & kisses all round I am your affectionate

Grandmother Cassatt

1. *La 6ᵉ exposition de peinture par Mlle Mary Cassatt—MM. Degas—Forain—Gauguin—Guillaumin—Mme. Berthe Morisot—MM. Pissarro—Raffaëlli—Rouart—Tillot—Eug. Vidal—Vignon—Zandomeneghi* was held April 2-May 1, 1881, at 35, boulevard des Capucines.
2. Mary Cassatt did sell the painting to the collector Moyse Dreyfus in 1881. This so upset the family that she was later forced to ask for it back to give to her brother. See Mary Cassatt to Alexander Cassatt, June 22 [1883].

ROBERT CASSATT TO ALEXANDER CASSATT

13, avenue Trudaine
April 18, 1881

My dear Son,

I have your two letters of 29th March & 4th inst. . . . I suppose you know by this time that we have taken the "Coeur Volant" for 6 mo. from 1st May—Mame took you to see it I think? It is quite near our last years place but does not belong to Marly le Roi, but to Louveciennes, & to that place our letters must be directed— We expect to move out the first week in May & your next letters after you receive this ought to be directed there to save time, & the risk of miscarriage if directed to Paris & forwarded thence—

We shall all be very much pleased to get out as the weather is pleasant & such as to invite one to the country— A good many people who have country houses are already going out— There is a very great deal of work going on in Paris now—new houses going up, old ones being washed & repaired—sewers being laid down, paving etc. etc. So that it is not very pleasant in town now & promises to be less so as the Season advances— So far our Spring has been very fine & just the opposite of what we read of yours— . . .

I sent you sometime ago a number of newspaper notices of Mame's exposition and promised to send more— I have a lot of others but there has been so much of it that we all cry "too much pudding;" So I spare you any further infliction, except the article from the Figaro¹—a paper that has always been bitterly hostile to the Independants, & never before deigned to take any notice of Mame— Mame's success is certainly more marked this year than at any time previous. It is noticable

that of the three American papers published in Paris the "Parisian" is the only one that notices the Exposition— Mame keeps the *colony* at such a distance that she cannot expect any support from them— The thing that pleases her most in this success is not the newspaper publicity, for that she dispises as a rule—but the fact that artists of talent & reputation & other persons prominent in art matters ask to be introduced to her & compliment her on her work &&& She has sold all her pictures or can sell them if she chooses— The things she painted last summer in the open air are those that have been most praised—

Tell Robbie, his Aquaduct is all right yet & that we are going to live this summer nearer to it than we did last summer & that we shall never look at it without thinking of him & how much he admired it— Many & many a time during the summer we shall talk not only of him but all the dear little ones & recal with pleasure there sayings & doings— Would to Heaven that they could run in on us every morning! . . .

With best of love to yourself Lois & the dear children I remain

<div align="center">

yr affectionate father
RSC
</div>

P.S. I have given you more on the other sheet than you most likely will have patience to read, & yet have omitted to say a word about your pictures— Mame, has been proposing to write you on the subject—but she never writes when she can help it, & you will not probably hear from her until she can tell you that she has the Degas in hand— Well you must know that in addition to the Pissaro, of which she wrote you she has bought for you a Marine by Monet for 800 fcs— It is a beauty, and you will see the day when you will have an offer of 8000 for it. Degas still keeps promising to finish the picture you are to have & although it does not require more than two hours work it is still postponed— However he said to day that want of money would compel him to finish it at once— You know he would not sell it to Mame, & she buys it from the dealer—who lets her have it as a favor and at a less price than he would let it go for to anyone but an artist— When you get these pictures you will probably be the only person in Philad[a] who owns specimens of either of the masters— Mames friends the Elders [in New York], have a Degas & a Pissarro[2] & Mame thinks that there are no others in America— If exhibited at any of your Fine Art Shows they will be sure to attract attention—

1. Albert Wolff, "Courriers de Paris," *Le Figaro*, April 10, 1881, p. 1: ". . . Mlle. Cassatt is a veritable phenomenon; in more than one of her works she is on the point of becoming a considerable artist, with an extraordinary feeling for nature, penetrating powers of observation, and an ability to subordinate herself to the model which is characteristic of the

greatest artists; then, after this marvellous intelligence has completed its work and, while it rests, a little spider takes the palette and brushes and leaves its mark on the canvas either in the inferior drawing of hands, or in touches of color which seem out of place, or even in a corner of the painting which is misshapen and monstrous which makes the viewer shudder and say, 'What a shame!' "

2. Louisine Elder had bought these paintings on Cassatt's recommendation within a few years after they met in the summer of 1874.

KATHERINE CASSATT TO ALEXANDER CASSATT

Coeur Volant, Louveciennes
(Seine-et-Oise)
September 19 [1881]

My dear Aleck,

I am almost afraid to say that I hope by this time you have received your pictures from the Custom House for it was such a mismanaged piece of business that I am dreadfully afraid you will have trouble. I suppose you have heard the whole story from your father & Mary so I needn't repeat it— Durand Ruel is so used to "ways that are dark" as to bills of lading & certificates that he seemed to think any fuss about the matter was absurd but at the same time very tenacious of his standing with the American Consul here— One of the tricks I never heard of before is to make out the bill for pictures at double what they cost so that the dealer may show them to buyers who never suspects that he (the dealer) is willing to pay the extra duty in order to double his profits— Mary was unfortunately under the impression that the duty was 30 instead of 10 per cent and as she had to pay for Degas' picture a thousand francs more than she expected to pay she was disposed to save all she could— She was furious at Degas and not a little provoked at Durand Ruel—at Degas because he knew perfectly well that the picture was for her & might just as well have sold it to her as not, and at Durand because he took so large a commission she being an artist & having just sold him a picture which he himself said in my presence was "not a price for a picture of that size," but which she refused to ask more for— She was very wrong however to consent to the arrangement which gives you so much trouble & I hope it will be a lesson to her. I couldn't sleep the night we got your letter and even now I am mortified at the trouble we gave you—

I suppose Gard has told you all the news about his trip— We thought him much improved in health— I ought perhaps to say in spirits for at first we found him very much depressed but he soon picked up & seemed entirely changed before he left— The fact is he lives

162

too much to himself—no man can stand living as he does so much alone—nor woman either for that matter— . . .

Do you think we may hope to see you next summer? If I thought so the winter would be less dreary—but I am afraid to urge it not knowing if it would not be too great a sacrifice to ask— Give best love to Lois and all the children from all of us—

Your affectionate
Mother

ROBERT CASSATT TO ALEXANDER CASSATT

Louveciennes
July 3, 1882

My dear Son,

Since having answered your letter of May 22 which I did immediately on its receipt, and which is the last we have had from any of you, we have the newspapers you sent, containing the public announcement of your intended resignation,[1] so that we now consider the matter irrevocably fixed and venture to look forward with something like certainty to the pleasure of seeing you once more in November— May God, in his kind providence grant us a happy & safe meeting! If we live to meet, you will find your mother and I both looking a great deal older than when you saw us last. At our respective ages that is a matter of course however— I fear also that you will notice a great change for the worse in Lydia's appearance.[2]— But that is not so certain, for her case is so peculiar that in spite of her ailments she sometimes looks surprisingly well for short periods— She has now had a long interval from severe suffering—only one of her bad headache attacks since last week in May & that *one* did not last as long as usual— But then the other symptoms which alarmed us so in the winter & early spring have reappeared in a modified degree.— She is in very good spirits just now & even talks of going to Divonne for a few weeks— But that is a risk I will never permit her to run— I am sorry to say too that your mother has had a return of those ugly symptoms about the heart attended with that little hacking cough which the Doctor dreads so much—owing as we all (including the Doctor) think in a great measure to her want of care of herself & improvidence, & perhaps also in some degree to the unfavorable weather since we have been in the country. . . . We find ourselves very well placed & comfortable in the house, more so than we were last year in the "proprieté de Cour Volant" though that house was larger it is not so conveniently arranged nor nearly so nicely furnished

nor so cheerful— This place has a little terrasse overlooking the park, village and grande route—which your mother "just delights in"!— We have the pony & cart in use & Mame, who has been saving up money for the purpose, is negotiating for the purchase of a riding horse—& carried me over to St. Germain yesterday to look at a thoroughbred 12 years old, which the *Vet* has found for her at 800 fcs.— He is an old *trooper* belonging to an officer, who will not part with him until after the military manoeuvers are over, which will not be for ten days yet— I was quite surprised to see so fine a looking animal (of even 12 years) offered for so small a price— We laugh a good deal at Mame who gets everything else ready before she finds the horse—

We are now very full of your coming & talk of it a great deal[3]— We shall not however take any active steps toward preparing for your arrival before the 15th September or 1st October— In the meantime you must keep us well posted as to your wishes—

Gard's a good-for-nothing scamp— I have been writing & writing him *positive* orders about money matters && He answers my letters and never even alludes to their contents nor obeys the orders— If he treats his customers generally in this way he will never become the founder of a great banking house, thats certain—

As we never see any American papers except Philad[a] Weekly Times, have never seen any notice of Mr. Kelso's horses[4]—

When there is anything of that kind in them you might send us the papers—

I dare say you will find this letter rambling & incoherent— Cant help it— I find more & more difficulty in writing as I grow older— Mame and I keep very well I do not notice any change in myself lately except as to sight—which is undergoing another, perhaps a last, change just now— Yesterday Mame & I returning from St. Germain came by Bas Prunay, one of the longest & steepest hills in this neighbourhood & walked up it under a burning sun— I did it with more ease to myself than Mame did to herself— Fact is I was astonished at my own strength & Mame was too—

I hope this will find you all well— Kiss the dear children for me remember me kindly to Lois & believe me as ever your affectionate father

RSC

Your mother & sisters also send love to you all— RSC

Mame has been working away out here but has not yet produced any-thing of consiquence— She has just now received a spur however in the announcement that *they* are to have a *winter* exhibition this year[5]— By *they* I mean the *impressionists*— Durand, the dealer, has an exhibition of

164

impressionist pictures in London just now & among others two of
Mames—

1. Alexander Cassatt resigned his position as first vice-president of the Pennsylvania Railroad on September 22, 1882.
2. Lydia Cassatt died after the family returned to Paris, on November 7, 1882.
3. The Alexander Cassatts left Philadelphia for Paris on November 8, 1882.
4. Alexander Cassatt was a thoroughbred-horse-racing enthusiast; while still prominent in the Pennsylvania Railroad, he preferred to race his horses under the name of "Mr. Kelso."
5. Mary Cassatt had withdrawn from the Impressionist exhibition that spring (1882) because of a squabble over the inclusion of Raffaëlli, a good friend of hers and Degas's. The proposed winter exhibition was not held, and there was not another Impressionist exhibition in Paris until 1886.

Aleck, Lois, and the children arrived in Paris at the end of November 1882. The following April, Aleck and Lois went to London to have Whistler paint Lois's portrait; the children stayed with their grandparents and Mary. At the end of the month, the family was reunited and sailed for home, leaving Eddie (age fourteen) in Paris to finish the school year at the Ecole Monge. Robert Cassatt accompanied Aleck and his family to Liverpool, and after the family sailed (cabling their departure to those left in Paris), he spent a few days visiting sites in England.

MARY CASSATT TO ALEXANDER CASSATT

<div align="right">

[black border]¹
13, avenue Trudaine
[May 1883]

</div>

Dear Aleck,

We received the telegram an hour ago, it arrived last night but so late that the concierge kept it until this morning. Father I suppose is at Dover, he said if Canterbury was not too far he would go over there today to see the Cathedral. It would never have done for me to go with the children though I was very much disappointed at not being able to do so, it would not have done to leave Eddie & Mother. I suppose the children have told you how badly poor Eddie felt; he is behaving very well and keeps up bravely, much more bravely than his poor Grandmother who has completely broken down several times. Poor Eddie reproaches himself with not having begged to have one of the children left with him he thinks if he had only begged hard enough Sister [Katharine] would have stayed with him.

He is 6th in his class; in version latine [Latin translation] *11*th out of

25, classement general in version latine 32nd out of 66—he had 19 for french recitation yesterday. I hope he won't feel too lonely. I wonder if Lois won't reconsider her orders not to let him play cricket on Sunday afternoon, tell her I am afraid he will be very dull with only us to talk to, I am going to church with him this morning so that he may not feel too wretched

Poor little Marthe is in despair; Eddie was in there last night to get something & says her little face looked as if she had been crying for a week. Unfortunately it was a very one sided affection I dont think Elsie returned it at all, but all the same tell her to write her a little letter before she sails it will console the child. Tell Katharine I thought of her toes yesterday & mailed her some plaster—if she cannot get any in London I will send her a box.

Mother sends much love to you all & with a great deal from Eddie

<div style="text-align:right">

Your affectionate sister
Mary S. Cassatt

</div>

1. It was the custom to use black-bordered stationery during the period of mourning following the death of a family member. The Cassatts used this stationery for two years after Lydia's death.

ROBERT CASSATT TO ALEXANDER CASSATT

<div style="text-align:right">

[black border]
13, avenue Trudaine
Friday, May 25 [1883]

</div>

My dear Son,

. . . You give me a very pleasant picture of the family— I see you all happy and rejoicing in the enjoyments of home and I heartily sympathize with you— You have much to be grateful for to the Giver of All Good, my dear Son and I hope you feel duly grateful for all his favors— Since my last we have been all pretty well I would say *very* well if your mother would let me—but she wont! . . . Whilst the Doctor found her ill she believed in him now that he finds her well or nearly so she calls him an ignoramus!!! Now not a hint of this from either you or Lois if you do not wish to have me *catch it*— Mame, has got to work again in her studio, but is not in good spirits at all— One of her gloomy spells—all artists I believe are subject to them— Hasn't put the finishing touches to your portrait yet[1]— Elsie's still in London[2]— Will send them as soon as possible— By some stroke of Durand Ruels financial policy Mame's pictures (3) were all entered on the catalogue as *not* for sale— The fact being that Elsie's was the only one that ought

166

to have been so marked— Any little contretemps of this kind
upsets Mame, & makes her think any thing but favorably of human
nature generally— I paid Potier [Portier] for packing pictures 46⁵⁰ fcs— I
would like to know if any "charges" followed those pictures to
Liverpool? That is any except freight. When you write let me know—

Eddie in his letter of last evening I suppose will have told you all about
himself. . . . We have been having most delightful weather—a little
warm at times but generally delicious—a little rain now would be
welcome.

With best of love from all to all

<div align="center">Yr aff father
RSC</div>

Dont in your letters refer to what I have said about Mame.

1. Mary Cassatt started a portrait of Aleck during his stay in Paris, but had a difficult time
with it. When they first arrived, Lois had written to her mother, ". . . She has not had the heart
to touch her painting for six months and she will scarcely now be persuaded to begin. . . ."
Patricia T. Davis, *End of the Line, Alexander J. Cassatt and the Pennsylvania Railroad*, p. 96.

2. Elsie's portrait was shown in the exhibition *Paintings, Drawings, and Pastels by Members of
"La Société des Impressionistes"* held at Dowdeswell and Dowdeswells', 133 New Bond Street,
London.

MARY CASSATT TO LOIS CASSATT

<div align="right">[black border]
[13, avenue Trudaine]
Friday, June 15 [1883]</div>

Dear Lois,

Eddie left for school this morning in a great hurry & evidently
thinking his letter insufficient he requested one of us to write a few
lines— Father is in England but I suppose will not stay long; he expects
to be in London today, was at Ryde (Isle of Wight) when he last wrote. I
am very much disappointed not to have been able to get to London this
spring, if we go in August all the exhibitions will be closed & it will be
as dull as ditch water. Mrs. Scott seems much pleased with Millais
portrait of Mollie, she also seems much disgusted with us for constantly
writing that we would be in London & not going; she had written to ask
us to stay at their hotel but the letter miscarried. Tell Aleck I will send
the portraits as soon as I get back Elsie's, & I have not the least idea
when that will be, the man who has the exhibition is making money and
won't close as long as the public are willing to go. Durand Ruel dont
trouble his head any more about it. Whistler has been awarded a third

20. James McNeill Whistler, *Arrangement in Black, No. 8: Portrait of Mrs. Cassatt*, 1883-86. Oil on canvas, 75¼ x 35¾ in. Private collection.

class medal at the Salon, he asked for one & the jury were determined to punish him for his nonsense by putting him in the 3rd class, he behaved like a fool here he and Oscar Wilde together; Whistler told me he would have been glad of twenty-five minutes more on your portrait [figure 20],[1] he told me he did not make you stand much you gave him but few sittings he said—

We were all much interested in the Races. Eddie very much pleased with Rica's success— Deauville is at the veternary school at Alfort, has been operated for lameness, the nerve cut just above the hoof.[2] A horse dealer told us yesterday to sell him immediately "On fiche quelqu'un dedans"[3] he said with a laugh; and when the lameness returns as it surely will; then the purchaser will hunt up the place where the nerve has been cut & he will understand that it is all up with that horse! The reason they cut the nerve was for a contraction of the foot. If Aleck would like me to be corresponding veternary for the farm I am willing to undertake the post—

Eddie is well & happy gets on very well with the boys now; I asked him if he thought Monge a better school than Haverford. He said *most certainly*. He has not lost his time here; I keep him up with his riding & Justin says he pays more attention & is doing very well; but he always wants to get off from his lesson.

With much love to Aleck & the children from Mother & self, believe me very sincerely yours—

Mary S. Cassatt

1. The American painter and printmaker James McNeill Whistler (1834-1903) settled in London in 1859, after spending four years in Paris in the circle of Degas, Legros, Bracquemond, and Fantin-Latour. He started the portrait of Lois in April 1883, but didn't complete and send it until at least four years had passed. It was the subject of many letters between Paris, London, and Philadelphia as well as several visits by Mary Cassatt and other Cassatt family members to Whistler's studio. The finished work was titled *Arrangement in Black, No. 8: Portrait of Mrs. Cassatt.*

2. Rica was Alexander Cassatt's first horse to become a major winner. Deauville was the horse Mary Cassatt had bought in the summer of 1882.

3. "Take someone else in."

MARY CASSATT TO ALEXANDER CASSATT

[black border]
13, avenue Trudaine
Friday, June 22 [1883]

Dear Aleck,

I have a few minutes before the mail goes out to tell you about the picture business. Dreyfus told me finally that I might have the group of Mother & the children for you.[1] I would rather keep it myself but I know he would not be pleased if I made him give it up to anyone but you. He won't take back the money for the picture, I am either to paint

a portrait of his wife or if she won't consent to that I am to give them another picture; so as soon as the London exhibition is over I will send you Elsies portrait and the group. Please tell Lois I think the group will look well in a light room; that is light paper & perhaps over a door; it is painted to look as much like frescoe as possible so that it would be appropriate over a door as the Italian painters used to do, they are called "dessus de porte" here. About your portrait I am undecided, I am not satisfied with it, I think the one I did at Marly the best of the two; I will make up my mind when Gard comes, I am anxious to know whether he will think it like; whatever his opinion will be I know he wont conceal it, frankness is his virtue. Your friends the Ellises are here & Eddie has dined with them, also he and young Ellis rode out yesterday in the Bois. It seems the Ellises were much astounded at the idea of his, Eddies, needing riding lessons; but he has improved very much can put his horse through the "haute école" quite well; I am going to make him keep it up for another month when the ticket will be used up & the holidays begin. I have been riding at the manège [riding-school] this week, I sent around my saddle & Justin was so pleased with it that he has written to London for one like it; he thinks it the best saddle he ever saw. "Deauville" is still at Alfort much to Fathers amusement, I believe that I wrote to Lois that your diagnosis was the right one, a contraction of the foot, they cut the nerve, we dont know yet if the operation is altogether successful. We are beginning to count the days now until Gard & Jennie[2] can be here; they will be able to take Eddie out with them sometimes; However he does not seem in the least dull, in excellent spirits; Mrs. Ellis told Mother they were struck with the change in him "à son avantage" as the French say. The school has done him good, he has been obliged to put up with an immense amount of teazing and nagging from the boys, it was very hard at first he says but he dont mind it now & answers them back. I cannot understand you & his Mother putting him to Haverford amongst those quakers [?] their grammar alone is enough. I am glad you are all pleased with the Fraülein. Katharine wrote to Eddie that she was not in the least like anyone they ever had before. Father sends this scrap to Elsie. With much love to all

Your affectionate sister
Mary Cassatt

1. Moyse Dreyfus was a friend and patron of Mary Cassatt. Her pastel portrait of M. Dreyfus was shown in the fourth Impressionist exhibition, in 1879. He had bought the painting *Mrs. Cassatt Reading to Her Grandchildren* (page 159) from the Impressionist exhibition of 1881.
2. Gardner had married Eugenia (Jennie) Carter in October 1882.

[black border]
13, avenue Trudaine
Friday, August 3 [1883]

Dear Aleck,

Eddie & father left for Antwerp this morning at a quarter to seven;
poor Eddie so delighted to be off he could hardly contain himself,
last night when I went to bed at eleven he was still awake, too excited to
sleep. Poor child it has been like a penitentiary to him, he told his
Aunt Jennie that no one knew what he had suffered at that
school although he felt that it had done him good. However his prizes &
seeing his name in the Papers as one of the best scholars was some
compensation. When I brought in the "Temps" yesterday & showed him
his name he was pleased but very sensibly said "Of course no one reads
that except those who are interested" A speech for which his Uncle
Gard praised him greatly. What I wanted to mention specially was his
health, I was pleased to have him go without his having been ill; the Dr
was rather alarmed about him before I took him to Fontainbleau &
yesterday told me to tell you that he ought to have salt bathing; I told
him Eddies health had always been very good, but this is the only
time there has ever been any strain on him & he almost broke down, he
worked very hard and he is growing so fast, so if you can give him salt
bathing when he gets home it will be good for him; And then he will be
in the country, we made a dreadful mistake staying in town on his
account as well as our own but there was no moving Mother this spring
she had not the energy for it. Gard and Jennie have gone to
Versailles, Gard is not very well I think they will give up their trip to
Switzerland and go to England with us, dont speak of it to *anyone*, but
Gard seems depressed about his business.[1] I believe they have not
made their office expenses this year & he will sell his house & put down
his carriage. Fortunately his wife is very sensible about it & would
much prefer staying where they are to running any risks by keeping up
style. He seems very happy with her.

Gard chose a horse for Mother & sold Bichette & the cart, the new
animal is a grey cob we call "Joseph" after Gard. I hope he will be useful,
he has no style; in fact is common looking.

Mother has just told me that she wrote to Lois yesterday so I suppose
she has told her everything nevertheless I will let this go. I will send your
Consul's certificate & pictures next week. With love to all

Your affectionate sister
Mary

171

1. Joseph Gardner Cassatt was having difficulties with his banking business because of a troublesome railroad stock, "Denvers."

MARY CASSATT TO ALEXANDER CASSATT

[black border]
13, avenue Trudaine
October 14 [1883]

Dear Aleck,

I have been meaning to write to you ever since we got back from England to tell you about my visit to Whistlers Studio, but what with looking for an apartement seeing people & now a very bad cold—it seems as if I could never find time to write at any length. However this mail it must go as I have promised little Marthe that her letter to Elsie should be posted tomorrow; she still fondly remembers Elsie, & her Mother says often dreams that she has seen her again, poor little lonely thing. I hope Elsie will soon answer her little letter, she was so delighted at seeing that she (Elsie) had remembered her in her letter to Mother she kissed the paper.

Annie & Mrs. Riddle were most hospitable to us in London, nothing could be kinder, Annie went with me to Whistlers studio where we were met by a pupil of his, he, himself was out of town, but he insisted upon this pupil being sent for to show me the studio. The portrait is not quite done yet I thought it a fine picture, the figure especially beautifully drawn, I don't think it by any means a striking likeness, the head inferior to the rest— The face has no animation but that I believe he does on purpose, he does not talk to his sitters, but sacrifices the head to the ensemble. He told Mother; she, you know went up to London before me & saw him at his studio; he told her that he would have liked a few more sittings, that he felt as if he was working against time; that I suppose is true enough. I told his pupil that you were very anxious to have the picture & that I hoped he would soon send it to you. After all I don't think you could have done better, it is a work of Art, & as young Sargent said to Mother this afternoon, it is a good thing to have a portrait by Whistler in the family. I hope you have Elsies portrait & the family group by this time; the box was sent the 10th of August to Richardson Spence & Co Liverpool to be shipped to you, but as it went by "petite vitesse" it may be a long time "en route." Mr Griscom who called today with his wife & little girl said he would mention it in a

letter to Mr Spence.

I did not send your portrait in the box because I really was not satisfied with it, I like much better the head I painted of you at Marly, & I could not bear to send you a poor thing. Monet is coming up, Petit the man you bought your Raffaelli from, has gone to Monets pictures with a will, bought forty of them from Durand, & it seems refused 10,000 frcs for one; if only your friend Mr Warren had known that; so hold on to your Monet's, I am only sorry I did not urge you to buy more. I met Mme Benard in the street the other day & she told me about the rise adding "We have ten it will be a little fortune some of these days." She came down to put her boy to school she said, & inquired very kindly after Eddie.

We are rather anxious about Gard, in fact I am *very* anxious; he did not seem well when he was over here and he worried himself ill I am afraid about his business, Jennie writes that he was threatened with Typhoid fever. He might well bring on a fever with that horrid Denver which I see is going *down down down* I do hope he will get out of it soon, without a great loss.

Annie & Mrs Riddle are at St Germain, we went out to see them yesterday & I thereby made my cold so much worse that I have been in bed all day. They will be in Paris soon & have taken an apartement at the Hotel Liverpool, where they will stay until Christmas; I got a box from them, about a week ago, which contained a most lovely *old* Japanese tea & coffee set, which I had admired in London! Little Mollie is a lovely child & seems very bright—

Mother was not so well after we got back from England & we talk of going South towards Christmas for a couple of months, but it depends upon whether we can move Father; we want to get away from this apartment, which is too sad for Mother & me; Father seemed very glad to see us back again & is not so unreasonable with me as he was before I left, indeed I think I should have gone crazy if it had gone on much longer.

Give our love to all the children, & tell them to write & tell me what they would like me to buy with 30 frcs which is the amount of the debt I owe to Eddie & I will put the things they want in the Christmas box. Mother says to tell Robbie that she sent him a kiss by Pansy Griscom & not to forget to take it from her.

With love to Lois & yourself

Your affectionate sister
Mary

[black border]

13, avenue Trudaine

November 30 [1883]

My dear Aleck,

On Wednesday last the 28th I sent to Liverpool care of Richardson, Spence & Co. a box with some things for the children which I hope will arrive safely & not much behind time. . . . I send Elsie something for her doll & Robbie a toy thinking him not yet too big for one & Eddie some books which his Aunt Mary chose for him & one which she says she thinks you yourself will read with pleasure—the one by About[1]—

I hope you have found the pictures by this time—it would be a great pity to lose Elsie's portrait for it really is nice— Your father kept saying & thinking it was the fault of the stupid Frenchman who shipped the box, but it turned out to our surprise that the English are in fault— Your father wrote you all about it of course—

You see we are not off yet as up to this time it has not been cold & as your father doesn't like the idea of leaving Paris & I don't think it just the right thing to leave him behind I have hesitated about deciding—just now I am trying daily frictions, but cannot judge yet if they will do good or not—if I get better I don't think we will leave Paris, but if not I must try something as I get a great deal worse— The other day I said I shall have to take to a cane & last evening there came a cane with a beautiful tortoiseshell handle tipped in gold from Mrs. Riddle & an exquisite black feather fan for Mary— I don't know if your father or Mary told you of the presents of porcelain Mrs. Scott sent us after we got home from England & you know she insisted on our being her guests at the Hotel in London— When they came here Mary asked Mrs. Riddle to sit for her portrait[2] [figure 21] thinking it was the only way she could return their kindness & she consented at once & Annie seemed very much pleased—the picture is nearly done but Mary is waiting for a very handsome Louis seize frame to be cut down to suit, before showing it to them— As they are not very artistic in their likes & dislikes of pictures & as a likeness is a hard thing to make to please the nearest friends I don't know what the result will be— Annie ought to like it in one respect for both Degas & Raffaelli said it was "la distinction même" and Annie goes in for that kind of thing— Lois wrote from London that Mrs. Riddle enjoyed buying pretty things for presents beyond anything & I suppose Annie does also, otherwise one would & indeed does feel overwhelmed— . . .

Your father is anxious to know if any of your friends appreciate the Monets you took home— We have one here now which Mary admires

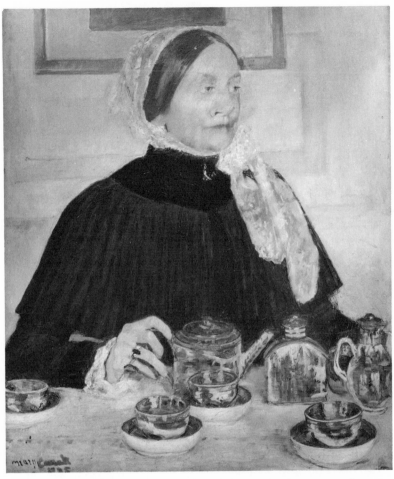

21. *Lady at the Tea Table*, 1883-85. Oil on canvas, 29 x 24 in. The Metropolitan
Museum of Art, Gift of Mary Cassatt, 1923.

immensely—it is a view of Amsterdam— Your father has allowed Mary
to change our "Trouville" for a sea piece—it is certainly one of those
which it would take an artist to appreciate or maybe a sailor—it is
a boat tossing on a great wave tipped with foam—the contrast of the
white foam & the very dark blue of the water is tremendous— Manet's
pictures are to be exposed at the Academie des Beaux Arts in a month or
two & then sold[3]—as the executors have managed the whole thing badly
it is thought some things may be picked up cheap— By the way Annie
went to Durand Ruel's the other day & bought a picture by Mary—

perhaps you may remember it—two young girls at the theatre—[page 147] She also seemed inclined to buy one by Renoir, but she says all her ideas of art are upset & she won't buy much until she knows exactly what she likes—at present she is somewhat in the dark— . . .

By the time you get this you will be busy preparing for Christmas & the children will be happy— Give them all my love— Also to Lois and yourself from your father & Mary and your affectionate

<div align="center">Mother</div>

1. Edmond François Valentin About (1828-1885) was a prolific and popular French novelist.

2. The portrait of Mrs. Riddle (*Lady at the Tea Table*) includes the Japanese tea and coffee set Mrs. Riddle and Annie Scott had bought for Cassatt in London.

3. Edouard Manet (1832-1883), leader of the avant-garde art movement that led to Impressionism, had died on April 30, 1883. Ironically, a large memorial exhibition held in early 1884 was mounted in the Ecole des Beaux-Arts, bastion of the Paris art establishment. The contents of Manet's studio were auctioned on February 4 and 5, 1884.

MARY CASSATT TO ALEXANDER CASSATT

[black border]
Fonda de Europa, Tarragona
January 5, 1884

Dear Aleck,

Here we are in Spain & what is not so pleasant waiting for the visit of a Spanish Doctor. Poor Mother is suffering with dreadful headaches, has not been able to leave the house hardly her bed since we have been in Spain. She was wretched before we left Paris & so stiff she could hardly move & her cough very bad, something had to be done & we thought a change of climate would be the thing. Her cough is much better certainly, in fact it has ceased almost entirely but the headaches have alarmed me very much. They assure me here that it is simply the first effect of a change of climate, that every one suffers more or less, but that of course it is harder for old people & sick people; however this morning Mother thought she had better see the Doctor. I felt very badly at leaving Father in Paris, more especially as he evidently considered the whole thing perfect nonsense, he really cannot be made to understand that Mother is a sick woman & that if we want to keep her with us, she *must* be taken care of. Annie Scott was shocked when she saw her in London. The fact is that apartment is too much for her, those five flights of stairs; Father does not feel them and thinks nobody else ought to. When you write to him you might say that you are glad to

hear that he intends to move, that you are sure it is too much for Mother & that you hope he is going into a house with a lift. Now *please* don't forget this, remember that it is *most important*. I dare not open my mouth, he wont listen to a word I say, he thinks I want to move for my own pleasure, whereas I like our apartement very much & would never dream of moving were it not for Mother, the sad associations are hard for her too.

We have got to the right place for climate—it is perfectly delicious here like the most delicious Spring weather, the town is on a rock some eight hundred feet high, on the Mediterranean about five hours from Barcelona. It is one of the oldest places in Spain built by the Cartheginians, the walls still standing. It is picturesque beyond description & the country around most beautiful, not in the least like Italy much grander; if it were not for Mother's health it would be most enjoyable.

I suppose you have the pictures by this time, & I hope they are not spoiled by their long journey. I have no doubt that the one of Mother and the children is rather black, with being shut up so long, I wrote to you that we had found a beautiful Monet for you; Manets sale takes place next month; and I told Portier what to buy for you if the prices were low enough. Annie Scott bought a picture & two pastels before the sale & I believe that she intends to buy something more at the sale. You cannot do better & as long as you have begun to get a few pictures you might as well go on. My poor painting is sadly interrupted, I have no time now for anything & the constant anxiety takes all heart out of me; my only hope is that this change will set Mother right for a time.

We did not intend stopping more than a day here we were on our way to Alicante much further south but Mother was so wretched we could not go on. Fortunately the hotel is much better than we had any right to expect, it is kept by Italians from Varallo, a place in Piémont I know well; when they found out that I knew all about their home they were doubly attentive. The cooking is quite good; this is a great place for wine and nuts. Tell Jenny when you see her that they dry hazel nuts in the oven just as we do ground nuts & that they are delicious, she is as fond of nuts as I am and will appreciate this reciept. Mother recieved Lois' last letter at Barcelona, she wants to know what you mean by sending her a message to the effect that *you* think Robbie a very nice boy, dont you think that she is of the same opinion? We both send love to all the family

Your affectionate
Mary Cassatt

[black border]
Hotel d'Angleterre, Biarritz
March 6 [1884]

Dear Aleck,

We got here from Spain about eighteen days ago & Mother since then
has been very ill, so ill that when the Dr first saw her here he thought
she had not long to live. I knew however that he was wrong & was not
so very much alarmed as he was; that was her heart. Since then she
has had an attack of acute rhumatism which made her suffer dreadfully &
the Dr had to inject morphine under her skin before she had any relief.
Since then her heart has recovered so much that the Dr thinks there
is no danger & that even the rhumatism may get better; that is the
stiffness. She is *very very* stiff can hardly walk at all, he is now giving her
warm salt baths & she is to be champood, I dont know if that is the
way to spell it. At Alecante I think she was doing better but she was
determined not to stay although the climate was heavenly; we met there
the Marquis Casa-Loring, Georges cousin, who is a man of about sixty
speaks English perfectly & was most kind to us, when we came away he
sent to Madrid for a carriage for us and we had a compartement reserved
for the journey. The journey from Madrid here was very fatiguing &
the change of climate was bad for Mother. I should never try it again,
this travelling with a sick person, if one is getting over a spell of illness
& wants a change of air all very well, but for anyone of Mothers age
& rhuematic as she is it is better to stay at home. I am so glad you wrote
to Father about the apartement, he sent me your letter & is now
willing to change; before that he kept saying he would but whenever it
came to the point he backed down. The Doctors forbid Mother to go up
even half a flight of stairs, I dont think Father gave in on account of the
money, because we really dont need it at all. Mother had money enough
saved for her journey this winter, & it was not so expensive as it
sounds; at Alicante we only paid 27 frcs, a day for all three of us
[including the maid] including everything. Besides that I am in hopes
that we can get the fifth floor above the Dreyfus' for 4000 frcs (with
a lift) & with one room more than we have which will enable me to take
a room for a studio. We can perfectly afford to pay 4000 frcs. rent this
winter if it had been necessary to practice strict economy we could have
dismissed Martin [the coachman] & sent Joseph out to board at the
vets at St Germain; whereas Father has had the carriage ever since we
left. When we were in England last summer Mother paid the
expenses with additions of what was saved out of her housekeeping
allowance; so you see Father has been at no extra expense at all. Our

apartement we could have rented easily & no doubt will soon find a
tenant again, but Father the moment we left for Spain told the concierge
not to allow it to be visited by any one. I hope he will not take the
1000 you sent but I am afraid he will, he is all wrong about money
matters & insists upon it that you are ruining yourself & points with
triumph to poor Gard not having got along so well. Poor Mother
was very much overcome at receiving your letter, she had a little crying
spell & felt better after it, Gard also wrote to her & it did her good;
her spirits have been very low. The Dr told me today that he found her
so much better that he thought I had better go to Paris on Saturday.

I am going up to look for an apartement & try & move before she
comes so that all the fuss may be over; then I will come back here
& fetch her, it is only sixteen hours, & Matilde is so devoted that I
can leave her in all confidence.[1] This place is full of English about
a hundred in this Hotel; some of the "bluest blood" in England opposite
me at the Table d'hote. I wish you could see them, husband and wife.
Alongside of me at table I have an English clergyman who is a rich
man as well, he is intelligent & tolerably well informed, but he cannot
understand how they can give a dinner party in America, where there is
no "precedence"? I propound difficult problems of precedence to him, he
little imagines the inward amusement he affords me. We also have some
Americans a Mr Warren & his wife, they met you & Lois once at a
New York dinner party, I am ashamed of them they are so loud voiced &
snobbish running after the English with titles, & the English are always
telling me how snobbish they are, & unfortunately I cannot deny it. You
never saw anything like the economy of these English some of them
actually live here for ten frcs a day, & this is a first class hotel, I
dont know how they manage it but they are awful screws. I am bored to
death here as you may imagine in fact I have had an awful winter but
if Mother only gets well I shant mind anything. Annie Scott has been
most kind writing frequently & sending us news of Father. I hope
you will both enjoy your trip to Mexico, I suppose Rob too will have a
great deal to write about when he comes back. We hear frequently
from Jennie. She & Gard complain a good deal of their health, Gard
takes a very gloomy view of his, or at least did so when he was here, but
really I did not see that he was so bad as he thought. I wish he was
getting on better in his business; I am sure that would make everything
right, but I always look carefully at the stock list & it seems to be
always the same. I will write again from Paris after I have seen Father. I
do hope we shall be able to move, but you know I cannot manage
Father at all, he thinks I want this change for myself, which of course is
nonsense. He hates to be forced into taking a decision by me as he
has no confidence in me. However after your letter he seemed to have

made up his mind. Mother sends her love to you all she will write soon, Elsie wrote me a nice little letter which I will answer next mail. With love to Lois & Robbie & a great deal to yourself—

<div align="center">

Your affec sister—
Mary Cassatt

</div>

1. Mathilde Valet was Mary Cassatt's maid and housekeeper until Cassatt's death in 1926. A native of Alsace, she frequently spoke German with Cassatt; during World War I she was forced into exile in Switzerland because of her German nationality.

MARY CASSATT TO ALEXANDER CASSATT

<div align="center">

[black border]
13, avenue Trudaine
March 14 [1884]

</div>

Dear Aleck,

I suppose you have had my letter from Biarritz and will be more easy in your mind about Mother. I feel very badly at leaving her even for a little, but only did so after the Doctor's repeated assurances that he thought there was no risk in it. Matilde is very devoted to her and I am sure she has every attention.

We have had several notes since I left, none to day for the first time, it seems as if it was a long time since I had seen her & I only left on Monday & this is Friday. It was time I got here for Father never would have consented to move except under compulsion, he is harder to manage than he ever was in his life & has grown more so since we left him, he must not if it can be helped be left alone so much; but I dont know how we can manage it as Mother will have to go away again in the summer. I signed the bill you sent & Father has written to Gard to give you back the money except what he has to pay for the pictures. I hope you will like what was bought for you [from the Manet sale]. There are two life size heads one a half figure, studies & neither of them cost 500 frcs. & the frame of one would cost 200 frcs. so they are bargains & are very decorative. We are bargaining with someone for this apartement they want a reduction of 240 frcs a year for three years & we have consented, it is most provoking that Father the moment our backs are turned had the notice taken down & refused to allow the place to be seen; for two people wanted it & would even have bought some of our fixtures so the concierge says. Fathers health seems excellent, rather too well for his age, as his mind is not equal to the

<div align="center">

180

</div>

body, in fact as he grows stronger in body he grows weaker in mind, less able to see things from a reasonable point of view. Mother is very weak still I hope to hear that she is gaining strength, & getting rid of the stiffness. You said in one of your letters that you thought of coming over again. Have you given that up or do you still think of it for next winter?

We were glad to hear that the children were well, what did the others think of your taking Rob with you? I am afraid Katharine thought it favoritism, she used to accuse even me of making a favorite of him. I hope Eddie is getting on well, I would not make him work too hard if I were you. Tell Lois I will answer her letter soon, she says I did not understand about Jennie and Gard about their not speaking about us but Gard was always very reserved, Jennie told me he had never told her anything about his family. We have had a letter from them since their trip they seem better.

With much love to all & hopes you have had a pleasant journey

Your affectionate sister
Mary Cassatt

MARY CASSATT TO ALEXANDER CASSATT

[black border]
13, avenue Trudaine
Friday, March 28 [1884]

Dear Aleck,

We are going down this afternoon to sign our lease for the apartement in the rue Pierre Charron, which I wrote to Lois about, the company have concluded to give us the 3rd servants room & we in our turn have consented to allow ourselves to be turned out of the stables & "remise" [coach house] when they are obliged to take them from us. After looking until I am worn out I dont think we can do better. We have to pay the people here five hundred frcs and abandon our gas fixtures, & they consent to take this lease off our hands; so if the thing does not fall through again, I dont think under the circumstances we could do better. I would have run the risk of renting but Father is so impatient that for his sake I want it all over. Our news from Mother continues to be tolerably satisfactory; Matilde who is inclined to take a gloomy view of things, wrote me a long German letter the other day & said she really began to see a slight improvement although "[illegible]". She (Matilde) is a most faithful creature, I cannot be too thankful that we

took her with us, Mother herself writes that her cough troubles her very much, and keeps her very weak; she is in better spirits since Mrs. Riddle & Annie are with her. I hope to get through my moving by the time they return. I suppose you will have got home by the time you receive this. Gard writes that you expect to be back by the 8th April; Jennie has written to us several times about the children & Katharine has written to her Grandfather. I still continue to look at the stock lists and do not find things a bit brighter. I wish for poor Gards sake they were more promising.

I shall go down to Mother as soon as we have moved & I hope to be able to bring her up by slow stages by the last of April; when therefore you write again direct 14 rue Pierre Charron.

With much love to all & hopes to hear soon of your safe return.

Your affectionate Sister
Mary Cassatt

MARY CASSATT TO ALEXANDER CASSATT

[black border]
Hotel d'Angleterre, Biarritz
Thursday, April 17 [1884]

Dear Aleck,

I suppose Father wrote to you that I had left Paris. I arrived here on Sunday and found Mother not so well as I hoped & on Monday the Dr found she had fever & congestion of the lungs, & since then I have been in great anxiety. Last night he found her symptoms better, but this morning the congestion was no better & the temperature just the same. She is so very weak that she could not stand a protracted fever, I am sure it would kill her. When I left her five weeks ago she was on the mend slowly, but surely, since then all the symptoms have changed & now I dont know what to think. The apartement in Paris is very nice & even Father seems satisfied now, but I sometimes despair of ever being able to take Mother back there. Father went on like a crazy man for the first three weeks & nearly killed me, but latterly he seems reconciled & I have no doubt will much prefer this apartement to the other. He was so unreasonable about allowing me to rent the other that he lost about 1000 frs by his obstinancy; he begins to realise I think that he is no longer able to manage matters for himself. If only we had Mother home with us, you cannot imagine what it is to have beef tea

made & try & tempt the appetite in a hotel. Matilde is a most devoted
creature, but she is not so intelligent as she is devoted, nor has she much
experience in nursing.

Mother sends you her love and with a great deal from me

> Your affectionate sister
> Mary Cassatt

Show this to Gard please as I have not time to write to both, I will
write again in a day or two if I have any better news.

MARY CASSATT TO ALEXANDER CASSATT

> [black border]
> Hotel d'Angleterre, Biarritz
> Sunday, April 27 [1884]

Dear Aleck,

I wrote to Jennie a few days ago & told her to give you the latest news
of Mother if you had got back from your journey. I gave very favorable
news then but since then we have had another slight relapse and
Mother has not been so well, to day however she is up & lying on the
sofa for the first time in two weeks. I found her very miserable when I got
here two weeks ago & quite overcome at the sight of me; she felt herself
rather abandoned, I am afraid. I stayed away from her much longer
than I thought would be necessary but I felt easy in my mind
whilst Annie Scott & Mrs Riddle were here. They were very kind and
have been very anxious about Mother.

I suppose Father has written you all about our new apartement, I think
he is quite reconciled to it now but the idea of moving was nearly the
death of him. More the idea than anything else, for we left his room &
the dining room to the last & we arranged them for him the first day
after we moved, so he was only upset for a few hours. He allowed me
to do as I liked about furnishing that is about curtains & hangings, & I
began to be quite interested, but had to leave to come to Mother before
anything was done & I dont know how things look. The house is very
handsome & the rooms are nicely furnished & ceilings much higher than
in Ave. Trudaine; Considering the difference in the house & quarter
the rent is not any higher in proportion. Father told me before we
went to Spain that he could pay 4000 frcs & this is 50 frcs under that.

I am very glad we have not a high rent one never knows what may
happen, & from the tone of Jennies letter of the 13 (which we received
along with one from you & one from Lois of 15th) Father may have

183

to come to Gard's aid. I am very sorry for him, & unfortunately we see Denver down to 14 since that letter was written.

Do you really think there is any danger of his breaking? Jennie is fearfully despondant, & I suppose she gets it from him. I see in the financial article in the English papers that in England they think the worst of the depression is over. I am glad you had such a pleasant journey. I have no doubt Robbie was a nice little companion arent you & Lois a little afraid of making the other children jealous? Dont be too hard on Eddie remember you would keep him home this winter, think how well he did at Monge, & we never had to speak to him about his lessons he never once neglected them. To be sure at our house that was all he had to do, but at home with all the amusements just at hand you could not expect him to stick to his books. Eddie is very young for his age but he is bidable enough, all he wants is not to be spoiled, he has a prodigious memory & should have plenty of ambition; excuse the remarks, but we were all provoked at you for keeping him at home this winter. Mother wants to know if you ever received a letter she wrote you from here; I hope sincerely that we may soon be able to get away, but the temperature is still at 100° or even above every evening showing that the inflamation is still there. I would not like to run any risks in taking her on to Paris, but Father is very impatient to have us back again. As for me I have been utterly upset, have had violent tooth ache & a swollen face, yesterday the dentist lanced the gum, but it seems worse to day; I think it is not only the tooth but all the worry and fatigue I have had. I will get the Monets for Mr Thompson [Frank Thomson] if I can at the price, I know of one that Annie Scott wanted to buy but thought it a little larger than she could find room for. When I was in Paris I found Portier had sold two of my pictures for me & more were wanted but I have not touched a brush since we left home, have not been out of Mothers room except for a walk, since I have been here. It will do me good to get to work again. Elsie's portrait was the first picture hung in the new apartement & looks much better there than in the old one.[1] I am going to take the Salon for a studio & Father has a small salon arranged for him. Jennie writes that Elsie has improved immensely in looks & has grown shy; little Marthe still speaks of her with adoration & uses her old ruler still.

Mother sends you love, she is back in bed again tired out, she is very weak still.

With love to all the family and especially to Elsie who has written to me twice (& tell her I am so busy I could not answer) love to you also from your affectionate sister

Mary Cassatt

1. Cassatt did two pastel portraits of Elsie. One, called *Elsie Cassatt Holding a Dog*, was exhibited in London by Durand-Ruel and then shipped to Alexander Cassatt in 1883. The other, called *Portrait of Elsie Cassatt*, stayed in Paris, hanging prominently in the Cassatts' apartment.

MARY CASSATT TO ALEXANDER CASSATT

[black border]
14, rue Pierre Charron
Monday, May 12 [1884]

Dear Aleck,

We arrived home safely this morning, after a dreadful journey from Biarritz. The heat was like summer heat at home, and under the impression that Mother had inflamation of the lungs, I had her covered with wadding, it is a wonder she did not die of the exertion of breathing only. I had written to Dr Fanny to be here as soon as possible after our arrival, He found Mother weak, which was not astonishing considering she had been in bed four weeks with hot poultices on her back; he disagreed entirely with the English Doctor, said that the congestion of the lungs was an old trouble, she has suffered with it in a chronic state for more than two years, he says as he has always said that the great trouble is weakness, & that her state may be described as a rhumatic state. The entire treatment of the man at Biarritz was wrong I am convinced & he kept her there too long, but we have escaped with our lives & that is something to be thankful for. Dr Fanny thinks the rise of temperature at night due altogether to weakness, if you could only imagine the relief it is to get her home, where we can get what we wish in the way of food & where we have people to wait on us & our minds relieved. Poor Matilde was as nearly crazy as I was. And that nut of a Dr kept telling me I must get her home so as not to die in a Hotel, that is, he told me that after he had got out of us everything he could. I never want to see an English Dr again as long as I live. Mother is very much pleased with her new apartement, all that she has seen of it at least, & with her own room, & is quite calm lying contentedly in bed taking what nourishment she can.

We hear from Gard that Eddie has been in bed a week I hope it is all right again. Please tell Gard about Mother & excuse this; I am thoroughly worn out and scarcely know what I am saying.

With love to all

Your affectionate Sister
Mary

*The Cassatts spent the summer of 1884 in the small town of Viarmes,
about twenty miles north of Paris. That winter Aleck and his younger
son, Robbie, paid them a month's visit in Paris; they arrived on Christ-
mas Day—a surprise for Mrs. Cassatt.*

MARY CASSATT TO LOIS CASSATT

14, rue Pierre Charron
December 29 [1884]

Dear Lois,

I seize a moment from housekeeping, painting & oyster frying, to let
you know that Grandmothers present arrived safely & well on Xmas
evening. You may imagine our surprise as the lift slowly rose in sight to
hear Father call out, "Hi, you don't know who is here" Mother nearly
fainted when she heard who it was. I am glad we did not know they were
coming until a few days before, for we would have been very uneasy as
the weather on the coast was fearful & we thought it would be so out
at sea, but on the contrary it seems they had a good passage.
Robbie Riddle who left four days latter on the Oregon arrived in Paris
the same evening. I felt sorry for dear little Rob for he was shy at first &
I was afraid he would be homesick. Edgar Scott is here for his vacation &
I hope Rob will see something of him as it will be less long for him.
Yesterday Mollie Scott & Anna Fisher came here & Robbie with
Mathilde went down with them to see the Xmas tree. Tonight we are to
take him to see the "Poule aux oeufs d'or" & we are now going down to
ask the Scott-Fisher party to go with us, but I am afraid they won't as
Annie does not allow Mollie to sit up after dark!— Before going there
we are to stop in & see the Panorama so I am in a great hurry & my head
is in a whirl. Aleck found Mother looking better then he expected but
that was the excitement afterwards he saw that she was much changed.
Aleck is going on to England very soon to stay a week. Robbie stays with
us in the meantime. I hope Aleck will get Whistler to give up your
portrait, he is now working on it I hear; Lucas at my request wrote to
him about it. I am sorry you don't like it, you remember I recommended
Renoir but neither you nor Aleck liked what you saw of his, I think
Whistler's picture very fine.

Rob is waiting in great impatience for us to be off so I have to stop.
I have just heard from Aleck that you did not send for any dresses
for which I am sorry as I have discovered a splendid woman very cheap

but makes for numbers of dressy people especially Miss Mackay! &
charges 50 frs for making!

With love from Mother & all to you & the children

<div align="right">

Yours affectionately
Mary—

</div>

KATHERINE CASSATT TO KATHARINE CASSATT

<div align="right">

14, rue Pierre Charron
January 21, 1885

</div>

My dear Katharine,

I received the very pretty towel you embroidered for me & would have
written sooner to thank you for it, but was so taken up with your
father & Robbie that I wrote to nobody— I told Robbie to tell you how
much obliged to you I was but he forgot it until his letter was closed &
so he put it on the outside— I was very glad to see that you are so
handy with your needle as it is a very nice thing to be able to sew well &
unless one learns very early in life it is not easy to learn later— I
think Elsie will also be handy as I have seen her working very nicely—
Your Aunt Mary had a little thing only two & a half years old to pose for
her & it was funny to see her pretending to sew—she put in the needle
& pulled it out exactly as if she was making stitches & exactly as she had
seen her grandmother do who was an embroideress by trade & by the
way she posed so beautifully! I wish Robbie would do so half as well— I
tell him that when he begins to paint from life himself, he will have
great remorse when he remembers how he teased his poor Aunt wriggling
about like a flea—he laughs & says he isn't afraid of the remorse—he
has just this instant opened the door to say "Aunt Mary would like you
to come here Grandmother" & I know it is to try to make him pose a
little as his father has just gone out.[1]

The posing is over for the moment & I come back to you. . . . I am
glad to hear that your music comes on so nicely— I hope you will
persevere until you can read music extremely well at sight as in my
experience it is not of much use unless one can do so and if you only keep
at it faithfully until you accomplish that you will never regret the time
& efforts it has cost you— All join in love to all the family

<div align="right">

your affectionate grandmother
Cassatt

</div>

1. Cassatt made a number of sketches of Robbie during this visit and began a large double
portrait of Aleck and Robbie that is now in the Philadelphia Museum of Art (figure 22).

14, rue Pierre Charron
January 28 [1885]

Dear Lois,

Your letter unfortunately only reached me on Sunday afternoon & we had said good-bye to Aleck & Robbie on Sunday morning, so that the dress order came much too late, for which I am very sorry. I went to see Arnaud this morning to ask her what her prices would be for two dresses such as you want, but I did not find her in. However I saw some of Miss Mackays wedding dresses, Arnaud is making her trousseau, sixty-five dresses![1] the whole thing is to be exhibited, the dresses on lay figures in the salon of Mrs. Mackay! & cards of admission are to be given, sixty-five pairs of shoes embroidered to match the dresses, &&. I should like to go for the fun of the thing, one of the dresses I saw this morning was very splendid white silk covered with hand embroidery; it was certainly very nice of her to give the whole order to Arnaud, who is a small dressmaker & to whom it was a great advantage, rather than give the order to one of the great houses who don't need it. They say she is a nice little thing.

We felt very blue after the travellers left, they had a good crossing fortunately, & I think must have had good weather in London, for it has been very fine here. Poor little Rob it seems from your letter that I wrote I was going to amuse him, he got very little amusement; posing for his portrait, did not suit him. I will send you a photograph as soon as it is done, the likenesses are not bad, but it is not yet finished, how I did want another week! But Aleck was anxious to be off, & he preferred the "Germania" to the "Ems," if they were only safe home we would feel more comfortable. Aleck is certainly better his "douches" did him good. I do hope he will go on with them, & that he will continue to take moderate excercise.

I did not get the nightshirts for Robbie because I could get nothing nice ready made at the Louvre,[2] nor summer drawers for the same reason, I did not get your gloves exactly the shade you sent because they had nothing but the suede colours, they are the fashion now & worn even with white dresses. Aleck will tell you about Mathilde's sister, Bertha, she is at Nice & cannot leave before the spring, she is a thoroughly reliable woman, an excellent ladies' maid, dresses hair very well & is a good milliner, she also makes dresses & sews well, at her present place she is a sort of housekeeper overlooks everything does all the preserving &&, she speaks better french than Mathilde & excellent *Italian* besides *Arabic*. Katharine wanted to learn Italian & as she has a taste for languages it would not be difficult, Bertha always speaks Italian

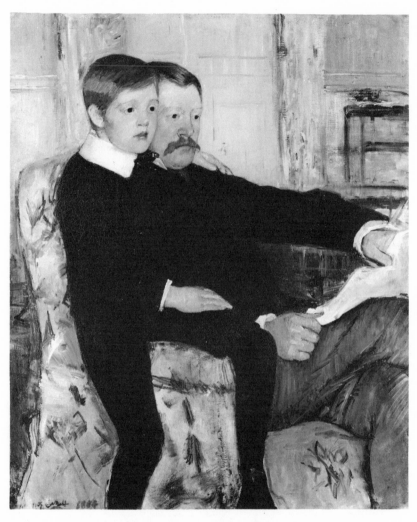

22. *Portrait of Mr. Alexander J. Cassatt and His Son Robert Kelso*, 1884-85. Oil on canvas, 39½ x 32 in. Philadelphia Museum of Art, The W. P. Wilstach Collection and Gift of Mrs. William Coxe Wright.

to her present mistresses grandaughter. Aleck will tell you about the "chef," we gave him eight days warning this morning, as he adds on to his bills too heavily, otherwise he is a decent man & a very good cook. I told him that tradespeople did not give commissions to the servants in America, but it seems that Louis, Aleck's man, told him that they had begun to do so in New York. I hope it is not true. With much love

to all from all of us & hope that the travellers will be safe home when you receive this.

<div align="center">
Affectionately yours

Mary
</div>

1. Evelyn Julia Bryant, stepdaughter of millionaire John William Mackay, married Prince Ferdinand Colonna on February 11, 1885.
2. Magasins du Louvre are shops across the rue de Rivoli from the Louvre.

MARY CASSATT TO LOIS CASSATT

<div align="right">
14, rue Pierre Charron

March 1 [1885]
</div>

Dear Lois,

We were glad to hear from Aleck that you are cured of your cold, the weather must be dreadful at home, & Aleck must be remorseful at having abused the climate here: ever since he & Robbie left we have had the most delicious weather warm sunny & dry, quite as fine as we had at Biarritz this time last year; the Scott party complain that it was drizzling at St Remo, so Robbie Riddle told us. I hope Aleck is better & has had no return of his vertigo, if he has had do make him take douches. Please tell him, if he is still troubled with his eye to try bathing it in very strong cold tea, I am trying it and find that it is very strengthening.

I have been expecting a letter from you about Bertha, she writes from Nice to know if it is quite decided and also what she is expected to do. Aleck said he would give $5 a week & if you did not all come over in two years, when of course she would come with you then she was to be sent back if she wished to come. What she is anxious to know is if it is all settled & in what capacity she is to be engaged. Where she is, she is nominally ladies maid but in reality is housekeeper & at times everything even cook; it is best to have everything decided beforehand so that there may be no disappointments. We have had a disagreeable experience in our "chef" who proved too much of a cheat & for two weeks were without a cook, when Matilde went into the kitchen & astonished us all by her talents. I must say I liked the chefs cooking. The other day Madame Berard was here & I told her I had never eaten such a good dinner as at her house and that it gave me a good opinion of chefs, she said hers certainly cooked well but he was never sober; & she had had him for ten years! Do you want Bertha to take you over anything if you do let me know in plenty of time.

I asked Arnaud about the two dresses you wanted she said she would

<div align="center">
190
</div>

make you the grey costume for 400 frcs. simple. I suggested steel bead embroidery & steel bead collar thus it would be about 700 frcs with mantle, black faill would be from 400 frcs to 600 frcs depends on how handsome you wish the trimming to be. Arnaud said if you wished anything to send a dress lining that fitted you well as well as your measures; You could send it in a newspaper.

Have you got Whistlers picture? We have just been reading Lord Malmesbury's memoirs, he says that Landseer painted the portrait of Lady M. & that he got the picture *fourty four* years afterwards from Landseers executors[1]—there's consolation for you. Whistlers lecture was very successful ("Truth" says), the English adore humbug[2]— Tell Robbie I am working away on his picture from all the sketches I ever made & all the old pastels & that he is very like himself. Give them all our love & hoping that you are well believe me

<div style="text-align:right">

Affectionately yours
Mary Cassatt

</div>

1. James Howard Harris, third Earl of Malmesbury (1807-1889), published his *Memoirs of an Ex-Minister* in 1884. He recalled how he commissioned the British painter Edwin Landseer to paint a portrait of his wife, Lady Emma Bennet, in 1833, but didn't receive it until 1877.
2. Whistler's "Ten O'Clock" lecture explaining his aesthetic theories was given in London, Cambridge, and Oxford in 1885.

MARY CASSATT TO LOIS CASSATT

<div style="text-align:right">

14, rue Pierre Charron
April 3 [1885]

</div>

Dear Lois,

Mother's letter to Aleck about the "chef" was on its way before I received yours of 20th March; by this time your mind is at rest on that subject, he would not do, besides he would not go to America he told me; his qualities besides his cooking were his excellent morals & obliging disposition. Bertha, I think from what we have seen of her & heard from the servants who have lived with her, will be an acquisition for you. She is a very good sempstress, & irons fine things very well, makes preserves & is housekeeper at the Courants & gets on well with the other servants. She has been with the Courants five years, & they pay her 70 frcs. a month & give her her wine & washing which is always counted here at 15 frcs. a month, so you see she gets here what amounts to only $56 a year less than you will pay her— They will be furious at her leaving, as she is their chief support the other servants won't stand the old lady, she is very hard to get on with. I cannot tell you yet when she

will be able to start, but she does not wish to leave until the family return from Nice thinking it would not be fair to go before they are settled at Poissy again. I will see about your dress as soon as your pattern comes & I hope also a repetition of your measures. The childrens photographs have arrived Elsie looks more herself but Katharine has changed a great deal, I hoped we should have the boys portraits, Eddie in his long tails Grandmother says. On Tuesday Edgar Scott was in Paris on his way down to San Remo to join the family, he lunched & spent the afternoon with us, he is a very nice boy has wonderfully good manners, he is longing to go home but his mother means to keep him at school another year— Has Aleck heard of Ross Johnstons death? Mr. McKnight sent us a Pittsburg paper with the news & a day or two ago Mother received a "faire part" [announcement] of the death of "Elizabeth Countess Soderini" who turns out to be Mrs. Stokes youngest daughter, & this morning we received the news of the death of a neighbour we took an interest in. He has left his family in a painful position, the wife obliged to sell her jewels, she sent them to me to keep for her, as she meant to sell them, a chance for any one who wanted a bargain. Poor woman she is left without a sous, fortunately the children have a fortune; so we are in a subdued mood. Father is out riding, Mother with a slight cold but otherwise well. With much love to all the family & hopes that you will get out of your servant troubles satisfactorily

> Your affec.
> Mary Cassatt

MARY CASSATT TO LOIS CASSATT

> 14, rue Pierre Charron
> Wednesday, May 6 [1885]

Dear Lois,

 Your maid we hope will be able to leave by the "Normandie" from Havre on the 16th. She comes here tomorrow & will probably go to Germany to see her boy & her parents before she sails— I will write again on Monday when everything is definately settled. Your dresses are "en train" as you did not limit me as to price, I settled on 600 frcs. a piece. Arnaud tells me that the black dress will cost her nearly that & that she won't have any profit on it, but she is anxious to get you for a customer. I believe it, as the material is very expensive, it is a stripe of moiré & an open stripe that looks like spanish lace—it is to be hand-somely trimmed with spanish lace & "moonlight" jet— The white dress

is crepe with pink rosebuds. I chose peach pink rosebuds as the color was more delicate. The skirt is to be white I believe, she asked me to leave it to her taste. The lining you sent is to be stuffed with horsehair & the dress fitted on to it.

Your "chef" or rather the one Aleck wanted is going to Switzerland. We had a letter asking for a character from a Baron somebody. Why have you such a horror of one? I should think you would find it the greatest comfort. Mme. Berard who spends seven or eight months a year in the country has a chef because she says a man cook knows better how to provide in advance & Mrs. Bickly told Annie Scott she never knew what comfort was until she had a man cook. I believe I wrote to you that Bertha was a beautiful ironer & Mother says they have all sorts of conveniences here, a great variety of utensils such as she thinks you have not at home, for ironing fine dresses &—if we were *sure* you had not the things required Mother would send them, but perhaps they are to be found there now.

We are going on much as usual very bad weather just now, & a great calm after the Russo-English scare, it was worthwhile to make all that row to back down after all! Edgar Scott spent last Thursday with us on his way back to school, he left them all well at San Remo, it seems, I have had several letters from Annie since they have been in the South & Mrs. Riddle is much better. Aleck thought Mrs. R. less broken than Mother, that is in appearance, but he would not think so now. Mother is still very lame, but is able to sew all day long & has been ten times to the dentists & walked up his stairs (the entresol)— We are sorry to hear of Eddies cough, I hope you tried the camphor, Mother still goes on, or rather has begun again her treatment. Eddies cough though is probably from the stomach if he is growing fast. I have been interrupted a dozen times since I began this I fear it is very incoherent. So Katharine is beginning to care for dress, we hear that she is growing very pretty, how time flies— I suppose she will soon be grown up— With love to Aleck & the children—

Very affectionately yours
Mary Cassatt

MARY CASSATT TO ALEXANDER CASSATT

14, rue Pierre Charron
May 17 [1885]

Dear Aleck,
Bertha I hope will have arrived safely by the time you recieve this,

she wrote to Matilde to say that the ship was magnificent, & that they
had 800 passengers on board. We sent her by the "Normandie" because
we found the price about the same as the other lines & it was more
convenient, the direct lines to Phila. do not take 2nd class passengers
& neither does the German Loyd. The passage on the other lines is 250
frcs, from the port they sail from to New York, of course the price
varies according to the distance from Paris. Mother gave Bertha a letter
to the agent of the P.R.R. and was in a great way about it not with-
standing that we pointed out to her that you could manage matters on
the other side & that our business was done when we shipped her—
Then at the last moment Mother in a very depressed state began to
wonder if she would really be as good as we thought she would. In fact
she was very nervous & upset partly on account of the weather— I gave
Bertha my large trunk so that the dresses should have plenty of room
& after mature consideration we changed the garden hat for Lois for
another kind, an English lady who saw it said "a hat to wear to a garden
party" Tell Lois that this height is mild for fashion here; her black
dress is right according to measurement but the white is I am sure too
narrow around the neck any way she sent some of the material to arrange
it— I sent you a photograph of Mrs Riddles portrait but I dont think it
very good I have not had yours & Robbies done yet. This morning I
went to see Degas & he insisted on my going to see the exhibition at
Petits gallery at once, as he wanted me to judge of the effect of the
Monets.[1] They have managed to nearly kill him— They were up until
three in the morning the day before the opening & every time one of
Monets pictures was hung the painters next took theirs away!
Finally they seperated all his pictures and put them in different corners!
We are looking out for notices of the Monets you sent to New York—
I met Bridgman[2] at Durands this week and told him about the way
Whistler was behaving about Lois' portrait. He said if he were in your
place he would give some one an order to forcibly bring it away from the
studio. I am in great hopes of his hearing of it through Bridgman who
was very indignant—

 We have not a country place yet, I went about two this morning but
nothing definite yet, but we take it calmly for the weather is cold &
changeable— I hope you are over your malaise, I sent you
Raspail. Have a litre of Eau sedative made & kept in the house it is
excellent for sprains, a bandage wet with it is much better than arnica—
With much love from Mother & me to all

<div style="text-align:center">

Your affectionate sister
Mary Cassatt

</div>

1. Monet showed ten works in the fifth *Exposition Internationale* at Galerie Georges Petit,

which opened on May 15, 1885. Monet was the only Impressionist in the group of twelve artists represented there, three of whom were members of the Institut, the official French academy of artists.

2. Frederick Arthur Bridgman (1847-1928) was an American who came to Paris in 1866 to study with Gérôme. He was well known in Paris and London, specializing in Oriental subjects.

The Cassatts spent the summer of 1885 at Presles, a small town north of Paris.

MARY CASSATT TO ALEXANDER CASSATT

Presles
Monday, September 21 [1885]

Dear Aleck,

I have no doubt that you will see Durand-Ruel by the time you get this, for he wrote to me that he intended going to America & as I was in town a couple of weeks ago I called & gave him your address. He wanted me to give him a letter to you but I thought that quite unnecessary. The New York Art Association have offered him their rooms for an exhibition[1] & he is going over to make arrangements— Affairs here he complains are at a stand still & he hopes to have better luck in America. I doubt it however. I gave him your address at your office— I am glad you will lend the pictures to Thomson, you never told me what was thought of the Monets you sent to New York— We are getting on much as usual here, I am at work again and have done a large pastel of Father on Isabelle with which he is much delighted [figure 23], but he says you will never believe that she is as handsome as I have made her— Just now, poor thing, she is under the weather, I had to have her fired for a splint on her foreleg. She had the splint when we bought her, but it did not lame her although she gave way slightly on that leg when she trotted. Father was loath to have her fired, I had the utmost difficulty in making him see that she was lame & then he said "sell her" just as he always does. She was fired two weeks ago on Friday & the sore is not nearly well yet in fact it is still running a little on the inside, for she was fired outside of the leg & also— She has been the delight of Father all summer as he has done most of the riding when I was ill. I will send the portrait to Gard as I have never given him a Portrait of Father & he is disgusted because I wont send him Jennie's portrait.

I had a letter from Stott a dreadfully cheeky young English painter who was in Paris last Spring. He had been to see Whistler & saw Lois'

195

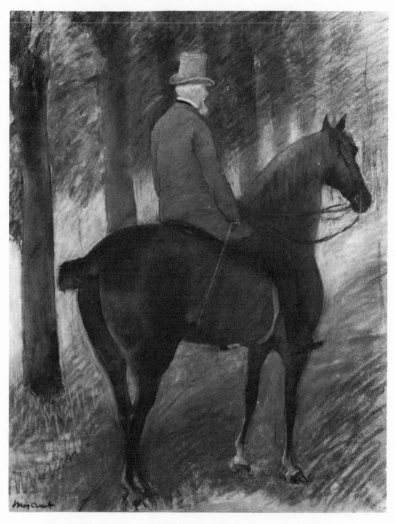

23. *Mr. Robert S. Cassatt on Horseback (Isabella)*, 1885. Pastel on paper, 35 x 28 in. Coe-Kerr Gallery, New York.

portrait which he said was very fine but not done yet, that Whistler was dreadfully distressed, but could not find a model to finish the dress with. We all take the greatest interest in the racing news, Mother seizes the paper the moment it arrives & wont give it up until she has read all about your horses, it is very funny as she does not know anything about the terms & appealed to me at first to know what a "ch c" was, I

suggested it must be a chestnut colt, but now she has it all pat although she declares that she wishes you would give it up—

We were very much surprised to hear from your letter that you had horses entered for the Grand Prix 1887; we had not seen it in the "Turf Field & &" & Mother rushed for the back no's but we found Father had given most of them to the servants to light the fires with— We are expecting a new no. to-morrow & will see your bunch at Coney Island.

The Scott party are in town but we have not seen them & do not know what their plans may be— The Fishers have gone home. Our stay here will soon be over, we have the place until the 15th Oct. & if the weather is not too bad we will stay until then— I think the place very nice & certainly it has done Mother an immense amount of good, although she will not own it, by any means, still she looks ten years younger than when you saw her, & has not see the Dr once this summer on her own account he came out once on mine. As for her rhumatism it still troubles her and I suppose always will but she can walk out to the carriage and get in by herself, also walks around the garden & we have discarded the wheeled chair for the garden— Father is as well as usual, he complains bitterly of the dullness here! I hope you are satisfied with Bertha, Rob of course delighted in showing her the farm. With best of love to the children from all & love to Lois & you

> Your affectionate Sister
> Mary Cassatt

P.S. Direct next letters to 14 rue Pierre C. Father says—you dont speak of your health so I suppose you are all right again

1. The exhibition, *Works in Oil and Pastel by the Impressionists of Paris*, took place the following spring. Alexander Cassatt lent several of his Impressionist paintings, including two by Mary Cassatt (*Reading "Le Figaro,"* page 139, and *Mrs. Cassatt Reading to Her Grandchildren*, page 159).

ROBERT CASSATT TO ALEXANDER CASSATT

> 14, rue Pierre Charron
> May 5, 1886

My dear Son,

Since I wrote you some time since about the graves of my father, and George Johnston, I have felt easier in my mind on that subject. . . . Since I wrote your mother has been very well—and so have I— Mame

though has been a good deal ailing— Something catarrous—trouble-
some and all that, but not enough to keep her indoors or interrupt
her work—until just now she has gone to bed with a very bad cold in the
head—& looking as if she had the grippe— We have been having very
fine weather but with sharp north west & north east winds— Cold-
giving weather, to the imprudent— Mame has been working very hard
lately preparing for their Exhibition which has been finally arranged &
fixed for opening 15th May[1]— They have secured a very central
position, & at a reasonable rent, in the Maison Doré Boulevard Italien—
rent 3000 fs.— Degas and his friend Lenoir Madame Manet (Morisot)
& Mame—are the parties who put up the money for the rent & are
responsible for all deficiency's in expenses, & are entitled to all profits if
there are any (needless to say they do not hope for or expect any)—the
other exhibitors being admitted free etc etc. Mame, has positively
forbidden the appearance of her name in the advertisements—neverthe-
less as you will see by the enclosed slip the papers have already got her
name as one of the exhibitors—but that is a different thing from being
one of the getters up of the affair— There are symptoms of trouble
already appearing But there always are when artists are concerned— So
it may go off well enough— Whistler, has a picture in the Salon this
year but it is not Lois' portrait. Mame, has not seen the picture but hears
that it is badly hung & has not anything remarkable in it— You will
have Mrs. Scott & family & Mrs. Riddle at home before this reaches you
I hope safe & well. . . .

I enclose an article of Scholls, one of the wittiest writers on the Paris
Press— It refers to a book that has made a great sensation already &
is probably destined to make a still greater— "France Juive" which has
already occassioned two duels & will probably give rise to a good many
suits for slander etc.[2]— Nevertheless it has hit a spot in the public heart
& roused a feeling of emnity to the Jews that has long been smoldering—
I dare say your papers will have full accounts of it— I send you Scholls
article as a *preliminary* as I propose to send you the 1st volume of the
book itself by fridays mail—

You will find that the author does not confine his anathemas to the
Jews but cuts right & left at Christians of all sexts & classes—but there
he blames all their faults on Jewish teaching— But read for yourself.

We all join in love to one & all

your affectionate père
RSC

1. The eighth *Exposition de peinture par Mme Marie Bracquemond—Mlle Mary Cassatt, MM
Degas—Forain—Gauguin—Guillaumin—Mme Berthe Morisot—MM C. Pissarro—Lucien Pissarro—*

198

Odilon Redon—Rouart—Schuffenecker—Seurat—Signac—Tillot—Vignon—Zandomeneghi was held May 15-June 15, 1886. Cassatt showed six oils and one pastel, including *Girl Arranging Her Hair*, page 130.

 2. Edouard Adolphe Drumont, *La France juive; essai d'histoire contemporaine*, Paris, 1886. Drumont's treatise was a widely read interpretation of the role of Jews in modern France; its anti-Semitic message is believed to have had an influence on the trial and conviction of the Jewish officer Alfred Dreyfus for treason in 1894.

MARY CASSATT TO LOIS CASSATT

Arques-la-Bataille,
Seine Inférieure
June 30 [1886]

My Dear Lois,

 Your letter reached me just in the midst of our preparations for leaving town & I put off answering it until we were settled here, so as to be able to give an account of the place— The weather in Paris for the last month was atrocious, we were almost afraid to leave town for fear we would find the country too damp, but the day we left was fine & since we have been here it has been delightful— I think we are a little too near the sea for Mother but she insisted upon trying it, & the house is low & sheltered— Aleck would be delighted with the country it is so like England the beautiful part of England, hedges neatly trimmed, broad meadows, & everything very green, for my part I prefer the valley of the Oise— The Bérards live about six miles & a half from here, it was partly our reason for coming, they expressed great pleasure at having us for neighbours, but they are rather far off, I rode over there to see them on Saturday, they have a pretty place an English park, they are rather isolated— André asked after Eddie I told him perhaps he would be here next year, that is in France and the oldest daughter is a little older than Katharine & would be a nice companion for her, she is growing up very pretty— The roads disappoint me very much they are good carriage roads but nothing for riding & we have to be careful of our beautiful Isabellas legs— Last summer we had two forests near us where we could gallop for miles on soft ground— Talking of horses we would like to be informed about the racing, Mother don't approve but still wishes to know all about it— The other day I had a good laugh at her, Gard sent me the New York papers with an account of the exhibition,[1] after reading about that Mother searched a good while and finely exclaimed with disappointment when she found we only had half the paper, she was hunting for the racing news! A still better story, yesterday Father had a long letter from Mrs Alden who sent him an

199

extract from one of the Chicago papers about Aleck, she said Cousin
Belle had sent it to her & that last winter Cousin B. had sent her
an account of his horses from one of the papers! He's corrupting all the
old ladies in the family—

I am glad Durand-Ruel has had some success with his exhibition.
Monet exhibited at Petits Gallery just before we left town & on the
opening day sold 7 pictures at 3000 frcs each, I am only sorry we did not
lay in more when they were at our price[2]—

I suppose you are settled at Long Branch now or will be this week &
are enjoying the sea air, it is good for the children, a very little of it is
enough for me, (it is blowing from Dieppe just now) We were all glad to
hear such good accounts of Eddie. He might practice a little letter
writing in our favor during vacation & give an account of the horses—

We will be soon looking for news of an arrival from Gard, it will
seem odd to the children to have another little Cassatt— Mother &
Father join me in love to you all

<div align="right">affectionately yours
Mary Cassatt</div>

P.S. Tell Aleck please that he's never told me what he thought of "La
Guerre et la Paix"[3] nor "La France Juive"

1. Durand-Ruel's exhibition of Impressionist art in New York. See Mary Cassatt to Alexander Cassatt, September 21, 1885, footnote 1.
2. Monet exhibited thirteen works in the V^e *Exposition internationale Galerie Georges Petit*, which opened on June 15, 1886. He sold twelve of these for a total of 15,100 francs.
3. A French version of Tolstoy's *War and Peace* (1863) was first made available in 1885. This and other Russian novels recently translated into French created a wave of interest in Russian literature.

MARY CASSATT TO ALEXANDER CASSATT

<div align="right">Arques-la-Bataille
September 2 [1886]</div>

Dear Aleck,

On Tuesday evening the paper containing the news of the "Bards"
victories reached us,[1] I was the first to open the "Turf & F" & read out
account of the races, afterwards Mother read it over to herself & the
next morning read it again, Father was very much pleased also, although
he never thinks the pace very fast & refers to the fact that Maud T trots
a mile in 2.08-3/4 & that "Flying Childers" ran a mile in a minute!
But we all congratulate you & hope that your luck may continue for a

while & that you will soon be able to retire on your laurels—

Your friend Mr F. Thompson has been in Paris & wrote proposing to pay us a visit, we replied inviting them all, & proposed they should stop here on their way to England, but when they found we were so far from Paris Mr Thompson wrote that he had not time to come & that they were going to England by Boulogne on account of some of the party being seasick; In his last letter he told us he had heard from you & was glad you had been so successful with your racing, then we had not yet received the paper so did not know the extent of the victory, Mother says to tell you that she is jealous because you wrote to tell Mr T. about it & not to her when she is so interested! Mr Thompson wanted me to send him a letter to Monet, he gave me too little time for that, so I telegraphed to Portier to call on him & as Mr T. wanted to buy one or two Monets I hoped that Portier might find a couple at a reasonable price, if Portier was not in Paris as I am afraid he is not, he will have to trust to the tender mercies of Durand Ruel, so I wrote to him—

Monet sold six or seven of his pictures during his exposition at Petits for 3000 frcs. a piece in June last. I told Portier to take a racing picture of Degas to show Mr Thompson if it was not sold, but as I said before I have no news & think Portier out of town— Father & I went to the first days races here, (between Arques & Dieppe) the ground is lovely. A beautiful green meadow with hills on either side there were not a great many people there the first day, but it was a beautiful sight, I must say I think Degas has done some very fine pictures of races, it is a pity he has given it up— We have had Isabella lame, & I have been treating her with success, that is when I dont ride her far or fast, she keeps well but if I trot too much then she limps a little the next day. It comes from a windgall on her right foreleg & the end of it will be that we will put her in the carriage & sell old Joe. She is younger & far better than he is, he is getting cranky; last spring we were going to sell him and buy another & Father went to Chines to bid on a cob that he thought would do, it seems he (the cob) was handsome, 11 years old & had windgalls too, but Father thought him worth 1200 frcs. & was prepared to pay that much for him, he sold for 5280 frcs! I am glad someone else got him & his windgalls; Father cares nothing for windgalls he says all the horses had them when he was young, the fact is all he cares for is beauty. I read out to him from the "Turf & Field" the other day, the editors remark that he preferred a plain trotter to a horse who was happiest when he was posing before the looking glass— Mother has just told me to get you to remind Eddie that he promised us a photo of the Bard— I hope Ed is well again & more careful of himself— We are all well here, Mother especially as she has entirely got over her cough since we have been here, the first time in years that she does not cough!

Father is very much as usual deafer perhaps but astonishingly well in other respects.

We are anxiously awaiting news of Jennie. Mother is rather worried about not hearing of the arrival of Ellen Mary— I hope we will soon hear that all is well— We are going to have a "grand manouvre" here this month it seems, 20,000 troops and the inhabitants are to feed them, we dont know if we will have to contribute or not.

With love from your Father & Mother & self to all

your affectionate sister
Mary Cassatt

P.S. We have just received a telegram from Gard, I am glad it is well over, but I would have been more delighted if it had been a girl[2]— Also just got a letter from Mr Thompson to tell me that Portier bought him two Monets or three, cheap, but he preferred buying one from Durand at 3000 frcs. I feel rather snubbed! I advised him to buy cheap, but I suppose he is the kind to prefer buying dear. I have very little doubt Portiers were the best pictures.

1. In 1886 Alexander Cassatt's racehorse, "The Bard," won the Preakness and every race he was entered in during August and September at Monmouth, Jerome Park, Baltimore, Coney Island, and Washington. He had a brilliant career until he was lamed in 1888.
2. Joseph Gardner Cassatt III was born on September 1, 1886.

KATHERINE CASSATT TO ALEXANDER CASSATT

14, rue Pierre Charron
Friday, December 10, 1886

My dear Aleck,

I send you by this mail a box with some little things for the children. . . . I wish you all a happy Christmas & wish I was nearer that I might see you enjoy it. . . .

We have not yet selected an apartment but Mary is busy looking about her— There are plenty of them but I seldom see one without thinking of the saying Degas once repeated to me, namely—"Bête comme un architecte" [as stupid as an architect]—and that à propos of his own brother-in-law— Why I actually saw an apartment on the 5th storey where the kitchen was so small that there wasn't room for a box large enough to hold a day's supply of wood and coal—and there was no pantry— They go on building long streets of houses whilst those of 3 or 4 years ago are many of them half empty—never have been occupied—

in this house there will be 7 apartments empty in April—two of the largest never have had tenents. I don't know what we would do without Mary to look for us—she has a knack of finding out what is to rent & don't mind scaling the stairs when the lift is not yet in working order—they have them now in most of the new houses and find it pays—

You know you are going to have Durand-Ruel in New York this winter again—he is in money trouble as usual I think but a New York house has a partner or agent here now who says there is no danger but that he will make money in America— He owned two or three of Mary's pictures which she heard he was going to take with him, but which she didn't think much of, & she asked him to exchange one of them for a new one—he took the new one & agreed to give her one back, but it was one he hadn't intended taking—she was very glad to get it, but as he seemed to like the others very much she let him take them— I hardly think she did right for it is a good while since she painted them & Degas thinks she has improved much especially in drawing— Every body concerned says there is absolutely nothing doing here in pictures and all the dealers are looking to New York to save them—

Tell Eddie he never sent us the photographs of the Bard. . . . All join in love to yourself Lois & the children and wish you a happy New Year.

Your affectionate
Mother

24. Lois Buchanan Cassatt and Edward Buchanan Cassatt at West Point.

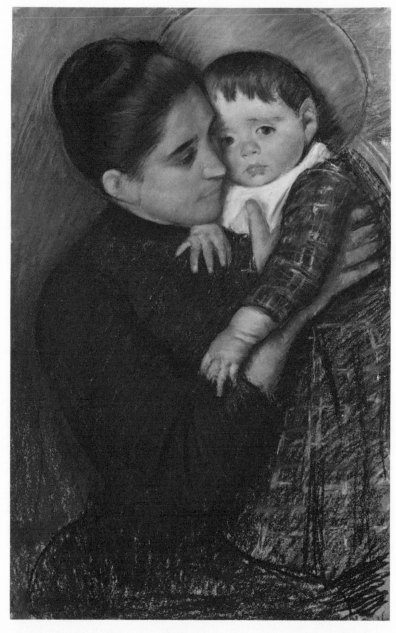

25. *Hélène of Septeuil*, c. 1890. Pastel on paper, 25 x 16 in. The William Benton Museum of Art, University of Connecticut, The Louise Crombie Beach Memorial Collection.

4

Maturity

1889-1898

For the first three decades of her career, Mary Cassatt's identity was largely shaped by the groups she belonged to. In the 1860s, she was a typical American art student; in the 1870s, she was one of the hordes of American artists working in Europe; and in the 1880s, she was a member of the French group of Impressionists. But in the 1890s, as she approached her fifties, she began to emerge as an individual. In her first one-person exhibition, in 1891, she gave the public a glimpse of her unique approach to printmaking, and in her second (in 1893), she showed a retrospective sampling of paintings, pastels, and prints that summed up her abilities in all media. When she agreed to execute a mural for the Chicago World's Columbian Exposition of 1893, she created a monumental painting that would stand out in the harsh glare of the American limelight. The artist revealed in these years was innovative, eager for new experiences, and confident of her abilities. When she saw that she had a chance for worldwide fame, she was both gratified by and disdainful of the signs of her success.

In this period, she also shed her identity as member of the Cassatt family group as her parents declined in health and died—her father in 1891, her mother in 1895. Although this meant a profound loss and years of loneliness, it also meant that Cassatt emerged as mistress of her own home, both in her Paris apartment and the country home at Mesnil-Beaufresne that she bought and renovated in 1894. With her mixture of artistic sophistication and personal simplicity,

she became a magnet for visiting intellectuals and a new wave of American art students abroad. Her personality surprised observers like the English writer Vernon Lee, who described her as ". . . nice, simple, an odd mixture of a self-recognising artist, with passionate appreciation in literature, and the almost childish, garrulous American provincial."[1] This wealthy, successful woman, who could have been a leading figure in Paris society, decided instead to preserve her individuality at all costs.

Cassatt's identity as an American had a greater effect on her career in this period than it had for many years. It was responsible for a chain of events resulting in her first individual exhibition, and it gave her the opportunity to try her hand at large-scale mural painting. While these honors led in Paris to her second individual exhibition and greater success, in America the result was more complicated, forcing Cassatt to pay more attention to her reputation in her own country.

Cassatt's first individual exhibition came about after she had been exhibiting prints for two years with a group of friends: Degas, Pissarro, Fantin-Latour, James Tissot, Rodin, Odilon Redon, and others. They had been organized into the Société des Peintres-Graveurs (Society of Painter-Printmakers) by Félix Bracquemond, who had worked with Cassatt, Degas, and Pissarro on *Le Jour et la nuit* ten years before. The Société held their annual exhibitions at Durand-Ruel's gallery, reviving the spirit of the discontinued Impressionist exhibitions. As in the past, Cassatt threw herself into her work, experimenting with etching and drypoint (see figure 26) to produce black and white prints that she pulled on her own press. In 1890 she, Pissarro, Morisot, Tissot, and others became interested in adding color to the prints, and their research was given a boost by the spectacular exhibition of Japanese color woodcuts held that spring at the Ecole des Beaux-Arts. However, when time came for the third exhibition of the Peintres-Graveurs, in 1891, the French artists were overcome by a wave of isolationism and declared that non-French artists could exhibit by invitation only. Although Pissarro (who was from the West Indies) and Cassatt would certainly have been invited, they took offense and chose to hold their

1. Vernon Lee to Kit Anstruther-Thomson, July 28, 1895, quoted in Frederick Sweet, *Miss Mary Cassatt, Impressionist from Pennsylvania*, p. 143.

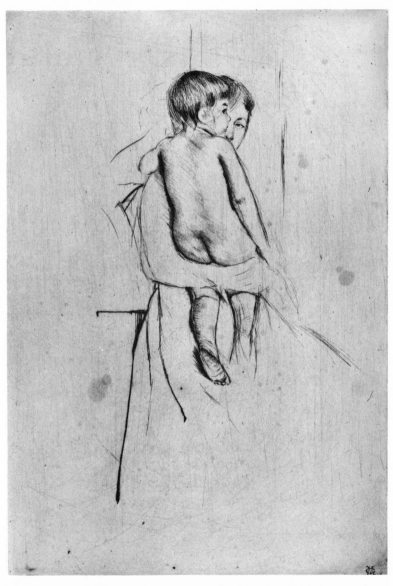

26. *Baby's Back*, 1890. Drypoint, 9³⁄₁₆ x 6⁷⁄₁₆ in. The New York Public Library,
S. P. Avery Collection; Astor, Lenox, and Tilden Foundations.

own separate showings in rooms adjacent to the group's at the
gallery. Seizing the opportunity, Cassatt parlayed her nationality
into an unexpected asset.

The next year, when officials of the Columbian Exposition were in Paris looking for an American woman artist to execute a large mural for the Woman's Building, Cassatt's name came up. A few years before, while the Impressionist exhibitions were still being held, she might have been considered too far out of the mainstream for such a commission. But in 1892, after she showed her series of color prints and four mother and child pictures (see page 204) in her first solo exhibition, she appeared more moderate in style and more prominent as an American.

Mrs. Potter Palmer, president of the Board of Lady Managers, wanted the Woman's Building to demonstrate the great strides that women had taken in modern times. Women's achievements in the fine arts were to be prominently displayed in the large "Hall of Honor" of the woman-designed building. At the ends of this hall, just under the curved glass roof, were to be two 12-by-58-foot murals, one depicting "Primitive Woman" (still in a state of servitude), the other showing "Modern Woman," free to pursue knowledge, art, and fame. Bertha Palmer, with the help of an American art agent in Paris, Sara Hallowell, chose appropriate artists for these two opposing states of womanhood. Mary Fairchild MacMonnies— who had studied the style of the classicizing muralist, Puvis de Chavannes—was equipped to evoke an image of the ancient world, while Cassatt, whose radical style stressed a close study of modern life, was a perfect candidate for "Modern Woman." Unfortunately, even though the artists' styles were appropriate to their subjects, they were not appropriate to each other. If Cassatt's mural had been seen (as her work usually was) in the midst of other Impressionist paintings, it would have seemed quite tame, but in this setting, surrounded by academic allegories, it was distinctly out of place. Its exaggerated colors, idiosyncratic borders, and abstracted figures attracted a great deal of criticism.

Cassatt herself was dissatisfied with the large painting, which had required a special studio with a large trench in the floor into which the painting was lowered for work on the upper regions. So much special equipment and assistance was needed for this cumbersome giant that Cassatt felt it was impossible to achieve good results in the short time allotted. But overall, she was glad to have had the experience and pleased with the store of sketches and designs generated by the mural (see figure 27), which she could use for future

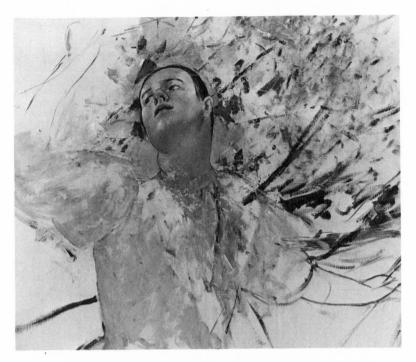

27. *Sketch of a Young Woman Picking Fruit*, 1892. Oil on canvas, 23½ x 28¾ in. Mr. and Mrs. Sigurd E. Anderson II, Des Moines, Iowa.

paintings and prints. In the end, the works that grew out of the mural project would be more lasting (the mural only survived the duration of the fair) and more important to her career.

Cassatt unveiled the mural-based paintings to great acclaim in her second individual exhibition at Durand-Ruel's, in November 1893. These paintings, shown with other paintings, pastels, and prints from the past fifteen years, demonstrated so definitively her stature as an artist that the French government requested an example of her work for the official collection of modern art in the Palais du Luxembourg. For an Impressionist artist, this was an opportunity to gloat, since only recently had their work begun to gain acceptance in official art circles. In view of their past stormy relationship with the Luxembourg, the Impressionists had ambivalent reactions to being so honored, and although Renoir let the state have a painting he showed in the Salon of 1892, Degas absolutely refused the request when it came to him the same year. Cassatt was pleased when the

Luxembourg approached her in 1893, but when the negotiations fell through because of a technicality, she assumed a scornful attitude toward the whole incident. In 1897, when the matter came up again, she quietly donated a pastel mother and child, which is now housed in the Louvre.

Cassatt's reputation in America was another matter. When she had become involved with the Impressionists, she had gradually stopped sending her work to exhibitions, dealers, and auction houses in the United States. Then, when Durand-Ruel began to exhibit and sell her work, with that of the other Impressionists, across the Atlantic, she was forced once again to consider how her art was being received in her own country. At first she was gratified to see how popular her black and white drypoints were with American collectors like Samuel P. Avery. But when Durand-Ruel tried to sell her color prints in New York, she was shocked to see that they were a complete failure. The coolness of the New York public was so daunting that Durand-Ruel put off holding a large exhibition of her work there until 1895. The difference between her reception in Paris and her reception in New York could not have been more marked.

But although Cassatt would have liked recognition in her native land, she refused to compromise to achieve it. When she embarked on the "Modern Woman" mural, for instance, she was thrilled to have gotten the commission—more because it was an artistic challenge than because it promised fame. Although she claimed that she wanted to cooperate with the fair officials, actually she asserted her independence every step of the way. She came close to resigning three months into the project because they requested a sketch, which she categorically refused to send. Consequently, neither the committee nor her comuralist had any idea what she had devised until the painting was almost finished. By then it was too late to prevent Cassatt's mural from clashing with its mate and with the rest of the decorations. Cassatt charmed them all with her explanations of what she had done, but made no effort to sacrifice any of her individuality for the good of her reputation. Moreover, she refused to allow her name to be used on the International Board of Judges, which would have boosted her fame back home and promoted the cause of women artists. And finally, when the mural was finished, she sent it off to Chicago without the least curiosity to see it in

place, and without the least desire to enjoy a triumphal return to the city where her paintings had burned over twenty years before.

Cassatt was much more interested in raising the quality of art in America than in promoting herself there. She was now more convinced than ever that *good* art (both Old Master and modern) should enter American collections whenever possible. She fanned the flames of the Havemeyers' collecting fever and encouraged others like the Potter Palmers and the John H. Whittemores to purchase art abroad. The growing outcry in France and Italy against the loss of European art treasures did not deter her; in fact, it may have egged on her only form of American chauvinism. When her friends—Monet, Degas, and others—campaigned successfully to keep Manet's *Olympia* from leaving the country in the hands of an American collector, she openly contradicted them, saying, "I wish it had gone to America."

Cassatt also contributed to the quality of art in America by taking under her wing young American artists abroad. Some were sent to her by her old colleague J. Alden Weir, who was now teaching at the Art Students League in New York; others were introduced by family friends. While she never took on students herself, she directed them to what she considered the best learning opportunities in Europe. She urged them to follow the path she had taken: avoid the deadening art schools in Paris, go out to the countryside to paint with a master like Pissarro or Armand Guillaumin, travel in Italy and Spain, and above all—study the Old Masters.

She became fond of these Americans like John H. Whittemore, Rose Lamb, and Eugenie Heller, using them to enlarge her circle of friends at a time when her family was shrinking. To them she wrote of her personal troubles as she suffered through her mother's last days. She faced the impending separation with profound sadness and resignation, writing, ". . . the depression is at times very great. In fact life seems very dark to me just now. . . ." When her mother died, her family and friends rallied around her, and although she benefited from their company and made an effort to keep active with her work, it was, as she described to Eugenie Heller, a time when she "was in great trouble."

Another relationship that flourished in these years was with Paul Durand-Ruel, the indefatigable dealer of Impressionist art. Brought

together by their mutual interest in building American collections, they became personal and business friends. Of the utmost importance to her in these years was his confidence in her as an artist and his willingness to take her work on a regular basis. The contractual arrangement that they worked out provided her with a reliable outlet for her work and the regular income that she needed to finance her travels and maintain her country house. During this decade he established patterns of judicious dissemination of her work in the United States and Europe that led to an enduring international reputation.

In the spring of 1887 Mary Cassatt moved with her parents into the apartment at 10, rue de Marignan (a block off the Champs-Elysées) that she would keep for the rest of her life. That summer they returned to the resort town of Arques-la-Bataille near Dieppe, where the Alexander Cassatts were also vacationing. The following summer was disrupted by a broken leg that Mary suffered from a horseback riding accident. After recuperating in Paris during the winter, she took her family to stay in the country at Septeuil, west of Paris, during the summer of 1889.

MARY CASSATT TO CAMILLE PISSARRO

10, rue de Marignan
November 27 [1889]

My Dear Mr. Pissarro,

Thanks so much for your kind letter, yes. I am quite well again &
have almost forgotten my broken leg[1]— We had a very pleasant place
this summer at Septeuil[,] the house of Chintreuil where, he is buried[2]—
& Lovely country—

I have heard nothing of an exhibition,[3] but am working at my etchings,
& have a printing press of my own which I find a great convenience, & a
great pleasure, one ought to print all one's own plates only it is too hard
work— The friends who were inquiring about etchings were Mr &
Mrs Havameyer[4] who bought so many pictures, they had the misfortune
to have a child fall ill with mucous fever & were so anxious about her
that they did not have time to see anything before they left— However
I spoke to Durand Ruel about it & told him to show them your etchings
in New York— Durand is doing very well in America[5]— As to the
Manet subscription I declined to contribute.[6] M. Eugène Manet[7] told me
that an American had wished to buy the picture & it was to prevent
its leaving France that the subscription was opened. I wish it had gone to
America—

Come & see me when you are in Paris & we will talk over an exhibi-
tion, it is time we were doing something again.

With kindest regards to Madam Pissarro & compliments from my
Mother

Very sincerely yours
Mary Cassatt

1. Degas wrote about the accident to his friend Henri Rouart [summer 1888]: " . . . poor
Mlle Cassatt had a fall from her horse, broke the tibia of her right leg and dislocated her left
shoulder. . . . She is going on well, and here she is for a long time to come, first of all
immobilized for many long summer weeks and then deprived of her active life and perhaps also
of her horsewoman's passion.

The horse must have put its foot in a hole made by the rain on soft earth. HE [Mr. Cassatt]
hides his daughter's *amour-propre* and above all his own."

Marcel Guerin, ed., *Degas Letters*, pp. 125-26.

2. Antoine Chintreuil (1814-1873) had been a popular landscapist in Cassatt's youth. His
house at Septeuil was called "Tournelles."

3. Cassatt and her friends renewed their interest in printmaking in the late 1880s and were
given an opportunity by Durand-Ruel to exhibit their work in the winter of 1889. He hosted
the *Exposition de Peintres-Graveurs* at his gallery from January 23 to February 14, 1889. Over a
year later, he gave them another exhibition, *Deuxième Exposition de Peintres-Graveurs*, which
was held March 6-26, 1890.

4. The Havemeyers arrived in Europe in June 1889.

5. Durand-Ruel established a New York branch in February 1888.

6. In 1889 Monet instigated a fund-raising project to buy Manet's *Olympia* by subscription and present it to the French state. He managed to raise 20,000 francs to acquire the painting from Manet's widow; he thus kept it from leaving the country and at the same time forced the Louvre to accept a painting by this notorious artist.

7. Eugène Manet was the brother of the painter Edouard Manet and the husband of Berthe Morisot.

MARY CASSATT TO BERTHE MORISOT

10, rue de Marignan
Tuesday [April 1890]

Dear Madame Manet,

Thank you very much for your letter and for your offer to look for a retreat for us for this summer, but we have Septeuil. At any rate we will be neighbors and I promise you I am not sorry to be returning there and to be spared the trouble of investigating other estates. We have rented it from the first of June and I hope that we will be able to move in on that day, I am eager to be in the country. A thousand thanks for your kind invitation. I haven't seen "la belle Louise" to deliver it for you but I know that for the moment she is making a dress for the wedding and she is completely absorbed in this occupation, and doesn't even have the time to see her friends; also I think she is vexed with me because Melle Germaine repeated to her that I believed she would *never marry!*

I think that for the time being I am not able to go and have lunch at Mezy, but if you would like, you could come and dine here with us and afterwards we could go to see the Japanese prints at the Beaux-Arts.[1] Seriously, *you must not* miss that. You who want to make color prints you couldn't dream of anything more beautiful. I dream of it and don't think of anything else but color on copper. Fantin was there the 1st day I went and was in ecstasy.[2] I saw Tissot there who also is occupied with the problem of making color prints.[3] Couldn't you come the day of the wedding, Monday, and then afterwards we could go to the Beaux-Arts? If not that day then another and just drop me a line beforehand. My mother sends her compliments and I send a kiss to Julie and my best regards to Monsieur Manet.

Yours affectionately
Mary Cassatt

P.S. You *must* see the Japanese—*come as soon as you can.*

214

Original in French.

1. An exhibition of 725 Japanese prints from French collections opened at the Ecole des Beaux-Arts on April 15, 1890. It was organized so as to show the history of the "Ukiyo-e" (colored woodcuts of scenes of Japanese daily life and amusements) in the eighteenth and nineteenth centuries.

2. Henri Fantin-Latour (1836-1904) studied with Courbet and was part of the Realist movement of the 1850s and 1860s in Paris. He was a friend of many of the Impressionist artists although he did not exhibit with them.

3. James Joseph Jacques Tissot (1836-1902), a painter and etcher, was an old friend of Degas who moved to London in 1871. He was very successful with his etchings, publishing a major series on the life of Christ in 1895.

MARY CASSATT TO GEORGE A. LUCAS[1]

<div align="right">

Septeuil (Seine-et-Oise)
[June 1890]

</div>

My Dear Mr. Lucas,

You would have heard from me before now, & I would have sent you the drawing for Mr Avery[2] if I had not had another accident— I was thrown from my carriage on the stones at the corner of the rue Pierre Charron & the Place de Iena & as I alighted on my forehead, I have had the blackest eye I suppose any one was ever disfigured with— The carriage was kicked to pieces the coachman pitched out & even the dogs wounded; & all because a man driving a van thought he would amuse himself cracking his whip at my cobs head, finding it frightened her. He leaned out of his wagon & continued his amusement until he drove her nearly mad with fright & then he drove off smiling!

Fortunately none of our wounds were very serious— I am well again but still with patches of red & blue on my forehead & around one eye— As soon as the Doctor would allow me, we came here where I am beginning to work & hope if nothing else happens to soon send you the drawing in question— Mr Avery wrote me a very kind letter, won't you, if you write to him mention why I have not answered him— I was very sorry to hear of his bereavement Mrs. Havameyer had told me of it.

Hoping that you are well & enjoying the sunshine as we are here believe me

<div align="right">

very sincerely yours
Mary Cassatt

</div>

1. George A. Lucas (1824-1909), from Baltimore, acted as an art agent in Paris, especially for American collectors, from 1857 to 1909.

2. Samuel Putnam Avery (1822-1902) was an engraver, a collector, and an advisor to other American collectors of art. He was one of the founders of the Metropolitan Museum of Art.

Septeuil
[June 22, 1890]

Dear Madame,

I am sending you by way of our gardener's mother a parcel of a book containing *The Romance of Dollard*.¹ I believe that Madame Gobillard² will find it an interesting subject for translation, since it treats a historical event concerning some little-known Frenchmen. I hope that everything is going well at your house; we have been at Septeuil for only eight days having been delayed by a carriage accident which left my head in a fine state, I still have a black eye— We are going to Paris for a few days. But I hope to go to see you when I return, or set a time for you to come see Septeuil. My mother sends her compliments and I send mine to Monsieur Manet and Mademoiselle Julie, affectionately yours,

Mary Cassatt

Original in French.
1. Adam Dollard des Ormeaux (1635-1660) was a romantic hero of early Canadian history. Arriving in Montreal in 1658, he led the French troops in a famous but futile battle to protect the city against the Iroquois.
2. Yves Morisot Gobillard was Berthe Morisot's sister.

KATHERINE CASSATT TO ALEXANDER CASSATT

10, rue de Marignan
January 23, 1891

My dear Aleck,

Though we have no letter from you we take it for granted that it is to you we are indebted for the good things we received yesterday evening and which we have been enjoying today. I think you would have laughed had you seen your father & Mary lunching on the oysters which were excellent—they ate so many that they had to wait between the plates full & I had to explain to your Father that the oven only held a certain quantity. The apples are beautiful, but I suppose they have been sometime en route for a good many are partly spoiled—and the sweet potatoes that were not spoiled were excellent. I think it likely that as they came by Antwerp (I suppose they did) & the river was frozen they have been longer reaching Paris than usual. Your father & Mary join me in thanking you for all those good things— I received letters from

Katharine, Elsie, Rob who seem to have enjoyed Christmas immensely; Poor Ed I suppose had to content himself with plum pudding at West Point.

You will have seen by the papers that we have had so far a very cold winter—two days ago a thaw set in which I hope will last for although at home we often have the thermometer down much lower, the air here is so much damper that the cold seems to penetrate to the bones— I heard of a lady who had her nose frozen whilst she was out paying visits.—she knew nothing of it until a lady on whom she was calling said "Why your nose is blue" and ran for a remedy— Mary had her chin touched by the frost and it is still sore to the touch though it is now nearly a week ago— The mortality among old people is great—the first week of this month 444 people died all over 60 years of age—this is considerably over one third of the deaths that week—and the rate that week was higher than usual—

Your Father has been very prudent for although he hates staying in the house he has been often ten days without taking a walk! Mary has been quite as busy as she was last winter—but this time it is with *colored* "eaux-forts" [etchings] & not with etching. It is very troublesome also expensive & after making the plates of which it takes 2 or 3 or 4 (according to the number of colors required), she has to help with the printing which is a slow proceeding and if left to a printer would not be at all what she wants. I am not sure that they will be so much liked by the public as the dry points, but that can not be known until the exhibition takes place in the spring.[1]

I see by the *Sunday Times* (a horrid paper to which your father subscribed three years ago) that the young people are having a wonderfully gay winter and that Katharine & Lois are enjoying it— also Jenny— Gard it seems has retired from gay society—prefers his bed after nine o'clock.

We have never heard whether the cook was a success or a failure— dont forget to mention it when you write, as first you thought she was improving—

With best love to all I am your affectionate

Mother

1. The group that Cassatt had exhibited with in 1889 and 1890 had recently decided to call themselves the "Société des Peintres-Graveurs *Français*" and to include foreigners by invitation only. Cassatt and Pissarro were so offended that they decided to hold their own exhibitions side-by-side with the original group at Durand-Ruel's. Both exhibitions were held in April 1891.

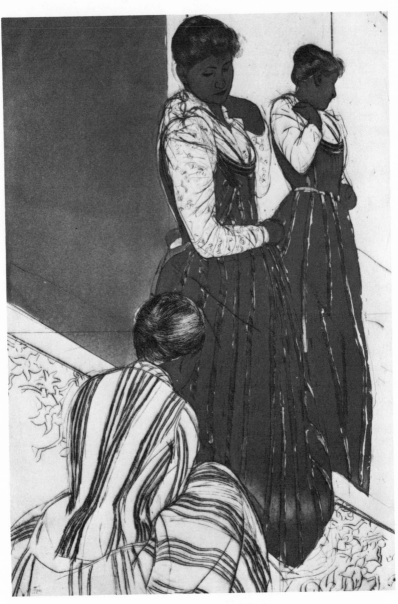

28. *The Fitting*, 1891. Aquatint, first state, 14⅞ x 10⅛ in.
The Art Institute of Chicago.

CAMILLE PISSARRO TO LUCIEN PISSARRO [1]

Paris
April 3, 1891

My dear Lucien,

It is absolutely necessary, while what I saw yesterday at Miss Cassatt's is still fresh in mind, to tell you about the colored engravings she is to show at Durand-Ruel's at the same time as I. We open Saturday, the same day as the patriots, who, between the two of us, are going to be furious when they discover right next to their exhibition a show of rare and exquisite works.

You remember the effects you strove for at Eragny? Well, Miss Cassatt has realized just such effects, and admirably: the tone even, subtle, delicate, without stains on seams: adorable blues, fresh rose, etc. Then, what must we have to succeed? . . . money, yes, just a little money. We had to have copper-plates, a *boîte à grain*, this was a bit of a nuisance but it is absolutely necessary to have uniform and imperceptible grains and a good printer. But the result is admirable, as beautiful as Japanese work, and it's done with printer's ink! When I get some prints I will send you some; incidentally I have agreed to do a series with Miss Cassatt; I will do some *Markets, Peasant Women in the Fields*, and—this is really wonderful—I will be able to try to put to the proof some of the principles of neo-impressionism. What do you think? If we could make some beautiful engravings, that would really be something.

I have seen attempts at color engraving which will appear in the exhibition of the patriots, but the work is ugly, heavy, lusterless and commercial. I am certain that Miss Cassatt's effort will be taken up by all the tricksters who will make empty and pretty things. We have to act before the idea is seized by people without aesthetic principle.

This is a bad moment for me, Durand doesn't take my paintings. Miss Cassatt was much surprised to hear that he no longer buys my work, it seems that he sells a great deal.— But for the moment people want nothing but Monets, apparently he can't paint enough pictures to meet the demand. Worst of all they all want *Sheaves in the Setting Sun!* always the same story, everything he does goes to America at prices of four, five and six thousand francs. All this comes, as Durand remarked to me, from not shocking the collectors! True enough! What do you want, I replied, one has to be built that way, advice is useless. But while waiting we have to eat and pay our debts. Life is hard!

1. Camille Pissarro, *Letters to His Son Lucien*, pp. 196-97. Lucien Pissarro (1863-1944), Camille Pissarro's artist son, was living in England.

CAMILLE PISSARRO TO LUCIEN PISSARRO[1]

<div style="text-align: right">Eragny
April 25, 1891</div>

My dear Lucien,

Before leaving Paris I went to see Miss Cassatt. I watched her make color prints of her aquatints. Her method is the same as ours *except* that she does not use pure colors, she mixes her tones and thus is able to get along with only two plates. The drawback is that she cannot obtain pure and luminous tones, however her tones are attractive enough. We will have to make a more definitive trial of our own method to determine which is to be preferred.— We had a long talk about the problem of selling pictures, I told her about my position *vis-à-vis* Durand; she is incensed at Durand on her own account and asked me if I would go along with her if she left Durand. We will probably exhibit with Degas. She will use all the influence she has to push our paintings and engravings in New York, she is very desirous of upsetting Durand. She has a lot of influence and Durand, who suspects that she is irritated with him, is trying to calm her down with promises and offers which he does not make good. Degas also is very irritated, he too has plans which bode no good for Durand. I am making some lithographs, Meyer would like to have them, the deal will really amount to something. If only I could drift for a while. I hope Miss Cassatt will get something of mine sold, she liked my three canvases very much and wanted to see them in their frames at Portier's.— Will anything come of it? I have had so many disillusionments that I don't dare expect too much. I don't depend on Portier at all, he cannot replace Théo van Gogh.[2] I think some good exhibitions would help us, particularly in New York. I believe Miss Cassatt is beginning to understand my recent work, she never before was as enthusiastic as this last time.

1. Pissarro, *Letters*, pp. 204, 206.
2. Théo van Gogh (1857-1891), Vincent's brother, had been director of the Parisian art gallery Boussod & Valladon.

MARY CASSATT TO CAMILLE PISSARRO

<div style="text-align: right">10, rue de Marignan
Thursday [June 1891]</div>

My Dear Mr Pissarro,

I have been applied to, to know if you would take pupils & if so whether they could be lodged at Erragny & at what expense— Also how much your charge would be for lessons, or rather "conseil."

Please let me know as soon as possible, as these young girls are waiting for an answer, & I ought to have written to you long ago about it.

I was at Trie on Tuesday but the place is too expensive for us.

with sincerest regards
Yours
Mary Cassatt

Although I am long in writing, the reason was I hoped to see you—

MARY CASSATT TO SAMUEL P. AVERY

10, rue de Marignan
June 9 [1891][1]

My Dear Mr. Avery,

I thank you very much for your kind letter, it is delightful to think that you take an interest in my work. I have sent with the set of my coloured etchings all of the "states" I had, I wish I could have had more but I had to hurry on and be ready for my printer, when I could get him— The printing is a great work; sometimes we worked all day (eight hours) both, as hard as we could work & only printed eight or ten proofs in the day. My method is very simple. I drew an outline in dry point and transferred this to two other plates, making in all, three plates, never more, for each proof— Then I put an aquatint wherever the color was to be printed; the color was painted on the plate as it was to appear in the proof. I tell you this because Mr. Lucas thought it might interest you, and if any of the etchers in New York care to try the method you can tell them how it is done— I am very anxious to know what you think of these new etchings. It amused me very much to do them although it was hard work.

Mr. Durand-Ruel is going to have an exhibition of my work pictures pastels & etchings in the fall, in New York. Will you be so kind as to lend him some of my early etchings? You are the only person who has everything that I have done in that line—

I received the Annual Report of the Metropolitan Museum you were so kind as to send me. I should like very much to give something to the Museum, but I don't feel as if I were well enough known yet at home to make it worthwhile. After my exhibition if I have any success with the artists & amateurs I will certainly present something to the Museum if you think they would care to have it.

Again thanking my dear Mr. Avery for your kind sympathy believe me.

Very sincerely yours
Mary Cassatt

1. There is some question as to the date of this letter. The Brooklyn Museum puts it in 1903, but the content suggests 1891.

KATHERINE CASSATT TO ALEXANDER CASSATT

> Bachivillers par
> Chaumont-en-Vexin (Oise)
> July 23, 1891

My dear Aleck,

We have no word yet of Eddie's having sailed but are in hopes he will soon arrive—he said he could probably leave on the 15th but perhaps not until the 22nd in which case he is not due for a week— We came out on the 2nd Mary & I driving out stopping over night at Pontoise—your father came the next day when we were here to receive him—he bore the journey very well although he complains of great weakness: his legs are still very much swollen up to the knees & even higher up & he is very short of breath but has no pain—his appetite is good but as he persists in thinking that it is from the stomach that all the trouble comes he is afraid to eat much especially in the evening—he takes a drive nearly every day but as the weather has been cool he regrets leaving Paris though this place is very pretty—that is the garden & park in which there are some very fine trees— I think the air must be good for we all have good appetites—the house (chateau they call it) is not large only about 100 years old & but scantily furnished but we are comfortable & our landlord & his mother who live close to our gates are very obliging & honest people—plain farmers but very rich they tell us and have 600 hectares (about 1500 acres I think). Mary is at work again, intent on fame & money she says, & counts on her fellow country men now that she has made a reputation here— I hope she will be more lucky than she is in horseflesh—her new horse has been down—this time when driving him— We thought he was perfectly sure footed but he has a thin skin & the flies set him crazy so that in knocking his head about and twisting about to bite them he came down—one knee is sure to be marked & of course his value if sold greatly diminished— Mary firmly believes she has bad luck & it looks like it—happily for her she is immensely interested in her painting & bent on doing something on a larger canvas as good as her pictures of last summer which were considered very fine by critics & amateurs, one of them could have been sold ten times but Durand-Ruel said he bought it for himself—you will probably see that one in New York next fall or winter. After all a woman who is not married is lucky if she has a decided love for work of any kind & the more absorbing it is the better—

Tell Elsie that her grandfather said yesterday that he ought to answer

her letter but he really hadn't the courage—in a day or two he will be 85
& she must excuse him & write soon again as he is much pleased when
he hears from her— I didn't tell you that he sleeps a great deal in his
chair & sometimes in the carriage—indeed he has failed greatly since you
saw him last summer. . . .

With best love to Lois & the children I am your affectionate

Mother

ROBERT CASSATT TO ALEXANDER CASSATT

Bachivillers
July 28, 1891

My dear Son,

I have yours of the 13th inst. It is a disappointment *certainly* Edd's not
coming, but I think in view of the short time he had allowed himself
for the voyage and visit he has done wisely not to risk it, as any
little accident might have prevented his answering at roll-call on the
28th. Besides if he had risked it he would have been worried all the time
with a desire to do something or another that he must forgo for want of
time. Up to ten days ago I had been counting with some certainty on the
pleasure I should have in seeing him again. Since then however I have
been prepared for what you tell me— I shall probably now never see
him again in this world. Give him my kindest love and tell him
with what pleasure I heard of his well doing— May God bless and keep
him and help him to become a good and useful man.— You do not
mention your health or that of any of the family so I take it for granted
that you were all well. Mary's Etchings for you and Gard were sent to
Potiers, the Packer & Shipper on the 10th of June with orders to
send them direct to Philadel[a]. Potier is the man who ships & packs for
Durand Ruel & has always sent Mary's things and no doubt they
have been sent all right. It takes a longer time to go by Philad[a] than
by New York, but Mame, has an idea that it saves you trouble to receive
them direct than through New York— However best inquire about
them and if there is anything wrong write us at once— Durand Ruel, is
still getting orders for sets and Mame invitations from different
societies to exhibit with them— This morning she has one from a
Holland Society which she intends to decline because she would have to
go into Paris and she wont take the trouble to do so!— We are very
comfortably placed here, in all essentials as much as we were at Septeuil
and in some respects much better— The country is finer and the
roads infinitely better and more varied— I often, when driving about
think of Elsie, and her pony tandem and how she would delight in their

223

smoothness and gentle windings. Vexin is a great and gently rolling plain extending from Chaumont to the gates of Rouen how wide I do not know.— It is a very nice district of pasturage as well as grain producing— In no part of France that we are acquainted with have I ever seen before so many & such fine cattle in the fields— Our rent is cheaper than at Septeuil—2300 frs only—*nothing* to pay the gardner & a full supply of fruit & vegetables free— Our landlords are noble— "Crevecoeurs" by name, very rich & very unpretending—large landed proprietors— They retain in their own hands a home farm of 1200 acres and their people supply us with excellent rich milk at 3 sous bottle or quart and the gardner brings us every morning an ample nay generous supply of fruit and vegetables— The Chateau though by no means so large as that of Septeuil is nevertheless large and convenient with two salons—dining room billiard etc on 1st floor and I do not know how many chambers on 2nd—more than we require however. The house is dry and the Park very pretty with some admirable Lindens in it etc— We are 4 miles from Chaumont but the road is so fine & finely graded that we do it without trouble in 25 minutes— That is as much as you will care to hear about it—and will I know have some trouble to decypher it all. Since I wrote you your mother & Mame have been pretty well—not so with me— I have been *very* unwell I may say ever since we came out— I need not particularize— Old age—general breaking up. . . . Why I keep on telling you all this I dont know so I stop with a God bless & keep you all

> Your aff père
> RSC

MARY CASSATT TO PAUL DURAND-RUEL

> Bachivillers
> [September 1891]

My Dear Mr. Durand-Ruel,

I have just had a note from M. Zilcken asking to know the price of my colored etchings. Will you be so kind as to send him the price? I wrote that the etchings did not belong to me but that I would write to you to let him know.

Hoping you have had a pleasant summer, believe me yours very sincerely,

> Mary Cassatt

Original in French.

MARY CASSATT TO PAUL DURAND-RUEL

Bachivillers
[September 1891]

My Dear M. Durand-Ruel,

I have just received a note from Miss Paget, who under the "nom de plume" of "Vernon Lee" is one of the most celebrated English writers.[1]

Miss Paget writes on Art very learnedly & is most anxious to see some of Degas pictures. I told her to ask for you [at] rue Lafitte & that I had no doubt you would show her your private collection. Could you get her permission to see Faure's collection?[2] I have written to tell her that I would ask you to be so kind. Miss Paget lives in Florence during the winter. She has a friend, a Miss Anstruther Thompson travelling with her—

Hoping I am not troubling you too much & with kindest regards to your daughters

Yours very sincerely

Mary Cassatt

1. Violet Paget (1856-1935) was a prolific writer on aesthetic and literary matters. Some of her works published before 1891 were *The Countess of Albany*; *Belcaro: Essays on Sundry Aesthetical Questions*; and *Baldwin: Being Dialogues on Views & Aspirations*.

2. Jean Baptiste Faure (1830-1914), the great French baritone, had become friendly with Manet and the Impressionists in the 1860s. He was a major collector of Impressionist art from the earliest days of the movement.

MARY CASSATT TO CAMILLE PISSARRO

10, rue de Marignan
Sunday [November 15, 1891]

My Dear Mr. Pissarro,

I write to you to ask you a favor— I have a young lady friend here in Paris, who has come in from Florence to see me & consult about her art studies. She paints already & has great feeling for art & is a great admirer of yours. I suggested that she had better see you & ask if you would be willing to give her conseil & advice next spring. In that case she would return to France in June & settle for the summer near you at Erragny— Will you allow her to go & see you with her maid & will you tell her how she can live at Erragny?

If you will do so—please send me a line as soon as you get this & I will send her to you the next day— I hope you have had a pleasant summer, we were delighted with Bachivillers but my Father is very ill, so ill that

we are in constant fear of the worst. With kindest regards to your family
& yourself.

<div align="right">Believe me yours most sincerely
Mary Cassatt</div>

My friends name is Melle Fabri—her brother is also an artist & wishes
to join her next summer

MARY CASSATT TO CAMILLE PISSARRO

<div align="right">10, rue de Marignan
Tuesday [November 17, 1891]</div>

My Dear Mr. Pissarro,

Thank you very much for your very kind letter which I at once took to
Melle Fabri. I think you will find her a very different person from any
Americans you have yet seen. She wishes to go to see you on Thursday
& I will if I can, accompany [her;] if not she will go with her maid. I am
very glad to hear that your eye is doing so well, I hope this winter will
pass comfortably for you. I envy you being in the country, every year it is
harder to have to come back to town.

<div align="right">Very sincerely yours
Mary Cassatt</div>

If the express of 9.15 is still running we will go by that & after looking
around Gisors will go out & see you—

MARY CASSATT TO ALEXANDER CASSATT

<div align="right">[black border]
10, rue de Marignan
December 17 [1891]</div>

Dear Aleck,

Neither Mother nor I have felt able to write to you since Father's
death.[1] It was very sudden at the last, the Doctor told me he would, he
thought, be able to go out again & that he saw no danger. That was the
week Jennie was at sea, but he was taken with paralysis of the brain
on Sunday & never recovered consciousness— I think he for an instant
recognized Jennie & the baby, but we cannot be sure, he seemed asleep
& so quiet all Tuesday that the baby went into his room & said "Poor
Grandfather has a bad headache." He seemed to sleep naturally but there

were slight convulsions before the end; both the nurses & the Doctor
assured us that he did not suffer in the least. The Doctor thinks it was a
merciful ending as if he had died from heart disease he would have
suffered very much. Madame Manet told me that her grandmother never
was able to sleep in a bed for two years before her death & she died at
ninety.

It was the cold he caught on coming back to town that made him so
ill, he got up one morning at four o'clock & opened all the windows
to give air & that after sitting over the heater.

I think if we could have gone South in the winter it would have
prolonged his life, but he would not listen to that. I don't think he had
enjoyed living since his health began to fail four years ago.

It was a great comfort having Jennie here & the baby has been a great
pleasure to his Grandmother all our friends have been very kind. We
are going South for a little, I think it will do Mother good, & I am very
much depressed in every way and long for a change.

Mother joins in love to all.

Your affectionate sister
Mary Cassatt

1. Robert Cassatt died on December 9, 1891. Before he died Mary's sister-in-law Jennie
Carter Cassatt arrived with her son, Gardner (age five).

*In 1892 Mary Cassatt and her mother began the practice of going south
for the winter. They stayed in the resort town of Cap d'Antibes on the
Côte d'Azur and then traveled in Italy, returning to Paris in April.*

MARY CASSATT TO PAUL DURAND-RUEL

[black border]
Villa St. Anne, Cap d'Antibes
(Alpes-Maritimes)
[February 17, 1892]

My Dear M. Durand-Ruel,

I enclose a note from M. Gaston Brigeau [?] who is desirous of having
one of my colored etchings. I received a similar note from M. Hirsch,
deputy at Digne. As my etchings have not sold in America, perhaps
it would be as well to sell them here separately.[1] I have answered these
gentlemen that your house has the disposal of them, such being my
arrangement with M. Charles[2]— I am greatly disappointed that there

have been no amateurs in New York, and after Monsieur Brigeau's very flattering note, I could do no less than say that I would ask your permission to sell him the proof he desires, as soon as I returned to Paris.

With compliments to your daughters, believe me very sincerely yours
Mary Cassatt

1. The series of ten color prints that Cassatt had shown in Paris in April 1891 was included in a large exhibition at Frederick Keppel & Co. in New York in October 1891.
2. Charles Durand-Ruel (1865-1892) was Paul Durand-Ruel's second son.

MARY CASSATT TO JOSEPH DURAND-RUEL[1]

[black border]
Villa St. Anne
February 18 [1892]

My Dear Sir,

I have just received yours of the 16th in reply to mine & I am afraid I expressed myself very badly or that you misunderstood me. I did not mean to advise you about the sale of the etchings & I have always been opposed to separating them. I replied both to M. Hirsch and to M. Brigeau that I had no power to sell them any proofs as the etchings were no longer my property. Only as M. Brigeau wrote me so very polite a note, I would ask your permission to give him a proof, or ask you rather to sell him one. I only thought that the etchings not having sold in America they were left on your hands. I am very glad you have any sale for them in Paris. Of course it is more flattering from an Art point of view than if they sold in America, but I am still very much disappointed that my compatriotes have so little liking for any of my work.

Thanks for the offer of the money, but I don't need it now; naturally later I shall be glad of it, as I have still my promise to Leroy to fulfill of giving him an advance sufficient to start as an independent printer.[2]

We do not return to Paris until April. I hope to come here next winter & do some etching, it is such a lovely place.

With kindest regards to M. Durand-Ruel, believe me very sincerely yours

Mary Cassatt

1. Joseph Durand-Ruel (1862-1928) was Paul Durand-Ruel's oldest son.
2. M. Leroy was considered the best copperplate printer in Paris and was used by other fine art printmakers as well as Cassatt.

[black border]
Bachivillers
June 17 [1892]

My Dear Mr. Pissarro,

I know through Portier that you are in England, otherwise as we are such near neighbours I should try & get over to see you to ask you my question instead of writing it.[1] Will you be at Erragny in August & September? I saw Melle Fabri in Florence & she & her brother still cherish the wish to be near you this summer—

We (my mother & I) are settled at Bachivillers for some months to come. I have begun a great decoration for one of the buildings in Chicago (for the Worlds Fair)— You ought to hear Degas on the subject of a woman's undertaking to do such a thing, he has handed me over to distruction[2]—

I am sorry I did not see your exhibition this winter, I heard great praise of it;[3] I hope next year we shall recommence our fight against the etchers— Mme Manet has her pictures on exhibition now at Boussod & Valladon a very charming collection.[4]

With kindest regards to your son

Yours most cordially
Mary Cassatt

I heard nothing more of the American pupil, I hope she turned out well—

1. Bachivillers is about ten miles from Eragny, where Pissarro had been taking his family since 1883.

2. A fragment of a letter from Cassatt to Louisine Havemeyer, preserved in an unpublished chapter of Mrs. Havemeyer's memoirs, elaborates on the effect Degas's reaction had on Cassatt:

I am going to do a decoration for the Chicago Exhibition. When the Committee offered it to me to do, at first I was horrified, but gradually I began to think it would be great fun to do something I had never done before and as the bare idea of such a thing put Degas in a rage and he did not spare every criticism he could think of, I got my spirit up and said I would not give up the idea for anything. Now, one has only to mention Chicago to set him off, Bartholemy, his best friend is on the Jury for sculpture and took the nomination just to tease him.

3. Cassatt had been wintering in the south of France and Italy with her mother and sister-in-law while Pissarro's exhibition was being held.

4. Morisot's exhibition was held at Boussod & Valladon on the boulevard Montmartre from May 25 to June 18, 1892. It was her first solo exhibition.

SARA HALLOWELL TO BERTHA PALMER[1]

16, impasse du Maine, Paris
July 22, 1892

My dear Mrs. Palmer,

Miss Cassatt came to see me before the enclosed letter was received.[2] It was written in the impulse of the moment after reading the contract which was received after I had left the Chateau de Bachivillers. She is convinced that you had never seen the contract and that the whole trouble was with the office of the chief of construction. Please destroy her letter which I send you in confidence, thinking you will appreciate her position the better from seeing it. In answer to your telegram received last night, I have to-day replied to you: "October completion. Submitting sketch. Terms of payment. Expenses of delivery."[3] The outlay is so enormous in doing a work like this—models & all else—, it seems to be strange for Mr. Millet (himself a painter) to O.K. such a contract.[4]

I have just written Mr. Ives that, with his approval, I would sail for America by the last of August or at latest first of Sept.[5]

Carrièr has just been decorated with the red ribbon of Legion of Honor, Rodin promoted to *Officer* of the order.[6]

With much love to you always,

devotedly yours,
Sara Hallowell

1. Bertha Honoré Palmer (1849-1918) helped her husband, Potter Palmer, to achieve great success as a Chicago real estate developer and businessman. She was the undisputed leader of Chicago society and her organizational skills led to her being named president of the Board of Lady Managers for the Woman's Building at the Exposition of 1893. In this capacity, she issued the invitations to Mary Cassatt and Mary MacMonnies to design the murals for the Woman's Building and oversaw their completion.
 Sara Tyson Hallowell (1852-1929) played an active role in organizing art exhibitions in Chicago. From her second home in Paris, she was able to introduce the latest art styles from France to art collectors and amateurs in America. She held the post of secretary to the director of fine arts for the Exposition.
2. The contract that Cassatt received after at least a month's work on the mural seemed so unreasonable to her that she wrote an angry letter to Sara Hallowell stating her objections. Apparently feeling that the tone was too harsh, she went to see Miss Hallowell before the letter arrived. Hallowell sent it on to Bertha Palmer, who apparently destroyed it as she was instructed to do.
3. Bertha Palmer's telegram evidently asked why Cassatt objected to the contract. Hallowell's reply lists all the terms that Cassatt felt were unacceptable.
4. Frank Millet (1846-1912) was head of the Department of Construction for the fair. His office issued the contracts for the decoration of all the buildings.
5. Halsey D. Ives (1847-1911) was director of fine arts for the fair.
6. Eugène Carrière (1849-1906) had begun his career as a student of Cabanel at the Ecole des Beaux-Arts, but evolved his own distinctive style of hazy monochromes, usually with a mother and child subject. He had become very successful exhibiting in the Salon in the late 1880s.

Auguste Rodin (1840-1917), a controversial artist, was recognized by this time as one of the foremost sculptors of his day.

MARY CASSATT TO SARA HALLOWELL

[black border]
Bachivillers
Friday [July 23?, 1892]

My Dear Miss Hallowell,

Your letter reached me this morning, thank you for cabling to Mrs. Palmer. I sent my cable after leaving you on Wednesday. "Contract received, conditions impossible, if maintained I must resign." I see by your letter that the stumbling block will be my not sending a sketch, and as I don't know why they should make an exception in my favor, I will wait a few days for Mrs. Palmer's answer to my cable then resign. I saw M. Ch. Durand Ruel and asked him to forward the answer from Chicago as soon as received by mail— At the same time I told him that I would cut down my canvass for my exhibition in New York.[1] He told me that he had just sold one of my pictures in Montréal, the purchaser saw the photograph. The fact is if I don't paint something for New York, I won't be able to have an exhibition there. I won't have anything to show if my pictures are to travel so far— I am very sorry for all this misunderstanding, but now that I am thrown off the track, I hardly feel as if I could get back on to it again. I am infinitely obliged to you for your sympathy & kindness in the matter.

We are having a very cool spell here, too cool for comfort, I hope it will warm up again soon & that we shall see you again at Bachivillers under a better sky—I shant have to work eight hours a day & can go about with you. My Mother joins me in kindest regards.

Ever yours most sincerely
Mary Cassatt

P.S. I think Mrs. Mc Monnies quite right about the payments, why should she advance all the money?[2] I had to pay cash as I went along.

[note on back page]:
Dear Mrs. Palmer,

That you may be *fully* informed on this subject, I conclude to send you Miss Cassatt's second letter on the subject.

Yours always,
Sara Hallowell
Paris, July 24

1. Durand-Ruel had proposed an exhibition of her work to be held in the firm's New York gallery. This exhibition did not take place until 1895.

2. Mary Louise Fairchild MacMonnies (1858-1946), born in Connecticut, had been a pupil of Carolus-Duran and a friend of the prominent French muralist, Puvis de Chavannes. She was awarded medals in major French and American exhibitions and was a member of the Society of American Artists as well as an associate member of the Société Nationale des Beaux-Arts. Her husband was the American sculptor Frederick MacMonnies.

BERTHA PALMER TO SARA HALLOWELL

Chicago
August 3, 1892

My dear Miss Hallowell,

. . . I received yesterday two letters from you enclosing one from Miss Cassatt, and I also received by the same mail a letter from Mrs. Mc Monnies returning her contract and asking to have two changes made in it, one as to the date of the delivery, the other as to the date of the payments.

Mr. Millet will willingly extend the time but you can see as well as I that Mrs. Mc Monnies' painting should be delivered some time before May first as we want the whole Building in order, and all of these important features that will require scaffolding mut be placed and out of the way at least a month before the opening so that the installations in the main gallery can be perfected. Mrs. Mc Monnies and Miss Cassatt must have their decorations here not later than the fifteenth of February or the first of March, at the last moment.

Mr. Millet says that it is the invariable rule for decorators to place their own decorations and assume the expense of it, and that he never knew of any case to the contrary. I think it is only owing to the inexperience of our decorators that they object to this.

Mr. Millet feels also that as Mr. Mc Monnies is such a very great beneficiary (he is quite sore about the difference between the compensation to architects and sculptors and to painters, the two former receiving large prices and making a profit out of their work while the latter are altogether out of pocket) and such a great gainer by the Exposition artistically and financially, that Mrs. Mc Monnies should be the last to ask for any special privileges not allowed to similar artists or to object to the terms of payment. I think this matter will not affect Miss Cassatt.

As to the date of the delivery and the submission of the sketch, Mr.

Millet waives the conditions of the previous contract and Mr. Burnham will appoint you the agent to accept the sketches of Mrs. Mc Monnies and Miss Cassatt; I, of course, am equally willing to trust to your taste and discretion.

I think these concessions will perhaps bring our decorators into line again. There is a great deal of feeling, I may say, on the part of the painters. They are certainly not having as good an opportunity either financially or artistically as the architects and sculptors have had. The former were provided for at the outset by the Construction Department and now at the last moment when the money is nearly exhausted, the artists are called in and have made their work largely a matter of patriotism. I regret that this is so, but it is the plain fact. Mr. Millet is working for a salary which amounts to only one half of his average expenses for the last two years, and he is hoping to have a decoration given him which may enable him to cover expenses. Mr. C.Y. Turner is working for $150 a month. There is some feeling because Mr. Melchers and Mr. Mc Ewen were given two decorations each and at a higher rate than any succeeding painters will be given. Miss Cassatt and Mrs. Mc Monnies case is on the terms as Mr. Melchers and Mr. Mc Ewen and so are among the best paid.[1] Of course it is unfortunate that Miss Cassatt had to build a studio which has increased her expenses,[2] but she is well enough off to make this a tremendous step on the road to fame.

I have written you thus fully so that you may understand the situation here and explain it to the ladies. The artists feel badly that they cannot get what they consider proper compensation, but they realize that it is too tremendous an occasion for them to let pass in silence. French artists would undoubtedly be delighted to come over and do the decorations for nothing or with such help as the French Government would give them, but we cannot afford to have any but our American artists shine on this occasion. This [is] their opportunity. They feel it, and if necessary would do the work for less than they are getting, and it is only the contrast between them and the architects and sculptors that makes them uncomfortable. They have to pay much more for their models and their living expenses are greater than they would be in Paris, and yet they are given less than Mr. Melchers and Mr. Mc Ewen receive.

This is only for your own eye and to be repeated to the ladies and not for general promulgation because we do not care to have the seamy side exposed to view.

I am delighted to learn about the Doucet Costumes and the lovely work Mrs. Mc Monnies is proposing to do and I know it will be superb.

I am now thinking of asking some of the American women to do small panels on a line with the bottom of the large panels and extend down two sides of the wall, and if we could have any indication of the

color scheme I think it might be readily carried out and made very effective.[3]

[Mrs. Potter Palmer]

1. According to the "Report of Daniel Burnham, Chief of Construction, 1893 World's Columbian Exposition," Gari Melchers (1860-1932) was to receive $6,000 for two murals and Cassatt $3,000 for one.

2. Cassatt decided to work on the mural at the château of Bachivillers, which the family rented for the second year in a row. She had a special studio built to accommodate the huge 12-by-58-foot mural. It had a glass roof and a long trench into which the canvas would be lowered so that she could work on any part of the surface without needing a ladder.

3. These artists and their panels were: Rosina Emmett Sherwood, *Republic's Welcome to Her Daughters*; Amanda Brewster Sewell, *Arcadia*; Lydia Emmett, *Art, Science, and Literature*; and Lucia Fairchild, *The Women of Plymouth*.

KATHERINE CASSATT TO LOIS CASSATT

[black border]
Bachivillers
[September 8, 1892]

My dear Lois,

I enclose a telegram [for you] sent here this morning. . . . I hope Rob is coming out to see us before leaving— Have you any news of Aleck since he left— . . .

Mary's help in the shape of a young Hebrew came out on Tuesday to work on the border of her decoration: Such a slow creature you never saw! May got out of patience when he said it would take six weeks to do what he had to do, so yesterday she left her models & got at the border hammer & tongs & when the day was over she said his part would be done in six days instead of weeks to which he replied "Well yes, we have worked!" All that he does is of the simplest; and then a gilder will have to come to put on the gold required which wont take very long but will cost like the mischief May says—

The new Contract has come & is addressed to Mary but inside the name of Mrs. Macmonnies is put in place of May's—so it had to be sent to her supposing that Mrs. M. has received May's— Evidently they are a little disturbed in the Art department at Chicago—

When are you coming out to see us again? . . .

With love to all I am yours sincerely

K. K. Cassatt

MARY CASSATT TO BERTHA PALMER

> [black border]
> Bachivillers
> September 10 [1892]

Dear Mrs. Palmer,

I received your most kind letter with great pleasure; knowing what your correspondence must be I hesitate even in sending you a line of thanks; you certainly must be the most written to woman in the world at present.

Thanks to your kind offices all my difficulties with the board of construction seem to be arranged, and my contract is here although not yet in my hands, as it was sent by mistake to Mrs. Macmonnies and hers to me. I sent her hers but she has not yet sent me mine having heard at Durand Ruels that I had already received one! However I suppose I shall get it sometime. Between you and me I hardly think women could be more unbusinesslike than some of the men are. Here is Mr. Millet sending me "the exact size of those tympana" at this hour of the day! It will entail on me a good deal of extra work which he might just as well have spared me by sending the exact size at first.

However, it would be ungracious to grumble for really I have enjoyed these new experiences in art immensely and am infinitely obliged to you for the opportunity you have given me, all I could wish would be a little more time, I am afraid my work will show signs of hurry, and it would have been better if we could have had two long summers instead of one.

And as if by a "*fait-exprès*" [as if on purpose] all my relations seem to have given each other rendezvous in Paris this summer & one cannot exactly refuse to see them.[1]

Yesterday we had a visit from a cousin who spoke of having been so charmed to meet you, Mrs. Sloane, her husband is professor at Princeton.[2]

I hope Miss Hallowell will have arrived safely before you receive this and that she was not quarantined, the last news here is the cholera may put off the exhibition a year.

Again thanking you my dear Mrs. Palmer & wishing you all success in your great work, I remain

> Most sincerely yours,
> Mary Cassatt

1. Both the Alexander Cassatts and the Gardner Cassatts were in Paris that summer.
2. Mrs. William Milligan Sloane's husband was writing a book on Napoleon at the time.

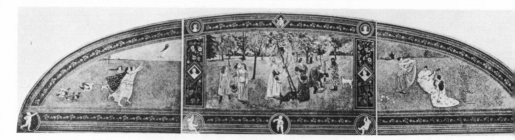

29. Mary Cassatt. *Modern Woman*, decoration of the South Tympanum, 1892-93. Woman's Building, World's Columbian Exposition, Chicago.

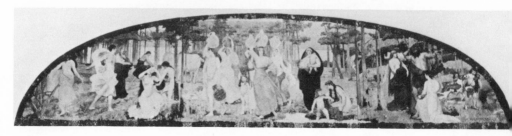

30. Mary Fairchild MacMonnies. *Primitive Woman*, decoration of the North Tympanum, 1892-93.

31. Exterior of the Woman's Building, 1893.

236

[black border]
Bachivillers
October 11 [1892]

My dear Mrs. Palmer,

Your letter of Sept. 27th only arrived this morning, so unfortunately this will not reach you by the 18th as you desired. Notwithstanding that my letter will be too late for the ladies of the committee, I should like very much to give you some account of the manner I have tried to carry out my idea of the decoration.

Mr. Avery sent me an article from one of the New York papers this summer, in which the writer, referring to the order given to me, said my subject was to be the "The Modern Woman as glorified by Worth"![1] That would hardly describe my idea, of course I have tried to express the

32. Interior of the Woman's Building, 1893.

237

modern woman in the fashions of our day and have tried to represent those fashions as accurately & as much in detail as possible. I took for the subject of the central & largest composition Young women plucking the fruits of knowledge or science &—that enabled me to place my figures out of doors & allowed of brilliancy of color. I have tried to make the general effect as bright, as gay, as amusing as possible. The occassion is one of rejoicing, a great national fête. I reserved all the seriousness for the execution, for the drawing & painting. My ideal would have been one of those admirable old tapestries brilliant yet soft. My figures are rather under life size although they seem as large as life. I could not imagine women in modern dress eight or nine feet high. An American friend asked me in rather a huffy tone the other day "Then this is woman apart from her relations to man?" I told him it was. Men I have no doubt, are painted in all their vigour on the walls of the other buildings; to us the sweetness of childhood, the charm of womanhood, if I have not conveyed some sense of that charm, in one word if I have not been absolutely feminine, then I have failed. My central canvass I hope to finish in a few days, I shall have some photographs taken & sent to you. I will still have place on the side panels for two compositions, one, which I shall begin immediately is, young girls pursuing fame. This seems to me very modern & besides will give me an opportunity for some figures in clinging draperies. The other panel will represent the Arts, Music (nothing of St. Cecelia) Dancing & all treated in the most modern way. The whole is surrounded by a border, wide below, narrower above, bands of color, the lower cut with circles containing naked babies tossing fruit, &&c. I think, my dear Mrs. Palmer, that if you were here & I could take you out to my studio & show you what I have done that you would be pleased indeed without too much vanity I may say I am almost sure you would.

When the work reaches Chicago, when it is dragged up 48 feet & you will have to stretch your neck to get sight of it all, whether you will like it then, is another question. Stillman, in a recent article, declares his belief that in the evolution of the race painting is no longer needed, the architects evidently are of that opinion. Painting was never intended to be put out of sight. This idea however has not troubled me too much, for I have passed a most enjoyable summer of hard work. If painting is no longer needed, it seems a pity that some of us are born into the world with such a passion for line and color. Better painters than I am have been put out of sight, Baudry spent years on *his* decorations. The only time we saw them was when they were exhibited in the Beaux-Arts, then they were buried in the ceiling of the Grand Opera.[2]—After this grumbling I must get back to my work knowing that the sooner we get to Chicago the better.

You will be pleased, believe me, my dear Mrs. Palmer

Most sincerely yours
Mary Cassatt

1. Charles Frederick Worth (1825-1895), an English couturier, came to Paris in 1845. His position as dress designer for the wealthy was assured when he became the favorite of Empress Eugénie in 1864. Cassatt and her sisters-in-law often ordered clothes from the House of Worth for themselves, and Cassatt may have had dresses made by Worth or another dressmaker as costumes for her models. She wanted her paintings to capture the spirit of "modern life" and felt that she could best accomplish this with clothes of the latest fashion.

2. Baudry's decorations, which Cassatt had seen in 1874 at the Ecole des Beaux-Arts, were on her mind as she worked, not only because of their height but also because of their subject—music. Baudry had depicted religious music by the allegorical *Dream of St. Cecilia*, a traditional image that Cassatt was determined to avoid in her mural.

MARY CASSATT TO ROSE LAMB[1]

[black border]
Bachivillers
November 30 [1892]

My Dear Miss Lamb,

Your very welcome letter finds us still at Bachivillers & likely to be here for several weeks yet. We have lit our fires & I have closed my studio door & pasted the cracks of the very flimsy structure over with paper & feel like the "Cigale" of the fable.[2] Though why I should I don't know as I certainly did not spend the summer in singing & dancing, but in the hardest of work. You complain of the rush of the life in America "a qui le dite vous"? as the French say.[3] Haven't I been in constant communication with Chicago ever since I last saw you? Ah Why take a house in Mount Vernon street if ever so pleasant. I really believe that a rational life is only to be lived on this side of the water. Stillman, I don't know if you ever read his articles, I always do they are so pessimistic, thinks that the World has no further use for painting, except perhaps as a lesson in leisure. That is a lesson Americans need to learn, and to think that I who have learned it deliberately gave myself away, & prepared to do a work for which I ought to have taken three years in six months! We had a sudden rush over of my eldest brother & his family in August, partly to escape the heat but principally to leave my youngest niece (seventeen) with her grandmother & me to go to school in Paris this winter. One look at the

size of the canvases [for the mural] was enough, back they all went again, my brother very much disgusted, it is the first time I have failed him. I suppose your baby nephew is delightful, just the interesting age for a baby from that on to eighteen months—, I sincerely trust they will spank him before he gets to be the age of our youngest hope whom you had the pleasure of travelling with.

I am so glad you saw the Degas in Faure's collection, you can now understand why the French artists put him so high so far above all the rest— I have only seen him once this summer for a few moments at the funeral of Ch. Durand Ruel, a most sad occassion. To tell the truth I needed all my sang-froid & Degas takes a pleasure in throwing me off the track, for years I have never shown him anything without its being finished. At Durand Ruels there has been an exhibition of a series of landscapes in pastel by Degas, not from nature.[4] I prefer his landscape when used as background for his figures—

I send you with this some photographs of the center canvass which I had taken for "Mrs. Palmer and the ladies of the Committee." They even wanted literature, a description of my picture! Poor M. Durand Ruel & his daughters were here a little while ago & thought I had given them too much for their money. One thing I have learned, the absolute necessity for system in painting. Prepare your *pallette*. I know you told me Hunt said not,[5] but he was wrong, Delacroix had a most elaborate pallett & it is very evident the old masters had & did not indulge in one happy go lucky style. My Mother & I propose to go to Pisa when I get through provided I am not entirely penniless by that time. Do let me hear from you, if you have time. We remember your visit with so much pleasure. My Mother joins in kindest regards & hopes of meeting again.

<div style="text-align:center">

Yours affectionately
Mary Cassatt

</div>

1. Little is known about Rose Lamb, who studied art in Boston with William Morris Hunt. She apparently met Cassatt in the summer of 1892 and struck up a friendship with her. There are three letters from Cassatt to her in the Museum of Fine Arts, Boston.
2. The fable of the "Grasshopper and the Ant."
3. "You're telling *me!*"
4. This exhibition of delicate pastel landscapes was Degas's only exhibition after 1886. He increasingly withdrew from Paris art circles.
5. William Morris Hunt (1824-1914) had studied in France with Couture and Millet in the 1850s. When he returned home to Boston he became a prominent teacher, basing his lessons on the nonacademic principles of his French masters.

[black border]
Bachivillers
December 1 [1892]

My Dear Mrs. Palmer,

Your telegram received today gave me the greatest pleasure. I am infinitely obliged to you for the kind thought which prompted you to send it.

The fact is I am beginning to feel the strain a little & am apt to get a little blue & despondent. Your cable came just at the right moment to act as a stimulant. I have been shut up here so long now with one idea, that I am no longer capable of judging what I have done. I have been half a dozen times on the point of asking Degas and come and see my work, but if he happens to be in the mood he would demolish me so completely that I could never pick myself up in time to finish for the exposition. Still he is the only man I know whose judgment would be a help to me. M. Durand-Ruel, poor man, was here with his daughters a week ago, it was most kind of him to come, they are all broken-hearted over the death of poor Charles. M. Durand was very kind & encouraging, said he would buy it if it were for sale, & of course from his point of view that was very complimentary but it was not what I wanted. He seemed to be amazed at my thinking it necessary to strive for a high degree of finish; but I found that he had never seen the frescoes of the early Italian masters, in fact he has never been to Italy except to Florence for a day or two on business.[1] I asked him if the border shocked him, he said not at all, so it may not look eccentric &, at the height it is to be placed, vivid coloring seems to me necessary.

I have one of the sides well under way & I hope to have the whole finished in time for you to have it up & out of the way by the end of February.

You must be feeling the strain too, with all the responsibility on your shoulders, I hope you will have strength & health to bear you through. With kindest regards & renewed thanks my dear Mrs. Palmer

Sincerely yours,
Mary Cassatt

1. Cassatt, on the other hand, had been studying the art in Italy as recently as the previous spring and planned to return as soon as work on the mural was completed.

Chicago
December 15, 1892

My dear Miss Cassatt,

I have received your letter written after the arrival of my telegram of congratulation, and I need not tell you how pleased I am to have a further description of the charming decoration.

I consider your panel by far the most beautiful thing that has been done for the Exposition, and predict for it the most delightful success. It is simple, strong, and sincere, so modern and yet so primitive, so purely decorative in quality, and with still the possibility of having an allegory extracted if one wants to look for that sort of thing. It does seem a pity to torture such a lovely piece of decoration with any attempt at forcing a stilted meaning into it. I am enthusiastic over your success, and am making myself odious by my boasting to all the men who are doing decorations, for I feel sure that your color is to be just as charming as your strong modeling and lovely composition. I must congratulate you most sincerely on having accomplished so successfully the heavy task which you had to perform in a very limited time.

I hear from Miss Hallowell that she has secured a charming example of your work for the Exposition.¹ I do not know the picture, but only know of her delight in obtaining it. I see from a notice sent me from New York, that a picture of yours is in an exhibition now going on there, a lady in white reading the *Figaro*, which seems much admired [page 139].

I am thoroughly delighted to have your things appearing in this country, and am very regretful that the Durand-Ruel exhibition of your work has not materialized.

May I not conclude, my dear Miss Cassatt, by asking a very special favor, that is, that you accept the position of juror on the New York Art Jury which has been or will be tendered you. I know your hatred of art jury service, and that your inclinations will be against this, and also that you will probably be in Paris at the time this jury acts. It nevertheless is a great point gained by women to have their names prominently mentioned on art juries, and this effort has been successful only after a long struggle. If it stands, therefore, even though you perform no service at all, it will help your sex who are generally entirely unrecognized in art matters. Pray do not refuse.

Of course you will come over to place your panel. When may we expect you?

With kindest regards, believe me

Most cordially yours
[Mrs. Potter Palmer]

MARY CASSATT TO PAUL DURAND-RUEL

[black border]
Bachivillers
December 19 [1892]

Dear Sir,

I am very grateful to you for having obtained for me the services of a local man and I am infinitely indebted to M. Rougon— It saves me the trouble of having workmen come from Paris to redo the arches of the canvas, and consequently a very large expense. I think that Mrs. Palmer's telegram is to inform me that I am on the jury for American paintings in Paris. Naturally I will refuse in spite of the desire that I have to be agreeable. It seems to me that I have enough of Chicago for the moment, and I will not be sorry to regain my freedom.

I beg you, dear sir, to accept my sincere regards,

Mary Cassatt

Original in French.

MARY CASSATT TO MARY MACMONNIES

[black border]
Bachivillers
Wednesday [December 1892]

My Dear Mrs. McMonnies,

I hasten to answer your note at once, certainly Chicago seems to reserve endless surprises for us—I should fancy from what you told me of your design & from what Miss Hallowell said your intention was, as regards the size of your figures it would be quite impossible for you to put a border of the width of mine around your composition. My object was to reduce the huge space as much as possible by a border in such a way as to enable me to paint a picture in each of the spaces left where the figures would be rather under life size— Therefore, I designed a border of one metre in depth to run along the whole base of the decoration consisting of bands of color with designs & divided by lines of gold, & in this I have introduced at intervals circles in which naked babies are tossing fruit, & &. The upper border is narrower about 75 centimetres wide repeating the colors & design of the lower border—

243

You will perceive that I went to the East for the foundation of the idea. I have divided the length into three by two panels of 80 centimetres wide— You may remember that I told Mrs. Palmer I intended doing so— The border is the only attempt I have made at decoration pure and simple.

Considering the immense height at which the pictures will be placed & the distance apart they will be, we agreed that unity of any kind was not necessary.

I think they will be placed much higher than Baudry's fine decorations at the Grand Opera & yet they are quite out of sight. When Miss Hallowell was here we thought the height would be at the top of the chimneys of this house, or about the *fourth* floor of the large apartement houses in Paris. I think if Mrs. Palmer realized this she would see that there could be no necessity for unity; if such a thing was in the scheme it is too late now.

I hope you won't have left for Chicago before we return to Paris. By the way, I had the "rentoileur"[1] of the Musée du Louvre here the other day, he thinks it will be impossible to place the decorations otherwise than on stretchers on account of the rounding top which would make it impossible to stretch properly on a flat wall.

<div style="text-align:right">

Yours sincerely,
Mary Cassatt

</div>

1. M. Rougon; a *rentoileur* restretches old canvases.

MARY CASSATT TO PAUL DURAND-RUEL

[black border]
Bachivillers
January 6, 1893

Dear Sir,

Thank you very much for your letter and for having sent me Monsieur Rougon's permit [?]. I hope to make use of it toward the end of the month. The terrible cold has slowed me down a great deal but I hope to finish in a few days and as soon as it is dry enough, we will return to Paris. I just received a letter from MMs. Boussod and Valladon asking me if I would give them photographs to be reproduced, they are the concessioners of the only illustrated publication. Can't I reserve the publication rights? I intended to use the designs for drypoints and I have no desire to see myself vulgarized by their processes. I have already (to my great regret and only to please those ladies) provided photographs for

an article which should appear in Harpers in March. Up to now I'm the one who has given everything, because the office of construction has fulfilled none of the conditions of the contract. I don't even have the least guarantee that they will accept and pay for the work. I have no doubt that they will do it, but they have never sent back my contract, nor any money as was agreed upon. Mr. Havameyer has lent at the request of Miss Hallowell (who I directed to him), his large Corot and the Courbet which you sold him last summer—

My mother joins me in thanking you and the Mademoiselles, your daughters, for their good wishes and for you and yours, dear sir, accept our best compliments

<div align="right">Mary Cassatt</div>

Original in French.

BERTHA PALMER TO MARY CASSATT

<div align="center">Chicago
January 31, 1893</div>

My dear Miss Cassatt,

I was perfectly astonished to learn that you and Mrs. Mac Monnies had not received your contracts and payments, long before this.

I went to Mr. Millet at once about the matter, and he was as much surprised as I, as he had made out the contracts some time ago, giving the necessary bonds for payments himself in order to facilitate matters. It has since developed that he sent these contracts to the offices of the Construction Department to be forwarded, and that in some mysterious way a package containing six contracts was lost in transito. Had it not been for your inquiries, it would not have been discovered for some time as the clerk to whom they were consigned not having received them, did not know they had been sent, and Mr. Millet naturally supposed they had been forwarded. Mr. Millet feels extremely sorry about it.

Of course you will appreciate that I have nothing whatever to do with the financial matters of the Exposition outside of our immediate office, but I have felt extremely annoyed to think of the inconvenience that you and Mrs. Mac Monnies may have been caused by this delay.

In regard to the jury work, I hope you understand that the committees were appointed by Mr. Ives and I supposed that you had been duly notified. Mr. Ives took the position that the names of women should only be added to the committees when their reputation was so great that

their names alone would add strength to the committee: With this in view, your name and that of Mrs. Mary hallock Foote[1] were added to the list after a contest, so that I beg that you will let it stand no matter what your personal feelings may be. It will serve at least as recognition of women as artists, and is considered a great compliment.[2]

I am quite sure that if you with-draw your name, no other woman will be appointed in your place, and women artists would therefore lose this honor.

Hoping soon to hear that you have received your contract and payments, I am

Most cordially yours
[Mrs. Potter Palmer]

1. Mary Hallock Foote, born in 1847, was a well-known illustrator of books and magazines.
2. The final list of artists on the International Board of Judges included three women: Foote, Emily Sartain, and Mary M. Solari.

MARY CASSATT TO SAMUEL P. AVERY[1]

Sienna, Italy
March 2 [1893]

My dear Mr. Avery,

Your letter of Feb. 10th I received just as we were leaving Paris & we have been travelling slowly ever since, so that I now for the first time have an opportunity of answering it. Thanks very much for the article about the exhibition at the Etching Club. I do not know who sent the proof spoken of. When I received your letter I was so immersed [?] in my work that I wrote to no one. Chicago is rather a hard task mistress the time given to me was so short that every minute of the long summer days was devoted to my work. I enjoyed the new experience in painting very much but the result of course is very imperfect, & you cannot excuse a work of art by explaining that the artist was obliged to do in six months what it required two years to do. I hope to do some dry points during my journey & certainly shall do something on my return to Paris, you may be sure I shall put by everything for you. I am always very grateful for your interest in my work. I will try to get you some proofs of Degas, but I cannot promise that I will be successful he is not an easy man to deal with, he has been talking for some time of doing a series of lithographs but I am afraid it will end in talk.

I wonder if you know this delightful place, it is the first time I have seen it & it enchants me. My mother and I go from here to Gineto [?] &

then to Padua & to the Villa Giacomelli to see the frescoes by Paul
Veronese we hope to be back in Paris by the end of the month. By that
time I will have had enough of the "Grand Old Masters" I have not seen
Mr. Lucas since last spring but have heard of him & hope to see him
on my return. How I wish I could consult you on a subject of which you
know everything and I nothing. I have been offered an old choral
book with illuminations of the 14th century—the miniatures are
good. There are but two & so are the capitals they ask 500 fcs for it. If I
only knew the value, but alas you are in New York. Believe me my
dear Mr. Avery ever most sincerely yours,

<div align="center">Mary Cassatt</div>

1. I am grateful to Madeleine Fiddell Beaufort and Jeanne Welcher Kleinfield for access to
this letter. They are currently writing an article elucidating the Avery/Cassatt relationship.

BERTHA PALMER TO MARY CASSATT

<div align="center">Chicago
March 3, 1893</div>

My dear Miss Cassatt,

You certainly must come to the Exposition. We cannot consent to
allow you to go to the ancients this summer,—you must come here
instead and see if you receive no inspiration from the Moderns.

I have not time to write a long letter and can only say I am looking
forward with the greatest eagerness to the arrival of the great decoration.
You must come over and see it in place.

I shall feel that the occasion is not complete unless you come to enjoy
the work in general and your own share of it in particular. We owe you a
thousand thanks for having so kindly assented to our wishes and
undertaken this painting which must have oppressed you, as it was so
exacting and the time so short. I congratulate you in advance upon your
success.

<div align="center">Most cordially yours
[Mrs. Potter Palmer]</div>

MARY CASSATT TO EUGENIE HELLER[1]

<div align="center">Bachivillers
June 28 [1893]</div>

Dear Miss Heller,

I am sorry I did not see you before I left Paris, & still more sorry that

you were not able to settle near Monsieur Pissarro, since that was your wish. At Erragny I knew it would be difficult but at Gisors I supposed you might have found something, or some other place near. However as you are settled at Bourron it is too late to speak of that now. I regret that I can give you no help at Bourron, in recommending you to an artist for aid & counsel, but I know no one in that neighbourhood. If I can at any time be of any use to you please let me know, I shall be very happy to help you if possible

<div style="text-align: right">

Very sincerely yours
Mary Cassatt

</div>

1. Eugenie M. Heller, born in 1868, studied painting with J. Alden Weir in New York and sculpture with Augustus Saint-Gaudens before traveling to Paris in 1893. On Weir's recommendation she contacted Mary Cassatt for advice about finding a teacher in France. In the next few years she also became friendly with Whistler, Rodin, and Aman-Jean. There are eight letters from Mary Cassatt to Eugenie Heller in the Watson Library of the Metropolitan Museum of Art and one in the New York Public Library.

MARY CASSATT TO EUGENIE HELLER

<div style="text-align: right">

10, rue de Marignan
Wednesday [1893]

</div>

My Dear Miss Heller,

I have had a conversation about Renoirs giving you conseil, but it seems he won't accept such a thing & besides would not perhaps be the man for it— I have thought of something better for you & Mrs. Smith, & shall try to see you tomorrow, if you do not see me, I shall have been prevented & will hope to see you the next day.

This is only to let you know I am not idle in your behalf & to beg your patience.

As to your friend who wishes to study design, tell her to go to the "Gar de Meuble" it is on the Quais, near here, there they will give her the address of the "Conservateur" M. Williamson, he will give her a card which will enable her to work there—

With regards to Mrs Smith & yourself

<div style="text-align: right">

Very sincerely yours
Mary Cassatt

</div>

MARY CASSATT TO EUGENIE HELLER

<div align="right">

10, rue de Marignan
December 21 [1893]

</div>

My Dear Miss Heller,

This is the address of, I hope, your future guide—Monsieur
Guillaumin 8 rue Garancière.[1] I will write to him this evening announcing
your visit. I hope you will be able to progress rapidly under his councils,
you will find they have nothing in common with anything you have
heard, up to this time, in Paris— The young English girl is hardly
advanced enough I should fancy to work with you, perhaps I am wrong,
but that is the impression I received, she is going to work at the
Louvre, & I believe is to receive advice from Carrière. Let me again
advise you both to stick to the Louvre, also if a good opportunity occurs
in the spring, take a circular ticket through the north of Italy, as far as
Florence. The first time I went, if I remember rightly I went 3rd
class, my family not wishing me to go alone, did not send the means, but
chains would not have held me— If at any time I can be of use to you
write to me, directing here, your letter will be forwarded— We are off, I
hope Saturday morning. With regards to both you & Mrs. Sprague
Smith, & best wishes for your progress

<div align="right">

Yours sincerely
Mary Cassatt

</div>

1. Jean Baptiste Armand Guillaumin (1841-1927) began his painting career in the 1860s.
A landscapist, he became a close friend of Cézanne and Pissarro and exhibited with them in the
Impressionist exhibitions of 1874, 1877, 1880, 1881, 1882, and 1886. In 1891 he won
100,000 francs in the lottery, which allowed him at long last to quit his administrative job for
the city of Paris and devote himself to painting.

MARY CASSATT TO JOHN H. WHITTEMORE[1]

<div align="right">

10, rue de Marignan
December 22 [1893]

</div>

(We are off to Cannes tomorrow but our address is the same)

Dear Mr. Whittemore,

This letter I intended to address to Mrs. Whittemore but having just
received yours of Dec 11th I will make it a family letter. I have seen Mrs.
Peters & the babies, I had the pleasure of a visit from them on
Saturday.[2] Mr. Peters was also of the party. Jack has grown a real boy in

trowers & is a lovely child, the baby is charming quite as pretty as she was & as there is more of her she is just so much more delightful. Mrs. Peters is looking much stronger than she was in the spring, they both seem very happy, I trust he is doing well, he is very busy—

I am glad you are getting on so well with the Independents[3] & am much obliged for your kindness in advancing my subscription, please have it refunded to you at Mess Durand-Ruels— Don't allow them to allot me any space in their exhibitions, my sympathy is with them, but I have no intention of sending anything. The advantage of such an exhibition is that one has space to develop oneself, & it would be much against my interests if only one or two of my pictures were sent, & yours would be the only ones— I am almost sure that there will be an exhibition of my pictures & etchings in New York this winter or spring, if it is only half as well received as the one just closed in the rue Lafitte I will be satisfied[4]— I can hardly imagine though, that the Metropolitan Museum will propose, to buy one of the pictures as the Musée du Luxemburg has just made me the compliment of doing[5]—

I am glad you saw the Degas & admired it, I also think your Manets better than my brothers as I remember his—

Comantron was here the other day[6] & I told him what I had written to you about the Degas, he says I am wrong, & that he would buy back the Degas you bought in the Spring at an advance— He seemed sincere— I don't think my friend in N.Y. would sell her pastel it would bring 20,000 fr. in Paris! Not a bad investment—

With kindest regards to both you & Mrs. Whittemore believe me with many thanks for your kind offer of service

<div style="text-align:right">

yours most sincerely
Mary Cassatt
</div>

1. John Howard Whittemore met Mary Cassatt in 1892 when he was studying art in Paris. Cassatt visited the Whittemores in Naugatuck, Connecticut, during her trip to the United States in 1898-99 and met their grandson, Harris Whittemore, Jr., with whom she corresponded until her death.

2. Mrs. Clinton Peters was J. H. Whittemore's cousin.

3. In 1884 several artists who were disgruntled with the jury system of the Salon formed the Groupe des Artistes Indépendants in Paris. Their yearly exhibitions admitted anyone who wished to join.

4. The *Exposition de Tableaux, Pastels et Gravures de Mary Cassatt*, held at Durand-Ruel's gallery (16, rue Lafitte) during November and December 1893, was a retrospective showing of forty-seven of her works. Among them were several paintings related to the mural project, such as *Young Women Picking Fruit* (see figure 33).

5. The Musée du Luxembourg housed the French state's collection of modern art. A committee selected works that they felt deserved to enter the collection, then purchased them from the artist.

6. Comantron was a collector in Paris.

33. *Young Women Picking Fruit*, 1892. Oil on canvas, 52 x 36 in. Museum of Art,
Carnegie Institute, Pittsburgh, Patrons Art Fund, 1922.

MARY CASSATT TO EUGENIE HELLER

> Villa "La Cigaronne," Cap d'Antibes
> (Alpes-Maritimes)
> January 30 [1894]

My Dear Miss Heller,

I have often wondered, since I left Paris, how you were getting on. I hope you & Mrs. Sprague Smith escaped the [illegible]! I see that M. Guillaumin's exposition is opened, I hope you have seen him & are profiting by his conseils— I have an idea that he must be able to impart his knowledge with facility—

For anyone fond of the sea, & color & light, to say nothing of boats, this is a wonderful place— Our villa is on the sea with the snow capped mountains in the distance & below them the olive clad hills— I believe there are a number of American landscape painters here— It (the landscape), is rather too panoramic for my taste, but doubtless could be interpreted by a great man, in an artistic way; I have never yet seen it done to my satisfaction.

I content myself with a little bit as background to my figures [see figure 34], & ought to be thankful for the sun & the long days. We have had, though nearly a week of steady rain, such a downpour as one does not often have in the North—

With kindest regards to yourself & friend & sincere hopes that all is going well with you

> very truly yours
> Mary Cassatt

MARY CASSATT TO JOSEPH DURAND-RUEL

> Villa "La Cigaronne"
> February 2 [1894]

Sir,

I just received a card from Monsieur Benedite with a note undoubtedly to remind me of the question of the painting for the Luxembourg.[1]

If Monsieur Durand-Ruel has returned, would you be so kind as to speak to him about it. I don't need to say that I would be very glad if that could be arranged, first for myself and then for my family.

I hope that Monsieur Durand-Ruel had a good trip and has returned to you in good health. We have beautiful weather here and my mother is doing well, we are very well situated, but the country is too beautiful, it grows wearisome. Unhappily the people bear no resemblance to the

34. *The Boating Party*, 1893-94. Oil on canvas, 35½ x 46⅛ in. National Gallery of Art, Washington, D.C., Chester Dale Collection.

country. I see by the newspapers that Guillaumin's exhibition is a success.

With my best compliments to Monsieur Durand-Ruel, I beg you to accept, Sir, my sincere greetings

<div align="center">Mary Cassatt</div>

Original in French.

1. Léonce Bénédite (1859-1925) was a museum director and writer on art. In 1880 he was in charge of the Champs-Elysées exhibitions; from that position he was put in charge of the museum at Versailles and then was named curator of the Luxembourg.

118 South 20th Street, Philadelphia
February 6 [1894]

My dear Mrs. Palmer,

Your kind remembrance of the 1st reached me here yesterday. I left Chicago eight days ago, but not being at all well for some days previous to my departure was unable to see you again—and this I much regretted. After a week of absolute rest, surrounded by kind friends, to-day I feel like myself again and hasten to write you to tell you that I have had to abandon the idea—for the present at least—of going to Miss Cassatt and the Riviera. It is a great disappointment, not made lighter by a delightfully urgent letter received today from Miss Cassatt. In this she sends you her "kindest regards and compliments," saying previously—in reference to the Luxembourg being in treaty for one of her pictures— "After all give me France—women do not have to fight for recognition here, if they do serious work. I suppose it is Mrs. Palmer's French blood which gives her her organizing powers and her determination that women should be *someone* and not *something*."

I wish I could send you the letter, but need it for certain directions given in the event of my going to Miss Cassatt later. Her exhibition was very successful and of this she writes modestly, "I'm sure you would have liked some of it."

I found it impossible to get any sort of reasonable accommodations on the Genoa-bound steamers sailing this month, only high-priced officers' rooms remaining, and so was *compelled* to abandon the idea of the Riviera—so again, I have no plans and just now am feeling (what an Irish bull!) more at sea than ever. Yet a little more quiet and I hope at least one of my little plans will develop. Thanking you again and again for your kind interest and ever full of gratitude to you and Mr. Palmer, with deepest regard,

ever sincerely yours,
Sara Tyson Hallowell

MARY CASSATT TO PAUL DURAND-RUEL

Villa "La Cigaronne"
Saturday [February 10, 1894]

Dear Sir,

I just received your letter of the 9th. I suspected what your response

35. *Woman with a Red Zinnia*, 1892. Oil on canvas, 29 x 23¾ in. National Gallery
of Art, Washington, D.C., Chester Dale Collection, 1962.

would be: I agree with you, it is ridiculous of them only to buy from
artists, the whole purpose is to have good pictures.[1]

However you must admit that it would have been unreasonable of me
not to hasten to respond to the compliment they paid me. It really
doesn't matter to me, but I couldn't say that. As for my family, that's
another matter.

I will write to M. Benedite. But the matter is settled. It was the only
painting that pleased them, they found it free of "sentimentality."[2]

255

I am glad to hear that you had a good trip. Please accept, dear Sir, my best compliments

<div align="center">Mary Cassatt</div>

Original in French.

1. The painting requested by the Luxembourg was already owned by Durand-Ruel. Since it was the museum's policy only to buy from artists, and Durand-Ruel would not give the painting up, they were at an impasse.

2. Two of the paintings in Cassatt's 1893 exhibition (from which the Luxembourg seems to have chosen) were owned by Durand-Ruel: a mother and child (now lost) and *Woman with a Red Zinnia* (figure 35). It is impossible to tell which one is the one in question. Four years later the matter was taken up again and at that time Cassatt gave to the Luxembourg the pastel now called *Little Annie Sucking Her Finger*.

MARY CASSATT TO EUGENIE HELLER

<div align="right">Villa "La Cigaronne"

February 14 [1894]</div>

My Dear Miss Heller,

Your letter of the 11th is just received. I am very much interested in your experiences, I was sure M. Guillaumin would be a good teacher & I am very grateful to him for devoting himself to you— I did not think you would like his work especially his figures, but you must remember that he is a landscape painter & looks at the figure more from a landscape point of view if I may so express it— He pays less attention to line, but looks to color values & character, he runs into charicature in his horror of anything insipid— As to his color, it is powerful if wanting in harmony— Remember that you have only just escaped the Philistines at Julien's & that Guillaumin is an artist & takes an artists view of things.[1]

It is just as well not to have too great an admiration for your masters work. You will be less in danger of imitating him.

I am quite looking forward to seeing what you have been doing, you & Mrs. Sprague Smith will be the only ones who have ever followed my advice, & I am greatly in hopes you will have found it of some use to you.

I had begun to answer your first letter but in consideration tore it up, as I think you had better follow your own ideas subject to Guillaumin without other advice for the moment

With best wishes for you both & kindest regards

<div align="right">Yours most sincerely

Mary Cassatt</div>

36. *The Bath*, 1893. Oil on canvas, 39½ x 26 in. The Art Institute of Chicago, Robert A. Waller Fund.

257

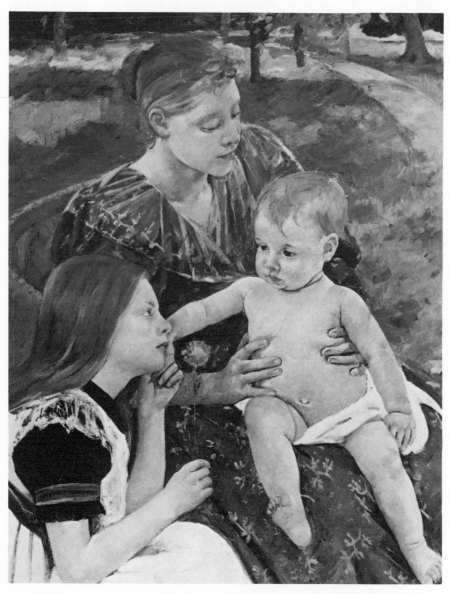

37. *The Family*, 1893. Oil on canvas, 32¼ x 26⅛ in. The Chrysler Museum, Gift of Walter P. Chrysler, Jr.

1. The Académie Julian was a large art school in Paris which was popular with Americans; it had been established in 1868 by Rudolph Julian.

MARY CASSATT TO JOHN H. WHITTEMORE

Villa "La Cigaronne"
February 15 [1894]

My Dear Mr. Whittemore,

Your very kind letter of Jany. 25th gave me great pleasure. I am delighted that you like the picture [figure 36]. To tell you the truth I am surprised that you received it in that way; I thought it was to be shown to you at an exhibition of my pictures, but M. Durand-Ruel has evidently given up any idea of the kind, for he sent me word, two more of my pictures were to leave this week for New York & makes no mention of any others— He also wrote to me a decided refusal to sell one of my pictures in his private collection to the Luxembourg, which ends my hope of immortality in that direction! It is delightful to me that you should want another of my pictures in the future, if I do anything I think particularly successful I will let you know. If you are in New York would you mind calling at Durand-Ruels to see a picture of three figures [figure 37], which has just been sent there, I should like to know what you think of it—

I have an interesting piece of artistic news for you. There was in Paris an amateur by name de Bellio, who had a large collection of Monets, Renoirs, one or two Manets, Degas, one, I believe, the Renoirs & Monets very fine. This man has died lately & it is most probable that his collection will be sold at the Hotel Druot. I remember you wanting to buy some good Renoirs, this will be a chance; in the collection was a picture by Monet which he called "An Impression". It was taken up by the papers & was the origin of the name "Impressionist." My brother offered M. de Bellio 5000 frs for it eleven years ago, that was a high price then, but he was refused. As soon as I hear anymore particulars I will send them to you.

Please thank Mrs Whittemore for her kind message and invitation, it would give me great pleasure to see you both in your home, [but] my mother is too old now for us to venture now on such a journey. Going out in a boat to study the reflections of the water, on the bay here has made me seasick, what would an ocean voyage be! I am most anxious to hear of the Independents, I will join them yet if I am to be put off much longer with promises about a private exhibition.

With kindest regards to both Mrs. Whittemore and you

Very sincerely yours
Mary Cassatt

In the spring of 1894 Cassatt purchased the château "Mesnil-Beaufresne,"
a few miles from the summer home Bachivillers that she had rented in
1891, 1892, and 1893. Although she was tempted to sell it again that
summer, once she had begun the necessary renovations the impulse
passed, and she kept it as her country home for the rest of her life.

MARY CASSATT TO PAUL DURAND-RUEL

Mesnil-Beaufresne, par Fresneaux
Montchevreuil (Oise)[1]
[Summer 1894]

Dear Sir,

I am writing to ask you if you would please tell Madame Aude that I have a favor to ask of her.[2] We are finally settled here and, even before we came, I had had enough of my role as landlord; I have given nearly three months of my time and I know that I still have a part of the summer to devote to giving orders, and I ask myself when will I find the time to do a bit of painting! Madame Aude knows the landowners of Trie, would she be so kind as to tell them I am putting Mesnil-Beaufresne up for sale?

The house is very good, very sound. I had water, &c put in. Indeed I cannot say that everything is not well, but I do not want to give any more orders to workmen, who don't follow them anyway.

We got the property for a good price, 39,000 frs. and 4 hectares of meadow are leased at 80 frs per hectare. We have incurred some expenses, but I do not yet know the figure.

What I want is the freedom to work. My mother is no longer of the age or the strength to concern herself with the outdoors, and I don't have the interest.

My brothers will surely laugh at me, but I won't say anything until I have sold it and won back my freedom. Certainly it is the best thing in the world.

I am completely fed up with the trouble I had to get a bit of work done.

Pray accept, dear Sir, my best compliments for you and yours. You don't know how lucky you are to be just a tenant!

M. Degas declares that architects are the lowest class of society!

Mary Cassatt

Original in French.

1. The first mention of Cassatt's purchase of the château of Mesnil-Beaufresne is in a letter to Durand-Ruel, dated March 1, 1894, directing him to put money in her account as she is "buying a property in l'Oise." The transactions apparently took place while she was vacationing in Antibes; when she returned, she plunged into the monumental task of bringing the château up to modern standards of comfort.

2. Mme. Marie Aude was Paul Durand-Ruel's daughter and Cassatt's neighbor in the Chaumont-en-Vexin area.

MARY CASSATT TO EUGENIE HELLER

Mesnil-Beaufresne
August 12 [1894]

My Dear Miss Heller,

I received your letter & one from Mrs. Sprague Smith some weeks ago, but have been very much occupied, since I have been here, with workmen & & so that I have had no time for writing.

I was very glad to hear that you were so comfortably settled in Switzerland & so satisfied with all your surroundings; with good will one can work anywhere & with such a delightful garden as you describe & on the lake too, I have no doubt you have both been making great progress & doing delightful things.

The season has been a rainy one here, & rather cool for working out of doors, at least with little children, but I have been too much employed getting settled to have regularly begun work yet, fortunately we are not limited here to a given time, as to going away we can do as we please.

I am afraid your project of coming here now is not feasable, I can see no place here for you to live, there never was but the one little house at Bachivillers, & that Mm Crèvecoeur is going to live in herself I believe; at any rate it did not suit you— There was only one room here that would have been suitable & that is not possible now, & probably would not have pleased you—

I am glad to hear that you are going to Spain, you will enjoy it I am sure, October is the month for Madrid, later it gets cold, but last of Sept. Oct. & November are delightful. With kindest regards to you both—

Yours very sincerely
Mary Cassatt

10, rue de Marignan
April 26, 1895

My Dear Miss Lamb,

Your letter gave me a most pleasant surprise this morning, & as you see I answer it at once, first because it is mail day & secondly because I don't know if I may have an opportunity soon again— I did receive a letter from you two years ago & not having answered it at once I mislaid your address—& have thought of you with remorse ever since.

Since I saw you last we, my mother and I have been here & in Italy in the South & again at Bachivillers & then in our own country place. My mother has been often ill & I often nurse for weeks at a time, & this last winter ever since 10th of Dec she has been a victim to grippe. [illegible]. She is now up & goes out but is still very ill, she says to tell you that the woman you knew as my Mother is no more, that only a poor creature is left! Which proves that her head is not quite so affected as she thinks, But there is no doubt that her head is affected & the depression is at times very great.[1] In fact life seems very dark to me just now; three weeks ago I was exchanging cables with my brother Gard & they were all including my sister in law & the baby (sister to the boy you remember) & the boy himself on the point of sailing. You who have taken care of old people know what it is— We bought a country house in the neighbourhood of Bachivillers a year ago. We were turned out of the latter place by the marriage of our fat landlord to a young woman desirous of living in a "chateau," so we bought one of our own— Last summer was spent in getting the workmen out of the house & getting it in order, & I now wonder if ever I shall take my mother to be there after all our trouble to make it comfortable for her. Our address in the country is Chateau du Mesnil-Beaufresne, par Fresneaux Mt Chevreuil (Oise)—& a letter here will always find us. If things go better with us, won't you when you do come over, come & make us a visit, my Mother wishes to see you again as much as I do. I am afraid there is no place I know of where you would be comfortable, Pissarro is getting old & his advice would not be so good as it was— We lost Mme Manet (Berthe Morisot) this winter carried off in five days by grippe.[2] Degas works as much as ever Bartholome is still at tombs,[3] I never see him.

I am much pleased at your liking my little pastel. I worked amid distraction this last winter & would have preferred putting off the exhibition,[4] hoping to see you over here soon & with much love from my mother & from me.

Yours affectionately
Mary Cassatt

1. Mrs. Cassatt died on October 21, 1895, in the château at Mesnil-Beaufresne.
2. Berthe Morisot died on March 2, 1895.
3. Albert Bartholomé (1848-1928) executed a number of tomb sculptures.
4. Cassatt's long-awaited New York exhibition was held at Durand-Ruel's, April 16-30, 1895.

MARY CASSATT TO EUGENIE HELLER

[black border]
10, rue de Marignan
Sunday [c. February 1, 1896]

Dear Miss Heller,

After I left you yesterday, it seemed to me I might have given you an impression of want of interest, & want of appreciation of your work— I can only say I did not mean to do so, I saw that you had studied & improved, I merely wished to give you if possible another direction, much more severe things have been said to me & I am thankful for it now. When I came to live in Paris after having painted in Rome & other places, the sight of the annual exhibitions, quite led me astray. I thought I must be wrong & the painters admired of the public right— It was then I fell in with our band & took quite another direction—

My sister-in-law, Miss Hallowell, & I are going this week to St Quentin for the day. In the Musée of St Quentin are eighty pastels of Latour which I very much wish to see.¹ Wont you go with us? We are going 2nd class, & will leave in the morning early & if possible stop over two hours at Compiègne to see the Hotel de Ville in that place & then go on to St Quentin where we will have 4 hours & back to Paris in time for dinner.

There are Latour's in the Louvre, but the St Quentin ones are celebrated. He was an artist, most simple most sincere, no "brio," no facility of execution, but his portraits are living & full of character—

I should like you to meet Miss Hallowell, she may be useful to you & you may be to her; I will explain to you my ideas of decoration which she is to help to execute besides having much taste of her own in that way. Your firm might find such correspondence over here useful— I want to help in that sort of thing & personally don't wish to make anything out of it—

We have not yet fixed on a day for St Quentin, but not Wednesday or Thursday— If the weather changes perhaps Tuesday, in the meantime I should be glad to see you soon if you come this way.

Yours sincerely,
Mary Cassatt

MARY CASSATT TO EUGENIE HELLER

[black border]
10, rue de Marignan
February 24 [1896]

My Dear Miss Heller,

Thanks for your note & the address for the furniture; I think however, it would hardly be worthwhile to send one or two pieces, I think I had better wait & if you should have an order for an entirely new & unique bedroom yellow & gold, or green or pink & gold, why write over to me & I will send you the furniture, such as the desk & chest of Garvers [?] you saw.

I am glad you have been enjoying your visit to London, at least as far as the weather is concerned, here we have a most disagreeable change cold & high wind with dust— Guillaumin has a very good exhibition of landscapes at Durand-Ruels, very strong & decorative, no figures—

If you at anytime wish me to do anything for you over here let me know & I will attend to it if it is possible— Please give my kind regards to Mr Weir when you see him & tell him I have not had the courage to write & thank him for his letter, it reached me when I was in great trouble—

I will not fail to give your message to Miss Hallowell when I see her, my sister-in-law joins me in kindest regards & wishes for your safe journey

very sincerely yours
Mary Cassatt

MARY CASSATT TO PAUL DURAND-RUEL

[black border]
Mesnil-Beaufresne
May 19, 1896

Dear M. Durand-Ruel,

Thanks for your kind pains & enclosed check, received this

264

morning— I am now settled here for the summer and working hard. I hope to submit to you some pastelles before long; if I were a landscape painter, I would [have] no trouble in seeking beautiful subjects— The country looks lovely not withstanding the drought— If you are not already settled in the country, perhaps some day you might find time to come and see me? If you are in the country will you please give my kindest regards to Madame Aude and tell her I regret so much having had to leave town without seeing her, and taking my little niece to see her little daughter.

<div style="text-align:center">

Most sincerely yours
Mary Cassatt

</div>

———————————

MARY CASSATT TO PAUL DURAND-RUEL

<div style="text-align:center">

[black border]
Mesnil-Beaufresne
July 14 [1896]

</div>

Dear Sir,

I received your letter of the 13th this morning, I wanted to bring you my two things myself, but I retreated from the heat and thought only of fleeing to the countryside. I must say that it's hardly cooler here today. As to the price, for the pictures, do you find one thousand francs too much for the pastel? My pretentions are for two thousand for the painting; I was extremely persistent with this, perhaps too much, but since I only finished it on Saturday, I am counting on it improving as it settles.

I hope that all yours are well—please remember me to Madame Aude and please accept, dear Sir, my best compliments

<div style="text-align:center">

Mary Cassatt

</div>

Original in French.

———————————

[black border]
Mesnil-Beaufresne
September 22 [1896]

My Dear Miss Heller,

Your letter found me here, at my place in the country where I have
been ever since May, with my brother & his family— I am sorry
you have not found more encouragement in your business ventures, but I
am afraid that the artistic part of furnishing will never pay, taste is so
different in even "artistic" people— As to the painted furniture I could
not attend to it just now, my idea was to have it seen in a set at some
large establishment, principally that Miss Hallowell would find an
opening for buying old furniture over here for some house— If you
would write to her directly as to getting you some pieces I think
you might get what you wish. She knows all the best places in Paris for
that sort of thing, & where things can be got cheap—her address is 1 rue
du Regard Paris— I hope that your painting will be so successful as to
compensate you for the furniture failure— I was only once at the
Champ de Mars last spring, & not at the "Salon."[1] I take very little
interest in the exhibitions, there is so much that one does not care to see
amongst a few good things— We have had a very dry summer here,
compared to a very wet one most every where else, but now are making
up for it by cold wet weather— I hope you will have a most successful
winter. I am sure you will see some good things sent over from here,
if you see Mr Weir please remember me to him. With kindest regards

Yours most sincerely
Mary Cassatt

1. In 1890 a number of artists banded together to form the Société Nationale des Beaux-
Arts, which held yearly exhibitions in the great hall of the Champs-de-Mars in Paris. This
exhibition rivaled the official Salon.

MARY CASSATT TO PAUL DURAND-RUEL

Mesnil-Beaufresne
January 22 [c. 1898]

Dear Sir,

I have just received a letter from a lady secretary of the Ladies Art
League, telling me that you promised her a choice of my pictures
belonging to you to show in the exhibition that these ladies are going to

have, subject to my consent. I refuse absolutely and I believe that you will not profit at all in showing my work in this exhibition. I know that my works have been sent even to the most amateur exhibitions of women artists in America. I doubt that this practice will do me any good, nor you. I would have thought that for selling, there would have been more opportunity last year in London.

Pray accept, dear Sir, my most sincere regards,

<div align="center">Mary Cassatt</div>

Original in French.

38. Mary Cassatt at Villa Angeletto, Grasse, c. 1910.

5

The Late Period

1900-1926

IN THE LAST PHASE OF HER LIFE, Mary Cassatt's correspondence is stamped not so much by the character of a working artist, but by the character of a *"grande dame"* of the art world. The term "grande dame" might at first seem misplaced in view of Cassatt's tiny 100-pound frame, her love of solitude, and her impatience with "poseurs" (snobs) of any kind; but in her own way, she played the role with a flourish.

Her social position was at its height after 1900. The sudden shift in her brother Aleck's position when he agreed to come out of retirement to become president of the Pennsylvania Railroad in 1899 affected the entire family. Cassatt was now sister of one of the most prestigious men in the United States. But she held her own in these exalted circles because, as an art expert, she could perform highly valued service for the captains of industry and finance who were her friends. With the Havemeyers, the Popes, the Stillmans, the Sears, and others, she could exercise the connoisseurship that resulted from her lifelong haunting of museums, art galleries, exhibitions, and artists' studios. She could pontificate with charm and authority on all facets of great art—both ancient and modern—which she saw as one continuous whole.

Her success in the role of art advisor came also from her adept handling of the innumerable details behind each transaction. Her letters to the Havemeyers, for instance, are crammed with reports of prices, shipping, insurance, customs, and the whole cast of char-

acters in Europe and America who supported this massive collecting craze. Dealers, local agents, impoverished aristocrats, shippers, restorers, writers, and "experts" were all brought into play in finding Old Master art and getting it safely into America. One acquisition that took several tortuous years to complete was the Havemeyers' prized El Greco, the *Portrait of Cardinal Guevara*.

Cassatt's prestige in the international art world during this period allowed her to preach her gospel of great art to an eager audience. As art institutions invited her to sit on juries or tried to award her prizes, she took the opportunity to recount the battle against juries and prizes that French artists had waged, resulting in the great art of Courbet, Millet, Manet, and the Impressionists that was now so eagerly sought. She accused Americans of fostering a level of "high average" in their art rather than nurturing the "one spark of original genius" that must not be extinguished. She goaded her fellow American artists to rise up against this system, especially when they saw European artists given preference in American exhibitions.

As a veteran observer of the Paris art scene, she was also encouraged to give her opinions of the art and artists around her. Consequently she turned a seasoned eye on her old friends Degas, Renoir, Monet, and Cézanne, as well as other contemporaries outside her circle such as Rodin, Sargent, and Cecilia Beaux. It irritated her to be asked about the new generation of avant-garde artists: Matisse, Picasso, and the Gertrude/Leo Stein circle, whom she felt missed the point of the Impressionist rebellion.

As the prices for Impressionist art went up, the artists themselves retreated from Paris art circles. Degas spent his time wandering through the city streets; Renoir and Monet, like Cassatt, lived in country estates. In spite of their distance, they responded to the new abstraction in art—Degas and Cassatt intensifying the color and boldness of stroke in their pastels; Renoir creating his "fat red women"; and Monet painting the reflections in water that Cassatt dubbed "glorified wallpaper." But the younger avant-garde artists did not return the favor; they chose to emulate Cézanne and Gauguin, which at first pleased the old radicals and then puzzled them. Cassatt was initially delighted that Cézanne was finally getting the recognition he deserved; but by 1910, when she saw the collectors' craze for Cézannes that erupted after his death, she questioned the direction of the new taste. It was a confusing time for her, as well as for

her whole generation of art-lovers. They retreated, finally, from the chaos of modern art to the safer world of the past.

The world itself was in an upheaval that led to the disasters of World War I. From the first, Cassatt was personally touched by these events—beginning with the torpedoing of the *Lusitania* with her friend Theodate Pope on board. As the war developed, it affected all aspects of her life. The Western Front cut diagonally across northern France, coming within fifty miles of her home at Beaufresne. She fled with her servants (her faithful housekeeper was German and had to be spirited across the border into neutral Switzerland; her chauffeur was about to be drafted) to the "Villa Angeletto," which she rented in the south of France. She returned several times to Paris and even to Beaufresne during the war, but her life and work were seriously interrupted.

While the war inflicted hardships on the aging Cassatt, it did not crush her spirit. Throughout the last twenty years of her life, she maintained a lively interest in ideas, politics, and world events that was as intense as at any time in her life. She was swept up in grand causes, feeling strongly that her experience and accomplishments enabled her to envision solutions to world problems. Just as she lectured on art matters in her letters, so did she freely express her opinions on the correct route to a better society. She was fierce in her condemnation of Theodore Roosevelt, and just as fierce in her support of the growing movement for women's suffrage.

Before this time, Cassatt's feminism had been individualist in nature. She felt that women should have the opportunity to work and should be given the recognition they deserved; but she did not participate in any of the organizations spawned by the women's movement. However, by 1910, the more conservative, focused character of the suffrage movement under the leadership of Carrie Chapman Catt brought such independent women as Louisine Havemeyer and Mary Cassatt into the ranks. By 1915 Cassatt had agreed to identify her name with the cause of women's suffrage and played an active role in organizing the *Suffrage Loan Exhibition of Old Masters and Works by Edgar Degas and Mary Cassatt* held at the Knoedler gallery in New York. Cassatt genuinely believed that women, because of their innate humanitarian concerns, would use the vote to improve the world situation. The advent of the war intensified this argument, its proponents pointing to Germany's "masculine"

society as the cause of German aggression. This argument proved to be a persuasive one: the suffrage amendment was passed by Congress early in 1919 and ratified by the states by August 1920.

Another movement that interested Cassatt in these years was spiritualism or "psychical research." While the melodrama of mediums, communicating with the dead, and tables rising off the floor seems out of character for this "realist," Cassatt's interest in these matters stemmed from her deep desire to find solutions to the world's problems. Above all else, she prided herself on her openness to new ideas, a quality that she felt had led her to a successful career as an Impressionist. Furthermore, the literature on spiritualism that shaped her ideas was considered intellectually sound. The research of such figures as Frederick Myers and William James was widely influential in England and America and forms an important chapter in the early history of psychology.

Certainly the open-minded, enthusiastic exploration of ideas that continued into Cassatt's old age was a facet of that rare quality that had supported her entire career: belief in herself. In each new work she made, up to the last, she was convinced she saw improvement. As the collectors and artists of her generation died, releasing their collections to the art market, she had the opportunity to confront and assess examples of her earlier work that she had not seen for many years. The shock of coming across a painting from her past never failed to trigger a reaffirmation of her accomplishments. She did not rank herself with the greats—such as Degas—but she was thrilled when, for a brief time, her work was mistaken for his in the clearing out of his studio after his death. And, as she began to settle her own affairs, she took great care that her best works would go to the museums and collections where she knew they would be appreciated.

The older Cassatt got, the more firmly rooted was her self-confidence. In a sad mix-up in 1923-24, she mistakenly had a series of drypoint plates printed, thinking they had not been printed before. When friends noticed the duplication of an earlier edition and tried to point this out to her, she was a lioness in her own defense. Not only did she defend herself against what she felt were accusations of fraud, but she was firm in her belief in herself as an artist: "I have had a joy from which no one can rob me—I have touched with a sense of art some people once more— They did not

look at me through a magnifying glass but felt the love & the life.
. . ." Clearly, when preaching to American art officials about the
"one spark of original genius . . . [that] will survive," she was, in
her heart of hearts, speaking of herself.

Cassatt's life after 1900 attained a pleasant regularity as she shuttled
between her Paris apartment and Mesnil-Beaufresne for the summer
and the south of France for the winter, only periodically interrupting
this schedule for long voyages to Italy and Spain (1901), the United
States (1908-9), and Egypt (1910-11). She kept up an active social
life by entertaining her brothers, her nieces and nephews and their
friends, and an international array of dealers, collectors, writers on
art, and artists. She occasionally complained that her social obliga-
tions took her away from her own art, which she continued to
produce until at least 1915. Cataracts and several unsuccessful opera-
tions on her eyes finally forced her to abandon it, although she was
never permanently blinded and attempted to write her own letters
until 1925. She remained vigorous both mentally and physically
into her eighties, when, finally, weakened by diabetes, she died on
June 14, 1926.

In 1898-99, Mary Cassatt had made her first visit to the United States in over twenty years. In addition to visiting her family in Philadelphia, she also traveled to Boston and to Naugatuck, Connecticut, where she renewed her acquaintance with the Whittemores and was introduced to Mr. and Mrs. Alfred A. Pope and their daughter, Theodate. She kept close ties with both families for the rest of her life.

MARY CASSATT TO ADA POPE[1]

Mesnil-Beaufresne
April 7 [1900]

My Dear Mrs. Pope,

I have put off answering your very welcome letter, hoping after a visit to Paris to be able to write you something of interest, & not only my thanks— You must know that I have been spending the winter here, quite alone, & have only been to Paris at rare intervals for a day or two at a time. I don't know anyone but Miss Pope who would care to do as I have done & even she might find this rather too much of a solitude.[2] I was very sorry to hear that she was not well, she who is such a picture of health; the new house must have been most absorbing work for her & very exciting.[3] I know what I felt when getting settled here, how I fretted to get the workmen away & then only to call them back again, & I have been doing nothing else ever since— I rather flatter myself you would not know Beaufresne again. I have done more plumbing, another bath room &&, I hope I am now nearly up to the American standard. I need not say that I am so far beyond my French neighbours, that they think I am demented. Mrs Havemeyer sent me a book on gardening "The English flower garden &" which I told her would be my ruin, & now that my lawns have all been properly turned over & levelled & walks designed & made I have gone into roses, & every day I bend carefully over my delicate "teas" to watch the shoots, I have over a thousand planted & already fancy myself sniffing the perfume & revelling in the color— Oh! you will enjoy your place. There is nothing like making pictures with real things— I feel very much all the kind things you say of my little picture,[4] it is a great pleasure to think you have it, it was thought pretty good here, the color an improvement.

Do come over this summer you wont regret it, Paris has changed.

274

The fine opening from the Champ Elysees through to the "Invalides" & the new bridge add much to one part of the town, & the exhibition is going to be very fine[5]— I quite long to see you again & Miss Pope might get some ideas from French gardens, they do know about gardening over here, tho' my gardener *would* plant crocuses in beds instead of sod. What does Mr Pope think of the "boom" in our set, 43,000 frcs for a picture of Sisley the original price 80 frs[6] & Renoir, poor man, crippled with rheumatism just as his turn has come. I don't believe you will resist the attractions of this summer over here. I shall hope to see you— Do give my warmest regards to Miss Pope & to Mr. Pope & our mutual friends at Naugatuck,[7] I long to see all of them again— Believe me my dear Mrs. Pope

<div style="text-align:center">

affectionately yours
Mary Cassatt

</div>

1. The foundation of Cassatt's friendship with the Pope family was their interest in collecting Impressionist art. Having amassed a large fortune in the steel industry in Cleveland, Alfred Atmore Pope (1842-1913) and his wife, Ada, had already begun to buy works by Manet, Monet, Whistler, and others in the 1890s. There are two letters from Cassatt to Mrs. and Miss Pope in the Hill-Stead Museum, Farmington, Connecticut.

2. The Popes' daughter, Theodate (Effie) Pope Riddle (1868-1946), was an enterprising and intellectually dynamic young woman with whom Cassatt established a longstanding friendship. She eschewed the life of a socialite in favor of such interests as running a tea shop in Farmington, volunteer social work, political activism for the causes of socialism and feminism, and spiritualism. She turned an interest in architecture into a professional career, designing several schools, houses, and monuments between 1900 and 1930.

3. Theodate Pope designed "Hill-Stead," the family home in Farmington, Connecticut. Construction of Hill-Stead began in 1899 under the supervision of the famous architect Stanford White.

4. The Popes owned two of Cassatt's works at this time: *Mother About to Wash Her Sleepy Child* (figure 39) and *The Barefooted Child*.

5. Construction for the Exposition Universelle of 1900 included two exhibition halls—the Grand Palais and the Petit Palais—the avenue between them (now called avenue Winston Churchill), and the new bridge (Pont Alexandre III) leading to the Invalides.

6. Alfred Sisley (1839-1899), one of the original group of Impressionist landscapists, did not live to see his painting *L'Inondation* (*Flood at Port-Marly*, 1876) bring such a high price in the sale of his friend Tavernier on March 6, 1900. Normally his paintings were sold for under 10,000 francs.

7. The John Howard Whittemores.

MARY CASSATT TO LOUISINE HAVEMEYER[1]

<div style="text-align:center">

Mesnil-Beaufresne
Christmas evening [1902]

</div>

Dear Louie,
About this time you have finished your luncheon, & no doubt you

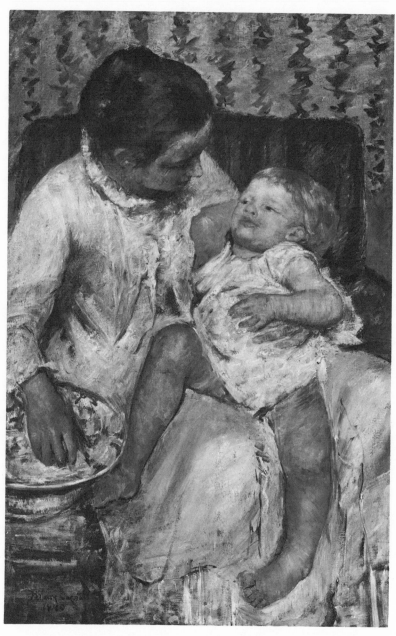

39. *Mother About to Wash Her Sleepy Child*, 1880. Oil on canvas, 39½ x 25¾ in. Los Angeles County Museum of Art, Mrs. Fred Hathaway Bixby Bequest.

are all looking forward to a gay evening, Adaline arrayed probably for "conquest and a ball" as Thackeray would have said. I celebrated the festival by working all day, but this evening eat a piece of turkey for dinner & sipped a little "grave" first meat I have tasted or wine drunk, since I dined with Aleck at the Castiglione [Hotel]. Vegetables & water seem to agree with me very well. I must thank you for the Burton book it has made me pass several very pleasant evenings.[2] I had read *his* life & all *her* Pscychical experiences, so I was doubly interested. Dr Bird & his sister from whose house she was married I met at Antibes, he used to come in the evenings to give me billiard lessons & talk. Burton was a very British husband, she needed devotion to put up with him, or else her biographer has put the case wrongly. The English love the East because they can lord it over the people out there, & that is their aristocratic instinct.

I hope you got the photographs of the Goya's.[3] What did you think of the prices? D. R. [Durand-Ruel] thinks that Madrazo's brother is the best intermediary, or he did think so, now he begins to write to "Pepita", it was natural for Madrazo to pile on the prices he knows what is paid for pictures. Pepita wrote to know if she was to communicate to D. Ranent Mr. Havemeyers affairs, I wrote back on no account, what is the use of paying so much more? I told her she was to attend to the four things Cardinal, balcony & Calle del Cruz two Goya's & refer to me. Wicht had not told her what commission he got so I wrote 5/o & explained that if she got the 'Cardinal' for 50,000 pesetas her share would be 2500 pesetas. She cannot make a mistake over that. Alava is doing the business & Pepita says expects a share of the commission. Sra Alava is intimate with the owner of the Cardinal & does not doubt she will succeed. As to Mr. Havemeyers business agent taking charge of the picture we must wait & see. I will cable as soon as anything serious occurs. I will after all send you the photo of the Titien, it may interest you to see it although not it seems to me in your line. I am so glad it pleases you, I *wish* Harmisch had let me know he had it in Paris.[4]

I was amused to hear that it was to paint the Elkins family Sargent is going to America, we were told in the "Herald" that it was to paint the President, which rather surprised me. To think of Aman-Jean being over there,[5] are they all bent on that Eldorado. Helleu I hear expects to net $50,000, if not more.[6] How did you like Miss Beaux?[7] I hope you did not make my Beaux mistake & talk *Art*? You ought to have heard John G. Johnson[8] lecturing me on my fatal mistake, in talking Art to any of them, "There is Miss Beaux, not without ability, but you must not talk Art to her." When one gets with the right person talking Art is pleasant as we know. I wish you knew Roger Marx you must meet him.[9] He told me that he considered Cezanne an incomplete artist,[10] yet he said Monet

owns a landscape of his (Cezanne's) "qui enfornce [?] tous ce qui est autours" Monet is painting a series of views reflections in water, you see nothing but the reflection! Marx was interesting on him. Did I tell you my brother had typhoid lightly. I am almost sorry you are in town there is so much about.

Lots of love to all & best wishes for the coming year.

ever affectionately
Mary Cassatt

1. Mary Cassatt met Louisine Elder Havemeyer (1855-1929) in the spring of 1874 when "Louie" and her sister came to stay in the Paris boarding house (Madame del Sarte's) where Emily Sartain lived. Louisine Elder was drawn into the lively circle of young artists and soon became interested in collecting modern art, acquiring works by Degas, Whistler, and Pissarro by 1880. Her marriage to Henry O. Havemeyer in 1883 and the births of her three children, Adeline (b. 1884), Horace (b. 1886), and Electra (b. 1888), kept her at home in New York for several years, but did not deter her from enlarging the art collection which she and her husband were devoted to. In 1889 the Havemeyers returned to Paris on a collecting trip and their friendship with Cassatt was reestablished. From that time until 1924, when a misunderstanding over the ill-fated series of Cassatt's drypoints caused ill will between them, the two women remained close friends. There are over two hundred letters from Cassatt to Louisine Havemeyer in the Metropolitan Museum of Art.

2. The biography and memoirs of Lady Burton (1831-1896) were published as *The Romance of Isabel, Lady Burton* in 1897 and 1900. She was the author of her husband's biography, *The Life of Captain Sir Richard Burton,* which appeared in 1893. Sir Richard Burton was the famous world traveler, author, and translator of Indian and Far Eastern texts.

3. In 1901 Cassatt had traveled with the Havemeyers to Italy and Spain in search of Old Master paintings for their collection. While in Spain they found several Goyas and El Grecos that they wanted to consider for purchase. After several years of negotiations involving various art agents such as Ricardo (?) Madrazo (brother of the Spanish painter Raimundo de Madrazo) and others, the Havemeyers acquired Goya's *Majas on a Balcony* and El Greco's *Cardinal Don Fernando Nino de Guevara*, now in the Metropolitan Museum of Art.

4. Arturo Harmisch, an art agent in Florence.

5. Edmond Aman-Jean (1860?-1936) was a successful Salon painter and portraitist.

6. Paul César Helleu (1859-1927) was a portraitist and painter of interiors in a fashionable turn of the century style.

7. Cecilia Beaux (1855-1942) studied in Philadelphia and Paris and then established her studio with great success in New York. She won a gold medal in the Exposition Universelle of 1900.

8. John G. Johnson (1841-1917), an immensely successful corporation lawyer from Philadelphia, began to collect art in 1880. In addition to his own fine collection of old Master and modern paintings which he left to the city of Philadelphia, he helped shape others such as the Wilstach Collection, part of the Fairmount Park Art Association, and the Pennsylvania Academy of the Fine Arts collection.

9. Roger Marx (1859-1913) was a collector and writer on art. He held the post of general inspector of the French museums.

10. Paul Cézanne (1839-1906) was an artist Cassatt admired greatly. She described him in a letter to Mrs. Stillman, c. 1894 (now lost): "He is like the man from Midi whom Daudet describes. When I first saw him I thought he looked like a cut-throat, with large red eye-balls standing out from his head in a most ferocious manner, a rather fierce looking pointed beard,

quite gray, and an excited way of talking that positively made the dishes rattle. I found later that I had misjudged his appearance for, far from being fierce or a cut-throat, he has the gentlest nature possible, *comme un enfant*, as he would say. . . . I am gradually learning that appearances are not to be relied upon over here. Cézanne is one of the most liberal artists I have ever seen. He prefaces every remark with *Pour moi* it is so and so, but he grants that everyone may be as honest and as true to nature from their convictions; he doesn't believe that everyone should see alike."

MARY CASSATT TO H. O. HAVEMEYER[1]

10, rue de Marignan
February 3, 1903

Dear Mr. Havemeyer,

I have just received a letter from Harmisch enclosing your cable; he had already written to me about the Titien, giving a glowing account of the quality of the picture, but this was the first I had heard of the subject [Danae]. I have answered him, asking him to make a pencil sketch of the picture, as the owners refuse to allow a photograph to be taken, & calling his attention to the fact that such a subject unless treated in a very unobjectionable manner, makes the picture unfit for a private collection especially yours, as you have young daughters &&. I will see what he answers. I feel certain of his judgement, he has given proof that he is to be relied on as to the qualities of Art, but this view of the matter may have escaped him, & I have seen more than one Danae you would not want, no matter how fine. The price seems to me moderate, for nothing after the [Prince] Brancaccio ideas. The Prince called again & brought photographs of the "Velasquez"[?] head, & a list of prices, the head 1,300,000 fcs! Only! I laughed & he assured me that *you* had offered 5,000,000 for the Doria Pope! Sangorgio [?] had told him so! I assured him that was an impudent lie. That you had never made an offer, were the owner of some old Masters celebrated the World over, had been a collector for twenty five years & no man living knew better the value of pictures, & that you would be highly amused at such monumental figures. I doubt if I convinced him. You will have received the copy of Bode's letter about these pictures, it is beyond me, & it was Bode it seems who endorsed the collection Mr Walters bought & for which he paid 3,500,000 fcs.[2] Lucas tells me that he has it on good authority that there were several excellent pictures in the collection & therefore he thinks Mr Walters got his money's worth. It would not be my way of buying pictures. George Durand-Ruel was here today with a letter from his father,[3] the woman's portrait is very fine but like all the Goya's will have to be relined, the owner won't sell on [one] without the

279

other & is not anxious to sell at all, these Spaniards are very slippery. I hope the old gentleman did not not go down for nothing, it was lucky of him to rush off as he did; I do hope Colonel Paine will get something worth having.[4] Louie wants me to keep a look out for fine Monets I have just heard of someone who has several good early pictures, the same period as mine, if you come over you might find something good, also I have seen a Corot figure but you have such fine ones it is not easy to match them, let alone surpass.

I am enjoying the beautiful bowls you & Louie were so good to send me, & thank you a thousand times for them. As I wrote Louie I am hoping soon for news of the Cardinal, I will cable as soon as I hear from "Pepita." I have not sent you an account of the funds belonging to you in my hands but they are still there!

With much love to all & best wishes for health

yours most sincerely
Mary Cassatt

1. Henry Osborne Havemeyer (1847-1907) inherited a prosperous sugar-refining business from his father and parlayed it (through the foundation of the sugar trust in 1887) into one of the largest American fortunes. When he married Louisine Elder in 1883 his interest in art collecting was already well established; he had begun to collect French landscape paintings and Oriental decorative arts which were displayed in their lavish new New York mansion. In the 1890s, under the influence of Mary Cassatt, he branched out into avant-garde French art by Courbet, Manet, and the Impressionists, and amassed a fine collection of Old Masters.

2. Wilhelm von Bode (1845-1929) was director of the Kaiser Friedrich Museum in Berlin and advisor to many American collectors.

Henry Walters (1848-1931) was chairman of the board of the Atlantic Coast Line Railroad Company in 1900; a Baltimorean, he was considered the richest man in the South. He continued to build the collection started by his father, William T. Walters, opening it to the public in 1909 and leaving it to the city of Baltimore upon his death in 1931. In 1902 he acquired the Marcello Massarenti collection, which included a vast and disparate group of objects from antiquity to the Renaissance.

3. Georges Durand-Ruel, son of Paul Durand-Ruel, was later put in charge of the firm's New York branch.

4. Colonel Paine was a friend and neighbor of the Havemeyers in New York.

MARY CASSATT TO THEODATE POPE

10, rue de Marignan
May 19 [1903]

Dear Miss Pope,

I am anxious to know if you arrived safely at your picturesque village & found *dry* quarters, those very beautiful old villages are apt

to be damp & rheumatic. I am sorry you sent back "Lady Burtin" but you can finish it when you come out to me, then you won't be bored— I must tell you that I returned again to the medium[1]— The experience was curious, in as much as it consisted of prophecies, but the oddest part was, that no sooner did she go off than she remembered all about the last séance, three months ago, & which she certainly in the natural course of things would not have recalled— I told her this when she woke & she said that "Julie" always remembered, that some Mexicans had a séance & that returning ten years afterwards, they told her that "Julie" had resumed the conversation just where it had been left off— This accords with the theory of the perfect memory of the "subliminal self"— I told her you had had a *complete failure,* & she said different things, but the one thing she said was that she was perfectly willing to have me interpret for Miss Hillard[2]— I hope to be at Beaufresne the last of this week & shall look after my roses & you must both come when they are in beauty— Do let me know how all is going with you & that you are enjoying the country even if wet—

I shall take this to the bank for your address

Love to you both

<div style="text-align:right">

affectionately yours
Mary Cassatt

</div>

1. Sharing an interest in spiritualism, Mary Cassatt and Theodate Pope visited a medium in Paris, Mme. Ley Fontvielle. Several years later, Cassatt went to a séance that she described to Louisine Havemeyer's daughter, Electra, in an undated letter: "The family who were experimenting were there and we sat around a table which rose from the floor four feet off the floor *twice.* Do you remember Mr. Stillman asking if there was a woman in Europe who could make that table rise off the ground? Well it rose."

2. Mary Hillard, a close friend of Theodate Pope, became headmistress of Westover, the school for girls in Middlebury, Connecticut, which she and Pope started.

MARY CASSATT TO AMBROISE VOLLARD[1]

<div style="text-align:right">

Mesnil-Beaufresne
Tuesday [1903]

</div>

Dear Sir,

I wanted to come back to your place yesterday to talk to you about the portrait of the little girl in the blue armchair [figure 40].[2] I did it in 78 or 79—it was the portrait of a child of friends of M. Degas— I had done the child in the armchair, and he found that to be good and advised me on the background, *he even worked on the background*— I sent it to the American section of the Gd. exposition 79 but it was

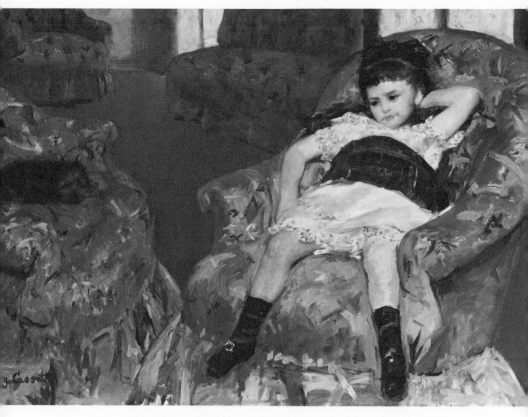

40. *Little Girl in a Blue Armchair*, 1878. Oil on canvas, 35¼ x 51⅛ in. National Gallery of Art, Washington, D.C., Collection of Mr. and Mrs. Paul Mellon, 1983.

refused.[3] Since M. Degas had thought it good I was furious especially because he had worked on it—at that time it seemed new, and the jury consisted of three people, of which one was a pharmacist! In thinking of the vases that I saw at your place, I see that I have been wrong, I was about to scrape the one that was fired, because I'm sure it won't come out, as with anything a trial run is needed.[4] I'm going to see if I can do something with the other because I'm not very well pleased with the band of flowers.

I expect to return to Paris in a week and if you want I will look over the things here that you chose, and also I will sign the two that you took yesterday.

To return to the vases I will do them better in Paris, but on the

282

other hand I have an abundance of flowers here for models, when it rains I can't work outside—

Please accept my best wishes

Mary Cassatt

Original in French.

1. The art dealer Ambroise Vollard (1865-1939) specialized in modern art, representing the Impressionists as well as Matisse, Picasso, and their followers.

2. As this painting had recently come onto the market, Vollard had requested more information about it.

3. She is referring to the Exposition Universelle held in Paris in 1878. Although this painting was refused, Cassatt had sent another (*Tête de Femme*), which was accepted.

4. Sometime in 1902-3 Cassatt began experimenting with the decoration of ceramic vases. Apparently she painted her design onto the body of the vase, then glazed and fired it. In spite of her difficulties, she finished at least one example, which is now in the Petit Palais (figure 41).

41. *Ceramic Vase*, c. 1903. Musée du Petit Palais, Paris.

MARY CASSATT TO PAUL DURAND-RUEL

<div style="text-align: center">Mesnil-Beaufresne
Monday [1903]</div>

Dear Sir,

I just received a very friendly note from Monsieur Manzi, wishing to see me on my next trip.[1] He would like, by way of his journal "La Mode", to promote the appreciation of "*my genius*"!! (I am surely not an imbecile) by the American public. It seems to me that color reproductions of my pastels in a fashion magazine, where I follow M. Tofau and others, is not the thing to flatter my very great vanity. I would be very happy for your thoughts on this matter before responding.

<div style="text-align: center">very cordially
Mary Cassatt</div>

Original in French.

1. Monsieur Manzi was an art dealer of the firm Manzi, Joyant et Cie. in Paris and a writer on art.

MARY CASSATT TO ADA POPE

<div style="text-align: center">Mesnil-Beaufresne
June 30 [1903]</div>

Dear Mrs Pope,

I hope this finds you all safe & well in England & all reunited again— There must have been a pleasant hour spent in Liverpool when you landed & plenty of pleasant home talk— The young ladies [Theodate Pope and Mary Hillard] will have told you that I had the pleasure of seeing them here a brief visit, marred by the unseasonable cold weather, but which I much enjoyed; they would hardly believe how differently the place looks now that the sun has brought the roses out. I am wondering if Miss Hillard got my letter, from Miss Pope's to me later I fear not, I addressed it to the bankers, as I address this— I ventured to say Theodate but I dont know if she will allow that in view of our divergence of opinion, for I see in her letter that she is still in favor of *bare walls*. I remember she wanted to banish the japanese prints to the portfolio, though they would be surprised to find themselves there being created especially in a decorative intention.

I hope all the same she will go & see the Holbein in Darmstadt,[1] she will forgive its existence as it has landed in a Public Gallery, no a gallery opened to the Public, & I am sure will feel its charm & that it is an intellectual stimulant, books must not have it all their way— I do

<div style="text-align: center">284</div>

most sincerely hope that Manheim will set you up, & be a real *"cure"*
& that you will enjoy your stay there, & then dear Mrs. Pope you must
let me get at least a glimpse of you before you turn homewards, I
wish you would all come here, but at any rate I will go to you in Paris if
you cannot lose the time coming here, but you have not seen Gisors!
With warmest regards to the party & sincerest hopes & wishes for a
pleasant summer believe me ever most cordially yours

<div align="center">Mary Cassatt</div>

Have you read (*Richard Yea & Nay*) by Hewit?[2] If not read it &
come & see Gisors where the scene is laid

1. Hans Holbein the Younger's *Altarpiece with the Madonna of Mercy and the Basel Burgomeister Jacob Meyer* (1528/30) is in the Grandducal Castle in Darmstadt.

2. Maurice Hewlett's *Richard Yea-and-Nay (The Life and Death of)* was published in 1900. It was set in medieval France and took place in Gisors, a town about ten miles from Cassatt's château.

MARY CASSATT TO THEODATE POPE

<div align="right">Mesnil-Beaufresne
[September 1903]</div>

Dear Miss Pope,

I ought to have answered your letter before this, but I have been very
busy & I waited knowing you would soon be again in this part of the
world— I had such a delightful letter from Miss Hillard & quite
counted on answering it in person in Paris. I am very much disapponted
to think I shall not see her again, & that she will be so busy with
the new school she will not, probably, be able to come over to Europe
very soon again—
You must not discourage her about Art, I am sure she will derive
great enjoyment from the effects in her surroundings, & also for herself.
I am quite sure she will begin to feel pictures in a different way, you must
remember that art is a great intellectual stimulus, & not reduce
everything to a decorative plane— What you say about pictures being
things alone, & standing for so much, & therefore the wickedness of
private individuals owning them, is I assure you a very false way of seeing
things, surely you would not have museums crowded with *undigested*
efforts of everyone? Only in years after an artists death are his pictures
admitted to the Louvre, I wish to goodness we had some sensible rule of
that kind at home, instead of that everything can be crowded into

public Museums, & no standard is possible in such a mess. I think it is very exhilirating to a painter to know he touches some individual enough for that person to want to own his work, & surely there is nothing wrong in a hard working lawyer or business man putting some of his earnings in a work of art which appeals to him, when we must all work for the state may I no longer inhabit this planet— I assure you when I was in Boston & they took me to the Library & pointed with pride to all the young ones devouring books, & that without guidance, taking up all sorts of ideas of other people; I thought how much more stimulating a fine Museum would be, it would teach all those little boys who have to work for their living to admire good work, & give them the desire to be perfect in some one thing— I used to protest that all the wisdom of the World is not between the pages of books; & never did I meet any one in the Boston Museum, where the state the pictures are in is a disgrace to the Directors— As to the Havemeyer collection about which you feel so strongly, I consider they are doing a great work for the country in spending so much *time* & money in bringing together such works of art, all the great public collections were formed by private individuals— You say "no collection can be interesting as a whole"— There again you are thinking of decoration, but I know two Frenchmen who are thinking of a journey to New York, *solely* to see the Havemeyer collection because *only there* can they see what they consider the finest modern pictures in contact with the finest old Masters, pictures which time has consecrated & only there can they study the influences which went to form the Modern School, or at least only there see the result— You see how others look on collections.

Enough of this we can talk of art when we meet, I do hope you will come down here I shall be so happy to see you, come on a Saturday evening—spend Tuesday or if the weather does not tempt you I will go up & see you; at any rate we must meet, I had a young couple today to see the place who were enchanted. Kindest regards to all the party & hope you are all well ever yours most cordially

<div style="text-align: right">Mary Cassatt</div>

MARY CASSATT TO PAUL DURAND-RUEL

<div style="text-align: right">Mesnil-Beaufresne
November 10 [1903]</div>

Dear Sir,

I am writing to remind you that I made an agreement last December

with M. Georges according to which I am authorized to request the sum of fifteen thousand francs for delivered pictures during the course of the year. To date I have only received seven thousand, therefore I am writing to ask you for the balance. I have always been afraid of giving you too many things. You must tell me if that is the case. At the present moment I am doing dry points. Less difficult to place.

I have just received a letter from Mr. Lawrence who tells me that in order to complete his collection of my pictures he needs two more, but smaller than those I ordinarily do.[1] I would be happy for him to have the picture of the young woman with the child in her arms. I believe you sent it to New York.

I was wrong to write to Mr. Lawrence last summer promising to send him a publication with reproductions of my pictures, I was talking about the article that Manzi was supposed to have published.
Mr. Lawrence is asking for it and I wonder if it isn't a joke on Manzi's part? In any case it keeps others from going ahead. I will tell you his [Manzi's] comments on Degas's nudes when I see you. He doesn't have any for sale.

Please accept my sincere regards

Mary Cassatt

Original in French.

1. Cyrus J. Lawrence began collecting works by Mary Cassatt in 1895; he eventually owned eight of her paintings and pastels.

MARY CASSATT TO PAUL DURAND-RUEL

Mesnil-Beaufresne
Tuesday [1903]

Dear Sir,

I have just received a letter from Mrs. Havemeyer about the statue.[1] She will have nothing but the original, and she tells me that Degas, on the pretext that the wax has blackened, wants to do it all over in bronze or in plaster with wax on the surface. What an idea, what does it matter that the wax is blackened? The price seems reasonable, which is what I wrote her. It is Degas who is not. Couldn't you arrange it, she wants the statue so much. She wants me to see it again which would be difficult, not immediately anyway, since I am in bed with a bad cold which I am taking care of in order to avoid bronchitis, a matter of a few days.

I hope I will have the pleasure of seeing M. Joseph here with the

children[?], but I am going to ask him to send me a telegram the day before so that I can offer them lunch. If they return by way of Beauvais, they won't regret it. There are few more thrilling sights than the sight of the Cathedral from the hill as you approach Beauvais from here.

Thank you for sending the articles on my exposition.[2] It is funny to read "Degas and Manet, those amusing Frenchmen." If those painter-journalists knew how entertaining they are. Unfortunately they are the ones who are going to shape art in America. I want to write Mr. [John G.] Johnson to ask him to get the Academy in Philadelphia to buy a Greco (when you have an answer). He told me that that they have $40,000 per year to spend. I wonder what they do with it. How silly I am to go to any trouble for them.

<div style="text-align: right">

Sincerely your friend
Mary Cassatt

</div>

Original in French.

1. Mrs. Havemeyer amassed a large collection of Degas's small sculptures of dancers and bathers, which she bequeathed to the Metropolitan Museum. The statue referred to here may have been Degas's famous *Little Dancer of Fourteen Years* (1880-81), which he modeled out of wax, painted, and dressed in a dancer's fabric costume and slippers.

2. The *Exhibition of Paintings and Pastels by Mary Cassatt* was held at the Durand-Ruel Galleries in New York, November 5-21, 1903. It consisted of fifteen paintings and ten pastels.

MARY CASSATT TO LOUISINE HAVEMEYER

<div style="text-align: right">

Mesnil-Beaufresne
November 20 [1903]

</div>

Dear Louie,

Here is a letter from poor "Pepita" which I think will interest you. If only we can circumvent Casa Valencia you may yet possess the Cardinal at a reasonable price. I answered her letter at once strongly impressing her with the necessity of secrecy as regarded the name of the would be buyer, for if the Conde suspected Mr. Havemeyer of wishing to buy the picture he would create all the difficulties possible. It would be rather a triumph to possess a really fine Greco, for with all their crowing none of them, not Manzi more than the others has a really good specimen of that artist. I imagine this is the finest thing outside the Public Galleries in Spain. As to the two "cadres" (so she translates quadros) of Rubens I told her to send photo's & that if the pictures were genuine & fine of course they would interest Mr. Havemeyer. The poor little woman is doing her very best, I feel quite a sympathy for her. I don't see why fine

Rubens should not be found in Spain he lived there for sometime &
certainly some of his greatest pictures are in the Prado. Will you sail over
to Gibralter & pick them up & carry them off? It will have to be thought
of as to who is going after the Cardinal when the time comes I will if
I am able to, but if not what is to be done D.R. pere is getting old &
George, him! [?] Well we will see. I have moneys of Mr. Havemeyer in
hand & no use for it in picture buying here, I hope to send it to Spain
to help buy the Cardinal my head is set on your having that picture for
the new gallery.[1] Tell me please situation & size of said Gallery. It has
been snowy much to our delight & is cold, but we so need snow for our
dead springs.

<div style="text-align:right">

Lots of love to all
ever yours affec
Mary Cassatt

</div>

1. The Havemeyer's house at 1 East 66th Street, New York, was designed by Charles
Haight and decorated by the Tiffany Studios. It was completed in 1890, but by 1900
the Havemeyers' art collection had expanded so much that a second picture gallery had to
be built.

MARY CASSATT TO THEODATE POPE

<div style="text-align:right">

Mesnil-Beaufresne
November 30 [1903]

</div>

Dear Miss Pope,

 You & poor dear Miss Hillard have not been out of my mind since
your letter was received. I little thought what sorrow you were going
through, I pictured you, on the contrary, full of plans & working happily,
& was with you in hopes for the success of the new building, the
knowledge of your bereavement is a great shock[1]— We don't seem to
progress in medical science as much as we think; how is it there are so
many mistakes made? The faculty of diagnosis is after all Psychical, &
few possess it. Poor Pissarro has just fallen a victim to a mistaken
diagnosis of his disease,[2] I feel sad over his loss I had known him for
so many years, & at one time we saw so much of each other, but he had
lived a long time, though he was in the full enjoyment of all his
faculties, but your friend was snatched away so young & without as far
as we can judge having fulfilled his earthly mission; no doubt he was
wanted elsewhere; oh! we must not lose that faith, the faith that life
is going on though we cannot see it, & you may sometime have a
convincing proof, just because he has gone before, I mean this for both, I
do so hope you may, what a consolation for those who have had it. I

wish I could know if you are working. Miss Hillard has so much to do, it will force her on, & if only you are helping her in her work; what a comfort you have in being able to speak of your loss together, you perhaps don't realize, oh if you could only know what it is to be quite alone in one's sorrow, it would lighten yours to think that at least is spared to you both— I do wish I could *fly* over & spend a few hours with you & hear all about your sad experience see you both, & cry with you too, I used to think I could never weep again, but I do when I see others suffer as I did. I am alone here & have been for a month. it is cold & there is snow, the first I have seen at this season for more than ten years— I work, & that is the whole secret of anything like content with life, when everything else is gone— I long for one thing for you, regular employment, you do look in, & that seems to me a good thing, but only with regular work. In the evenings when I sit here all alone, I read Myers book.[3] The more I read it the more I admire, & the more I hope— I wonder if you have seen Hodgson, & Mrs. Piper,[4] I think I would if I were you, Myers would approve of that for you— This writing when one longs to talk, is but a poor substitute, I cannot say all I long to say to you both, I feel as if I had known the young man you spoke of him so often, it seems so short a time since then & for you both it must seem as if you had crossed a gulf since— I don't think I will see you this winter, but perhaps; give my love to both Mr and Mrs Pope & thanks for their invitation I appreciate it, & with love & deep sympathy for both Miss Hillard & you believe me ever your affectionate

Mary Cassatt

1. John Hillard, brother of Mary Hillard and fiancé of Theodate Pope, died at the age of twenty-six.

2. Pissarro died on November 12, 1903.

3. Frederic William Henry Myers's book *Human Personality and Its Survival of Bodily Death* was published in 1903. Myers (1843-1901) was a British classical scholar and philosopher who played a large part in the Society for Psychical Research in London, which was founded in 1882. His primary interest was in the possibility of communicating with the dead, and his book compiled every shred of evidence of life after death down through the ages. The scholarly nature of this massive two-volume study assured Myers's credibility among contemporary philosophers and psychologists such as William James.

4. Dr. Richard Hodgson was Myers's friend and collaborator, finishing Myers's book and preparing it for publication after his death. He was secretary of the American Society for Psychical Research.

Mrs. Leonora E. Piper was a prominent researcher into the phenomenon of automatic writing in the United States. She was one of four women (in the United States, England, and India) who felt they were receiving messages from Myers after his death in the form of automatic writing.

MARY CASSATT TO HARRISON MORRIS[1]

10, rue de Marignan
March 15, 1904

My Dear Mr. Morris,

I have received your very kind letter of Feb. 16th with the enclosed list of the different prizes awarded in the Exhibition. Of course it is very gratifying to know that a picture of mine was selected for a special honor and I hope the fact of my not accepting the award will not be misunderstood.[2] I was not aware that Messrs Durand Ruel had sent a picture of mine to the Exhibition. The picture being their property they were at liberty to do as they pleased with it. I, however, who belong to the founders of the Independent Exhibition must stick to my principles, our principles, which were, no jury, no medals, no awards. Our first exhibition was held in 1879[3] and was a protest against official exhibitions and not a grouping of artists with the same art tendencies. We have been since dubbed "Impressionists" a name which might apply to Monet but can have no meaning when attached to Degas' name.

Liberty is the first good in this world and to escape the tyranny of a jury is worth fighting for, surely no profession is so enslaved as ours. Gérôme who all his life was on the Jury of every official exhibition said only a short time before his death that if Millet were then alive, he, Gérôme would refuse his pictures, that the world has consecrated Millet's genius made no difference to him. I think this is a good comment on the system. I have no hopes of converting any one, I even failed in getting the women students club here to try the effect of freedom for one year, I mean of course the American Students Club. When I was at home a few years ago it was one of the things that disheartened me the most to see that we were slavishly copying all the evils of the French system, evils which they deplore and are trying to remove. I will say though that if awards are given it is more sensible and practical to give them in money than in medals and to young and struggling artists such help would often be welcome, and personally I should feel wicked in depriving any one of such help, as in the present case.

I hope you will excuse this long letter, but it was necessary for me to explain.

Thanking you again for your letter believe me, my dear Mr. Morris

Very sincerely yours
Mary Cassatt

1. Harrison Smith Morris (1856-1948) was managing director of the Pennsylvania Academy of the Fine Arts in Philadelphia.

2. She was awarded the Walter Lippincott Prize of $300 for the best figure picture available for purchase in the 73rd Annual Exhibition of the Academy.

3. The 1879 Impressionist exhibition was *Cassatt's* first but the group's *fourth*.

MARY CASSATT TO CARL SNYDER[1]

<div style="text-align: right">

10, rue de Marignan
April 21 [1904]

</div>

My Dear Mr Snyder,

Both your letters are here, but not the Bode article which has evidently gone astray— Don't give yourself any more trouble about it. From your first letter you should be soon in Paris. I hope you will come and see me and I will give you a note to my friend Mrs Havemeyer; You won't find many Primitifs in their collection but such as they have are genuine, at least that is my belief.[2] As to those now on exhibition here, you will see that some seen at Bruges have undergone a certain transformation. Of course an immense amount of nonsense is being talked and written about the French superiority, one would think that the most rabid nationalistes might leave something to other nations. The French part is large enough Heaven knows, in these later times. I will quote you a saying of Degas— "Il faut s'incliner devant les Primitives, car ils ont tous fait"[3]— One thing though which is required of us they did not have, each artist a distinct technique and personality—

I am afraid I cannot contribute more than that sentence to an article on Degas, I don't know how to write, and have a horror of print, to say nothing of want of time— I have not yet recovered from the effect of seeing my note on the Museums in the Herald, the Boston Directors did not reply, but they bought a fine portrait of Greco in Madrid, which was much more to the purpose. Chicago is to be rated for the sum necessary to buy the Assomption, so we are not wasting our time. You should be here for the Marne [?] sale, when an Antonella da Messina and a Clouet are to be sold, the battle will be hot, as the Museums are in line— Hoping to see you soon, believe me

<div style="text-align: right">

Very sincerely yours
Mary Cassatt

</div>

1. Carl Snyder was writing a book called *American Private Collections*.

2. The taste for the so-called Italian Primitives can be traced to the early nineteenth century in Rome. Artists and writers revived an interest in Italian art of the fourteenth and

fifteenth centuries, which, compared to the High Renaissance style of the early sixteenth century, appeared "primitive." The great wave of interest in collecting Italian art at the turn of the twentieth century brought more and more of these works into the limelight.

3. "We must pay homage to the Primitives, because they have done everything."

MARY CASSATT TO CARROLL TYSON[1]

<div style="text-align:right">

Mesnil-Beaufresne
Monday, July 11, 1904

</div>

Dear Mr. Tyson,

I hope the train was all right and the return to Paris not so uncomfortable as the journey here. I have been thinking of you and your friends and your efforts, your future efforts to obtain recognition. Where the real trouble lies I think is in not having a good intelligent dealer in Philadelphia. If there is such a man he must be a recent acquisition. In these days of commercial supremacy artists need a "middle man," one who can explain the merits of a picture or etching, "work of art" in fact, to a possible buyer. One who can point to the fact that there is no better investment than "a work of art." If an intelligent young man with some knowledge, some enthusiasm, and a good deal of tact would arrive in Philadelphia he would do much to create a race of *buyers*. If I had the doing of it my shop would be near the commercial element, and I would turn my back on the society side, for in that set pictures are mostly bought from motives of vanity. Once a cousin, (N.Y.) said to a member of my family that she much regretted not being rich enough to buy pictures—she had $70,000 a year! Let the dealer take for motto Degas' answer to Vibert about pictures being articles of luxury. "Yours may be, *ours* are of first necessity." You will think me absurd perhaps, but the question interests me beyond others, and I half wish myself young again to take part in the battle. If a man like Vollard for instance was in Philadelphia your friend Mr. Ullman would have sold pictures ere this.[2]

Wishing you the smoothest of seas and a hard working summer and loads of amateurs believe me always

<div style="text-align:right">

Very sincerely yours,
Mary Cassatt

</div>

1. Carroll Sargent Tyson, Jr., was a young American artist and collector who worked in Philadelphia.

2. Eugene Paul Ullman (1877-1953) studied first in New York and then moved to France in 1899.

MARY CASSATT TO HARRISON MORRIS

[Mesnil-Beaufresne]
August 29 [1904]

My Dear Mr. Morris,

I greatly regret that I cannot cable my acceptance of your very kind
and flattering offer to serve on the Jury. That is entirely against my
principles, I would never be able to forgive myself if through my means
any pictures were refused. I know too well what that means to a
young painter and then why should my judgement be taken? Or any one
elses for that matter in the hasty way in which pictures are judged.
One of the men who served oftenest in the Paris Jury, told me that after
seeing a few pictures, some hundreds say, he was *abruti* ["senseless"]
and could not tell good from bad. I abominate the system and I think
entire liberty the only way. I did allow my name to be used on the jury of
the Carnegie Institute but it was only because Whistler suggested it
and it was well understood I was never to serve, and I hoped I might be
useful in urging the Institute to buy some really fine old Masters to
create a standard. In this hope I was naturally disappointed.
Please believe that if there were anything else I could do for the
Academy I would be delighted to do it.

Begging you again to forgive me, and with many thanks for your very kind
letter, believe me my dear Mr. Morris,

Most sincerely yours,
Mary Cassatt

JOSEPH DURAND-RUEL TO WILLIAM FRENCH[1]

Durand-Ruel & Sons, New York
November 23, 1904

Dear Sir,

Our representative, Mr. E. C. Holston, who is now in Chicago, sends
me a newspaper, announcing that Miss Mary Cassatt has won a $500.
prize for one of the pictures now exhibited at the Art Institute.[2]

Miss Cassatt is now in Paris and I have not communicated with her
about this matter, but feel empowered to state unhesitatingly on her
behalf that while she will feel honored by the distinction conferred on
her, she will decidedly refuse to accept the money, and will ask you
to dispose of these $500. for some deserving artist who needs the money,

or in any other way which you think proper. I am writing to Miss Cassatt to advise her of what has happened.

<div align="center">
Yours very truly,

Jos. Durand-Ruel
</div>

1. William Merchant Richardson French (1843-1914), brother of the famous sculptor Daniel Chester French, became director of the Art Institute of Chicago in 1882 and held the post until his death.

2. She was awarded the Norman Wait Harris Prize for *The Caress*. As she requested, the prize money was bestowed on an American art student studying abroad, Alan Philbrick.

MARY CASSATT TO THEODORE DURET[1]

<div align="center">
Mesnil-Beaufresne

November 30 [1904]
</div>

Dear Sir,

In response to your letter, I have no intention of selling my Cézanne still life; but I know that the Pissarro's have a painting of flowers by him which they intended to sell if they found an amateur— Mme Pissarro told me that she was going to have a sale in the spring of everything her husband left; but I know that in the meanwhile if she found someone willing to pay the asking price she would accept. She also has several landscapes by Cezanne that I am not familiar with—

I see that the Cezannes have had great success at the Salon d'Automne[2]—it was about time—

Did you see the portrait of the Cardinal when it was in Paris? It is the most beautiful Greco to have left Spain. But the Assumption is also a beautiful painting for a museum and so interesting as a transition piece. I hope that now that Mr Pierpont Morgan is Director of the Metropolitan Museum in New York that some truly fine paintings will be acquired.[3] It's not money which is lacking because the Museum has an income of $250,000 and Mr. Morgan has several millions, if he wanted to spend it that way.

<div align="center">
Very cordially yours,

Mary Cassatt
</div>

Original in French.

1. Jules Emmanuel Théodore Duret (1838-1927) was a wealthy, well-traveled connoisseur of art when he met Manet in 1865. Turning his attention to both radical art and political movements, he settled in Paris in 1867 to pursue a career as a journalist. He had an important collection of Impressionist and Old Master art and was very active in the art market. Six letters

from Mary Cassatt to Duret and nine letters from Louisine Havemeyer to Duret from this period are preserved in the Fondation Custodia in Paris.

2. The Salon d'Automne, an unjuried annual exhibition that attracted many young radical artists, was instituted in Paris in 1903. In 1904 it included a special exhibition of thirty-one works by Cézanne, and in 1907, after his death, a larger exhibition of fifty-six works.

3. John Pierpont Morgan (1837-1913), the powerful banker and financier, was an art collector of wide-ranging interests. He was active in the founding and early direction of the Metropolitan Museum in New York and became its president in the fall of 1904.

MARY CASSATT TO JOHN W. BEATTY[1]

Mesnil-Beaufresne
September 5 [1905]

Dear Mr. Beatty,

I have long been wanting to write to you, & have hardly known how. It is so long ago that I had the pleasure of meeting you in Paris that you may have forgotten the conversation we had at that time. I then tried to explain to you my ideas, principles I ought to say, in regard to jurys of artists, I have never served because I could never reconcile it to my conscience to be the means of shutting the door in the face of a fellow painter. I think the jury system may lead, & in the case of the Exhibitions at the Carnegie Institute no doubt does lead to a high average, but in art what we want is the certainty that the one spark of original genius shall not be extinguished, that is better than average excellence, that is what will survive, what it is essential to foster— The "Indépendants" in Paris was originally started by one group, it was the idea of our exhibitions & since taken up by others, no jury, & most of the artists of original talent have made their début there in the last decade, they would never have had a chance in the official Salons. Ours is an enslaved profession, fancy a writer not being able to have an article published unless passed by a jury of authors, not to say rivals—

Pardon this long explanation, but the subject excites me, it seems to me a very serious question in our profession, these are my reasons for never having served on the jury of the Institute, if I could be of the least service in any other way I would most gladly. I would consider nothing a trouble to serve the Institute of which you are so devoted a Director.

As to sending pictures, this year I have none, they have been sold in Paris and I could not ask the owners to send them so far as it would seem to them.

With my sincere regrets & my renewed excuses, believe me, my dear Mr. Beatty most sincerely yours

Mary Cassatt

1. John W. Beatty (1851-1924) was an American artist who served on various fine arts committees for American world's fairs. He became director of fine arts of the Carnegie Institute in Pittsburgh.

MARY CASSATT TO CLARENCE GIHON[1]

Mesnil-Beaufresne
September 13 [1905]

Dear Mr. Gihon,

Your card has just reached me. I am sorry I cannot be of any use to you in this matter of the Exhibition— The truth is I have not served on the jury, never will serve on any jury, nor be the means of repressing the works of another painter. I think the whole system wrong & have written to Mr Beatty requesting him to withdraw my name—

You may be surprised after this statement that my name should have appeared as a member of the jury. Some years ago Mr. Beatty told me that Whistler had suggested my being asked, it was I think the first year of the exhibitions at the Carnegie Institute, I accepted on the condition I was never asked to serve, & in the hopes of being able to get the Trustees to invest some of the funds in the purchase of *genuine* Old Masters & thus form the beginning of a Museum, & thereby give to American artists some of the advantages of the artists on this side— My hopes have proved vain, no such pictures have been bought by the Institute they have gone to private collections.

As for this years exhibition, I saw from a letter in the Herald that only one American was on the jury & only five American pictures were accepted. The American artists have the remedy in their own hands, let them refuse to send until the conditions of admission are changed— Our group were the founders of the "Indépendents". After we gave up our exhibitions the name & principles were adopted by a younger set & have prospered— Our profession is enslaved, it is for us to set it free.

The jury system has proved a failure since hardly a single painter of talent in the last fifty years in France has not been a victim to the system— Amongst those refused again & again, are Corot, Courbet, Millet & hosts of others, these men were kept back for years. We need a new system, the old one is used up— I hope you will help to inaugurate a new one; I do regret I cannot be of use to you in this case but if it helps to raise you against juries, I will regret it less.

Believe me very sincerely yours

Mary Cassatt

1. Clarence Montfort Gihon (1871-1924), an artist from Philadelphia, moved to Paris in 1894.

Within a two-year period, Cassatt was saddened by several deaths. Her niece Katharine succumbed to an incurable illness in 1905, and her beloved brother Aleck passed away late in 1906. Aleck's term as president of the Pennsylvania Railroad (1899-1906) had been brief but distinguished; his most notable achievement was the construction of the Pennsylvania Station in New York and the tunnels leading to it under the Hudson River. In 1907 she lost her good friend Henry O. Havemeyer.

MARY CASSATT TO LOIS CASSATT

[black border]
10, rue de Marignan
January 27 [1907]

Dear Lois,

Thank you very much for your letter. I know how much it must have cost you to go over all those last hours. I can imagine what an immense number of messages you must have had, and the only way possible for you was to answer by a printed card. Even I who know so few people have received letters from some whom I never supposed would write, and all are full of admiration for Alecks work and regrets at his loss. Some of the letters I will keep for the children to add to those you already have for them about their Father— As to the letter I wrote to Aleck, please read it and destroy it, if I had known Aleck was so ill I never would have written it and I regretted it afterwards— As I told him I knew another generation would not take the interest in Robbies grave that we would, and after I am gone there would be no one, after Gard, to see that it was kept in order, if there is anything left— I would like to have all at Mesnil, where I can take steps to have all taken care of.[1] I had not the heart to go to Germany after I knew that Aleck was ill, and so nothing has yet been done, and as I said I am only sorry I wrote to him about it—

Poor Elsie must of course be depressed. I hope she is better in health. I am glad you had Baby[2] with you at first, poor little dear, it is sad for her, but fortunately youth does not stay so long in grief or else nothing would be done in this world. I hope you will not break down after all you have been through, and that Baby and Elsies little ones will be a comfort

to you— My love to all and hopes that all are well in health.

Affectionately yours
Mary Cassatt

1. Mary Cassatt's elder brother, Robert Kelso Cassatt, had died in 1855 in Darmstadt, Germany, and was buried there. In 1907 she traveled to Germany to bring his remains back to France where he would be buried in the family sepulcher at Mesnil-Beaufresne with her mother, father, and sister Lydia.

2. Lois Cassatt's granddaughter and namesake, Lois.

MARY CASSATT TO JOHN W. BEATTY

Mesnil-Beaufresne
October 6 [1908]

My Dear Mr. Beatty,
In reply to your form of Sept 16th asking for my photograph, I don't possess one, and it would be very disagreeable to me to have my image in a catalogue or in any publication.

It is always unpleasant to me to see the photographs of the artists accompany their work, what has the public to do with the personal appearance of the author of picture or statue? Why should such curiosity if it exists be gratified?

With regrets & kind regards

Believe me
Most sincerely yours
Mary Cassatt

Mary Cassatt made her last trip to the United States in 1908-9. She visited family members in and around Philadelphia and went to New York to be with Mrs. Havemeyer on the anniversary of her husband's death.

She returned to France and resumed her regular habit of spending summers at Mesnil-Beaufresne, winters in the rented Villa Angeletto at Grasse in the south of France, and the rest of the year in Paris. She continued to paint and to keep up an active interest in current exhibitions and the art market. After her return from the United States, she showed

a fresh interest in American politics, including the women's suffrage movement, and in other aspects of contemporary American culture.

MARY CASSATT TO THEODATE POPE

Mesnil-Beaufresne
Wednesday, October 12 [1910]

Dear Theodate,

I have been wanting to write to you ever since I heard of Prof. James death,[1] and also to thank you for the books & pamphlets on Indian philosophy— I call Prof James going a national loss, I have such an admiration for his philosophy. & love his books— You must feel his going very much, do if you have the occasion give my sympathy to his son, I dare not send a card to Mrs. James. I know her so slightly, I met her only once— We are in the midst of unrest, no letters or papers have reached us to day & we don't know when the strike will extend, I hope the train got off to Cherbourg this morning, but am not sure— Are you still a Rooseveltian?[2] Or does his present attitude give you to reflect, as the French say— One man power ought not to appeal to us, here they need or think they need that sort of thing, flattering the masses is a dangerous game, & leads to what we are suffering from now— No Frenchman now in power has got there except by flattering the workmen & then has to turn against them— I do hope you are going to be interested in the suffrage.[3] Mrs Havemeyer wants to know if I havent talked to you on that subject, you must talk to her—

I heard from Mrs. Hood that you had not appeared at Braemar where she was prepared to welcome you— Now poor woman she is in London waiting for her baby, & we are all anxious about her as her journey down from Scotland was very trying— Poor women need courage— I hope you got Buckles lecture on Womens contributions to knowledge and that Miss Hillyard will read it to her girls[4]— I think hers is a splendid occupation & yours too in helping her, but you have other interests too— I trust you found all well at home, do remember me to the Whittemores; my kindest regards to Mr. & Mrs. Pope— I hope I may see them over here sometime again— I am looking forward to Egypt,[5] don't you want to see that birthplace of architecture? I have just got back from Brussels, the exhibition was interesting from the collection of Rubens lent, though it might have been more complete— If I can do anything over here for you at

any time let me know. I will with pleasure. With love & hopes you are well & happy

<div align="center">
affectionately yours

Mary Cassatt
</div>

1. William James, born in 1842, taught physiology, psychology, and philosophy at Harvard College from 1872 until 1907. He died on August 26, 1910.

2. Theodore Roosevelt (1858-1919), twenty-sixth president of the United States, left office in 1909. In a lecture tour of 1910 he revealed socialist tendencies, making the famous statement "Property shall be the servant and not the master" in a speech on August 31, 1910.

3. Women's suffrage—an issue in which Louisine Havemeyer and Mary Cassatt had become interested.

4. Henry Thomas Buckle's lecture before the Royal Institution (London), "The Influence of Women on the Progress of Knowledge," March 19, 1858, was republished in 1910. Buckle was a British historian whose life's work was the *History of Civilization in England*.

5. She went with the Gardner Cassatts on a tour to Constantinople (Istanbul) and Egypt in the winter of 1910-11.

MARY CASSATT TO LOUISINE HAVEMEYER

<div align="center">
Mesnil-Beaufresne

Sunday evening, November 13 [1910]
</div>

Dear Louie,

The Cabotin is beaten, what a relief, let us hope we hear no more about him.[1] What a man! Of course to him the unkindest cut of all must have been the defection of his neighbors. Oyster bay against him. I was in town Wednesday & heard the news there. I lunched at Mr Stillman's with his sisters & the Von André's.[2] You may imagine how pleased Mr. S. was. Afterwards we went to see Mr Harrimans bust at Rodins, very poor thus far, for he only saw him ill, & afterwards they sent him the death mask.[3] What an old humbug Rodin is. There was the Duchesse de Choisseul [?] there, one of the Condests [?], whose sister married Gleanzer, *so* common & painted, & of course booming Rodin & the, in my opinion very poor things he had to show. To inspire him he had one of Renoirs nudes on the wall. What he had which was really fine was a small Egyptian head, such a beauty. Why don't he copy that instead of Renoirs nude? Well they are too much for me. I met T—, the Director of the Munich Gallery, and now I know why Bourroughs spoke to you of Cezannes "nature morte."[4] It is Scheid [?] who infects them all. I told him what I thought of Cezanne, I was one of his first admirers, but I certainly never put him where they do, & drew the line as to his being a great figure painter ah, *no*. Interesting but very

incomplete. I told him one could judge when one saw your gallery. He Scheid actually admires this Matisse.[5] When they get there they should be shut up. We went after Rodin to see a Mr Whitneys collection of Persian potteries. Mr Stillman had been told that Tiffany considered it the best in Paris.[6] There were some very fine plates, no vases, no irredescent, after yours, & after Kelekians of course nothing, or rather little.[7] Kensington has accepted all Kelekians conditions and his collection is going there. The Stillmans sail on Saturday from England they go, the sisters to London tomorrow he follows on Wednesday. I am so very anxious you should know them. You will be doing a kind action if you invite them to see the collection. The eldest has real artistic taste, she painted. The youngest is a musician & sang very well, but Mr S says has been operated on, and broke down from too much exercise, riding. Just now they are going home to have her treated for headaches brought on from the matter forming behind her eyes! Dreadful suffering, he wanted them to stay & go to Wiesbaden to a great oculist there, but they think she can be cured in New York. I told him I thought they were right to try, how forlorn they would be in winter in Wiesbaden. I think you can help them, by giving them an interest in Art. I do so like them, as will you, & of course this is confidential.

I am waiting impatiently for a letter with all the particulars about Electra and the little daughter, when will you have them all in New York? Give Electra a kiss for me. I don't suppose one is allowed to kiss the baby.

Yes my dear Mr Havemeyer was already on the road to the French Gothic. I never miss an opportunity to tell people that the country owes him & you a debt. Of course few will ever know or understand. How I want to talk with you. We go to town on Thursday the day the family sail. I don't know when we will be off for Egypt. Baron Von André told me the best way to get there was by way of Constantinople. Then you only had a day & a half of sea & it was generally smooth, while if you went from Naples it is three days & from Marseilles four! I am beginning to tremble. Kelekian has engaged a first class dragoman for us, who is to attend to everything. I have just cabled to him in Cairo to take a diabeah he cabled to ask about with six rooms & 9 beds. Another of seven rooms & 10 beds he did not like so well. I hope my brother will be satisfied for it all is left to me, & I left it all to Kelekian who has been kindness itself. They told his brother in New York that you were to be 3 Months in Chicago, & how then could you decide about the statue! Rodin had a virgin & child, of later date in his studio, but it wasn't in it with your angel or the Saint. Why will he make his figures crawling on all fours? Humanity grown up; humanity does not take that posture. Heaps of love to you & all the family & hopes Electra

will soon be about. She must look lovely as an "accouché."

always yours affectionately
Mary Cassatt

1. "Cabotin" (a histrionic politician) refers to Theodore Roosevelt. He had brought about the nomination of Henry L. Stimson for governor of New York, who was defeated in the election of November 1910.

2. James Stillman (1850-1918) was president and later chairman of the board of the National City Bank of New York. He maintained a home in Paris from the 1890s but did not settle there until 1909. He collected Cassatt's work and consulted her on other purchases.

3. Edward Henry Harriman (1848-1909), chairman of the board of the Union Pacific Railroad.

4. Bryson Burroughs was curator of painting at the Metropolitan Museum from 1909 to 1934.

5. For Cassatt's opinion of Matisse see her letter to Ellen Mary Cassatt, March 26, 1913.

6. Louis Comfort Tiffany (1848-1933), the decorative arts designer and founder of the Tiffany Studios, had created many pieces for the Havemeyer mansion in New York.

7. Dirkan Kelekian was a prominent dealer in Persian rugs, textiles, and pottery.

MARY CASSATT TO THEODATE POPE

Pera Palace Hotel, Constantinople
December 23 [1910]

Dear Theodate,

I need not ask you if you believe in telepathy, but it seemed to me an added proof when your letter reached me here—my family landed on Nov 24th & ever since then, every day, we have talked of you & Mary Hillard & your joint effort for the school[1]— I could not remember the name, names always escape me, but my sister in law mentioned it in connection with the daughter of one of her friends. Mary Mitchell, is the young girls name a grand daughter of Dr Weir Mitchells of Philadelphia. This child is wild about the school, one can see what Miss Hillyard can do with girls from her report— Isn't it splendid to be able to influence whole generations? You ought to be happy to have cooperated —& in fact without you she would not have had the chance—now this is the point, my two nieces are with us,[2] & the youngest wants to go to boarding school, wants friends & companionship, her age is 13 she will be fourteen next August in her fifteenth year when the school year begins. Is she too young? and if not has Miss Hillard a place for her? I think I may count on your influence in her favor, & also on Miss Hillards— She is intelligent & will work but needs training her mother

303

feels this & I have told her all I know & all you told me as to Westover & then Miss Hillard all must feel what she is. Do answer when you have a moment to 10 rue de Marignan, from where my letters will be forwarded, probably up the Nile—

I wonder if you know this wonderful place. I don't believe you have been here, it is something to see, I am so glad we came though quarantine regulations will prevent the three days trip in Asia Minor which we had hoped to take. We hope to be in Cairo on January 3rd & have two months in Egypt— My brother & his family are enjoying it all as much as I am— It seems so odd not to be working all day, but seeing sights & enjoying the young friends of my nieces— I am glad you will be in New York & seeing Mrs. Havemeyer often I hope— She has had hard times, just think how much better if women know all about the men's work— At present men lead double lives— What we ought to fight for is equality it would lead to more happiness for both— Of course with that great big heart of yours, you lean towards socialism up to the present time it don't work, then too I believe if we are to be led to the promised land of more equal rights it will be by a silent leader there has been far too much talking & Roosevelt has been the sinner— I am not hard at least I hope I am not, but I am an individualist, & I'm of Gissings opinion.[3] He said when he saw certain individuals he wondered the world did not move faster, but when he saw the crowd he wondered it ever moved at all— I am more interested to know if you don't intend to bestow that heart of yours on some individual than to know you are bestowing it on the suffering, the latter though do wring my heart, old & worn as it is— We can do so little for others, except in the way of education. Did you ever read the "Benefactress"?[4] It is by the author of Elizabeth & her German Garden. May your poor little invalid recover— We were so interested in Sophia to hear of the great longevity—our Doctor called in for a sore finger declared that individuals of ages varying from 140 to 150 were scattered over the country & he knew personally a man, Jew, still retaining all his faculties, of 135 years— Of course most people would not care to go nearly as long as that, but it is interesting to know some can—

I am quite sure Henry James is a fine man & he has improved since he first wrote, then he was inclined to be society, but superior people soon get over that—[5]

This scrawl is getting too long, only one word more, do tell me how Jaccaci is & how the book fares[6]—

I will send you postals along our route

My love to you & also Mr. & Mrs. Pope. & hopes you will have a

splendid cure for your little protege & the best of times in New York

<div align="right">Your affectionate friend
Mary Cassatt</div>

My eldest niece & namesake is only 3½ years the senior of
the youngest, Eugenia, but has always found her best companionship
amongst older people her Father and Mother myself & of course
the youngest is a child to her

1. The Westover School for Girls, built by Theodate Pope with Mary Hillard as the first
principal, was intended for wealthy girls who would dress and "live simply according to the
highest ideals."

2. Gardner's two daughters were Ellen Mary (1894-1978) and Eugenia (1897-1951).

3. George Gissing (1857-1903), the British novelist, was author of New Grub Street, Born in
Exile, and The Odd Women.

4. The Benefactress, by Countess Elizabeth Mary Russell, was published in 1901. It is a novel
about a young woman who resists marriage.

5. Henry James (1843-1916), the American novelist, settled in London in 1876. Although
his and Cassatt's paths may occasionally have crossed, they moved in distinctly different
American circles abroad.

6. Augusto Floriano Jaccaci (1857-1930) was a connoisseur and art agent who coauthored
(with John La Farge) the lavish book Concerning Noteworthy Paintings in American Private
Collections in 1909.

MARY CASSATT TO THEODATE POPE

<div align="right">Sheppards Hotel, Cairo
Sunday, February 19 [1911]</div>

Dear Theodate,

Your letter reached me here & I return duly signed & witnessed the
paper for Westover. Thank you very much for sending it, Miss
Hillard told Mrs. Havemeyer that she would surely take Eugenia did we
wish it. I think there is no doubt that Eugenia will be ready as to
studies. The only one who has really profited by our Nile journey is
she— She has literally bloomed like a rose, she is intelligent &
very active & likes to work, is as tall as I am & has grown quite stout
from being a reed— We are much worried over the break down of
my brother.[1] The climate has not agreed with him, he has fever,
we hope only Nile fever & is in bed now with a nurse, but things look
brighter today, tomorrow we will know the result of the blood test. I
trust there is nothing very serious & that he will be able to leave
Egypt the first— The climate & even the country is a great
disappointment, & apart from some of the Temples there is nothing to

<div align="center">305</div>

see. Temples & Tombs still one learns— I am so glad to hear that
you are enjoying your winter and are pleasantly situated at the St Regis,
it isnt socialism, but that is far away, in the dim future— So you
think my models unworthy of their clothes? You find their types coarse. I
know that is an American newspaper criticism, everyone has their
criterion of beauty. I confess I love health & strength. What would you
say to the Botticelli Madonna in the Louvre. The peasant girl & her
child clothed in beautiful shifts & wrapped in soft veils. Yet as
Degas pointed out to me Botticelli stretched his love of truth to the
point of painting her hands with the fingernails worn down with field
work! Come over & I will go to the Louvre with you & teach you to see
the Old Masters methods. You don't look enough at pictures. Paul
Veronese had a jacket which he took about with him & constantly
painted on all his models, I doubt if they were "cultured" how I hate
the word, these are elemental things which no culture changes. Then
who do you think makes the fashions? The uncultured girls, & they are
launched by the "free lances" also uncultured but copied by the sheltered
women— No you must learn more before snubbing me. I certainly
won't paint you a picture, try one of the *refined* American ones produced
in New York— Almost all my pictures with children have the
Mother holding them, would you could hear them talk, their philosophy
would astonish you. France has always been the home of Art & reason
too as regards the race— When am I to see you to thrash this out
together, it is always stimulating to talk things out with you! Lots of love
& go on enjoying yourself, but I must hear that you have another
destiny in view

> Always affectionately yours
> Mary Cassatt

1. Gardner Cassatt died in Paris on April 5, 1911.

MARY CASSATT TO LOUISINE HAVEMEYER

> Hotel d'Angleterre, Biarritz
> January 9 [1912]

Dearest Louie,

All your good things are in Paris, and we, Mathilde and I and Pierre
are here. We left in rain which continues all the time. I took a vapor
bath in the auto. I who left with the doctors orders to seek sunshine to
complete the cure! I don't find it quite a cure yet. Dr Boignard

whom I saw at [illegible] before I left hinted that I was worn out with the treatment, and also advised my going away and getting to sunshine. I may find that at Cannes but we haven't seen it here. The mild damp weather makes me feel so weak. We start for Pau tomorrow, & from there across by Toulouse & Montpellier to Cannes, notwithstanding the down pour. I confess to feeling very blue. This afternoon I went to Bayonne to see the Bonnat Museum.[1] Bonnat gave it to his native town. It is badly arranged, & was so dark I could not see the pictures well. There is his portrait by Degas, and a portrait of his brother in law also by Degas. Some fine drawings by Ingres, these seem to me to be the best, though there is a Rembrandt sketch. I think my two Courbets which I mean to give to the Academy in Philadelphia would shine in the Bonnat Museum.[2] You know Mr Johnson has no Courbets and these two therefore will be the only ones in Philadelphia. Duret will of course have writen to you about the Courbet landscape. I am sure you will like it. Mr. Stillman did not find it enough a composition. He wonders you don't have any American landscapes in your collection. I try to make him understand that we have produced nothing original as yet, and that copies of others are not the finest things. "Now all can have the flowers since all can have the seed." Did not Tennyson say that who found the seed? Miss Stillman also wants to ask why our landscapes are better than our figures & why there are more of them. I will tell her how much easier it is to paint and especially to draw a landscape, & how much our modern painters use the camera. And what a long apprenticeship is needed to make a figure painter. The ride here from Bordeaux through "Les Lourdes" was beautiful and different from anything I ever saw before. The trunks of the trees were covered with moss of a rich *orange* color, the dry ferns & leaves such a brilliant brown and the branches of the trees such a delicate grey and then the broad green of the pines. Altogether I would have liked to be young & strong once more & come down here for a few weeks, in the midst of the forest at Mont de Mersau there is a good hotel.

I hope you have enjoyed your New Year festivities and that all are well and happy. My poor people are glad it is over these first holidays after a loss like that are so sad. Who knows better than you do?

Mathilde has a cold I wish she were better she sends her best wishes & remembrances so does Pierre. Heaps of love to you all to Annie & Addie. I write to Annie by this mail I think of her so often.

ever yours affectionately
Mary Cassatt

1. Léon Bonnat (1833-1922), an academic painter whom Cassatt despised during her early days in Paris, gave his collection to the city of Bayonne in 1903.

2. Cassatt gave a *Portrait of an Unknown Lady* and *Mayor of Ornans* to the Pennsylvania Academy in 1912.

MARY CASSATT TO LOUISINE HAVEMEYER

Villa Angeletto, Route de Nice, Grasse
(Alpes-Maritimes)
January 11 [1913]

(So Jaccaci is still in New York? He is too much for me. Do tell me about Theodate.)

Dear Louie,

The nuts are here, my dear what a lot, and the fruit, though I never touch sugar I think one or two of those won't hurt me. Then the shawl, such a good thick warm one. Though the weather is so delightful here, it is cold in the evenings and I laid the shawl over my knees & found it very comfortable in my tiny salon, even with the radiators. It is a queer climate. I wish more people with nerves & rheumatism could enjoy it. I hoped to hear from Mrs Havemeyer at Mirsheux that she is better, tho I scarcely expected to, for I am sure she is not being properly treated. It is cold at Mirsheux and she ought to be out of doors all day, as she could be here. I must take some of your nuts to Renoir, who suffers at times greatly, senile gangrene in the foot.[1] His wife I dislike and now that she has got rid of his nurse and model she is always there. He is doing the most awful pictures or rather studies of enormously fat red women with very small heads. Vollard persuades himself that they are fine. J. Durand-Ruel knows better. He (Joseph) promised to write to Parma for those photo's of Parmigianino pictures. I am pretty sure now that they havent any made. It would only be what one ought to expect. Kelekian sent me two cards which came with your letter, one from Boston where he had seen the Sears.[2] He thinks Mr Peters collection very fine now. He wrote before seeing you, he greatly enjoyed seeing you at home. I am sorry indeed to hear about his [Kelekian's] brother. I knew his ankle had been broken in six places, but thought that could be mended now a days. The Mother must feel so badly, if they have told her. Kelekian is very good to her & she is a fine woman. I suppose I may see them down here, he generally brings the whole family down for a week or so. I haven't seen Mr. Stillman he may be on his road to New York, in his last letter he was uncertain. He has had an interesting time as Mr. Herrick is an old friend of his, they are both such antisuffragettes it is one bond. Monsieur Carriot told me here the other evening when he called with his Mother in law, my proprietaire, that he

saw Mrs Herrick at the Franco American Society banquet between Leon Bougeron [?] and the Minister of Brazil, neither of whom spoke a word of English & Mrs Herrick does not possess a word of French, nor does Mr H. Wilson cannot find him a successor, with 75000 fcs a year it is not possible without a private fortune. I hoped to hear of Augustas having her baby before this. The Spaniards have an impertinent proverb, women have but one count to keep and cannot keep that.

I hope your babies are all right, you must dread anything wrong with the ears. Surely if taken in time things can be avoided. We are in the midst of a change. My cook suddenly or suddenly to us, showed herself a drunkard, a very bad one too & left in a hurry; by one day we missed an excellent one, and are now waiting for an "extra" to get well enough to come. To go back to your letter, I don't see why women should pay taxes, except on their earnings, mostly they are living on their incomes made by the husbands therefore they are represented. I believe that the vote will be given freely, when women want it, the trouble is that so many don't want it for themselves and never think of others. American women have been spoiled, treated and indulged like children they must wake up to their duties. It seems that Mr S says, so Joseph D.R. tells me as he told him, that women and men have different spheres and each must stay in their own. I would like him to define these spheres. Nothing he enjoys more than ordering clothes for his daughter, I should say that was their sphere. Most men think they could dress women better than women can.

Sunday. I don't feel as excited over questions as I used to, it is age, and having been so near the border here for so long, of course in those long sleepless nights and idle days, full of pain I thought so much of what might be beyond. Then living so much alone, and having so many gone before. You who see all these young lives expanding around you must be so interested in their future. It is hard for me to keep up with people and work. Americans have a way of thinking work is nothing. Come out and play they say. Mrs Warren could not see why I did not throw over a days work and go to her. I can understand how hard Mrs Sears finds it. Here I am scribbling on. Heaps of love and many thanks for the nuts and the nice warm shawl. We will have it over our knees when you come.

<div align="right">ever yours affectionately
Mary Cassatt</div>

1. Renoir had moved to Cagnes, in the south of France, in 1900, seeking a warmer climate to ease his rheumatism.
2. Mrs. J. Montgomery Sears and her daughter Helen (Mrs. Cameron Bradley) became acquaintances of Mary Cassatt through Louisine Havemeyer.

MARY CASSATT TO ELLEN MARY CASSATT[1]

<div align="right">Villa Angeletto

March 26, 1913 [?]</div>

Dearest Brown,

Yours of the 17th is just here; and as the weather is storming and a pouring rain has been our portion all night and likely to be all day, I have plenty of time before me to answer some of your questions about cubists and others. No Frenchman of any standing in the art world has ever taken any of these things seriously. As to Matisse, one has only to see his early work to understand him. His pictures were extremely feeble in execution and very commonplace in vision. As he is intelligent he saw that real excellence, which would bring him consideration, was not for him on that line. He shut himself up for years and evolved these things; he knew that in the present anarchical state of things—not only in the art world but everywhere—he would achieve notoriety— and he has. At his exhibition in Paris you never hear French spoken, only German, Scandinavian and other Germanic languages; and then people think notoriety is fame and even buy these pictures or daubs. Of course all this has only "un temps"; it will die out. Only really good work survives. As to this Gertrude Stein, she is one of a family of California Jews who came to Paris poor and unknown; but they are not Jews for nothing.[2] They—two of the brothers—started a studio, bought Matisse's pictures cheap and began to pose as amateurs of the only real art. Little by little people who want to be amused went to these receptions where Stein received in sandals and his wife in one garment fastened by a broach, which if it gave way might disclose the costume of Eve. Of course the curiosity was aroused and the anxiety as to whether it *would* give way; and the pose was, if you don't admire these daubs I am sorry for you; you are not of the chosen few. Lots of people went, Mrs. Sears amongst them and Helen; but I never would, being to old a bird to be caught by chaff. The misunderstanding in art has arisen from the fact that forty years ago—to be exact thirty-nine years ago—when Degas and Monet, Renoir and I first exhibited, the public did not understand, only the "élite" bought and time has proved their knowledge. Though the Public in those days did not understand, the artists did. Henner told me that he considered Degas one of the two or three *artists* then living.[3] Now the Public say—the foreign public—Degas and the others were laughed at; well, we will be wiser than they. We will show we know; not knowing that the art world of those days did accept these men; only, as they held "L'assiette de beurre,"[4] they would not divide it with outsiders. No sound artist ever looked except with scorn at these cubists and Matisse.

<div align="right">[Mary Cassatt]</div>

1. Cassatt's niece and namesake, daughter of her brother Gardner, was born in 1894. This letter is quoted in George Biddle, *An American Artist's Story*, pp. 223-25.

2. Gertrude Stein (1874-1946), like Cassatt, was born in Allegheny City, Pennsylvania, spent part of her childhood in Europe, and was strongly influenced by the intellectual spiritualism of William James. She had settled with her brother, Leo, in Paris in 1903, and by 1906 she was an important figure in the Paris art world.

3. Jean Jacques Henner (1829-1905) was a successful academic artist, prominent in the 1870s when the Impressionists first exhibited.

4. Literally "plateful of butter," an expression meaning a soft government job.

MARY CASSATT TO LOUISINE HAVEMEYER

Villa Angeletto
December 4 [1913]

Dear Louie,

Your last letter from the country is here this evening, with one from Mrs Havemeyer's trained nurse. She is going to take the copalchis but with the medicine which Dr Whitman gave to Dr Magain (her doctor) or rather told him about, she thinks the directions "vague." They are as simple as "kiss my hand," but I have written her the directions a child could understand. I rather wonder at the nurse. The point was she was not told when to take these three glasses of water, it does not make a bit of difference when she takes them provided the powder is steeped in the water eight hours, then the water drunk, the powder left in the bottom of the glass the glass again refilled & left eight hours, the water drunk and then the glass once more filled. So that the same powder is used for three glasses in the twenty four hours, the water to stand between each dose eight hours. Could anything be more simple? I have no doubt the remedy is ages old, perhaps may have been used by the inhabitants of the lost continent of Atlantis, as they probably had our ills. We poor humans don't change much. It is odd that you write about honey for I had just written to my gardener who is ignorant of the subject of bee keeping to apply to the "facteur" at Fresneaux who is an adept. Our honey is delicious the bees feeding on Linden flowers, so delicate. We had a good crop of cider apples this year, that and the pears are the only fruit except strawberries we had, in such a cold wet season.

You ask about my sending Dr Osler a pastel, no not yet. I brought seven pastels to town, four were large; a nude boy and his Mother [figure 42]. They were in many respects the best I have done, more freely handled & more brilliant in color. I kept one only. It is one of the best & very important I felt I ought to keep something of mine for my family. I kept also a round which I intended for Harrisburg.[1] The Durand-

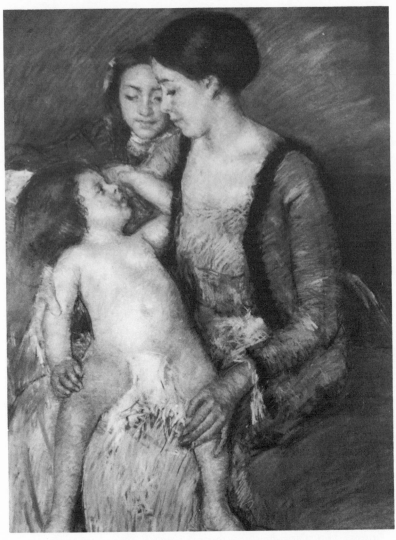

42. *Mother and Son on a Chaise Lounge, Daughter Leaning over Them*, 1913. Pastel on paper, 43 x 33½ in. Memorial Art Gallery of the University of Rochester, Marion Stratton Gould Fund.

Ruels were most anxious to buy and the other dealers, too, these two represent a good sum. My things sell for very good prices at the Paris sales. The other three pastels were more studies & would not have pleased Dr Osler. I hope that here I may do something suitable. I am working but not yet two seances a day. I am taking a breathing spell, &

getting models together. If you should see the photo taken here last spring & see me now you would see the difference, I can bear a good deal of fatigue, of course very few women work. I mean at a profession, so that they don't know that fatigue. If I were not doing that I could do as well as any I know, but I have always started on a journey after a long spell of work & naturally it has tired me. I hope when you come over not to be tired out with work then I can travel easily only I want Mathilde with me I cannot use my brain all day looking at pictures & pack my trunk & start the next day. Men have the advantage of women there, their clothes are more easily packed and they don't require so many. I suppose you will be as strenuous as ever and leave your maid behind you. Then I must be careful of my diet & also have a hot bath when I can get it. I have been like you. I have overlooked my bodily welfare, but I have worked so hard besides, and nothing takes it out of one like painting. I have only to look around me to see that, to see Degas a mere wreck, and Renoir and Monet too.

I am very glad you are lending your Manets to the Durand-Ruels for their opening, I hope they will have a good one. They have always been so conservative and honest. I like Joseph I like him better than his Father. The old man has been tenacious, but not generous to painters though he has given money too—but he thinks when artists sell to others it is treason to him. Yet he would not buy the things from Degas that Vollard gladly took and sold again at large profits. Vollard is a genius in his line he seems to be able to sell *anything*. When do you think you will come? Of course mid April is the time for Italy, if the season is good. You ought to land at Cannes then we can have a few days here, it is often lovely here at that time though last year we had a severe snow storm on April 14th! It was also very cold in Italy. . . .

<div style="text-align:right">

always most affectionately yours
Mary Cassatt
</div>

1. In 1905 Cassatt designed two round compositions of mothers and children, which she intended to submit to a mural competition for the state capitol of Pennsylvania in Harrisburg. Disillusioned by reports of graft in the project, however, she withdrew from the competition. One was kept for her family, while the other was sold to Harris Whittemore in 1915.

MARY CASSATT TO LOUISINE HAVEMEYER

<div style="text-align:right">

Villa Angeletto
December 11 [1913]
</div>

Dear Louie,

Mrs Warren was here yesterday & spoke very gratefully of your inviting

her to stay with you & investigate Eusapia [?]. She explained that nothing of that kind interested her, Psychical Research, she thinks is "material" she only cares for spiritual things, the spiritual side. I cannot follow her nor can I follow Florence Nightingale altogether. I am now reading F N's life & she certainly had the "saintly" side.[1] When she founded trained nursing little she thought that so many who adopt this noble calling would desert it to become parasites to the rich. It requires a great sense of duty and a religious feeling for that calling. I wish I could feel as they do people like F. N., towards God, but I cannot understand a *personal* God, Master of the Universe, I think we are surrounded by spiritual forces but I agree with Fabre in thinking the human brain unfit to grasp the universe.[2] Thus the love of God unless translated into a love of one's fellow creatures I don't understand.

Dec 15th. I was stopped here and perhaps just as well, we can discuss these things when we meet. I have the Life of Florence Nightingale, you must read it. She was of course a modern Saint, as I wrote above, & all the Saints had one thing in common, they all had a call, & all felt their duty towards humanity at large of more importance than to their immediate belongings. Fathers Mothers did not count except in a secondary degree. That is really being unselfish. To come back to other things, have you seen the "Illustration" with an account of the new Museum the André Jacquemart?[3] As I thought it is of no great account only very few fine things. She wasn't an artist, she told the "vendeuse" who is also mine at Laferniere that she was to be married and could then throw away her palette! No my dear your collection is *the* one, this of the André's has nothing of the 19th Century French, and nothing very good in the 18th Century. We will see it together in Paris, I hope. The weather here is *divine* this is the season. Yet people come later on in January when it is often dull grey and cold, and March is windy. This will come to you near Xmas time may you all be Merry and Happy together Heaps of love from

<div align="right">
Yours always affectionately

Mary Cassatt
</div>

1. Probably Sarah A. Tooley's *The Life of Florence Nightingale*, 1905.

2. Jean Henri Fabre (1823-1915) was a world-renowned entomologist and educator. His many books on insect life (*The Life and Love of the Insect, Social Life in the Insect World*, etc.) were quickly translated into English in this period.

3. The Musée Jacquemart-André, consisting of the house and art collection of Edouard André and his wife, Nélie Jacquemart, was left to the state in 1912.

Villa Angeletto
February 17 [1914][1]

Dear Sir,

Thank you very much for the "Magazine." I have just received a letter from Miss Brown who asked Ollendorf for the right to translate Segard's book into English.[2] He answered yes, and asked her five hundred francs and a price to be determined for the reproductions. She is writing Brentano in New York. Do you think that it might be successful?

Other news— Mrs. Havemeyer will arrive in Genoa on March 20th! I was thinking it would be April 20th, I do so much want to get some work done. I really can't be away for more than two days and it is so tiring to travel and converse all the time. I can't do it. I saw Renoir this afternoon, very well and painting and with pretty color, no more red. Madame was not there, she had gone to Nice.[3] He told me that she was also very well. But their cook told Mathilde that that wasn't true, that she was not herself and that she (the cook) thought that her diabetes was going to her head. This woman had been in her service for a very long time. Now he won't follow a diet, but they say if you go to Vichy regularly it isn't necessary.

My compliments to Madame Durand-Ruel and please accept, dear sir, my best regards

Mary Cassatt

Original in French.

1. This letter was dated 1915 by Venturi in his *Les Archives de l'Impressionisme* (Paris, 1939), but according to the Durand-Ruel files, it was received in 1914.

2. Achille Segard's *Mary Cassatt, Un Peintre des enfants et des mères* was published by Ollendorf in 1913. It was based on interviews held at Mesnil-Beaufresne in 1912.

3. Renoir had married Aline Charigot (whom he used frequently as a model) in 1890.

Mesnil-Beaufresne
July 3 [1914]

Dear Mr Biddle,

I have your letter with the kind offer of Mr Poole to hold an exhibition in Chicago of my work— There is to be an exhibition of pastels & pictures of Degas & of mine in New York in the autumn—to which I have promised to send all of my work I own. Four in all three

paintings and a pastel—to do what Mr Poole ask is quite impossible, even if I wished it, as most of the pictures are owned abroad—

I am glad to know you are pleasantly settled in Munich, which seemed to me when I was last there an agreeable place to live in— We are all here living the "simple life." The girls taking French lessons and long walks & seemingly content to be quiet— With kind regards from us all

<div align="center">

sincerely yours
Mary Cassatt
</div>

1. George Biddle (1885-1973) was an artist and writer from Philadelphia. He became acquainted with Cassatt through her niece, Ellen Mary. At this time Ellen Mary and some of the other nieces and nephews were visiting Mesnil-Beaufresne.

MARY CASSATT TO JOSEPH DURAND-RUEL

<div align="right">

Mesnil-Beaufresne
Wednesday [July 1914]
</div>

Dear Sir,

I received a letter from Miss Hallowell yesterday, a confidential letter, in which she writes me that Mr. Alder and Mr. Poole are one and the same, that is, they are both agents of the [Chicago] Art Institute. Even though I wrote Mr. Biddle that I wouldn't hear of an exhibition, he wrote to different members of my family to ask for pictures. I sent him a letter yesterday that will put an end to it. As for the two other individuals, their great worry is that my exhibition won't measure up to that of Mrs. B[1]— Miss H. wrote me that the portrait that the Luxembourg acquired, of Annunzio, by Mrs. B. is a real daub, truly the worst, but someone told them it was a masterpiece— Probably one of these gentlemen. If she has many nudes like the two she showed, the Chicago police could well step in. I told Mr. Biddle that anyone who lends a painting of mine to this exhibition will no longer be a friend of mine. What I'd like to know is, whether Mrs. B. is the instigator of this insult, because it is an insult.

I haven't heard a word from M. Segard. No doubt he is furious at receiving the pastel. How wrong I was to help him at all with the book. It was out of the goodness of my heart. And furthermore, he understood that.

I received a very nice note from Madeleine. If I could, I would go Saturday, but we have company and I can't get away, I hope she will be very happy. Everything seems promising.

<div align="center">

316
</div>

All my best to the whole family. I hope that Monsieur Durand-Ruel is well.

<div align="center">

Cordially yours

Mary Cassatt

</div>

1. Romaine Goddard Brooks (1874-1970) was an American artist who spent most of her life in Europe. Her *Portrait of Gabriele d'Annunzio, le poète en exile* (1912) was acquired by the Luxembourg in 1914.

The summer of 1914, which had begun so pleasantly for Cassatt as she entertained her nieces and nephews, turned dark on August 4 when Germany declared war on France. Her German maid, Mathilde, was forced to flee with her sister into neutral Switzerland, and the château at Mesnil-Beaufresne was endangered several times by the fighting in northern France. Cassatt herself was forced to wait out most of the war in her villa at Grasse.

MARY CASSATT TO LOUISINE HAVEMEYER

<div align="right">

10, rue de Marignan

Thursday, November 11 [1914]

</div>

Dearest Louie,

I have yours about your musicale & your speech.[1] Do lean Louie on the fact that German "Kulture" was purely masculine, and for that reason must disappear. That the victory of the Allies means liberty for Germans, a liberty which they had not temperament to acquire for themselves. Above all things there was no place for the intellectual qualities of women in their system. I was told the other day by Mme Acillas that this war has made men accept the fact of women voting with more tolerance, the womens movement has progressed.

Duret was here yesterday he thinks you ought to buy back the Veronese, he ranks it high. I haven't seen it since it has been restored. Also I am to see a Courbet, womans figure on Sunday. No word further from Mathilde I don't think I shall wait longer than Tuesday but hope to have her & Julie across the frontier. Demotte is coming to see me. I will add what he says. A dreadful struggle is going on now likely to be decisive, that is a supreme effort for the enemy to get to Calais. The Russians are doing well.

Demotte has just gone he tells me that half of Brussels Museum has

<div align="center">

317

</div>

43. Mary Cassatt at Villa Angeletto, Grasse, c. 1914.

been sent to Germany they have stolen everything at Lille, at Arras, and they fear at St Quentin! A German Art Critic! has advised their stealing all works of Art. The Rubens' at Maline are burnt! It is too sickening Oh! to see that wretched William made away with all his hoard [?] The news is not so good today they have taken Dixmude.

For them to get to Calais would indeed be a disaster. Heaps of love dear and love to all the family

<div align="right">every affectionately yours
Mary Cassatt</div>

It is cold here I need the sun

1. Louisine Havemeyer held regular Sunday musicales and often gave speeches for the women's suffrage movement.

MARY CASSATT TO JOSEPH DURAND-RUEL

<div align="right">Villa Angeletto
November 27 [1914]</div>

Dear Sir,

Mrs. Havemeyer cabled me last week urging me to sail for New York when you do. She is very kind, but I am much better off here as I am so sick at sea.

Now as to the prices and the insurance, I don't want to sell anything but the pastel. It seems to me that we will be running a great risk if a German boat should be in the North Atlantic.

I would like to have seen Madame Durand-Ruel and the children before I left, but I had a bad cold. We had an easy trip, but my heart was in my mouth the whole time because Pierre [her chauffeur] had lost his [driving] permit just as we were about to leave. He drove quickly because he knew he was about to be drafted. In fact, the notice arrived at the same time we did. It was for St. Malô, but he was accepted at Nice, a simple matter of form because everyone is ready.

I wish you all a good trip and a return in Peacetime, believe me, dear sir, very truly your friend

<div align="right">Mary Cassatt</div>

Original in French.

MARY CASSATT TO LOUISINE HAVEMEYER

<div align="right">Villa Angeletto
February 1, 1915</div>

Dearest Louie,

You must be busy, I hope the exhibition will be a success.¹ Of course

you have seen Joseph [Durand-Ruel], he has all the pictures I own. I
hope they got there safely. I really cannot give any of those to be raffled
for nor do I think it a good thing, it is lowering Art. You ought to do
well without that. I wish I had sent over Degas. Fancy giving that to be
raffled for and its falling into the hands of some one knowing nothing of
Art. How many do you think would appreciate anything outside of a
[illegible]. No don't lower the exhibition by anything like that. Keep
it very high. I would far rather give $5000 than one of my pictures. I
think the best thing you could do would be to get the Colonel to lend his
Degas also in the Old Masters room to lend some of your finest Courbets.
There would be a chance to show Courbets besides Rembrandts.

Of course everything here is the same. We look with apprehension
towards Spring and the spread of disease. Now we have convalescent
typhoid patients, & it is cold & bright, but when the heat comes? There
is a disease, even the pest propagated by a bug, which the blacks bring
with them. War is an infamy. The poor Belgians are still fleeing.
Mme Cachin writes that there have arrived those from the borders of
Holland, she has some in her district. Then the poor soldiers who have
recovered from their wounds & have to go back. Mathilde saw Mr
Stillman pass in an auto at San Remo. I have heard nothing from him. I
dont believe Italy is going to move. Heaps of love to you all

<div align="right">

ever yours affectionately
Mary Cassatt

</div>

1. The *Suffrage Loan Exhibition of Old Masters and Works by Edgar Degas and Mary Cassatt*
took place at M. Knoedler & Co., New York, April 7-24, 1915.

MARY CASSATT TO LOUISINE HAVEMEYER

<div align="right">

Villa Angeletto
February 4 [1915]

</div>

Dearest Louie,

George D.R has just written to me about Mrs R's portrait.[1] My dear I
would give it to you at once, (of course to be left to a Museum.) only
I have more than half promised it to the Petit Palais.

On no account shall Bessie Fisher ever own it. She sent me the most
decided messages regretting that there was so little likeness to her
Mother! The line of the back & the hand & that is all. Even the worm
will turn, & I see no excuse for her too evident desire to snub me.
Well let her rejoice in Miss Beaux portraits & leave me alone. Jennie

wrote that she was told Edgar Scott was crazy to get the picture. He or Brothers children are the only one's who could have even the shadow of a claim to it. I wonder if any one will care for it at the Exhibition. I doubt it, its home ought to be in Paris where I painted it.

Well things are moving our Ambassador insulted publicly in Berlin. Really the Germans are raving mad. What it is to hate! A lady who arrived in Nice from Boulogne a couple of days ago told our Vice Cousul that a German officer stabbed his English nurse & killed her in the Boulogne hospital & was taken out and shot! Of course he was in a fever but hate of the English went to his brain.

I am going over to see Mathilde soon & if possible take her to Florence with me for a few days, later on when the days are a little longer. Heaps of love dear & kisses to the babies. You must have the house full. Love to Annie & Addie

<div align="right">ever affectionately yours.
Mary Cassatt</div>

1. The portrait of Mrs. Robert Moore Riddle (*Lady at the Tea Table*, page 175); see Katherine Cassatt to Alexander Cassatt, November 30 [1883]. Cassatt had put the portrait aside, refusing to exhibit it, after the family of the sitter rejected it in 1886. She came across it again in 1914 while going through her storage area for works to be shown in an exhibition in Paris that June. It caused a sensation in the exhibition, prompting both the Luxembourg and the Petit Palais to offer for it. Before deciding, she sent it to the suffrage exhibition in New York, where it was acquired by the Metropolitan Museum.

MARY CASSATT TO COLONEL PAINE

<div align="right">Villa Angeletto
February 28 [1915]</div>

My dear Colonel Paine,

I come to appeal to you as a patriotic American to lend your Degas to the exhibition Mrs Havemeyer is arranging. The sight of that picture may be a turning point in the life of some young American painter. The first sight of Degas pictures was the turning point in my artistic life.

Never mind the object of the exhibition. Think only of the young painters. As to the suffrage for women it must come as a result of this awful war. With the slaughter of *millions* of men women will be forced, are now being forced to do their work, & we have only begun. Far worse is yet to come these next months. Brain and heart are so tortured we cannot settle to anything.

If the Allies get to Constantinople it will shorten matters, & though Bulgaria has a treaty with Germany it cannot be carried out; for 90

percent of the population are with the Allies & there would be a revolution. Oh! for a revolution in Germany but I am afraid that is hopeless. The emancipation of Germany will have to come from without.

Please excuse this letter but I have the success of this exhibition at heart.

<div style="text-align: right">With kind regards sincerely yours
Mary Cassatt</div>

MARY CASSATT TO LOUISINE HAVEMEYER

<div style="text-align: right">Villa Angeletto
March 12 [1915]</div>

Dear Louie,

Yours of the 26th Feb was waiting for me when I got back from Monte Carlo where I had been lunching with Kelekian & Seligman.[1] It is worthwhile to talk with Kelekian he knows the Balkans thoroughly, was much upset by the Greeks behaviour but to tell the truth had expressed fear about their conduct when he lunched here. I did not care to meet Seligman but found him very different from what I expected he had come here with K to luncheon. Seligman has a son & son in law officers at the front & he is giving most generously. The *French* are not; the rich parvenu manufacturers here are too mean for words. Fancy a woman letting her gardener be at the front since August & not giving the wife or child one sou nor sending a sou to the gardener! Her family are safely "embarqué." I tell you dear I am becoming absolutely socialist in my sympathies.

I think I needed to see a few people I am so depressed over all that is going on. In London they are very optimistic & think it will soon be over!

I have a letter from Annie, she says you speak so well. I was sure you would. Annie is tepid over the suffrage & thinks that the exhibition is less interesting than the poor, if she could prove to me that every dollar spent to see pictures would be given to the poor were there no exhibition, yes, but that isn't the case. I wish you had asked Mr Walters for the Degas head. Is it too late? I have no hopes of the Colonel, but I should think Theodate might persuade her Mother to lend. I am surprised at the coolness I show in thinking of exhibiting with Degas alone, but one thing Louie I can show, that I don't copy him in this age of copying. I cannot open a catalogue without seeing stealings from me. Vollard & Mme Renoir come to luncheon tomorrow M.R. wanted

to come. You may be sure she did not urge him. I am not working. Lots of love to you all, I am so glad to hear of Lulu's expectations, of course Addie & Mr P. are pleased. K. told me he had two splendid pieces of Persian in happenstance they would please Horace.

<div style="text-align: center;">

ever affectionately,
M. C.

</div>

1. Jacques Seligman (1858-1923) was an art dealer in Paris who specialized in eighteenth-century art.

MARY CASSATT TO THEODATE POPE

<div style="text-align: center;">

Villa Angeletto
June 8 [1915]

</div>

My dear dear Theodate,

What an awful experience you have had.[1] If you were saved it is because you have still something to do in this World— As long as we we live, we do not know to what usages we are to be put. What they must have felt at home until they got your cable— Mrs Havemeyers letter telling me you had sailed, only reached me after the catastrophe & I wired to the Paris office & heard you were saved— Did it need this aweful crime to rouse our people to a sense of their duty? And now what is to be the result, can we do enough to stop the war. Our help will be financial what can our fleet do? I leave here for Paris by motor on Saturday providing my papers are properly signed & hope to be in the rue de Marignan (no 10) the middle of the week— I intend going to Beaufresne later.

The cannon is no longer heard there. Mathilde is in Switzerland with her sister she has gone to pieces since the war. I got her safely to Italy she did not have to go to camp. Yet she lost thirty lbs & pined, & drove me nearly crazy— She showed no courage at all— It surprised me very much, but German women are like that— If the women of Germany were more on an equality with the men, the atrocities of this war would have been avoided—

I am so anxious to see you— Will you be able to come to France? Do let me know— Since I saw you last I have been so ill, no one thought I would recover—but I did, then I overworked & when the war cloud burst, I broke down under my responsibilities & it has taken me all winter to get well again,—& my sight is enfeebled[2]—

Much love & sympathy dear Theodate. Your courage will return I am

<div style="text-align: center;">

323

</div>

sure & life once more interest you, even I am absorbed by this great drama we are going through

Very affectionately yours
Mary Cassatt

1. Theodate Pope was one of the passengers on the *Lusitania*, sunk by a German submarine on May 7, 1915.
2. Cassatt had been troubled by cataracts since 1912.

MARY CASSATT TO LOUISINE HAVEMEYER

10, rue de Marignan
July 5 [1915]

Dearest Louie,

I feel like a perfect brute having written you those letters, but indeed dear I was upset, you dont know all I do. Joseph [Durand-Ruel] was here, & as to the exhibition he said it was the cause which kept many people away, "society" it seems is so against suffrage. Many regretted to him that they missed seeing a fine exhibition but their principles forbade their going. Also he said that if women voted it would be for peace at any price. That B would be the next President & &. In fact a goose, not too great tho' [to] take advantage of Degas still. Enough, I am disgusted at all their ways & feel I never want to sell a painting again. We must meet before I can tell you all. Fancy having Degas pastels retouched by Dan Domeinzo!

I am so glad you spoke to all those people, surely it will do good. Do you think if I have to stop work on account of my eyes I could use my last years as a propangadist? It wont be necessary if the war goes on, as it must. Women are now doing most of the work. I never felt so isolated in my life as I do now. Your letters are the only things that made me feel not altogether abandoned.

I was interrupted here. The last day in town is always so full of things to do. We leave today for Beaufresne, I have at last my permission it is a question if I can stay. I am so glad for Addie & Mr Peters. "Welcome Peters" is at last here, my love and congratulations to them all. I saw Trotti yesterday, he has seen much of Mr Stillman who has been very ill, & is now better, but his heart is affected seriously. He is at Lucerne with Doctor & much delighted when Trotti is there. My dear I believe remorse has something to do with it. Poor man, he is as you said last year abject. Such is a man when the woman fails. You know he has come round to suffrage. The "high-brows" at Mrs Vanderlip converted him. I

saw a fair Kings head at Kelekians, 13th Century from Rheims, different from yours but very fine. Trotti wants money. Mr S talks of buying a picture from him out of gratitude for his kindness during his illness. Perhaps he may. I went to see his house as a hospital certainly very comfortable.

I told Trotti the one thing you wanted was the Titian, he said he didnt think Cook would give it up. If this war goes on, many things will be for sale. I expect Demotte today about the tables for the hall at Kelso[1] one would suppose easy to find, but they are not.

Theodate leaves today for Brittany & then Bordeaux, for home. I got her a permission to see an 18th Century Brittany house near St Malo. She is subdued & calm. I tried my best for Harris Whitemores[2] sake to get her to buy a fine piece of renaissance carving to put over the door, it was only 300 fcs, but she wouldn't. I bought it or rather Kelekian did & kept it for me. No use putting it at Beaufresne now, for the Germans must be out of France before we can feel safe. They will never be driven from France. The only hope is defeat in another quarter. Trotti says the Italians found a *room* full of typhoid germs. Those poor survivors were of course possessed. German science is indeed a danger.

Heaps of love dear & don't mind my nerves

<div style="text-align:right">

always affectionately yours
Mary Cassatt

</div>

1. Gardner Cassatt's family's country home near Berwyn, Pennsylvania.
2. Harris Whittemore, Jr., was the grandson of Cassatt's old friend, John Howard Whittemore, whom she had visited in Connecticut in 1898-99.

MARY CASSATT TO HARRIS WHITTEMORE, JR.

<div style="text-align:right">

Mesnil-Beaufresne
Thursday, July 8 [1915]

</div>

Dear Mr Whittemore,

I have been long in answering your very kind letter which I received nearly two weeks ago. The reason is that I have been impressing on myself the absurdity of keeping a picture to leave to a nephew or niece, who care nothing for art, & certainly not for my pictures. It is a great pleasure and gratification to me that you like and want to own that particular picture the "Tonda" for I have always thought it one of my best— Will you do me a favor? Take the Tonda, & keep it for sometime, if once you have it on your walls & continue to like it then I will sell it to you, the price is five thousand dollars. I don't want the

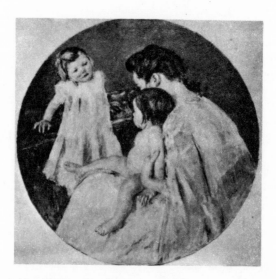

44. *Tondo Mural for Harrisburg Statehouse, #2*, 1905. Oil on canvas, diameter: 39½ in. Location unknown.

money now, later when the period of destruction is over & reconstruction begins it may be useful—

I came out here day before yesterday, it took me more than two weeks to get all the papers necessary to allow me to come here in my auto as this is in the army zone— To live here without horses & without an auto is to be a prisoner— I am hoping the Generals at Beauvais will give me a permission to use my auto in a strictly limited area, it is all I can ask— We are within fifty miles of the front & General Jeuffre's headquarters are at Chantilly I am told, that is thirty miles from here[1]—

As you say the world is mad just now. When is it to end— The French as an English Admiral wrote to me, are fighting gloriously & we all of course are sure of the ultimate victory—

I saw much of Theodate in Paris, she is very calm & seems none the worse for her terrible experience, but nerves have long memories— She sails on the 24th I envy her, & would love to accept your kind invitations to visit you all in that lovely mountain home which I saw only in early spring— I feel chained here—& have duties I must fulfill— With kindest regards to you, and all the family believe me always

Most sincerely yours
Mary Cassatt

326

1. Joseph Jacques Joffre (1852-1931) was the commander of the French troops during the battle of the Marne, which saved France from being immediately overrun by the Germans in the first months of the war.

MARY CASSATT TO GEORGE BIDDLE

Mesnil-Beaufresne
August 1 [1916]

Dear Mr Biddle,

I am sending you the book "l'Ornine,"—which you left here, with my excuses, I have only just learned that it was here—no one told me—

I am afraid you had a very fatiguing ride the other day if I had known, it was so far I would have suggested your bringing your bags & spending the night— As I am not to have my auto, I hope you will do so when you come again, then you can see the Larnies [?] "Falaise d'Anneuil" where it was thought the great battle would be fought which was fought in the Marne— The weather is hot enough now and I am hoping my eyes will benefit by the change— I look forward with longing to a return to Grasse in the autumn, where I shall not be quite so near the great tragedy— I wonder since I have been in the South why more painters don't go there, last January one could have worked out of doors all the month— Renoir had himself carried out to his garden nearly every day— With kind regards

Sincerely yours
Mary Cassatt

If only the Russians go on All my authorities think we must have another year!

MARY CASSATT TO GEORGE BIDDLE

10, rue de Marignan
September 29 [1917]

Dear Mr Biddle,

I must send you a line to congratulate you on the news you send me— even though I must not use my eyes at present.

I wish you every happiness and hope I may have the pleasure of making Mrs Biddles acquaintance. As to your being now engaged in the Art of war, I hope you will have every success against the enemy— We you know are war worn and weary, it seems as if the Arts of peace were gone for ever—

Degas died at midnight not knowing his state—

His death is a deliverence but I am sad he was my oldest friend here, and the last great artist of the 19th Century— I see no one to replace him— With kind regards

Sincerely yours
Mary Cassatt

MARY CASSATT TO LOUISINE HAVEMEYER

10, rue de Marignan
Tuesday, October 2 [1917]

Dearest Louie,

Of course you have seen that Degas is no more. We buried him on Saturday a beautiful sunshine, a little crowd of friends and admirers, all very quiet and peaceful in the midst of this dreadful upheaval of which he was barely conscious. You can well understand what a satisfaction it was to me to know that he had been well cared for and even tenderly nursed by his niece in his last days.[1] When five years ago I went to see them in the South, and told them what the situation was, his unmarried niece hesitated about going to see him, afraid he might not like her to come, but I told her she would not be there a week before he would not be willing to part with her, of course she found this true [?], and now for two years and a half she has never left him. She was at the [military] hospital at Nice and had training enough to know just how to nurse her Uncle. I put her in the hands of my neighbor Monsieur Theret [?] one of the well known Paris notaries and thanks to his advice everything is as it should be, for Degas brother had meant to have everything and rob his sisters children of their share. One sometimes can help a little in this World, not often. There [will] of course be a sale.[2] The statue of the "danseuse" if in a good state you ought to have. Renoir spoke of it enthusiastically to me. It is a very fine and original work. Of course M. Duret has written to you about the Veronese. He says Trotti will take 40,000 fcs. It is not the Old Masters which are selling dear but the Moderns. I have just had a Courbet brought to me to look at a very fine nude price 125,000 fcs. So you see the Courbets have gone up. There are people who have money, who will have any if this war goes on. Paris is full of Americans and English. Sat has been here for a day but as he has not signed for the war he will soon be released,[3] and will come here to see if he can find anything to do, or if he had better go home and find something there. The situation is not at all clear. If the Russians are treated as the Belgians are it may revive them.

328

The sanitary situation is *very* bad, in the country my Doctor told me he had whole families, *all the children* infected by syphillis by the Father when he returns on permission. An Army doctor told Sat that such a state of affairs had never been heard of. And I was told yesterday that it leads to leprosy! The Indian and African troops have spread the disease. This when men feel that they are going to be killed they are reckless. Oh my dear Louie humanity is always the same.

My operations are not yet. I am to see Dr B.[4] this week, he talks of the 10th but I doubt very much. I shall go South and have it done if it is not yet ripe. Miss Sudono [?] will take you this letter if she goes off on Saturday. Heaps of love how I want to see you.

<div style="text-align:right">

always affectionately yours
Mary Cassatt

</div>

1. Degas's niece, Jeanne Fèvre, later recounted reminiscences of him in her book, *Mon Oncle Degas* (Paris, 1949).

2. There were four sales of the contents of Degas's studio held by Galeries Georges Petit: May 6-8, 1918; December 11-13, 1918; April 7-9, 1919; and July 2-4, 1919.

3. "Sat" was the nickname for Cassatt's nephew, Gardner (b. 1886). The United States joined the war in April 1917.

4. Dr. Louis Borsch, a doctor from Philadelphia practicing in Paris.

MARY CASSATT TO LOUISINE HAVEMEYER

<div style="text-align:right">

10, rue de Marignan
December 12 [1917]

</div>

Dearest Louie,

Here I am still but shall I hope to be South in a few days. I hate to go and leave Sat still uncertain of his fate. He has passed his physical examination but not the mental, whatever that may be, & after that Washington must give him his commission, & that also will take time. His brother in law is here, and is often in Paris, as the Headquarters of the transport is here so he has society, as also everyone seems to be over here. I shall be very lonely, and as my sight gets dimmer every day, the operated eye will not help my sight much even tho' the secondary cataract is absorbed altogether which is very doubtful if not quite sure. I think you must have written to Grasse, as I have no letter for two weeks. There are many things I should like to tell you, one thing we all agree on that at home you none of you understand the conditions here. One thing is sure, the interest in Art remains, the Degas sale will be a sensation. I am glad that in the collection of pictures of other

<div style="text-align:center">

329

</div>

painters he owned I will figure honorably, in fact they thought the two, a painting, & a pastel were his at first. The painting is of the same date as the portrait you are keeping for me, the year after, as it is not a maternal subject.[1] I said to J.D.R. [Joseph Durand-Ruel] it would not sell so well, but he said otherwise. It was the one he asked me for and gave me the nude in exchange. There will be no nude like mine in the sale. The statue is in perfect condition. Joseph says it will be a more sensational sale than Rouarts. J. will send you through his Brother letters of Degas Renoir Monet, & I enclose some of my precious signatures. I cannot say how much I should like to see you once more, will it ever be? Heaps of love to you, and to Addie & all

most affectionately yours
Mary Cassatt

1. The painting Cassatt refers to, *Girl Arranging Her Hair* (page 130), is now in the National Gallery of Art, Washington, D.C. The portrait Mrs. Havemeyer was keeping for Cassatt was that of Mrs. Riddle (page 175).

MARY CASSATT TO LOUISINE HAVEMEYER

Villa Angeletto
December 28 [1917]

Dearest Louie,

I am here at last. Since the 16th, I was very reluctant to leave Paris, but I was only here two days when Sat got his promotion as 2nd lieutenant, and is on Genl Alterburys Staff so he won't miss me.

I send you a letter Degas wrote to me 30 years and more ago, and which his niece found amongst his papers it was never sent, but I remember the time.

I told Sat to offer you my Degas if I die before I can see you. I fixed the price for the three at $20,000, now dearest Louie if you don't want them don't take them, of course they will be sold as no one in the family can understand them or would care in the least for them. The nude is considered by everyone as one of his best, better than Marx's. There is nothing so complete in what he has left of nudes. Joseph is enthusiastic over the picture I gave in exchange. I would like a Museum to buy it but none of ours would dream of such a thing. In looking back over my life, how elated I would have been if in my youth I had been told I would have the place in the world of Art I have acquired and now at the end of life how little it seems, what difference does it all make.

I am nearer despair than I ever was, operating on my right eye before

the cataract was ripe, was the last drop. I asked Borsch if it was ripe and he assured me *it was*! The sight of that eye is inferior but still I saw a good deal in spite of the cataract now I see scarcely at all. Oh Louie what a World we live in. I feel more and more that this is the end of civilization.

May this year see an end to some of the suffering. As to the millenium after the war I don't believe in it.

Heaps of love to you all. I can not see to read letters and soon won't be able to write.

always affectionately yours
Mary Cassatt

MARY CASSATT TO LOUISINE HAVEMEYER

Villa Angeletto
September 8 [1918]

Dearest Louie,

Your letter with the article on our aviation. The account is not encouraging. An officiale here told me our own fleet would be here in action in two months, that was two weeks ago. I had a letter from Rene Gimpel who was in New York on July 4th & saw the parade & heard the speeches in the evening. He was quite cowed away. How little the majority feel as I do, some do though, as the same official said to me "the Elite of F[rance] has fallen," he might have added, and is falling. We are spending our future. Think of the misery of the families of the boys 20 & more. Of course Mme Joseph D.R wont leave France while her boy is in danger. George told me he was soon going to the front. Rene went to see Monet and found him at work on large panels of water lilies. One would have to build a room especially for them I suppose. I must say his "Nemphas" [Les Nymphéas] pictures look to me like glorified wallpaper. You have some of [the] best work. I wont go so far as D who thinks he has done nothing worth doing for 20 years, but it is certain that these decorations without composition are not to my taste. Impossible to hang these with other pictures, & alone they tire one. The weather here is good it has rained, that is there have been storms. *Dont* overdo Louie the machine will give out. We are all machines. I hope Electra is well give her my love. We are not yet in the thick of it with all our troops our time comes later. Heaps of love dear I hardly see to write.

ever affectionately yours
Mary Cassatt

Villa Angeletto
March 22, 1920

Dearest Louie,

I have yours of March 1st this morning & answer at once. You did well indeed to turn down the pastel of M de Mottes at such a price! I dont remember what it sold for at the Manzi sale,[1] but the portrait of the little girl sold for 15000 fcs! less by 100 fcs a pastel of mine. All the Degas went for almost nothing at that sale. Mme Manzi told me many Experts & all the dealers combined against her & J D.R. told me Manzi was not liked! Of course you had better get the one Aleck bought if they sell it I know nothing of the disposition of the pictures & to whom they are to go.[2] My Mothers portrait might go to Rob but it may not. I want to tell you something & to ask you to do something for me. Before leaving Paris I sold to the D R's all I had left of my dry points & a lot of pastel drawings, & amongst them one unique etching of Degas, un essai wet grain which Braque [Bracquemond] had got him to try, including therefore, in all there were 95 or 100 things. I asked them 10,000 fcs for the lot, that was in the Spring when I learnt about what the Grolier Club was going to do for my etchings.[3] They [Durand-Ruels] refused in the most decided manner alleging that there was no sale for my dry points & etchings at any good price, the most they could get was $4 or $5. Before coming here, as I wanted a reserve with them I let them have the lot for 5000 fcs. Just after that was concluded I had a letter from a Club asking if for $100 I would let them have something "a pencil sketch." Then came the picture of the man in the boat which I offered to give to Brown [Ellen Mary], she forgot to even thank me, seeing she did not care I sold it for the very moderate price of 10,000 fcs. Now the D R's will find a purchaser. I disposed of my sketches because I know at least they would be preserved. Now I have another picture in their hands, probably you know it the woman in shadow holding a child in her arms, if I sell it to them I want dollars, do you know at what price my pictures will sell. It seems to me I ought to have $3000. They never got over my selling that round picture to Harris Whittemore for [?] $5000, and oh! how they behaved about the pastel you bought. When I told that to Renoir he said they were like that. At that time I was so angry I wanted never to have anything to do with them again. I have done so much for them Renoir says I saved the house of course Mr Havemeyer & you did, but there were many others I sent them. Well dont bother about it if it gives you the least trouble. Only because, Oh my dearest Louie, how I should like to see your Courbet with you, but my dear my sight doesnt permit me to see pictures. The sight of the

332

left eye on which all depends is returning *very* slowly it is 5 months today since the operation. I see no signs of having sight enough to see in the summer.

Jaccacci is here, he was ill in Paris & was sent down here he has heart disease. What a man! One thing he avoids above all things, no responsibilities, he wants to talk, to amuse himself. He has just been made a correspondent of the Academie des Beaux Arts, honor which he declares he never took any steps to obtain also the red ribbon! I lent him books, you should have heard [him] talk of Tolstoi, he appreciates him as a great artist & says Russian literature is the only one based on a moral sense. But where is the morality in his case.

I wonder if he calls us Louie & Mary "behind" our backs? Every one else is called by their Christian names. He tells me that Theo has the money strictly in her own bank & isnt it possible that he may find he has not made a good thing out of it. I am enclosing a letter I received from a friend of the Kelekians, an American woman from California I believe who gives an account of Adnie's state. Of course it would be the best possible thing for the child to get away from her surroundings & amongst American girls I fancy Westover would not do, but you would——K. to ——[?]. I think the letter will please you.

I hope to be off from here in a month, when the family is coming I don't know. Mrs. Sears was to be in Paris the last of May or the beginning of June. If only you were coming, but I can well understand you cannot. We seem to be in a nice Mess, are we not going to declare that we are *not* at war with Germany? Poor Mathilde I cannot get her our money to her, nor send her any from Paris, except small sums at great loss. What a different mentality is hers from the class I have now, making use of me all the time, not my Swiss, but the Italian. My dearest Louie one does get tired of the World & one wants to go when lonliness & struggle is all there is to look forward to. I have not done what I wanted to but I tried to make a good fight of it. Heaps & heaps of love dearest friend to you & yours.

As always affectionately yours
Mary Cassatt

1. The Manzi sale took place in March 1919.
2. After the death of Lois Cassatt in January 1920, the collection that her husband, Alexander, had amassed (with Mary's aid) was to be dispersed.
3. In April 1919 the Grolier Club of New York asked Cassatt's aid in mounting an exhibition of her graphic work and in preparing a complete catalog of her prints.

Dec 28th 1922

Dear Mr St Gaudens

VILLA ANGELETTO
ROUTE DE NICE
GRASSE (A·M·)

I have taken refuge here from the gloom of Paris & I suppose you and Mrs St Gaudens are there & I regret I shall not have the pleasure of seeing you — I hope your Committee have found you some good things, but they are a jury.

It may interest you to know what Degas said when he saw the picture you have just bought for your Museum. It was painted in 1891 in the summer & Degas came to see me

after he had seen it at Durand-Ruels. He was chary of praises but he spoke of the drawing of the woman arm pushing the pivot & made a funny gesture indicating the knee & said No woman has a right to draw like that. He said the colour was like a hint which was not my opinion, but spoke of the picture to Berthe Morrisot
who did not like it. I can intestimet that if it has some feet of truth & be well drawn its place is a Museum might show the present generation that one worked & learnt our profession, & which will a task

MARY CASSATT TO HOMER SAINT-GAUDENS[1]

Villa Angeletto
December 28, 1922

Dear Mr. St. Gaudens,

I have taken refuge here from the gloom of Paris & I suppose you and Mrs. St. Gaudens are there & I regret I shall not have the pleasure of seeing you— I hope your Committee have found you some good things, but they are a Jury.

It may interest you to know what Degas said when he saw the picture you have just bought for your Museum.[2] It was painted in 1891 in the summer,[3] & Degas came to see me after he had seen it at Durand-Ruels. He was chary of praises but he spoke of the drawing of the woman's arm picking the fruit & made a familiar gesture indicating the line & said no woman has a right to draw like that. He said the color was like a Whistler which was not my opinion, he had spoken of the picture to Berthe Morisot who did not like it. I can understand that. If it has stood the test of time & is well drawn its place in a museum might show the present generation that we worked & learnt our profession, which isnt a bad thing— I hope you had a pleasant time in Rome. My best wishes to you & Mrs. St. Gaudens for the coming year. May it bring you all this troubled world can give of good.

Sincerely yours
Mary Cassatt

1. Homer Saint-Gaudens (b. 1880), son of the sculptor Augustus Saint-Gaudens, was director of fine arts of the Carnegie Institute, Pittsburgh.

2. *Young Women Picking Fruit* (page 251) was purchased by the Carnegie Institute in 1922.

3. The painting was actually done in the summer of 1892 rather than 189?. Durand-Ruel's stock book shows that it was received from the artist in August 1892.

In October *1923* Cassatt's housekeeper, Mathilde Valet, came across a group of twenty-five copperplates in storage, which had been worked in drypoint but appeared not to have been printed. Since Cassatt's eyesight was too poor to allow her to examine the plates herself and since the work had been done too long ago (over twenty years) for her to remember the original circumstances of the printing, she asked George Biddle to look at them. Both Biddle and her printer, Delâtre, found evidence on the plates that they had never been printed; they noted the presence of "blacking" and oil on the surface—both substances used to prepare the plate and wiped off before it is printed—and, next to some lines, the presence of a "burr" (the excess metal thrown to the side of the line by the scratching of the drypoint needle), which is worn away during printing. This evidence convinced Cassatt that they were indeed unprinted plates and that collectors would be eager to have impressions of them. She had Delâtre print six sets of the plates and had two of them sent to New York, where Mrs. Havemeyer took them to William Ivins, the print curator of the Metropolitan Museum. After Cassatt's happy experience with the rediscovery of the portrait of Mrs. Riddle (Lady at the Tea Table), which Mrs. Havemeyer had been instrumental in placing in the Metropolitan Museum, she may have expected to see the prints received with the same enthusiasm. But instead, Ivins immediately saw that the series was merely a poorer quality edition of designs that had already been printed and sold to museums and collectors many years before. He had some interest in this new edition, but he knew that it was less important than the original printing and could not command the same price. Both he and Mrs. Havemeyer explained the situation to Cassatt, suggesting that the misunderstanding was the fault of Mathilde, Biddle, Delâtre, or all three, and that for the sake of Cassatt's reputation, the prints could not be falsely advertised as new work.

Cassatt was unshaken in her belief in the prints. She defended herself and her collaborators and expressed her amazement at Ivins's response and at Havemeyer's disloyalty. Havemeyer's further attempts to soothe Cassatt only increased her outrage until Cassatt broke off the relationship entirely. In the face of this opposition in America, Cassatt turned to the French, whom she always believed had a greater appreciation of her work, and donated the series to the museum of the Petit Palais. The primary casualty of this affair was Cassatt's friendship with Havemeyer, which she never resumed. Havemeyer, on the other hand, although estranged from Cassatt, relinquished the friendship only at Cassatt's death.

Villa Angeletto
January 13 [1924]

Dear Sir,

We left Paris just in time, a day later and we would not have been able to cross the bridges on the flooded road. [Illegible] was in a bad state and the flu set in. I hope that none of you have caught it?

I had a visit from Mlle. Fèvre and her brother and sister-in-law. . . .

I have a letter from Mrs. Havemeyer. It seems that Mr. Ivins[1] has no desire to exhibit my dry points, according to him inferior, the plates worn. Mrs. Havemeyer didn't say a thing. She accepts Mr. Ivins' opinion! I am obliged to believe him. The two portfolios must be delivered to M. George [Durand-Ruel] who will keep them [at the Durand-Ruel Gallery in New York] until I have made a decision. Obviously they embarass Mrs. Havemeyer. Strange way to treat a friend. To console me she assured me that my well known name was to be used by their political party![2] I had written her earlier to say that I absolutely disapprove of their ideas. She was offended by this and then told herself that I would do what she wanted! Mr. Ivins finds my dry points expensive. He finds everything expensive. He complained the only time I saw him that you had sold him the Degas portrait $800 and that the price was exorbitant. Do you think that if I had made a gift of one series he would have found the other series so bad? I'm sure I don't know. [Illegible]. . . . The climate here is not at all good, I need some time to get used to it. When I am used to it, it is time to leave. In the Herald, the story of the René de Gas[3] children is really funny . . . [Illegible]. . . .

Life here is very expensive, but we found the hotels on the way exactly the same price as last year. I send you, dear sir, to all of you, my best wishes for this year and please believe me very truly your friend

Mary Cassatt

Original in French.

1. William Mills Ivins, Jr. (b. 1881), had become the first curator of prints at the Metropolitan Museum in 1916. A lawyer by training, he was known for his sharp tongue.
2. Mrs. Havemeyer had been active in the National Woman's Party.
3. René de Gas was Edgar Degas's brother.

Villa Angeletto
January 17, 1924

My dear Mr. Ivins,

Your letter is here, I must at once correct a wrong impression first as to my sight & then as to my memory. I can perfectly see my etchings & am not likely to forget those I have done, I see them every day when at home they are framed & line the walls— As for poor Mathilde What has she [done] to Mrs. Havemeyer [who] wishes to make her a scape goat for what I have done—it isn't necessary. I take all responsibility for my acts— Mr. McVitty was in Paris & impressed by the atmosphere of artists allowed himself to admire.[1] But quickly recovered, he told me he had all I showed him as new. When I showed him he had not he said nearly the same but so—it is the usual thing. the execution & the art— As to your kindness in giving me the money value Mr. McVitty told me that the price of my etchings went from $70 to $150 & that an average of 80 was very fair. I attach but little importance to the money part & amateurs who own any dry points of mine need not fear. As to your citing the prices paid at the Marx sale, you will be shocked to hear that a little pastel sketch of mine, for which he paid a few hundred francs sold for 4 or 6,000 frs—to the Petit Palais. I live over here & have no dealings with dealers at home. There will be no necessity to put out regulations on me—

But I have had a joy from which no one can rob me— I have touched with a sense of art some people once more— They did not look at me through a magnifying glass but felt the love & the life. The greatest living optitian when he saw the etching of the naked baby burst out oh! the baby is living & told me he had spent two hours the evening before looking at the etchings two hours of delight— Can you offer me anything to compare to that joy to an artist—

It is not pleasant to be accused of wanting to overcharge & cheat— even though poor Mathilde is to bear the burden—so I must tell you that etchings were passed or rather drypoints with little on them for 1950 frs which with the taxes made them come to over two thousand francs. It is the first time in my life that I have been accused of wanting to over-charge.

I have had my joy I have once more stirred a feeling of art—and nothing you or any one else can offer me, could give me that pleasure. Do not allow yourself to be upset. All the same the plates had never been printed before. I send your letter to Delatre he will understand

Sincerely yours
Mary Cassatt

338

1. Albert E. McVitty collected a number of paintings, pastels, and prints by Mary Cassatt.

MARY CASSATT TO JOSEPH DURAND-RUEL

Villa Angeletto
January 19 [1924]

Dear Sir,

I must be boring you with all these stories, but I have another letter from Mrs. Havemeyer, who is completely beneath contempt in this matter. She says that your brother was afraid that the drypoints were on the market. Doesn't he know the story?

The first person to see the drypoints was Mr. George Biddle who is a printmaker. It was one evening and I told him what we had just found and since I don't see work on copper very well, I showed them to him. He immediately saw the work and told me that there was still some black which one applies to help see the line and also the oil on the plate which facilitates the stroke of the needle. Now as you might imagine there was still a burr beside the line. When a plate is to be steel plated it must be brushed to remove all the oil. That also removes the burr. Delatre told me that my plates or rather my proofs show the burr. That is what proves, it seems to me, that they are not old worn out plates, as that imbecile said. The work is completely different than with old drypoints. Your brother will understand that and so will you. Now, I don't see any use in sending Ivins letter to Delatre, but do as you think best. What I want above all is not to lose it [the letter]. Mrs. Havemeyer assures me that what they all want is to protect my reputation! to prove that I am not a fraud! I will never forgive that. I told her that I could take care of my own reputation and that she should take care of hers. Poor woman, there wasn't a word, a gesture, nothing that one might have expected. But since she has become a politician, journalist, orator, she is nothing anymore. Now let's speak only of the drypoint series. If your brother knows any printmakers who are real artists and wants to show the things, let him do it, emphasizing above all that they were sketches from nature.

I am keeping them. I am not in a hurry.

Best regards
Mary Cassatt

To think that they have made me sick! Indeed I have been sick and am not yet recovered.

Original in French.

MARY CASSATT TO JOSEPH DURAND-RUEL

> Villa Angeletto
> March 1 [1924]

Dear Sir,

 I have indeed received your letter and the catalogue of the exhibition.
I can't believe that that [the matter of the prints] would have any
effect on my reputation as a painter. The Museum of the Petit Palais
[accepted the drypoints(?)] and I was asked to do a retrospective
exhibition. Now, I wanted to ask you, if you intended to borrow a pastel
or a painting from Mrs. Havemeyer, to not do it, because I have
broken off completely with her. I would like to have my two portfolios
of prints back and M. Georges wanted to have them wrapped and
shipped to me one addressed to rue de Marignan. They have never been
exhibited. If you want to give me the other, I will send them back to
my nephew. There was a similar story concerning a drawing by Degas,
but he had been dead for three years. I called on a friend who had taken
care of the matter.

 I hope the weather will be better in a month, since it is freezing every
night now.

 Please accept my kindest regards

> Mary Cassatt

Original in French.

MARY CASSATT TO HARRIS WHITTEMORE, JR.

> 10, rue de Marignan
> May 12, 1924

My Dear Mr. Whittemore

 I have been meaning to write to you for some time. You will easily
know why, to thank you for your offer to buy several of the series of dry
points which Mrs. Havemeyer offered for sale without the slightest
authority from me and without telling me what she was doing. These
plates representing states were found put away in the closet of my
painting room—found there by Malthilde, were shown to an artist
friend, an engraver, taken to Delâtre, son of Whistler's printer who was
also mine and Degas.' The proofs were shown to artists and amateurs and
generally admired. They were all dry points except two, one being an
aquatint of my Mother; that one I knew had already been printed, the
others had never been seen.

 I sent two sets to Mrs. Havemeyer to show to Mr. Ivins with a request

that he might exhibit them or rather one set and that if the Museum
wished to buy a set the price was to be $2,000. I based the price on what
my etchings are sold for here, at auction. My surprise and anger were
great when I was confronted with an accusation of fraud! Mrs.
Havemeyer immediately sided with Ivins and advanced the excuse that
my sight had so failed that no blame was to be attached to me, but to
Mathilde using her as a scapegoat! She then wrote that "they,"
Ivins, herself, and a collector who boasts of having all my etchings, were
so jealous of [my] reputation they were going to save me. I answered
that I could take care of my reputation and she of hers. I at once cabled
to send the etchings to George Durand-Ruel. She cabled that my
etchings were in the hands of the Durand Ruels, but they were not, only
one set had been sent as Joseph D-R. wrote to me. She had kept the
other to show to you and others, to sell them! There are only six sets for
sale, three I keep. As to the price Ivins most impertinently fixed and
what you know and I was to sign every proof the date of 1923
frankly accepting the fact that these were a series of plates previously
printed. They have sent me photos of my dry points to prove this. I took
them to my printer and he said what does this prove? I know there may
be one or even two proofs of them but I defy them to show a series.

I have no respect for the opinion of Mr. Ivins. I had a note from him a
few years ago when he told me that Whistler's etchings looked as if
spiders had been running over the plates! A most unbecoming attitude
for the Director of Print Department of a great museum to sneer at
Whistler indeed. Ivins cannot touch Whistler's fame. Mine is different.
He has accused me of fraud and Mrs. Havemeyer has accepted the
charge—of course all is over between us.

The etchings, not a full set, but twenty are in the Petit Palais. The
Prefet de la Seine in his own name and in the name of the City of Paris
has just written to thank me. One more word—there has never been a
question of money. I am very indifferent to that as I have all the comforts
I need and more money than I feel I ought to have. France is still the
easiest and the cheapest place to live in.

How I wish I could have seen your sister and your daughter when they
were here. My love to them and to Mrs. Whittemore. I am afraid I
shall never see them again unless they return to France and I can still
hope I may see you and tell you how much I appreciate your kindness.

With kindest regards most sincerely yours

Mary Cassatt

MATHILDE VALET TO MABEL [?][1]

[October 1925]
[enclosed with unintelligible
letter from Cassatt on
Mesnil-Beaufresne letterhead]

Dear Madame,

Mlle Cassatt is a little better right now she eats and sleeps a bit better, but she cannot walk any more, when it is nice weather we carry her out in the garden in an arm-car [voiture à bras]; she suffers very much from rheumatism because the weather has been so bad, we are hoping for a nice November. Our poor Sami[2] has been very sick for fifteen days now, we think an animal bit her, she seems like she has been poisoned we care for her as best we can I'm not sure we can save her, I hope so.

Mlle is always very nervous, she doesn't leave me a minute to write. I hope Madame is well

My respectful greetings
Mathilde Valet

Original in French.
1. The addressee is unknown.
2. One of Cassatt's Belgian griffons.

Mary Cassatt died on June 14, 1926.

LOUISINE HAVEMEYER TO [JOSEPH] DURAND-RUEL

Stamford [Connecticut]
June 16, 1926

Dear M. Durand-Ruel,

Thank you very much for the cable which I received this morning. I had already received the sad news, and while I am glad that Miss Cassatt is at last at rest, her death is a very, very sad loss to me. It is the breaking of a lifelong friendship.

I send you all my kindest messages and trust you are all well.

I am sending this to rue de Rome as I do not know the *new* address. I remain

very sincerely yours
L. W. Havemeyer

Chronology

1844

May 22—Mary Stevenson Cassatt is born in Allegheny City, Pennsylvania (now part of Pittsburgh). She is the fourth of five surviving children of Robert Simpson Cassatt (1806-1891) and Katherine Kelso Johnston Cassatt (1816-1895). Her siblings are Lydia Simpson Cassatt (1837-1882), Alexander Johnston Cassatt (1839-1906), Robert Kelso Cassatt (1842-1855), and Joseph Gardner Cassatt (1849-1911).

1850-55

The Cassatts travel in Europe, spending long periods in Paris, Heidelberg, and Darmstadt, where the children attend local schools.

1858-60

The Cassatts live at 1436 South Penn Square, Pennsylvania.

1860-65

The Cassatts shuttle back and forth between their Philadelphia residence and their country house in Cheyney, Chester County, Pennsylvania. Mary studies at the Pennsylvania Academy of the Fine Arts.

1866

c. January 1—Mary goes to Paris to further her art studies; she takes private lessons from Jean Léon Gérôme.

1867-68

With her friend from the Pennsylvania Academy, Eliza Haldeman, Cassatt travels to Courances and Ecouen (small art colonies near Paris) to study with various French masters, including Edouard Frère and Paul Soyer. Cassatt's submission to the Salon is refused.

1868

Cassatt's *La Mandoline* is accepted by the Salon; she returns to Paris for the duration of the exhibition. After the Salon she settles in Villiers-le-Bel, near Ecouen, where she studies with Thomas Couture.

1869

Cassatt paints in Paris at the beginning of the year. Spring—her submission to the Salon is refused. She takes a sketching trip with Miss Gordon throughout the Piedmont region of France and Italy.

1870

Cassatt studies in Rome with Charles Bellay. Spring—her *Une Contadina di Fabello; val Sesia (Piémont)* is accepted by the Salon. Fall—she returns to her family, now living at 23 South Street, Philadelphia, to escape the Franco-Prussian War; she sets up a studio.

1871

Cassatt moves with her family to Hollidaysburg, Pennsylvania (near Altoona). Fall—she visits Pittsburgh and Chicago, where some of her paintings are destroyed in the Great Chicago Fire. December—she arrives in Europe with her friend Emily Sartain.

1872

Cassatt and Sartain work in Parma, renting rooms at 21 Borgo Riolo. Fall—Cassatt

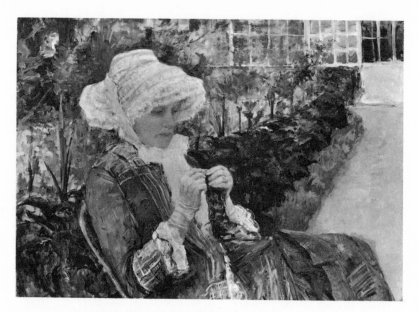

45. *Lydia Crocheting in the Garden at Marly*, 1880. Oil on canvas, 26 x 37 in. The
Metropolitan Museum of Art, Gift of Mrs. Gardner Cassatt, 1965.

goes to Madrid and then Seville, where she has a studio at the Casa de Pilatos.
 1873
April—Cassatt goes to Paris to see the Salon, where her *Torero and Young Girl* is on
view. She and her mother visit Holland and Belgium, spending the summer at 37,
place de Meir, in Antwerp. Fall—Cassatt travels south, stopping over in Parma on
her way to Rome.
 1874
Spring—Cassatt consults with Charles Bellay in Rome, then returns to Paris.
Summer—she works with Couture at Villiers-le-Bel. Fall—she settles in at 19, rue
de Laval, Paris.
 1875
Summer—Cassatt takes a trip home to Philadelphia.
 1877
Spring—Cassatt accepts Edgar Degas's invitation to exhibit with the Impressionist
group. Fall—her parents and Lydia come to live with her in Paris, at 13, avenue
Trudaine.
 1878
The planned Impressionist exhibition falls through, and Cassatt's debut with the
group is postponed to 1879.
 1879
Cassatt exhibits with the Impressionists for the first time (she participates in their

344

exhibitions again in 1880, 1881, and 1886). She works with Degas on a proposed (and never realized) print journal, *Le Jour et la nuit*. Summer—she travels to England, then retraces her 1869 sketching trip through the Piedmont region, spending the end of the summer in Divonne-les-Bains on Lake Geneva.

1880
Summer—Cassatt and her family, including Alexander's children, stay at Marly-le-Roi, near Paris.

1881
Summer—Cassatt and her family rent "Coeur Volant," a house in Louveciennes, near Paris. The dealer Paul Durand-Ruel begins representing Cassatt.

1882
November 7—Lydia dies from Bright's disease.

1884
January—Cassatt and her mother go to Spain, where her mother suffers severe ill health. Spring—Cassatt and her parents move to 14, rue Charron, Paris. Summer—they stay at Viarmes, about twenty miles north of Paris.

1885
Summer—Cassatt and her parents stay at Presles, north of Paris.

1886
Cassatt helps organize the eighth Impressionist exhibition. Her work is shown in the first major exhibition of Impressionist art in the United States.

1887
Spring—Cassatt and her parents move to an apartment at 10, rue de Marignan, which Cassatt would keep for the rest of her life. Summer—they stay at Arques-la-Bataille, near Dieppe.

1888
Summer—Cassatt breaks a leg in a horseback riding accident.

1889
Cassatt's interest in printmaking is revived, and she joins many of her Impressionist friends in a group called Société des Peintres-Graveurs, which exhibits at Galerie Durand-Ruel. Summer—Cassatt and her parents stay at Septeuil, west of Paris.

1890
Summer—Cassatt and her parents rent "Tournelles," a house in Septeuil.

1891
April—Cassatt's first individual exhibition, consisting of color prints, pastels, and paintings, is held at Galerie Durand-Ruel. Summer—Cassatt and her parents stay at the Château Bachivillers, the country house outside Paris she rented from 1891 to 1893. December 9—her father dies.

1892
Winter—Cassatt and her mother begin their practice of going south for the winter; they stay in Cap d'Antibes on the Côte d'Azur, then travel to Italy, returning to Paris in April 1892. Cassatt receives a commission to paint a mural for the Woman's Building at the World's Columbian Exposition in Chicago. She paints it at Bachivillers, shipping it to Chicago in early 1893.

1893
November—a major retrospective of Cassatt's work is held at Galerie Durand-Ruel.

1894

January-February—Cassatt and her mother stay at Villa "La Cigaronne," Cap d'Antibes. Spring—Cassatt buys and renovates the château at Mesnil-Beaufresne, fifty miles northwest of Paris; it remains her country house for the rest of her life.

1895

The Durand-Ruel Gallery in New York holds Cassatt's first individual exhibition in the United States. October 21—her mother dies.

1898-99

Cassatt visits the United States for the first time since 1875, going to Philadelphia, Boston, and Naugatuck, Connecticut.

1899

Alexander J. Cassatt becomes president of the Pennsylvania Railroad.

1901

Cassatt travels to Italy and Spain on a collecting trip with her friends Henry O. and Louisine Elder Havemeyer.

1904

December 31—Cassatt is named Chevalier of the Légion d'Honneur.

1906

December 28—Alexander J. Cassatt dies.

1908-9

Cassatt visits the United States for the last time.

1910

Cassatt travels to Egypt with her brother, J. Gardner Cassatt, and his family. Gardner becomes ill and dies on April 5, 1911.

1914

The outbreak of fighting in northern France during World War I forces Cassatt to leave Mesnil-Beaufresne and spend a major portion of the war years at the Villa Angeletto in Grasse (near Nice).

1915

Cassatt enthusiastically participates in the *Suffrage Loan Exhibition of Old Masters and Works by Edgar Degas and Mary Cassatt*, which was organized by her friend Louisine Havemeyer and held at M. Knoedler & Co., New York. Her eyesight failing, she undergoes the first of several operations for cataracts on both eyes.

1923-24

Cassatt finds a group of copper printmaking plates at Mesnil-Beaufresne that she had worked in drypoint, which she believes have never been printed. She has them printed in Paris and puts several editions up for sale. When museums and collectors discover that the plates had indeed been printed twenty years before and try to tell her so, Cassatt takes offense. The bitter argument that ensues terminates her lifelong friendship with Louisine Havemeyer.

1926

June 14—Mary Cassatt dies at Mesnil-Beaufresne.

Genealogy

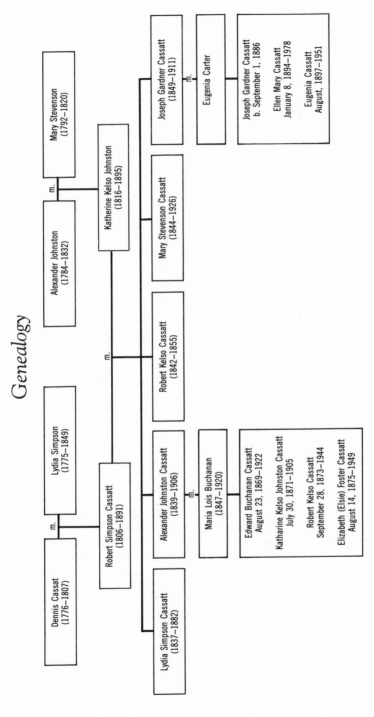

Acknowledgments

A project of this sort depends on the cooperation of a large number of people and institutions; I'm grateful for the opportunity to acknowledge the kindness shown me at every turn.

I would like to recognize at once the generosity of those branches of the Smithsonian Institution that directly supported my research as a Smithsonian Postdoctoral Fellow in 1982. The staffs of the National Museum of American Art, the Archives of American Art, and the National Portrait Gallery deserve recognition *en masse* for their untiring helpfulness. In particular I am grateful to Charles Eldredge, Harry Rand, Bill Treuttner, Lillian Miller, Ellen Miles, Garnett McCoy, Arthur Breton, and Karen Weiss for their special efforts on my behalf. Above all, those who earned my tremendous gratitude are Lois Fink, the excellent Curator of Research, and my friend and advisor, Adelyn Breeskin, Senior Consultant of Twentieth-Century Art, National Museum of American Art. In my estimation, Mrs. Breeskin's lifetime of superior connoisseurship assures her the highest place in Cassatt studies.

Equally essential has been the gracious cooperation of the many Cassatt heirs and those who are current possessors of Cassatt letters and documents. I would not have been able to proceed without the support of Mrs. Minnie Cassatt Hickman and other family members such as Mrs. Eric de Spoelberch and Mr. and Mrs. J. Robert Maguire. Another whose assistance was invaluable was Frederick Sweet, the original organizer of Cassatt correspondence. In Paris, I was fortunate in the kind cooperation of Charles Durand-Ruel, who allowed me to study the Cassatt letters in the extensive Durand-Ruel archives. I am also grateful to Robert Schmit for allowing me access to the Cassatt letters to Pissarro in his possession. Others who have been instrumental in calling letters to my attention include Madeleine Fidell-Beaufort, Alicia Faxon, Kathy Martinez, and Catherine Chartier.

I would like to express my sincere appreciation to those who granted me permission to publish letters in their collections: The Archives of American Art, Smithsonian Institution, Washington, D.C.; the Art Institute of Chicago; the Baltimore Museum of Art; the Brooklyn Museum; the Chicago Historical Society; the Fondation Custodia, Paris; the Hill-Stead Museum, Farmington, Connecticut; the Thomas J. Watson Library of the Metropolitan Museum of Art, New York; Moore College of Art, Philadelphia; the Museum of Fine Arts, Boston; the Pennsylvania Academy of the Fine Arts; the Philadelphia Museum of Art; Mr. J. Howard Whittemore; and Ms. Jeanne Welcher.

I would also like to thank friends and colleagues who have supported this effort and made valued contributions to it. I would especially like to thank my friends at Randolph-Macon Woman's College who acted as ready reference for areas outside my own. My warm appreciation goes to Dr. Elise Lequire who helped me tackle the translation of Cassatt's French letters. In addition, I would like to recognize once again the continuing support of Gert Schiff and Linda Nochlin, advisors of my doctoral research at the Institute of Fine Arts, out of which this book has grown. I would also like to recognize my conscientious and perceptive editor, Nancy Grubb.

Finally, I would like to take this opportunity to express my appreciation to my brother, Kenneth U. Mowll, and my friend Cathy D. Hemming for providing homes away from home when research demanded it, and to my mother, Slava E. Mowll, for being proud of me. N.M.M.

Sources

Archives of American Art, Smithsonian Institution, Washington, D.C.

Mary Cassatt to Ambroise Vollard	[1903]
Mary Cassatt to Carl Snyder	April 21 [1904]
Mary Cassatt to John W. Beatty	September 5 [1905]
Mary Cassatt to Clarence Gihon	September 13 [1905]
Mary Cassatt to John W. Beatty	[October 6, 1908]
Mary Cassatt to Homer Saint-Gaudens	December 28 [1922]
Mary Cassatt to William Ivins	January 17, 1924
Mathilde Valet to Mabel [?]	[October 1925]

The Art Institute of Chicago

Sarah Hallowell to Bertha Palmer	July 22 [1892]
Mary Cassatt to Sara Hallowell	[July 23, 1892]
Mary Cassatt to Bertha Palmer	September 10 [1892]
Mary Cassatt to Bertha Palmer	October 11 [1892]
Mary Cassatt to Bertha Palmer	December 1 [1892]
Mary Cassatt to Mary MacMonnies	[December 1892]
Sara Hallowell to Bertha Palmer	February 6 [1894]

Avery Archives, Glen Cove, New York

Mary Cassatt to Samuel P. Avery	March 2 [1893]

The Baltimore Museum of Art

Mary Cassatt to George A. Lucas	[June 1890]

The Brooklyn Museum

Mary Cassatt to Samuel P. Avery	June 9 [1891]

Chicago Historical Society

Bertha Palmer to Sara Hallowell	August 2, 1892
Bertha Palmer to Mary Cassatt	December 15, 1892
Bertha Palmer to Mary Cassatt	January 31, 1893
Bertha Palmer to Mary Cassatt	March 3, 1893

Durand-Ruel & Cie., Paris

Mary Cassatt to [Paul] Durand-Ruel	[September 1891]
Mary Cassatt to [Paul] Durand-Ruel	[September 1891]
Mary Cassatt to [Paul] Durand-Ruel	[February 17, 1892]
Mary Cassatt to [Joseph] Durand-Ruel	February 18 [1892]
Mary Cassatt to [Paul] Durand-Ruel	December 19 [1892]
Mary Cassatt to [Paul] Durand-Ruel	January 6, 1893
Mary Cassatt to [Joseph] Durand-Ruel	February 2 [1894]
Mary Cassatt to [Paul] Durand-Ruel	[February 10, 1894]
Mary Cassatt to [Paul] Durand-Ruel	[Summer 1894]

Mary Cassatt to [Paul] Durand-Ruel	May 19, 1896
Mary Cassatt to [Paul] Durand-Ruel	July 14 [1896]
Mary Cassatt to [Paul] Durand-Ruel	January 22 [1898?]
Mary Cassatt to [Paul] Durand-Ruel	[Summer 1903]
Mary Cassatt to [Paul] Durand-Ruel	November 10 [1903]
Mary Cassatt to [Paul] Durand-Ruel	[1903]
Joseph Durand-Ruel to William French	November 23, 1904
Mary Cassatt to [Joseph] Durand-Ruel	February 17 [1914]
Mary Cassatt to [Joseph] Durand-Ruel	[July 1914]
Mary Cassatt to [Joseph] Durand-Ruel	November 27 [1914]
Mary Cassatt to [Joseph] Durand-Ruel	January 13 [1924]
Mary Cassatt to [Joseph] Durand-Ruel	January 19 [1924]
Mary Cassatt to [Joseph] Durand-Ruel	March 1 [1924]
Louisine Havemeyer to [Joseph] Durand-Ruel	June 16, 1926

Mrs. Page Ely, Old Lyme, Connecticut

Mary Cassatt to J. Alden Weir	March 10, 1878

Fondation Custodia, Institut Néerlandais, Paris

Mary Cassatt to Théodore Duret	November 30 [1904]

Hill-Stead Museum, Farmington, Connecticut

Mary Cassatt to Ada Pope	April 7 [1900]
Mary Cassatt to Theodate Pope	May 19 [1903]
Mary Cassatt to Ada Pope	June 30 [1903]
Mary Cassatt to Theodate Pope	[September 1903]
Mary Cassatt to Theodate Pope	November 30 [1903]
Mary Cassatt to Theodate Pope	October 12 [1910]
Mary Cassatt to Theodate Pope	December 23 [1910]
Mary Cassatt to Theodate Pope	February 19 [1911]
Mary Cassatt to Theodate Pope	June 8 [1915]

The Metropolitan Museum of Art, New York

Mary Cassatt to Louisine Havemeyer	December 25 [1902]
Mary Cassatt to H. O. Havemeyer	February 3, 1903
Mary Cassatt to Louisine Havemeyer	November 20 [1903]
Mary Cassatt to Louisine Havemeyer	November 13 [1910]
Mary Cassatt to Louisine Havemeyer	January 9 [1912]
Mary Cassatt to Louisine Havemeyer	January 11 [1912]
Mary Cassatt to Louisine Havemeyer	December 4 [1913]
Mary Cassatt to Louisine Havemeyer	December 11 [1913]
Mary Cassatt to Louisine Havemeyer	November 11 [1914]
Mary Cassatt to Louisine Havemeyer	February 1, 1915
Mary Cassatt to Louisine Havemeyer	February 4 [1915]
Mary Cassatt to Colonel Paine	February 28 [1915]
Mary Cassatt to Louisine Havemeyer	March 12 [1915]
Mary Cassatt to Louisine Havemeyer	July 5 [1915]
Mary Cassatt to Louisine Havemeyer	October 2 [1917]
Mary Cassatt to Louisine Havemeyer	December 12 [1917]

Mary Cassatt to Louisine Havemeyer	December 28 [1917]
Mary Cassatt to Louisine Havemeyer	September 8 [1918]
Mary Cassatt to Louisine Havemeyer	March 22 [1920]

Moore College of Art, Philadelphia

Emily Sartain to John Sartain	December 15, 1871
Emily Sartain to John Sartain	January 1 [1872]
Emily Sartain to John Sartain	January 12, 1872
Emily Sartain to John Sartain	January 22, 1872
Emily Sartain to John Sartain	February 18, 1872
Emily Sartain to John Sartain	March 7, 1872
Emily Sartain to John Sartain	April 1, 1872
Emily Sartain to John Sartain	October 9, 1872
Emily Sartain to John Sartain	November 17, 1872
Emily Sartain to John Sartain	May 8, 1873
Emily Sartain to John Sartain	June 17, 1874

Museum of Fine Arts, Boston

Mary Cassatt to Rose Lamb	November 30 [1892]
Mary Cassatt to Rose Lamb	April 26, 1895

The New York Public Library

Mary Cassatt to Eugenie Heller	[1893]

Pennsylvania Academy of the Fine Arts, Philadelphia

Eliza Haldeman to Samuel Haldeman	January 26, 1860
Eliza Haldeman to Samuel Haldeman	February 4, 1860
Eliza Haldeman to Samuel Haldeman	December 21, 1861
Mary Cassatt and Eliza Haldeman to The Committee on Instruction	March 7, 1862
Eliza Haldeman to Samuel Haldeman	March 7, 1862
Eliza Haldeman to Mrs. Samuel Haldeman	March 17, 1862
Edward A. Smith to the Misses Welch, Haldeman, Cassatt, Lewis	March 26, 1862
Mary Cassatt to Eliza Haldeman	January 2, 1863
Mary Cassatt to Eliza Haldeman	March 18 [1864]
Eliza Haldeman to Samuel Haldeman	[Spring 1864]
Eliza Haldeman to Mrs. Samuel Haldeman	October 28, 1866
Eliza Haldeman to Samuel Haldeman	December 4, 1866
Eliza Haldeman to Alice Haldeman	February [1867]
Eliza Haldeman to Mrs. Samuel Haldeman	February 19-20, 1867
Eliza Haldeman to Mrs. Samuel Haldeman	March 8, 1867
Eliza Haldeman to Mrs. Samuel Haldeman	May 15, 1867
Eliza Haldeman to Mrs. Samuel Haldeman	September 5, 1867
Eliza Haldeman to Samuel Haldeman	October 1, 1867
Eliza Haldeman to Samuel Haldeman	April 24, 1868
Eliza Haldeman to Mr. and Mrs. Samuel Haldeman	May 8, 1868
Eliza Haldeman to Alice Haldeman	May 13, 1868

Eliza Haldeman to Mrs. Samuel Haldeman	May 28, 1868
Eliza Haldeman to Mrs. Samuel Haldeman	October 15, 1868
Mary Cassatt to Eliza Haldeman	August 17, 1869
Mary Cassatt to Emily Sartain	[Spring 1871]
Mary Cassatt to Emily Sartain	May 22 [1871]
Mary Cassatt to Emily Sartain	June 7 [1871]
Mary Cassatt to Emily Sartain	July 10 [1871]
Mary Cassatt to Emily Sartain	October 21 [1871]
Mary Cassatt to Emily Sartain	October 27 [1871]
Mary Cassatt to Emily Sartain	May 25 [1872]
Mary Cassatt to Emily Sartain	June 2 [1872]
Mary Cassatt to Emily Sartain	October 5 [1872]
Mary Cassatt to Emily Sartain	October 13 [1872]
Mary Cassatt to Emily Sartain	October 27 [1872]
Mary Cassatt to Emily Sartain	January 1, 1873
Mary Cassatt to Emily Sartain	June 25 [1873]
Katherine Cassatt to Emily Sartain	July 4 [1873]
Mary Cassatt to Emily Sartain	November 26 [1873]
Emily Sartain to Mary Cassatt	[May 25, 1875]
Mary Cassatt to Harrison Morris	March 2, 1904
Mary Cassatt to Harrison Morris	August 29 [1904]

Philadelphia Museum of Art

Mary Cassatt to Lois Cassatt	August 1, 1869
Robert Cassatt to Alexander Cassatt	October 4 [1878]
Katherine Cassatt to Alexander Cassatt	November 22 [1878]
Robert Cassatt to Alexander Cassatt	December 13, 1878
Robert Cassatt to Alexander Cassatt	May 21, 1879
Robert Cassatt to Alexander Cassatt	September 1, 1879
Katherine Cassatt to Alexander Cassatt	April 9 [1880]
Mary Cassatt to Alexander Cassatt	November 18 [1880]
Katherine Cassatt to Alexander Cassatt	December 10 [1880]
Mary Cassatt to Edward Cassatt	January 1881
Katherine Cassatt to Katharine Cassatt	April 15 [1881]
Robert Cassatt to Alexander Cassatt	April 18, 1881
Katherine Cassatt to Alexander Cassatt	September 19 [1881]
Robert Cassatt to Alexander Cassatt	July 3, 1882
Mary Cassatt to Alexander Cassatt	[May 1883]
Robert Cassatt to Alexander Cassatt	May 25 [1883]
Mary Cassatt to Lois Cassatt	June 15 [1883]
Mary Cassatt to Alexander Cassatt	June 22 [1883]
Mary Cassatt to Alexander Cassatt	August 3 [1883]
Mary Cassatt to Alexander Cassatt	October 14 [1883]
Katherine Cassatt to Alexander Cassatt	November 30 [1883]
Mary Cassatt to Alexander Cassatt	January 5, 1884
Mary Cassatt to Alexander Cassatt	March 6 [1884]
Mary Cassatt to Alexander Cassatt	March 14 [1884]
Mary Cassatt to Alexander Cassatt	March 28 [1884]
Mary Cassatt to Alexander Cassatt	April 17 [1884]
Mary Cassatt to Alexander Cassatt	April 27 [1884]
Mary Cassatt to Alexander Cassatt	May 12 [1884]

Mary Cassatt to Lois Cassatt	December 29 [1884]
Mary Cassatt to Katharine Cassatt	January 21, 1885
Mary Cassatt to Lois Cassatt	January 28 [1885]
Mary Cassatt to Lois Cassatt	March 1 [1885]
Mary Cassatt to Lois Cassatt	April 3 [1885]
Mary Cassatt to Lois Cassatt	May 6 [1885]
Mary Cassatt to Alexander Cassatt	May 17 [1885]
Mary Cassatt to Alexander Cassatt	September 21 [1885]
Robert Cassatt to Alexander Cassatt	May 5, 1886
Mary Cassatt to Lois Cassatt	June 30 [1886]
Mary Cassatt to Alexander Cassatt	September 2 [1886]
Katherine Cassatt to Alexander Cassatt	December 10, 1886
Katherine Cassatt to Alexander Cassatt	January 23, 1891
Katherine Cassatt to Alexander Cassatt	July 23, 1891
Robert Cassatt to Alexander Cassatt	July 28, 1891
Mary Cassatt to Alexander Cassatt	December 17 [1891]
Katherine Cassatt to Lois Cassatt	[September 8, 1892]
Mary Cassatt to Carroll Tyson	July 11, 1904
Mary Cassatt to Lois Cassatt	January 27, 1907
Mary Cassatt to George Biddle	July 3 [1914]
Mary Cassatt to George Biddle	August 1 [1916]
Mary Cassatt to George Biddle	September 29 [1917]

Collection Denis Rouart, Paris

Mary Cassatt to Berthe Morisot	[Fall 1879]
Mary Cassatt to Berthe Morisot	[Spring 1880]
Mary Cassatt to Berthe Morisot	[April 1890]
Mary Cassatt to Berthe Morisot	[June 22, 1890]

Galerie Schmit, Paris

Mary Cassatt to Camille Pissarro	[1881]
Mary Cassatt to Camille Pissarro	[1881]
Mary Cassatt to Camille Pissarro	November 27 [1889]
Mary Cassatt to Camille Pissarro	[June 1891]
Mary Cassatt to Camille Pissarro	[November 15, 1891]
Mary Cassatt to Camille Pissarro	[November 17, 1891]
Mary Cassatt to Camille Pissarro	June 17 [1892]

Thomas J. Watson Library, The Metropolitan Museum of Art, New York

Mary Cassatt to Eugenie Heller	June 28 [1893]
Mary Cassatt to Eugenie Heller	December 21 [1893]
Mary Cassatt to Eugenie Heller	January 30 [1894]
Mary Cassatt to Eugenie Heller	February 14 [1894]
Mary Cassatt to Eugenie Heller	August 12 [1894]
Mary Cassatt to Eugenie Heller	[c. February 1, 1896]
Mary Cassatt to Eugenie Heller	February 24 [1896]
Mary Cassatt to Eugenie Heller	September 22 [1896]

The J. H. Whittemore Company, Naugatuck, Connecticut

Mary Cassatt to John H. Whittemore	December 22 [1893]

Mary Cassatt to John H. Whittemore February 15 [1894]
Mary Cassatt to Harris Whittemore, Jr. July 8 [1915]
Mary Cassatt to Harris Whittemore, Jr. May 12 [1924]

PUBLISHED SOURCES

Biddle, George. *An American Artist's Story*. Boston: Little, Brown, and Co., 1939.

Mary Cassatt to Ellen Mary Cassatt March 26, 1913

Guerin, Marcel, ed. *Degas Letters*. Translated by Marguerite Kay. Oxford: Bruno Cassirer, 1947.

Edgar Degas to Count Lepic [1879]

Camille Pissarro. *Letters to His Son Lucien*. Edited with the assistance of Lucien Pissarro by John Rewald. Salt Lake City: Peregrine Smith, Inc., 1981.

Camille Pissarro to Lucien Pissarro April 3, 1891
Camille Pissarro to Lucien Pissarro April 25, 1891

Selected Bibliography

Biddle, George. *An American Artist's Story*. Boston: Little, Brown, and Co., 1939. Includes important reminiscences of Cassatt from the perspective of a younger American artist abroad.

Breeskin, Adelyn. *Mary Cassatt, A Catalogue Raisonné of the Oils, Pastels, Watercolors, and Drawings*. Washington, D.C.: Smithsonian Institution Press, 1970. Admirable first effort to organize the large corpus of mostly undated works. Second, revised edition is now underway.

Breeskin, Adelyn. *The Graphic Work of Mary Cassatt, A Catalogue Raisonné*. New York: H. Bittner & Co., 1948. Second edition, Washington, D.C.: Smithsonian Institution Press, 1979. Survey of Cassatt's prints, including important introductory remarks.

Davis, Patricia T. *End of the Line, Alexander J. Cassatt and the Pennsylvania Railroad*. New York: Neale Watson Academic Publications, Inc., 1978. Extensively researched history of Alexander Cassatt and his contribution to the American railroad industry.

Guerin, Marcel, ed. *Degas Letters*. Translated by Marguerite Kay. Oxford: Bruno Cassirer, 1947. Rough translations of the few known letters of Edgar Degas.

Hale, Nancy. *Mary Cassatt, a Biography of the Great American Painter*. Garden City, N.Y.: Doubleday & Co., 1975. A worthy attempt to write a complete Cassatt biography, but occasionally bogs down in personal detail and questionable psychological interpretation.

Havemeyer, Louisine W. *Sixteen to Sixty, Memoirs of a Collector*. New York: Privately printed, 1961. Exuberant account of the collecting activities of Mr. and Mrs. Henry O. Havemeyer, including a tribute to Cassatt and her role in shaping their collection.

Pissarro, Camille. *Letters to His Son Lucien*. Edited with the assistance of Lucien Pissarro by John Rewald. Salt Lake City: Peregrine Smith, Inc., 1981. Rich source of information about Impressionist activities from 1883 to 1903. Frequent mentions of Cassatt.

Segard, Achille. *Mary Cassatt, Un Peintre des enfants et des mères*. Paris: Librairie Paul Ollendorf, 1913. The first major study of Cassatt's work. The interpretations are still valuable, especially since much is drawn from interviews with Cassatt.

Shapiro, Barbara Stern. *Mary Cassatt at Home*. Boston: Museum of Fine Arts, 1978. Catalog of an important exhibition that juxtaposed Cassatt's paintings with the objects in them from her home and studio.

Sweet, Frederick. *Miss Mary Cassatt, Impressionist from Philadelphia*. Norman: University of Oklahoma Press, 1966. The first biography to be based on the Cassatt letters and still a most reliable survey of her life and work.

Venturi, Lionello. *Les Archives de l'Impressionisme*. 2 vols. Paris: 1939. Publishes a number of the letters by Impressionist artists in the Durand-Ruel archives, including thirty-one by Cassatt.

Index

357

Photography Credits

All photographic material was obtained directly from the collection or photographer indicated in the caption, except for the following: Courtesy The Art Institute of Chicago: plate 31; E. Irving Blomstraan: plate 25; Will Brown, Philadelphia: plate 17; Bulloz, Paris: plates 12, 41; Courtesy Chicago Historical Society: plates 29, 30, 32; Armand Delaporte [?] (courtesy Archives of American Art, Smithsonian Institution, Washington, D.C.—Frederick Sweet Papers): plate 38; Rick Echelmeyer, Philadelphia: plate 1; Baroni E. Gardelli (courtesy The Pennsylvania Academy of the Fine Arts): plate 5; Gihon and Nixon (courtesy The Pennsylvania Academy of the Fine Arts): plate 3; Courtesy Library of Congress, Washington, D.C.: plate 7; Courtesy the estate of Mrs. John B. Thayer: plates 20, 24, 43, 46; Eugene L. Mantie: back cover; Courtesy New York Public Library, Astor, Lenox and Tilden Foundations: plates 8, 11, 13.